The QUEEN'S PICTURES

ROYAL COLLECTORS
THROUGH THE CENTURIES

SPONSORED BY

Coutts&Co

IN ASSOCIATION WITH
National Westminster Bank

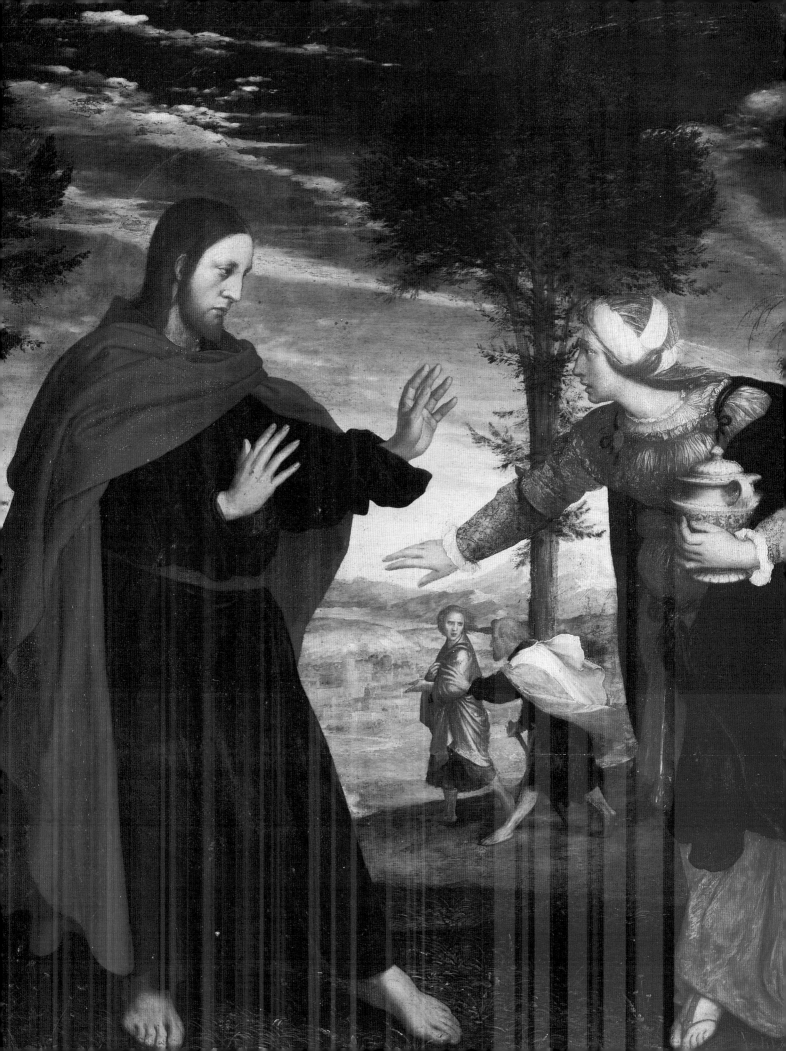

The QUEEN'S PICTURES

ROYAL COLLECTORS THROUGH THE CENTURIES

CHRISTOPHER LLOYD

WITH AN ESSAY BY
SIR OLIVER MILLAR

NATIONAL GALLERY PUBLICATIONS, LONDON
IN ASSOCIATION WITH
HARRY N. ABRAMS, INC., PUBLISHERS, NEW YORK

© National Gallery Publications Limited 1991

First published in Great Britain in 1991 by
National Gallery Publications Limited, London

Library of Congress Catalog Card Number 91-62092

ISBN 0–8109–3761–1

Clothbound edition distributed in the United States of America and Canada
in 1992 by Harry N. Abrams, Inc., New York. A Times Mirror Company

Designed by Simon Bell
Printed and bound in Great Britain by
Butler and Tanner Limited, Frome and London

Acknowledgements

The Queen's Pictures: Royal Collectors through the Centuries has been a joint undertaking by the Royal Collection and the National Gallery. A number of people from both institutions have helped to bring the project to fruition in a spirit of friendly co-operation.

For the National Gallery Michael Wilson (Head of Exhibitions), assisted by Mary Hersov and Joanna Kent, Martin Wyld (Head of Conservation), Margaret Stewart (Registrar) and Jean Liddiard (Press Officer) have been instrumental in the organization and in dealing with administrative matters. Erika Langmuir (Head of Education), Joan Lane (Media Resources Officer) and Herb Gillman (Designer) have all played an invaluable role in the mounting and presentation in the new exhibition space of the Sainsbury Wing.

For the Royal Collection Caroline Crichton-Stuart (Secretary to the Director) has overseen all aspects of the exhibition from its inception. The Hon. Caroline Neville (Loans Officer) has made a fundamental contribution in arranging transport. The conservators, Viola Pemberton-Pigott with Rupert Featherstone and Karen Ashworth, as well as Elizabeth Calvert and Joe Cowell, have been tireless in the enormous task of preparing the pictures and the frames. Simon Bobak, Lucilla Kingsbury and Keith Laing also undertook important conservation projects connected with the exhibtion. Dr Christopher White (Director, The Ashmolean Museum, Oxford) gave useful advice during the early stages.

The firm of Arnold Wiggins, through the kind offices of John Morton-Morris of Hazlitt, Gooden and Fox, gave generous assistance at a critical juncture in the restoration of some of the frames and made available a period Morant frame for the portrait of *Pope Pius VII* by Sir Thomas Lawrence. Michael Gregory, Pippa Mason and members of Wiggins's workshop all played a significant part in these preparations.

I am indebted to Patricia Williams (Director of Publications), Felicity Luard (Publisher), Sue Curnow (Production Manager), and Emma Shackleton (Editorial Assistant) of National Gallery Publications Limited for their work on the catalogue, and to Simon Bell, Denny Hemming and Luci Collings.

For help and guidance over particular problems arising in the catalogue entries thanks are due to Sir Roy Strong, Adrian Hollis, Professor J. B. Trapp, Dr David Ekserdjian, Timothy Wilson, Dr Maurice Keen, Dr Christopher Brown, Jane Martineau, David Jaffé and Dr Elizabeth McGrath. The kindness of the Librarian of the National Gallery, Elspeth Hector, and her counterpart in the Library of the Department of Western Art, The Ashmolean Museum, Oxford, Eunice Martin, facilitated the writing of the catalogue entries.

Everyone who works on the paintings in the Royal Collection owes an incalculable debt to the scholarly achievements of Sir Oliver Millar, whose knowledge of individual pictures both in the art-historical sense and in the context of the collection itself is unrivalled. The catalogue entries could not have been written without the groundwork undertaken by Sir Oliver in his published catalogues and in the copious notes deposited in the files of the Royal Collection. To be able to refer to the typescript of his *Catalogue of the Victorian Pictures in the Royal Collection* before publication was also a particular advantage. It is therefore apt that one of the two introductory essays in this book should have been written by Sir Oliver Millar. Similarly, it is appropriate that Dr Nicholas Penny, Clore Curator of Renaissance Art in the National Gallery, should have helped greatly in the compiling of the second essay, complementing Sir Oliver's. These two contributions help to set the paintings and the catalogue entries in a more specific context.

Finally, on a more personal basis, I am deeply grateful to the two people who typed my manuscript: first of all at the start my wife, Frances, and, secondly, Caroline Crichton-Stuart, who was responsible for the lion's share and succeeded in a most professional manner and against all odds in turning my messy manuscript into an immaculate typescript.

Christopher Lloyd
SURVEYOR OF THE QUEEN'S PICTURES

Contents

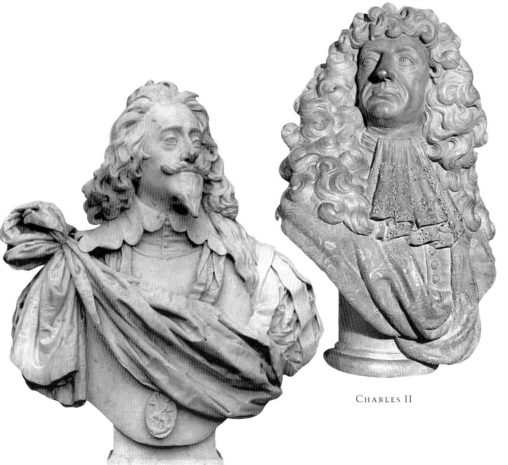

CHARLES I

CHARLES II

FREDERICK, PRINCE OF WALES

CATALOGUE 43

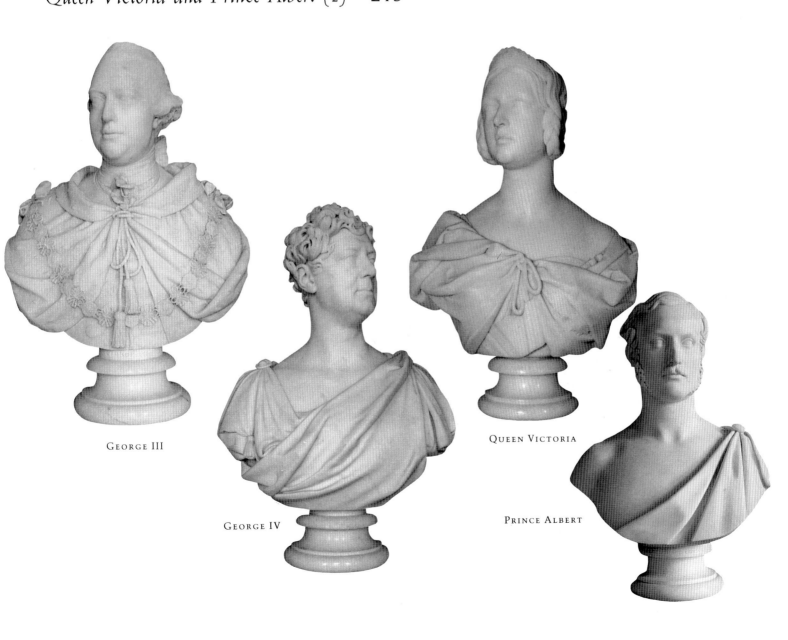

GEORGE III

GEORGE IV

QUEEN VICTORIA

PRINCE ALBERT

Sponsors' Preface

SINCE our origins in 1692 Coutts & Co have maintained close and strong connections with the arts and therefore it is appropriate that, in association with our parent, National Westminster Bank, we are sponsoring an exhibition of paintings at the National Gallery.

Next year we shall celebrate the Bank's Tercentenary and during our 300-year history famous artists have come to bank with us: Augustus Egg, Henry Fuseli, Benjamin Haydon, Frederic Leighton, John Everett Millais, Joshua Reynolds, George Frederick Watts, etc., etc., the list seems endless.

It was in the spring of 1824 that, with support from the Prime Minister, Lord Liverpool, MP George Agar Ellis and King George IV, Parliament voted £57,000 to buy for the nation the thirty-eight paintings of the financier, John Julius Angerstein, following his death. The cheque for this amount was paid through Coutts' books on the 2 July 1824, and the collection formed the nucleus of the newly founded National Gallery. The paintings first went on view to the general public in Angerstein's old home, 100 Pall Mall. Although no record survives, it was probably at this time that the Gallery became the Bank's customer for both Angerstein and his son had accounts with Coutts & Co. In 1838 the National Gallery moved to its new home on the north side of Trafalgar Square, where it is today, a mere stone's throw from Coutts' Head Office.

But Coutts' connections with the National Gallery and our reasons for sponsoring this exhibition of paintings in the Sainsbury Wing go far deeper than close location and historical connections with famous artists. Like the National Gallery, we have always striven to achieve standards of excellence in our field, and I believe a common bond exists between us, in that while both institutions are long-established, each has retained traditional standards, while seeking also to respond to modern-day needs.

We wished our 300th Birthday to reach out in some way to the community and we are delighted to support the Gallery by enabling this unique collection of paintings to be exhibited together for the first time in the splendid new Sainsbury Wing of the National Gallery.

Coutts' parent company, National Westminster Bank, has always been heavily involved in sponsoring the arts, and I am grateful to Lord Alexander, Chairman of National Westminster Bank and a Trustee of the Gallery, for his advice in this joint venture.

Sir David Money-Coutts
CHAIRMAN, COUTTS & CO

Foreword

AMONG THE GREAT GALLERIES of Europe, it is perhaps the distinguishing feature of the National Gallery that it is *not* a royal collection. The Louvre and the Prado, the Hermitage and the Uffizi are in essence and in origin collections formed by rulers. Only in Britain has the national picture collection been built up by the public (through gifts and parliamentary grants); while the Royal Collection has continued to survive and to grow, one of the world's great picture collections, but still in its essentials a private one. The two collections differ sharply in their purpose, their composition (the Royal Collection is much larger) and in their history. But both contain some of the greatest European paintings of the last 600 years. There could therefore be no more fitting celebration of the National Gallery's good fortune in being given the Sainsbury Wing than to inaugurate its temporary exhibition galleries with this exhibition of 'The Queen's Pictures'.

Yet if the National Gallery is not the Royal Collection, the two have always enjoyed the closest links. In the 1840s and 50s the Prince Consort took a deep and informed personal interest in how the Gallery's Collection should be displayed. He himself was among the most discerning buyers in Europe of early paintings and after his death a number of the most important were presented to the Gallery by Queen Victoria. And over many decades loans from the Royal Collection have complemented the Gallery's strengths in other areas.

Through the regular exhibitions at The Queen's Gallery in Buckingham Palace, the public have for many years been able to see the greatest pictures in the Royal Collection. The present exhibition, however, should allow us to see something else, and to see it perhaps for the first time – how the Royal Collection was made. We have not presented pictures in the order in which they were painted, but as they were collected. Throughout, we have shown together the old-master and the contemporary purchases of individual monarchs or princes, allowing a comparison between their patronage of living artists and their collecting of artists of the past.

Our greatest debt of gratitude is of course to Her Majesty The Queen for so generously lending so many and such important pictures. The Surveyor of The Queen's Pictures, Christopher Lloyd, has written the catalogue, and he and his colleagues in The Royal Collection Department have worked unstintingly on a project which has required much time. Sir Oliver Millar, The Surveyor Emeritus of The Queen's Pictures, has provided a fascinating essay on the surveyorship.

The exhibition could not have taken place at all without the generous and enthusiastic sponsorship of Coutts & Co and National Westminster Bank. May our gratitude find its expression not only here, but in the pleasure and instruction which this exhibition will certainly bring to the many thousands of people who visit.

Neil MacGregor
DIRECTOR

Introduction

CHRISTOPHER LLOYD

*This catalogue, following the arrangement of the
exhibition it accompanies, is divided into six chap-
ters, each representing a major period of acquisition
from the Tudors to Queen Victoria and Prince
Albert. Within each chapter the pictures are arranged
chronologically. Ninety-six paintings from the Royal
Collection are illustrated and discussed, including
two (Nos. 95 and 96) that were presented to the
National Gallery by Queen Victoria in 1863. In his
introduction Christopher Lloyd, Surveyor of The
Queen's Pictures, considers changing taste as reflec-
ted in works commissioned by the Royal Family and
in those they collected. In the essay that follows Sir
Oliver Millar, Surveyor Emeritus of The Queen's Pic-
tures, briefly sketches the history of the Surveyorship
over nearly four centuries and considers his own
experiences in the light of his predecessors'. Finally,
there is an anthology of visitors' impressions of the
collection from the sixteenth century to the reign of
Queen Victoria.*

THE ROYAL COLLECTION, of which the paintings
are only a single but most important element, holds a
unique place in the history of collecting. There is,
first of all, the wide chronological span extending
from the Tudor dynasty at the close of the fifteenth
century to the present House of Windsor – a period of
some 500 years. Secondly, there is the quality of
works in the collection, which includes, for example,
large and highly significant groups of paintings by
Van Dyck, Canaletto and Landseer acquired in dif-
ferent reigns. The strength of the Royal Collection,
therefore, might be said to be cumulative with the
tide of history operating in close conjunction with an
open-ended policy of acquisition. It reflects directly,
on the one hand, the history of an important institu-
tion, and indirectly, on the other, the political, social
and economic aspects of the country as a whole.

The intrinsic fascination of the Royal Collection
undoubtedly lies in its association with the
monarchy, the role it has played in Britain through
the centuries, and, indeed, its mere survival. But the
chief characteristics of the Royal Collection
ultimately stem from the monarchs' personal taste.
This is where, in fact, it differs from those national
collections found today in London, Paris, Vienna,
Madrid, Berlin, Washington and elsewhere, some of
which have themselves been established on the basis
of former royal collections. By definition the Royal
Collection is a private collection, held in trust by
each monarch in turn for those who will succeed to
the throne. The status of the collection, quite apart
from its size (some 7,000 pictures) and quality,
determines that a considerable portion of the paint-
ings should be – and indeed are – on public display in
those royal residences that are open to the public. In
several other respects, such as the initiation of exhibi-
tions and the loan of pictures, the Royal Collection
also operates like a national collection in the public
demesne. However, the Royal Collection remains an
expression of the personal taste of each monarch and
is intended first and foremost to adorn the walls of
royal residences. This has, through the centuries,
been the source of its strengths and also its weak-
nesses, for where the Trustees of national collections
feel a sense of responsibility in acquiring pictures of
suitable quality to illustrate the development of art
for the general public, this does not apply – at least in
a self-determining way – in the case of the Royal
Collection.

The establishment of the collection has occurred as
the result of two methods of acquisition. The first has
been through the collecting instincts of specific
monarchs whose achievements have been widely
acknowledged. These instincts, in fact, materialised
with the Tudors, particularly Henry VIII, and they are
still apparent today, but certain monarchs have been
both highly successful and ardently zealous in the art
of collecting. Charles I's purchase of the Gonzaga col-
lection in Mantua in 1625–7, George III's purchase of
Consul Joseph Smith's collection in 1762, George IV's
acquisition of the Baring collection in 1814, and the
acceptance by Prince Albert in 1847 of the Oettingen
Wallerstein collection as surety against a financial
loan attest the acquisitive nature of these particular

individuals, as well as their sense of quality. Of course, the acquisition of these collections also indicates the artistic preferences of these individuals: Charles I's appreciation of the sensual qualities of Italian, especially Venetian, painting; George III's respect for the topographical proclivities of Canaletto; George IV's unerring eye for the seventeenth-century masters of the Dutch and Flemish schools, and Prince Albert's pioneering admiration for primitive Italian and German painting. In addition, the contribution of Frederick, Prince of Wales, the son of George II, should not be forgotten, since some of the finest Flemish and Italian paintings dating from the seventeenth century were added to the Royal Collection as a result of his enthusiasm for art. These high points in the growth of the Royal Collection are expressions of personal taste often formed in accordance with the taste of the times and so shared with other collectors. While the praises of Charles I, George III, George IV, Queen Victoria and Prince Albert have quite properly been sung in this respect, Queen Anne, George I, George II and William IV have been regularly denigrated, and with some justification. The former monarchs can rightly be described as leading connoisseurs, whereas the latter, for one reason or another, do not deserve such an accolade. Yet, it would be wrong to dismiss them as wholly uninterested, since portraits and paintings of military and historical subjects continued to be added, although not by artists of the first rank. George II failed to appreciate the visual arts in general and William Hogarth in particular, but his wife, Caroline of Ansbach, was more enlightened.

The second method of acquisition for the Royal Collection lies within the sphere of patronage. For some monarchs the question of patronage was closely allied to their collecting instincts in so far as both activities were underpinned by a sense of quality. Charles I's employment of both Rubens and, above all, Van Dyck singled him out as a patron of the greatest distinction, whose wide-ranging appreciation of European art was to some extent paralleled by Queen Victoria in her patronage of lesser artists like Winterhalter, Von Angeli and Tuxen. Similarly, George IV's patronage of Lawrence represents a perfect fusion of taste. Where such painters held official positions at court they were, of course, working in an official capacity. The terminology used for court painters varied over the years: the title of Serjeant-Painter is found during the earlier centuries and subsequently Principal Painter (often divided into separate categories of Portraits, Military, Landscape, History, Marine, Miniature, Animal and sometimes percolat-

ing through to separate Royal Households). It should also be remembered that certain Surveyors, like Benjamin West, served in a dual capacity as overseer of the collection and as artist in residence.

Of greatest interest is the fact that the formal relationship between the monarch and those painters who held these official positions was often uneasy. Even Sir Joshua Reynolds, the first President of the Royal Academy, which was, after all, a royal foundation, was treated rather brusquely by George III. The statement that 'The King and Queen could not endure the presence of him: he was poison to their sight' seems puzzling, almost shocking, in the light of George III's idealism and Reynolds's didacticism. The feeling might have been mutual, since some of Reynolds's least distinguished work was done for the Crown. Nonetheless, the failure of George III to respond to Reynolds's particular skills is sad and in the end the king preferred West, who as a painter was undeniably versatile, adroit and potent. As he grew older and his mind deteriorated, George III was equally dismissive of Beechey, declaring vehemently in 1804 that he 'wanted no more of his pictures'. Fortunately Beechey fared better during the reigns of George IV and William IV, as did Wilkie. Wilkie's inaccuracy as a portrait painter, however, incurred the wrath of the young Queen Victoria and led to his dismissal on account of the failure of his State Portrait (Fig. 1) and *The First Council of Queen Victoria* (Fig. 2), which she described with characteristic forthrightness as 'one of the worst pictures I have ever seen, both as to painting & likenesses'. On a formal basis his successor, Hayter, began well by painting a successful second State Portrait (Fig. 4) and a distinguished Coronation picture (Fig. 3), but the queen soon tired of him and his position was undermined by Winterhalter. It is difficult to account for the failure – if such it was – of these artists, but it is not unlikely that the degree of expectation, as much as the volume of work, did not so much outweigh their talent as cramp their style. There are two notable exceptions to this disjunction between rank and performance: Ramsay during the early years of George III's reign and Lawrence in the service of George IV. Ramsay's beautifully textured and calm, reflective style captured the essence of the retiring, idealistic and slightly priggish young king and the shyness of his wife, Queen Charlotte; while Lawrence's prestidigitatorial efforts perfectly matched the panache and floridity of George IV's court.

Counterpointing the dutiful activities of these official court artists was another form of patronage exercised by monarchs who commissioned paintings

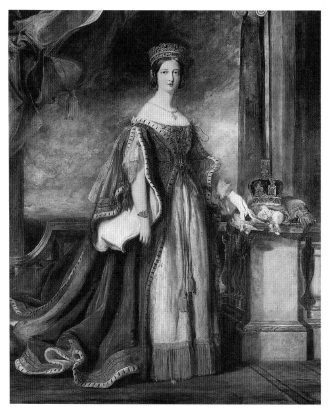

from other contemporary artists whose work they admired more, or with whose style they felt a greater sympathy. George III clearly preferred the homeliness of Zoffany and the conviviality of Gainsborough to the cerebral approach of Reynolds. George IV had an active interest in the paintings of artists such as Wilkie, Turner, Haydon and Mulready, whose work extends across a wide spectrum of British art, in addition to supporting Reynolds, Gainsborough, Stubbs, Hoppner and Lawrence. This diversity was shared by Queen Victoria who admired Landseer, Frith, Leighton, Maclise, Roberts, Holl, Leslie, Lady Butler and a host of lesser names. Queen Victoria's interest in art was nurtured by Prince Albert and developed over the years, before being widowed, as a result of her own practical abilities and assiduous attendance at exhibitions at the Royal Academy and the British Institution. The queen had confidence in the ability of artists to record not just the principal events of her reign, but also the social mores of the Victorian world. Indeed, she appears to have positively relished

Fig. 1 LEFT Sir David Wilkie, *Queen Victoria*, 1840 (detail), Port Sunlight, Lady Lever Art Gallery.

Fig. 2 BELOW Sir David Wilkie, *The First Council of Queen Victoria*, 1838, The Royal Collection.

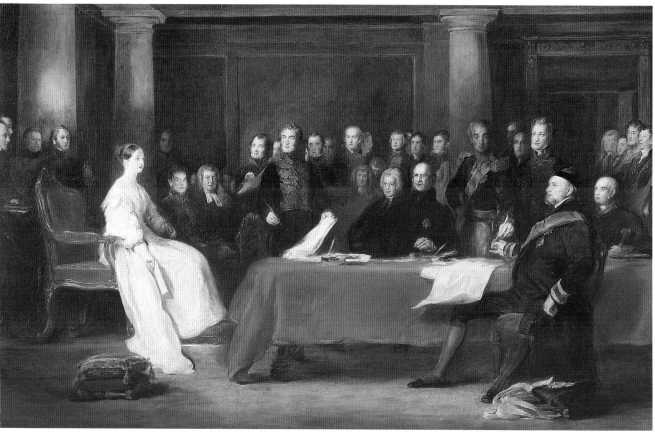

the situation at a time when photography was still being perfected. To a certain extent, therefore, the rejection of those artists appointed to official positions at court, and the broadening of support for those artists who independently won the attention of the sovereign, is an index of the monarch's personal taste. This tension between 'official' and 'unofficial' royal patronage is evident from the time of the Stuart court onwards, and to a certain extent it forms the basis of the Royal Collection. From the start, sovereigns have had to exercise official patronage in order to establish and to sustain the identity of the monarchy, and thus the collection has grown even during the reigns of Queen Anne, George I, George II and William IV. If the Royal Collection has on rare occasions been neglected in the past, it has never at any time in its history been ignored, and in the present reign it is receiving more attention than ever before. Continuity and diversity are the hallmarks of the Royal Collection, but always in accordance with the circumstances and commitment of the sovereign.

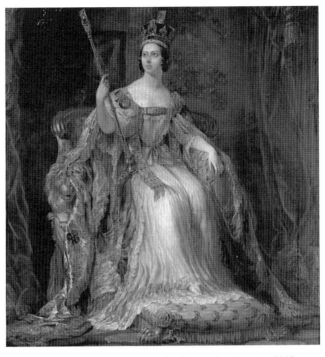

Fig. 4. ABOVE Sir George Hayter, *The Coronation Portrait*, 1840 (detail), The Royal Collection.

Fig. 3 BELOW Sir George Hayter, *The Coronation of Queen Victoria*, 1838, The Royal Collection.

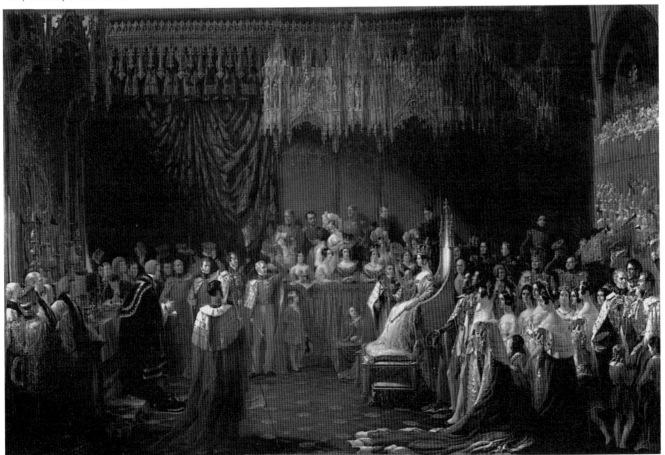

Caring for The Queen's Pictures: Surveyors Past and Present

SIR OLIVER MILLAR

Sir Oliver Millar, GCVO, FBA, retired in 1988 as Surveyor of The Queen's Pictures and Director of the Royal Collection. The post of Surveyor requires a rare combination of skills – art-historical, curatorial, practical, courtly and administrative; for the Royal Collection is not only one of the world's great assemblages of pictures, but a working stock, constantly required to furnish State and Private Apartments, and offices.

THE HISTORY of the Surveyorship of Pictures begins, appropriately, a few weeks after the accession of Charles I. For some years before the death of his father, on 27 March 1625, he had been assembling a distinguished collection of pictures and works of art, some of which had belonged to his famous elder brother, Henry, Prince of Wales. Not long before his untimely death on 6 November 1612 Prince Henry had taken on, as Keeper of his Cabinet Room at St James's, the Dutch medallist Abraham van der Doort (Fig. 5). Before his accession Charles I was employing Van der Doort in the same capacity, and on 21 April 1625 he confirmed him in the post. The contents of the Cabinet Room included miniatures and, probably, small and especially precious pictures. Van der Doort was responsible for 'Colecting, Receiving dilivering soarting placeing remoaving . . . such things as wee shall thinke fitt and alsoe to keepe a Regester booke of them.' His experience and meticulous devotion to his work must have rapidly become apparent to Charles I; and on 25 May he was appointed Overseer or Surveyor of 'all our pictures', not merely those in the Cabinet Room but those 'at Whitehall and other our houses of resort'. The care of the royal pictures before that date – and in 1603 James I had come into possession of a great many dispersed among the various royal residences – may have been, perhaps rather imprecisely, the responsibility of the Keepers of the Standing Wardrobes in the different houses. It was, for example, to the Keeper of the Privy Lodgings and Standing Wardrobe at Hampton Court that Charles I entrusted a little group of works of art in 1647. Van der Doort's new responsibilities as a Surveyor only need to be slightly expanded to become a 'job description' for the Surveyorship today. 'Soe much as in him lyeth' he was to prevent the pictures from being damaged or 'defaced'; he was to 'order, marke and number' them; to keep a 'Register' of them; to be responsible for receiving them and dis-

Fig. 5 Attributed to William Dobson, *Abraham van der Doort*, Leningrad, Hermitage Museum.

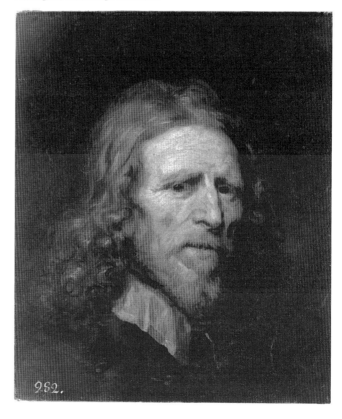

patching them. He was to organise the 'makeing and coppying' of pictures as the king or the Lord Chamberlain should direct. In order that he could carry out his duties properly he was to have access 'at convenient Times' to the galleries, chambers and other rooms 'where Our Pictures are'.[1]

Van der Doort was a distinguished craftsman; and for more than 200 years all his successors were practising artists. On the eve of the Civil War two painters, Jan van Belcamp and Daniel Soreau, were responsible respectively for the pictures on the king's side and the queen's side of the royal residences. After the Restoration, George Geldorp who, with Emmanuel de Critz, had played an active part in assembling what was left in this country of the Royal Collection after the devastation wrought during the Interregnum, was rewarded with the post of Picturemender and Cleaner. The King's Closet or Cabinet at Whitehall, in which small and precious works of art were kept as they had been in the old Cabinet Room in Van der Doort's time, was in the care of Thomas Chiffinch, who had been appointed Keeper of the King's Closet and Pictures after the Restoration, partly in recompense for loyal service. He was succeeded in 1666 by his younger brother William, who signed the section in the inventory of James II's goods which lists the pictures and other works of art.[2] Thereafter the post of Keeper or Surveyor of Pictures was often linked with that of restorer and it is not easy to establish the lines of demarcation between their responsibilities. Charles II, for example, appointed Gerrit Uylenburgh in December 1676 to be 'Purveyor and Keeper' of his pictures, for their better preservation from decay. By April 1679 Parry Walton had succeeded him and in 1682 we find Henry Norris described as the Keeper, and Walton as the 'Cleanser', of the pictures. At the Revolution of 1688 Walton was retained as 'Mender and Repairer' of the pictures, but Frederick Sonnius, who had been a friend of Lely and one of his assistants, was appointed in 1690 Keeper in Ordinary of the king's pictures, drawings and other rarities and antiquities. Walton was succeeded in 1701 by his son Peter, who eventually became Surveyor and Keeper of Pictures, a post he combined, until his death in 1745, with that of 'Mender and Repairer'.

Peter Walton was succeeded by the minor portrait painter Stephen Slaughter, who was actively employed in the reorganisation of the pictures after the accession of George III and was himself succeeded in 1765 by George Knapton, painter in 1751 of the colossal group portrait of the Royal Family, hung in the Prince of Wales's Dining-Room at Hampton Court.[3]

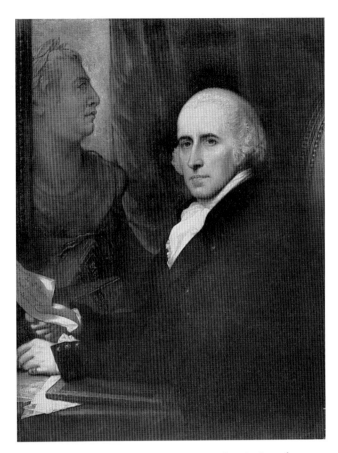

Fig. 6 Benjamin West, *Self Portrait*, 1793, London, Society of Dilettanti.

In 1778 Richard Dalton, more learned but apparently far less scrupulous than any of his predecessors since the time of Van der Doort, was appointed Surveyor and Keeper. When he died in 1791 Benjamin West (Fig. 6), for whose work the king had an unquenchable admiration, was appointed Surveyor and, understandably, Cleaner and Repairer. George III and his favourite painter died within a few months of each other. George IV gave West's post to William Seguier (Fig. 7), whom he had employed in various ways on the pictures at Carlton House since at least 1818, and who was the first Keeper of the new National Gallery and Superintendent of the British Institution.

Seguier survived until November 1843 and it had been the earnest wish of Queen Victoria and Prince Albert that he should be succeeded by the distinguished landscape painter Augustus Wall Callcott, who was assured that the appointment was an honorary one, with very slight duties attached to it; but he was already in poor health and only held the post until late in 1844. He was succeeded by Thomas Uwins, on whose death in 1857 the queen offered the

Surveyorship to Richard Redgrave (Fig. 8): a prolific painter, less accomplished than Callcott but a conscientious Academician who was involved, as Inspector-General for Art in the Government School of Design and Director of the Art Division of the Education Department, in the administration of the arts and in the development of art education in this country. By the late 1870s he was nearly blind and late in 1879 he sent in his resignation to the Lord Chamberlain. His successor, who had the ardent support of the Crown Princess of Prussia (she reminded the queen that 'dear Papa thought *so* highly of his knowledge of ancient art'), was J. C. Robinson, a brilliant connoisseur, whose purchases on behalf of the South Kensington Museum laid the foundations of its richness in Renaissance works of art, and an active collector much involved in buying and selling, but less well adapted than Redgrave to royal service. He was replaced within a few weeks of Edward VII's accession on 22 January 1901 by Lionel Cust, Director of the National Portrait Gallery and a member of the Marlborough Club, where he had first met the future king, whom he worshipped, five years earlier. He found it possible to combine the Surveyorship with (until 1909) the Directorship of the National

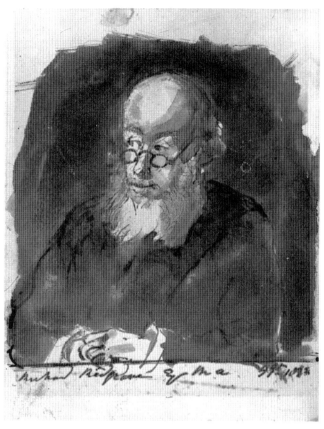

Fig. 8 Sir Francis Grant, *Richard Redgrave*, 1872, London, National Portrait Gallery.

Fig. 7 John Jackson, *William Seguier*, 1830, London, National Gallery.

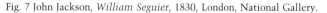

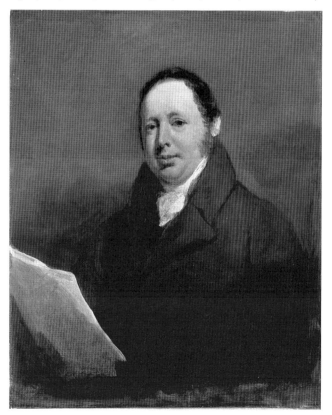

Portrait Gallery, the joint editorship (1909–19) with Roger Fry of *The Burlington Magazine* and duty as a Gentleman Usher. Early in 1928 he was succeeded by C. H. Collins Baker, at that time Keeper and Secretary of the National Gallery. His not wholly happy tenure of the post ended in 1934, when, at George V's insistence, Kenneth Clark, Director of the National Gallery, took on the job of 'expert adviser on royal paintings', as it was then described. In order that the routine work on the pictures could be carried out, Clark secured the appointment of Benedict Nicolson as his Deputy in April 1939. Clark resigned at the end of the war and, on 1 April 1945, was succeeded by Anthony Blunt.[4]

Redgrave had pointed out in no uncertain terms, as early as 1867, that the duties of the Surveyor, which involved artistic knowledge, sound judgement and experience, could not possibly be carried out properly on a part-time basis or by anyone retired from active duties. A great deal of travelling had to be done in making the 'Register' and in supervising (which he scrupulously did) the work of all his restorers in their different studios. In 1932, and again just before

Blunt's appointment, Sir Owen Morshead had re-iterated that the Surveyor's job could not be done by a part-time and over-driven official like Collins Baker or Clark, and had sketched a blueprint for the Surveyorship of the future. Nevertheless, Van der Doort's successors continued, to a varying degree, to hold the Surveyorship on a part-time basis. Ben Nicolson was editor of *The Burlington Magazine* and Blunt Deputy Director, and then Director, of the Courtauld Institute. No regular secretarial assistance was available to a Surveyor until Margaret Brown was enlisted to help in organising the big exhibition of *The King's Pictures* at the Royal Academy in 1946–7, and for many years thereafter she too worked part time. Until comparatively modern times the Surveyor does not appear to have had an office; and only quite recently was a room off the State Apartments in St James's made available. The inventories were brought there from Windsor, and, together with a room next door filched from one of the Examiners of Plays, it remained our headquarters until, with the enlightened support of Sir Peter Miles, Keeper of the Privy Purse, and his successor Sir Shane Blewitt, we and our Works of Art colleagues were given the use of Stable Yard House as our headquarters, on the site of Henry, Prince of Wales's mews.

In 1947 a full-time Assistant was appointed to join the Surveyor's Office. In due course he became a fully established member of the Royal Household. Forty years later the Surveyorships of Pictures and Works of Art were reorganised, and merged with the post of Librarian – in so far as he is responsible for the prints and drawings at Windsor – to form a new Royal Collection Department, a sixth Department of the Royal Household. Up to that time the Surveyor of Pictures had worked under the wing of the Lord Chamberlain. In a list of Charles I's Household the two picture-keepers appear as members of the Chamber and its offshoots.[5] Thereafter the Surveyor, until the recent reorganisation, was listed among the miscellaneous members of the Lord Chamberlain's Department. The formal break with our old colleagues was overdue. It had become increasingly frustrating to be tied so closely to them and to have limited freedom of action. Much time and effort were wasted in going through long-established procedures or along repetitive lines of communication; but if it seems, in retrospect, eccentric that the administration of a great collection should have been to a large extent in the hands of a succession of charming retired Lieutenant-Colonels of the (generally 1st) Foot Guards, they were delightful to work with and I remember with particular gratitude the period in which we worked with Sir John Johnston. By the end of our long association he may have come to realise that it is not impossible for an art historian at least to try to be a competent administrator and even to master the rudiments of financial management.

Redgrave was the only one of Van der Doort's successors to carry out, as thoroughly as he had done, instructions to keep a 'Register' of the pictures. Among surviving records Van der Doort's own Register is unique: the first draft (Fig. 9) of a projected inventory, filled with notes, amendments, insertions and the occasional overwrought complaint about a courier's irresponsibility or obstructiveness; and the fair copies (Fig. 10), drawn up for the king's own use, of two particularly important sections of the collections at Whitehall. Van der Doort's entry on a picture includes a full description, measurements, a note on provenance, a description of the frame and, very often, a note on condition. Surviving inventories from the next 300 years are normally little more than lists, in which even measurements are frequently omitted. Benjamin West naturally worked to a slightly higher standard when, at the request of the Prince of Wales, he compiled in 1818–19 three volumes of inventories of the pictures at Kensington, Buckingham House (with St James's) and Carlton House. In 1816 an independent inventory and valuation of the pictures at Carlton House had been drawn up for the Prince by Michael Bryan with help from Sir Thomas Lawrence. Both Seguier and Uwins had produced for Queen Victoria printed *Catalogues* of the pictures in the principal rooms at Buckingham Palace. In 1857, when Redgrave took over from Uwins, it was made plain, no doubt at the instigation of the Prince Consort and the queen herself, that the job had to be carried out with 'more earnestness than had yet been brought to bear upon it'. The *Art-Journal* had, however, pronounced that the post could be regarded as a 'sinecure and is probably considered as a boon to an artist in the decline of years, and in the decay of power'. Some years later Sir Henry Cole told the Comptroller of the Lord Chamberlain's Office, Sir Spencer Ponsonby-Fane, who always gave Redgrave splendid support but is perhaps best known today as one of the founders of the I.Z. cricket club, that there was no one who more thoroughly understood the work that needed to be done than Redgrave, or was more zealous in doing it. On 16 June 1879 Redgrave in his diary offered thanks to God that he had been allowed to complete a work which had occupied so many hours and years of his life. His sight was failing by now but, 'I have, notwithstanding my infirmity, worked very hard lately': to complete the great record, on over 1900

separate sheets, of the pictures, which he had planned in 1857 with the approval of the Prince Consort. On each sheet (Fig. 11) he aimed to provide full descriptive notes on the pictures, details of signature, inscriptions and frame, with information to be found on the back, and notes on condition, provenance, payment and movements. Some art-historical and bibliographical information was included or subsequently inserted. To each sheet was added a photograph. The sheets were designed so that they could be kept up to date, but Robinson and Cust neglected their responsibilities in this respect and made no sustained attempt to keep Redgrave's beautiful sheets, all written in his own wonderfully legible hand, up to date or to provide fresh sheets for new acquisitions. As a result, the reigns of Edward VII and George V are, from the point of view of the documentation of the collection, among the most inadequately covered in

Fig. 9 ABOVE LEFT Abraham van der Doort's draft of a section of his Register, MS Ashmole 1514, f.179v, Oxford, Bodleian Library.

Fig. 10 BELOW LEFT Abraham van der Doort's fair copy of a section of his Register, MS f.10, Windsor Castle, Royal Library.

Fig. 11 BELOW Sheet from Richard Redgrave's inventory for Justus of Ghent's *Federico da Montefeltro, his Son Guidobaldo and Others listening to a Discourse*, The Royal Collection.

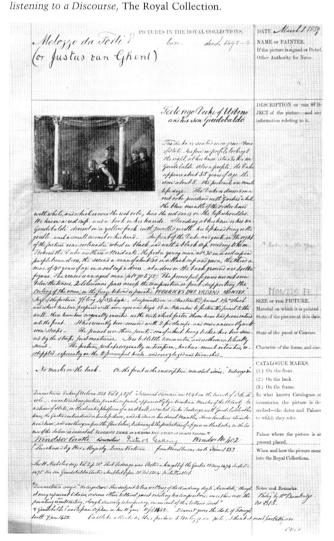

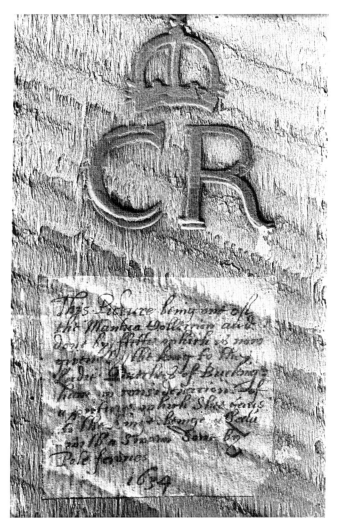

Fig. 12 King Charles I's brand and a label, on the back of Domenico Fetti's *Vison of Saint Peter*, Vienna, Kunsthistorisches Museum.

its entire history; and it is Ben Nicolson's index of the original sheets that became the basis for all subsequent work on the pictures. The pictures at Osborne House were dealt with on Redgrave's behalf by Doyne Bell, Secretary to the Privy Purse, who gave Redgrave invaluable support; and from his privately printed *Catalogue* (1876) of the contents of Osborne one can see something of the quality of Redgrave's work. Van der Doort had applied brands and beautifully written labels (Fig. 12) to the backs of many pictures. Thereafter Redgrave was the first Surveyor consistently to 'order, marke and number' the pictures, giving to a picture the number, by paint on the front or by stencil on the back and on the frame, which had been allocated to it on the sheets. This numbering remains in force, except at Buckingham Palace, where a Superintendent began, but did not

complete, a new inventory for which he initiated a different and confused set of numbers.

Not until comparatively recently were the movements of pictures always reliably recorded. There is, from Van der Doort's time, one snippet: an acknowledgement, dated 6 November 1628, from William George, that Van der Goes's great *Trinity Altarpiece* had been delivered to Van der Doort at St James's.[6] During that intensely active period when George IV was building up his collections at Carlton House, when there was a ceaseless coming and going of objects of all kinds, the Inspector of Household Deliveries, Benjamin Jutsham, kept in three folio volumes a record of the receipt and dispatch of pictures and works of art (after the king's death he records the sending of pictures to Mrs Fitzherbert and the ageing sultana, Lady Conyngham). Jutsham's volumes came to light in the office of the Inventory Clerk at Windsor, who nowadays has a knowledge of all movements of pictures that would do credit to Jutsham himself. In 1879 a 'Pictures Register' was initiated, to be laid at regular intervals before Queen Victoria so that she should be aware of all the movements of her pictures. Slackness in keeping conscientious records led to such unhappy episodes as the temporary loss of a little group of pictures whose absence had not been noticed. They were successfully retrieved; but one wonders how William van Huls, Private Secretary to William III and later Clerk of the Robes and Wardrobe, had managed to get hold of such pieces as Bruegel's *Three Soldiers* (now in the Frick Collection, New York) and Saenredam's huge *Interior of St Bavo's Church* (now in the National Gallery of Scotland), which had been acquired, respectively, by Charles I and Charles II but were included in the auction of Van Huls's pictures in 1722.[7] These works, and other pictures no longer in the collection, were in the Store Room at Somerset House in 1714, when a change of dynasty may have made those involved with royal goods a little less circumspect. As the twentieth century comes to a close, members of the new Royal Collection Department have started to prepare a computerised inventory of everything for which they are responsible. When this immense task has been completed some of the hazards to which the pictures have been subjected in the past will, it is hoped, be removed.

There is, of course, no substitute, when beginning to learn about the royal pictures, for protracted research in archives combined with a thorough, constantly repeated, examination of the pictures themselves and with long solitary hours going through the rooms and through the stores. Even in these days,

when the photocopier can produce at the touch of a button masses of new material for the files, you can only learn about the history of the pictures by actually transcribing documents. I cannot exaggerate the pleasure, or the wealth of insights gained, in simply copying out Van der Doort's manuscripts; the valuations made for the sale of the king's goods; huge chunks of material from the beautifully bound blue volumes in the Duchy of Cornwall Office, in which is recorded all the expenditure of Frederick, Prince of Wales, and his wife; and, in the Royal Archives, extensive and fundamental material on the patronage and collecting of George IV, Queen Victoria and Prince Albert. There is still much work of this nature to be done. Above all, there lies uncharted in the Public Record Office, I am sure, all the documentation for the maintenance of the pictures when West and Seguier were in charge. The arrival and arrangement of Consul Smith's pictures, the cleaning and restoration undertaken by West, the fitting up of the Picture Gallery at Buckingham Palace: these will be among the themes we will be able to recount in detail after those papers have been studied. It is exhausting work, but by doing it you learn about the significance of parts of the collection which seem, on the surface, unimportant; and it is the essential complement to the examination of the pictures themselves. Many of the royal pictures are large and inaccessible. The Surveyor rarely has the chance to look at them in 'museum conditions'. Preparation for a new volume of the *Catalogue* can involve hours in dusty and overcrowded stores or in the sub-arctic interior of Balmoral in April, when the Resident Factor has turned a deaf ear to a modest suggestion that the central heating might be turned on, just for an hour or two. You also have to seize an opportunity, which often arises unscheduled, to get fresh measurements and see backs of paintings: when, for example, a phase in the redecoration at Buckingham Palace involves taking all the inset canvases out of their holes in the walls of the Principal Staircase, the Marble Hall or the 1855 and 1856 Rooms; or when, early on a bright summer morning at Windsor, all the portraits in the Waterloo Chamber were taken down before the room was redecorated.

By far the most important injunction laid on Van der Doort, however, was that he should, 'soe much as in him lyeth', prevent the pictures from being damaged or 'defaced'. This must always take precedence over every other aspect of the Surveyor's duties; and it is obligatory for him to give unstinting support to his restorers and always to be available for consultation and encouragement. Some of the environmental hazards that faced Van der Doort or Redgrave, notably a heavily smoke-charged or gas-laden atmosphere, have been to a great extent removed. On the other hand we can cite nowadays in many collections acts of vandalism as sinister, if less predictable, than the attack on royal pictures and statues by parliamentary soldiers during the Interregnum. Much damage was also caused in the past by the crowding, and careless placing, of pictures in store. Van der Doort was scrupulous in describing the condition of pictures: from those that were 'defaced' to one so utterly ruined and 'peeled off' that it seemed inconceivable that it could ever be repaired. Some of the pictures acquired from the Gonzaga collection in Mantua arrived in an appalling state, and Richard Greenbury, John de Critz and Soreau worked on them at that time; but when Lodewijck Huygens saw the royal goods displayed for sale at Somerset House in January 1652 (by order of the Council of State after the execution of the king) he was saddened to see the paintings 'all so badly cared for and so dusty that it was a pitiable sight'.[8]

Harsh treatment was meted out to the pictures when, during Charles II's rebuilding of the State Apartments at Windsor, many of them were cut down or enlarged so that they could be set over doors or fireplaces in the new schemes of decoration. The cutting down and enlarging of pictures has persisted throughout the history of the collection. Even in modern times a Superintendent did not scruple to slice a large piece off the top of a group by Zoffany or to reduce a fine pair of large Winterhalters so that they would fit better into a room at Balmoral (one of these, moreover, was put into a frame taken off a portrait by West). These are among unhappy sequels to the occasion when the Superintendent at Windsor, early in Queen Victoria's reign, cut down Gainsborough's lovely full-length group of the three eldest princesses. Nowadays, when a canvas is reduced, later additions are turned over the stretcher, but this is a recurring problem. In the King's Drawing-Room at Windsor (Fig. 13), for example, *Winter* (No. 38) by Rubens had been enlarged in the time of Frederick, Prince of Wales, to make it balance *Summer* (No. 37). The reduction of the earlier picture to its original size did not disturb the balance of the walls too much; but what do you do with other problems in that room? For Van Dyck's *St Martin* a magnificent frame by Paul Petit was made in 1748. Subsequently the picture was put in a simpler frame so that it could hang, in a new display at Buckingham House, as a pair to an equestrian portrait of Philip II. Petit's frame was then adapted to fit the equestrian portrait of the Archduke

Fig. 13 Joseph Nash, *The King's Drawing-Room, the Rubens Room, at Windsor Castle, King Louis-Philippe receiving Addresses*, 1844, The National Trust, Anglesey Abbey.

Albert, painted in the school of Rubens, a picture which had itself been much enlarged and was entirely different in proportion from *St Martin*. Petit's frame, reduced on its shorter axis, extended down the longer axis, is now ruined, its rhythms cramped or dissipated. It has been possible, however, to restore Rubens's *Holy Family* (No. 39) to its original shape by removing extensive additions, and by modifying the frame, although this will alter the role the picture plays in the decoration of a room. A purist art-historical approach cannot be sustained, it has to be (at times reluctantly) conceded, in a collection which is actually in use as opposed to hanging on the walls of a gallery.

It is easy to be dismissive of what our predecessors did, or to be unaware of why they did it. We were always anxious, for example, to remove as many as possible of the unattractive frames, made by William Thomas, in which Prince Albert reframed all the (predominantly Dutch and Flemish) pictures in the Picture Gallery at Buckingham Palace. Early eighteenth-century gilded frames, such as would have been made for the pictures in the eighteenth century, have been successful because they will look well in any part of the collection; but putting early dark frames, which are in theory so appropriate, on a number of small Dutch pictures and on such masterpieces as the Vermeer, the Hals and Rembrandt's *Shipbuilder and his Wife*

or *Lady with a Fan* was a less happy move because the frames, which looked right on plastered or panelled walls in the seventeenth century, have never been suitable for the richly articulated and heavily gilded interiors at Windsor or Buckingham Palace. The heavy 'compo' additions applied by George IV to the seventeenth-century frames of many of the Van Dycks at Windsor were removed with profit; but when, as an experiment, we took Crouzet's additions (Fig. 14) off the charming Venetian frames on Canaletto's two views of London, it was at once obvious that frames (Fig. 15) which must have looked so well on Consul Smith's walls were embarrassingly inadequate in George IV's Corridor at Windsor. We made the same sort of mistake in putting Van Dyck's two small portraits of Henrietta Maria in 'Sunderland' frames; but I would not regret the radical transformation carried out in the Chapel Corridor or 'Holbein Room' at Windsor. In this room, created by Blore when he constructed the Private Chapel between the State and Private Apartments, Prince Albert had assembled many of the earliest royal (and other) portraits and packed them on the walls in frames of uniform pattern and size. He had enlarged many of the portraits or adjusted the section of the frames to make them all the same size (Fig. 16). We removed the inferior and irrelevant pictures, restored the better portraits to their original proportions and

Fig. 14 Canaletto, *Venice: The Grand Canal from the Carità towards the Bacino*, showing additions made to the frame by Joseph Crouzet, The Royal Collection.

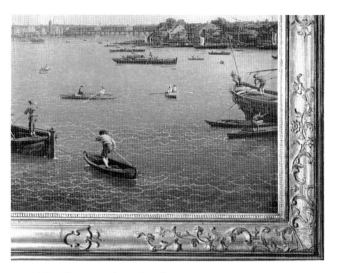

Fig. 15 Canaletto, *London: The Thames from Somerset House Terrace towards the City*, after the removal of Crouzet's additions to the frame, The Royal Collection.

commissioned, chiefly from Paul Levi, frames more suitable to the date, proportions and function of these little works of art.

It is also difficult to know how didactic you should be in planning a fresh 'hang' in one of the occupied palaces. I believe that in the Royal Collection there are opportunities to show the public certain uniquely rich 'holdings' of works by such artists as Lawrence, Canaletto, Holbein or Van Dyck and that to show them as groups enhances the experience of looking at them. No one would wish to break down the concentration of Lawrences in the Waterloo Chamber; and the display of nothing but Van Dycks, all of exceptional quality, in the Queen's Ballroom (Fig. 17) provides an infinitely precious insight, to the imaginative beholder, into the personality of a great artist and the spirit of the court to which he had been summoned. I was also anxious to retain permanently for the public, at Windsor, the experience of seeing together the fourteen views of the Grand Canal by Canaletto because, I considered, they gained immeasurably from being seen as a set and, as such, would be of real interest to the student of Canaletto and the lover of Venice. The Van Dycks still hang together; but the *Prospectus Magni Canalis*, criticized as hung by one with the instincts of a stamp-collector, was dispersed.

It is impossible to judge what damage was done to the pictures before Redgrave drew up plans to tackle those works in a 'failing condition' at Hampton Court: by, for instance, those shadowy 'Cleansers and Repairers' employed by the Stuarts; by Stephen Slaughter, for whom a room at Kensington was spe-

cially set aside in 1748 so that he could carry out the Lord Chamberlain's instructions to clean and repair the pictures; by John Anderson, Joseph Goupy, John Wootton and Isaac Collivoe who cleaned pictures for Frederick, Prince of Wales; by Collivoe and Slaughter, early in the reign of George III; or by George Simpson and William Seguier in the service of George IV. Seguier probably handled pictures more carefully; but Redgrave, when he embarked on his conservation programme, found the work of earlier restorers had been crude, hasty and 'improper'. Much of the restoration he commissioned, such as Buttery's work on the Van der Goes *Trinity Altarpiece*, was probably

Fig. 16 The 'Holbein Room', Windsor Castle, *c*. 1930.

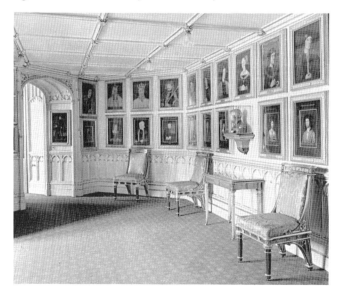

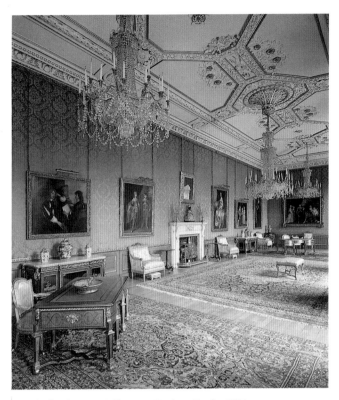

Fig. 17 The Queen's Ballroom, Windsor Castle, 1990.

tion. Long-term problems can be worked on; and our restorers can be summoned to any part of the collection at short notice. In these happier times, moreover, the queen's restorers are in constant touch with colleagues at, for example, the Hamilton Kerr Institute and the National Gallery: a marked change from the immediately post-war days when conservation was to some extent bedevilled by controversy and hampered by secrecy.

Overall maintenance and surveillance, through that access 'at convenient times' which Van der Doort was promised, is essential in a collection which is used to so great an extent by the Royal Family and by those who work for them. Apart from damaging atmospheric conditions, and the sometimes no less damaging effects, in our time, of central heating and the immense difficulties involved in trying to provide a stable environment, the chief hazards to the royal pictures must always have been implicit in the collection's very nature as a group of pictures, hung either in often unsatisfactory conditions in the unoccupied palaces or in equally vulnerable positions in the occupied ones. In this respect the collection provides its custodians with a unique and never wholly soluble problem. A principal benefit to the collection of having a full-time Surveyor and, nowadays, a properly staffed Royal Collection

Fig. 18 The Royal Collection conservation studio.

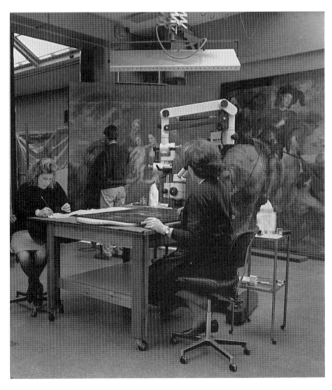

done with sensitivity and restraint; but the choice of Morrill as liner was unfortunate; a great many of the Hampton Court pictures have been sadly flattened. By the time Redgrave retired the condition and arrangement of the pictures at Hampton Court gave serious concern to an enlightened Continental critic such as the Crown Princess.[9] Redgrave was always aware of the difficulties inherent in sending pictures out for restoration instead of being able to deal with them under some central roof, such as was eventually made available with the active support of the Lord Chamberlain, Lord Maclean, in St James's Palace in 1981. Before that moment a number of eminent restorers had worked on the royal pictures since the war. The most notable achievement was unquestionably John Brealey's restoration of the *Triumphs of Caesar* by Mantegna (pictures which had caused Redgrave such profound concern). It had become increasingly impossible to supervise work carried out at studios some way from the office; and restorers did not always see the need to supply proper reports on what they had done. Nothing in the history of the Surveyorship has been more beneficial to the pictures than the establishment of the studio at St James's Palace (Fig. 18). Proper standards of conservation and maintenance of the pictures can be established. They can be cleaned and restored before they go on exhibi-

Department, is that the presence of those who care for the collection has become perforce a fact of life in the Queen's Household. The Equerry's tea-time kettle can possibly still boil away undetected underneath a Wootton, but it is no longer possible for a colleague in another department to be unaware of the rules ('no picture to be touched or handled') laid down with the Lord Chamberlain's backing. In the old days the Superintendents at Windsor and Buckingham Palace only occasionally felt obliged to consult the Surveyor, whom they probably seldom saw. The situation at Buckingham Palace was so bad in Collins Baker's day that I believe he virtually refused to go there; certainly he wrote practically nothing about the pictures there. I vividly remember going into the Picture Gallery one summer afternoon to discover that *all* the pictures had been taken down on instructions from the Superintendent who, a few years later, stuck adhesive labels to the *surfaces* of the pictures so that they would be readily identified in the event of a fire.

Ceaseless vigilance is also required when redecoration or rewiring is being planned. Even the most effective early warning system cannot wholly remove the menace of the scaffold-pole or the ladder, or prevent a zealous electrician from altering a picture-light while it is still on the picture. The Surveyor has to be a creature of compromise; he must realise that the Master of the Household's staff is under intense pressure. It has to carry out big works programmes every year; functions of all sizes have to take place; and there has to be mutual understanding between Surveyors and members of the Master's staff at Buckingham Palace and Windsor. The interference of members of the Surveyor's team has to be tactfully organised and carefully integrated into the Master's schedule. Indeed, a flask of healing oil is as important a part of a Surveyor's kit as his torch and measure: especially when he finds painters at work in a room that has four great pictures by Stubbs still hanging on the wall.

Van der Doort's 'job description' contained nothing about the purchase of pictures, nor can the Surveyor's responsibility for giving advice to the sovereign in artistic matters be rigidly defined. He has, of course, to put forward advice on artistic matters whenever it is required or whenever he feels it necessary; but the presence of a resident 'expert' (if the term, not always popular, may be allowed) should never be held to inhibit the sovereign from seeking outside help or advice. In Van der Doort's time there were men in the king's circle, such as, pre-eminently, Inigo Jones, who probably were more experienced in connoisseurship than he was and, to Van der Doort's irritation, traded

on their former associations with the king's famous brother. In 1898 Robinson was chagrined to learn that, at A. J. Balfour's advice, Poynter and Claude Phillips were to be called in to comment on his scheme for cleaning the pictures at Buckingham Palace.[10] The extent to which a Surveyor had the ear of the sovereign, the sovereign's willingness to discuss things informally, and encouragingly, with the Surveyor, varied from reign to reign. William III, possibly not wholly satisfied with the advice he might have got from the resident 'Keeper', had discussions about pictures with his secretary, Constantine Huygens, before he had even reached London in his *coup d'état* in 1688. Huygens was later particularly active in fitting up for the king the radically new displays at Kensington Palace. Lord Hervey was ordered by George II instantly to remove the pictures with which, in the king's absence and at the instigation of the queen, he had endeavoured to improve the quality of the display. The king's legendary distaste for painting did not prevent him from wanting back his 'gigantic fat Venus' in place of 'those nasty little children' by Van Dyck. Frederick, Prince of Wales, a kindlier person, liked to accept advice from such people as Mercier, Vertue, Sir John Guise, the old Duchess of Marlborough and Sir Luke Schaub; and perhaps few of his successors have been so consistently approachable or appreciative. George III as a young man would have been more influenced in artistic matters by his mother and Lord Bute than by his first Surveyor, Stephen Slaughter. Richard Dalton, on the other hand, was the most active of all Surveyors in the acquisition of pictures and works of art for the king and was, above all, involved with Bute's brother in the acquisition of Consul Smith's collection. William Seguier was employed in buying paintings for George IV: for example, he bought for £2,100 Claude's *Rape of Europa* (No. 56) for the king in May 1829. Again, as in the time of Charles I, grander advisers also had the ear of the sovereign. Lord Hertford bought pictures on the king's behalf; Lord Farnborough and Sir William Knighton played an active part in the formation of the collection and in dealings with painters; and it was Wilkie and Sir Francis Chantrey whom the king summoned at the end of his life to help him in arranging the pictures in the Corridor at Windsor (Fig. 19). West had earlier received help from Reynolds in arranging pictures at Buckingham House. At no period in the history of the collection, moreover, was the Crown so active on the art market as it was in the time of George IV.

During the reign of William IV, who according to Uwins 'did not know a picture from a window-shut-

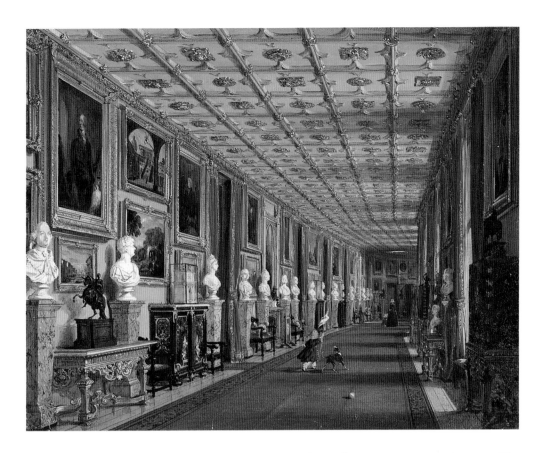

Fig. 19 Joseph Nash, *The Corridor at Windsor Castle*, 1846, The Royal Collection.

ter',[11] Seguier may have had an easy time, but there is little evidence that his successors, including Redgrave, were much involved in purchases or, except through normal official channels, in providing general advice on the pictures on anything approaching a personal basis. For advice on many artistic matters, including purchases, arrangements and re-decoration, Queen Victoria and Prince Albert employed Ludwig Gruner between 1843 and 1881. Negotiations with contemporary artists were almost invariably carried out on the queen's behalf by members of her Household – Marianne Skerrett, Sir Henry Ponsonby, Sir Charles Phipps, Lady Ely and the like. When Robinson tried, perhaps rather too aggressively but always intelligently, to play a more prominent part over purchases he met with little positive response from the queen. It was also thought that he was not bestowing enough attention on the pictures.

The Surveyor would not expect invariably to be consulted on the arrangement of pictures, especially those in the private apartments of the occupied palaces. Prince Albert, for example, the most intelligent and encouraging of all those for whom the Surveyors have worked, naturally summoned Callcott when, in 1844, he was sorting out a great many pictures and wished to organise the restoration of some which had

arrived at Windsor from Hampton Court. His insistence that the pictures at Hampton Court were an integral, inalienable part of the collection, a point made in 1839 at a time when the palace was opened to the public, is still valid today. However, when the prince and the queen were hanging pictures in their 'new "Paradise"' at Osborne House in the Isle of Wight (Fig. 20), the Surveyor was not summoned because everything in the house was 'our *very* own'.

Lionel Cust, on the other hand, who came of a family of courtiers and had 'yearned' for the Surveyorship, was actively involved with Edward VII at the outset of his reign in the complete overhaul – understandable but hugely to be mourned – of the royal houses and the dismantling and removal of an immense amount of his parents' achievements. It is remarkable that a man of Cust's experience should not have felt the need to recommend an occasional pause for thought, particularly as 'I sometimes sat by him at table'. It is doubtful if Collins Baker achieved, or would have aspired to, such intimacy in the next reign. To a serious scholar of austere views it must have been galling to be told by Queen Mary, to whom he reported that he had found the correct attribution (to Mercier) for the little picture of Frederick, Prince of Wales, and his sisters making music: 'We prefer the

Fig. 20 James Roberts, *The Prince's Dressing-Room, Osborne*, 1851,
The Royal Collection.

picture to remain as by Nollekens.' Partly at the instigation of Lord Harewood, a friend of the notoriously unreliable Tancred Borenius, Collins Baker's scholarship was impugned at a more fundamental level. There was even a move, discussed between the Lord Chamberlain and the Keeper of the Privy Purse, after he had left for America, to commit to the flames, at proof stage, Collins Baker's *Catalogue* of the Windsor pictures.

Although a Surveyor has no prescriptive right to be consulted when rooms are redecorated at Buckingham Palace and Windsor, the pictures are the principal embellishment of any room and the Surveyor inevitably will have come to know a good deal about how the rooms may originally have looked, what pictures used to hang there or what other pictures might look well, and which spirits might be conjured up for those with a sense of the past and a respect for it. Such knowledge, allied to his involvement with the pictures, will lead him at times inevitably into conflict over the extent to which

reconstruction, in its broadest sense, should be undertaken and into argument over the rights and wrongs of preservation. It should be borne in mind always that there is infinite scope – and more than enough evidence – for potentially splendid and imaginative recreations of past glories (and this is *not* merely a boring antiquarian attitude), but that it is also desperately easy to demolish a unique and significant room or series of rooms and that anything done in a modern, or partly modern, idiom to replace it will, within a very short time, look out of date and, far worse, inappropriate. The patina of historical associations is as rich as it is vulnerable. In the unoccupied palaces the situation is simpler and here, in Kensington, Hampton Court, Kew and, most recently, at Frogmore,[12] the Surveyors and their staff have worked happily with friends from the old Department of the Environment – notably Harold Yexley, Percy Flaxman, Pamela Lewis and John Thorneycroft – to produce reconstructions which may sometimes seem a little raw but have always been painstakingly worked out.

Despite occasional frustrations, and constant worries about the hazards to which the pictures are subjected and to which they seem so desperately vulnerable, and bearing in mind that its pressures drove Van der Doort to suicide, the Surveyor's is the best job in the world. He has, after all, the incalculable privilege of untrammelled access to one of the greatest and most fascinating collections of pictures ever assembled and the opportunity, if he gets his priorities right, to pursue research into its history. He has the means, particularly through the exhibitions in The Queen's Gallery, to make known the results of such research. It is the Surveyor's duty to promote the interests of the sovereign, the public and the pictures themselves; and he will be doing his best for the two first of these if he endeavours always to make available to the public, in appropriately worthy surroundings (and only on deserving occasions) as many pictures as possible and in the best condition. Loans should if possible be restricted to exhibitions which are going to be professionally organised and will make a genuine 'contribution to knowledge'. Those which might be tainted with political or commercial interests should be eschewed. The Surveyor has endless scope for putting new ideas forward and, especially in the unoccupied palaces, for carrying out new schemes. He works, in the Royal Household, with a most charming set of colleagues who do so much to make life easy for him that there is a danger that he may find their company so beguiling that he can imperceptibly let standards drop and lose caste in the serious world of art-historical scholarship outside. A good Surveyor, because he cares so passionately for them and because they are the great love of his professional life, is always likely to be considered too possessive of the pictures. He is fully entitled to support when he really needs it; but he must not mind if encouragement seems sometimes in short supply; and he must not invariably expect thanks. Nor must he feel frustrated by what may seem at times a negative attitude towards purchases, whether of old or modern pictures. The improvidence of Charles I or George IV, the enthusiasm of Frederick, Prince of Wales, or, before her widowhood, Queen Victoria, provided rare and unrepeatable moments in the collection's history; but Queen Elizabeth The Queen Mother has to the full their uninhibited love of good painting, their sympathy with artists and liking for their company, and their lively concern in what happens to the royal pictures. A contemporary Surveyor is fortunate in working for a sovereign who cares deeply for the pictures and who has supported the developments with which the Surveyors have tried to modernise the administration of the collection; and, by association, with a Consort who has steadily built up a private collection which illustrates many facets of his personality.

A Surveyor will learn to appreciate the shrewdness of the advice once given by a very wise colleague: it doesn't matter how much you enjoy your job, what *does* matter are the footsteps you leave for a successor to tread in. And to work on the royal pictures and their past does lead you along delightful tracks: from the footpath beside the Dee, where you try to get the blood going after an April day's work inside Balmoral, through many other enchanted spots to the sunlit rooms and passages of Osborne where, posing as a convalescent, you can work by the hour in the shadow of Prince Albert. It is wise to avoid distractions and outside commitments, to scorn delights and live laborious days with the pictures themselves; and when, in theory, you retire, to look forward, as Redgrave did in *his* retirement, to visits from friends who told him 'something about his beloved pictures in the royal palaces'.

Notes:

1 For a brief account of Van der Doort's career, see 'Abraham van der Doort's Catalogue of the Collections of Charles I', ed. O. Millar, *Walpole Society*, XXXVII, 1960.

2 Harl. MS., British Library, 1890. The inventories of the royal pictures and related material are described in detail in the bibliographies of the official *Catalogue*. The best to be published hitherto is in L. Campbell, *The Early Flemish Pictures in the Collection of Her Majesty The Queen*, 1985, pp. li–lxii. The section therein dealing with Queen Victoria will be considerably expanded in the forthcoming *Catalogue of the Victorian Pictures in the Collection of Her Majesty The Queen*.

3 O. Millar, *The Tudor, Stuart and Early Georgian Pictures in the Collection of Her Majesty The Queen*, Oxford 1963, no. 573.

4 Chapter and verse for this short account of the Surveyorship can be found at the relevant points in O. Millar, *The Queen's Pictures*, London 1977. To this should be added important accounts of Callcott, *Augustus Wall Callcott*, by D. Blayney Brown, London 1981, and a volume of essays on Redgrave, *Richard Redgrave*, ed. Susan P. Casteras and R. Parkinson, London and New Haven 1988.

5 G. E. Aylmer, *The King's Servants*, London 1961, p. 473.

6 Glynde MSS, now in East Sussex Record Office, Lewes.

7 L. Campbell, op. cit., p. xliv.

8 L. Huygens, *The English Journal 1651–1652*, ed. and translated by A. G. H. Bachrach and R. G. Colloner, Leiden 1982, p. 61; O. Millar, *The Queen's Pictures*, op. cit., pp. 47, 65, 81.

9 O. Millar, *The Queen's Pictures*, op. cit., pp. 96, 101, 103, 105, 118. Simpson's very interesting accounts for cleaning pictures were published in the *Burlington Magazine*, CXXVIII, 1986, pp. 586–92. The Crown Princess's comments are printed in Sir M. Levey, *The Soul of the Eye*, London 1990, p. 9.

10 O. Millar, *The Queen's Pictures*, op. cit., pp. 84–5, 93, 96–103, 118–20, 147–8, 199.

11 Mrs Uwins, *A Memoir of Thomas Uwins, R.A.*, 1858, II, pp. 269–70.

12 On Frogmore in particular, see J. Cornforth in *Country Life*, CLXXXIV, 1990, no. 33, pp. 46–51; no. 34, pp. 42–5.

Vignettes of Royal Collections and Collectors from Queen Elizabeth to Queen Victoria

THE MUSEUMS which we now know as the Uffizi, the Louvre and the Hermitage (to name only three of the most notable national collections) were originally the palatial galleries of the Grand Dukes of Tuscany, the Kings of France and the Tsars of Russia. They were public collections before they became state collections, for it was not usually difficult – at least for anyone of obvious respectability – to visit them, and they were also formed with an eye to impressing visitors as well as delighting their owners. Furthermore, such princely collections, even when they originally reflected the taste of a particular prince, came to be regarded as the accumulated treasures of a succession of rulers. This is true of the English Royal Collection, which is, however, unusual because it survives in royal possession. It is also unusual because of the frequency with which it has been moved and the degree to which it has been, and still is, divided between different palaces and houses. Today it can be seen in some buildings to which public access is permitted (parts of Windsor Castle and most of Hampton Court, for instance) and also in special exhibitions mounted in The Queen's Gallery in Buckingham Palace. This essay provides some idea of the ways in which the collection was visited and the manner in which it was displayed in the past – and lets us glimpse some of the men and women who established, neglected, altered and extended it.

In the spring of 1564 James Melville was invited by Queen Elizabeth to spend a few days at her court. He had been conducting complex negotiations on behalf of Mary, Queen of Scots, whom Queen Elizabeth wished her favourite, the newly created Earl of Leicester, to wed:

She took me to her bed-chamber, and opened a little cabinet, wherein were divers little pictures wrapt within paper, and their names written with her own hand upon the papers. Upon the first that she took up was written, 'My Lord's picture'. I held the candle, and pressed to see that picture so named; she appeared loath to let me see it; yet my importunity prevailed for a sight thereof, and found it to be the earl of Leicester's picture. I desired that I might have it to carry home to my Queen; which she refused, alleging that she had but one picture of his, I said, your Majesty hath here the original; for I perceived him at the farthest part of the chamber, speaking with Secretary Cecil. Then she took out the Queen's picture, and kissed it, and I adventured to kiss her hand, for the great love therein evidenced to my mistress.[1]

This cabinet of miniatures, which also contained jewels, was certainly an intimate possession, but the privacy of the circumstances is easily exaggerated, for the royal bedchamber was a room of some importance in the ceremonial of the court and Melville and the queen were not alone there. The high value attached to 'portraits in little' at the Tudor court dates back to the patronage by Elizabeth's father, Henry VIII, of Lucas Hornebolte, Hans Holbein and Levina Teerlinc.[2] Although Elizabeth commissioned work from the great Nicholas Hilliard and valued miniatures, at least as portraits, she gave salaried employment to relatively few artists, and Hilliard's high praise of King Henry as a 'Prince of exquisite Jugement: and Royall bounty' in his treatise on limning is perhaps a tacit criticism of the queen's lack of munificence towards him.[3]

It is unlikely that many visitors saw the royal cabinet of miniatures and jewels, but it was not diffi-

Fig. 21 William Scrots, *Edward VI*, 1546, London, National Portrait Gallery.

cult to see the interiors of the royal palace of White-hall, London. Application was made to a servant of the Royal Household. A tip would have been expected, constant surveillance would have been a condition of the visit and a commentary on the objects seen was often delivered. Lupold von Wedel visited 'Weittholl' in the summer of 1584:

> A man, in whose keeping the rooms of the palace are, took us out of the garden and led us to see the inner part of the palace, to which there are only two keys. On mounting a staircase we got into a passage right across the tiltyard; the celing is gilt and the floor ornamented with mats. There were fine paintings on the walls, among them the portrait of Edward, the present queen's brother, who was cut out of his mother's womb, he remaining alive, whilst the mother died. If you stand before the portrait, the head, face, and nose appear so long and misformed that they do not seem to represent a human being, but there is an iron bar with a plate at one end fixed to the painting; if you lengthen this bar for about three spans and look at the portrait through a little hole made in the plate in this manner O you find the ugly face changed into a well-formed one. This must indeed be considered a great piece of art.[4]

Von Wedel's delight in William Scrot's portrait of Edward VI (Fig. 21) was shared by most visitors: a fascination with such tricks of perspective of this kind was widespread. It is referred to in Shakespeare's *Richard II* and it is found in the strange device of the skull in Holbein's *Ambassadors* in the National Gallery. A further account of the palace is supplied by Baron Waldstein in 1600. He marvelled at its size and at the 'magnificence of its bedchambers and living rooms which are furnished with the most gorgeous splendour', and he also noted the works of art on display:

There is a bust of Attila, King of the Huns, and a circular table made of some foreign wood decorated in gold. There is a picture of a cripple being carried on a blind man's shoulders. . . . There is the meeting of the Emperor Maximilian I and Henry VIII near Tournai and Therouanne; King Henry VIII's entry into – and his magnificent display at – Boulougne when he had made preparations to receive the King of France there, done in two pictures; a portrait of Edward VI in 1546 at the age of nine – note artist's ingenuity in perspective; a map of Boulougne; an extremely well-painted portrait of that Earl of Mountjoy who has just been sent to Ireland; the Papal battle in which King Francis I of France was taken prisoner by the army of Charles I in 1524 [Pavia]; the battle of Maximilian I and Pope Julius II with Louis XII of France before Ravenna on Easter Day 1512, where 23 thousand men lost their lives; and a genealogical table of the Kings of England. There is a large looking-glass with a silk cover; a most beautifully painted picture of a woman, a goldsmith's wife, of such lovliness that she is said to have been Henry VIII's mistress. Portraits of Henry VIII of England, Louis XII King of France, Richard II, Elizabeth Queen of Transylvania, widow of Charles XII of France, Julius Caesar, and Charles Duke of Burgundy. There are three globes; there is a ship made of gold and silver, which has its awning, woven of pure silk and gold thread.

Another room has a picture of the battle against the Saracens in Piedmont, and the siege of Malta. There are also some very rich hangings.

A portrait here shows Queen Elizabeth when she was still young, in the dress which she wore when going to attend Parliament; there is a sundial in the form of an elephant; and an organ (in their language they call it 'an instrument') made of mother-of-pearl with the following verses inscribed on it: Angelica nunc plantas, plantas et Hybernia proles [etc]

One of the paintings is a very lifelike represen-
tation of plums, cherries, pears, and similar kinds
of fruit. . . .

In one very fine gallery or dining-hall can be seen:
a mother-of-pearl bookrest; a sundial in the form of
a monkey; portraits of the Prince of Orange, of
Elizabeth the daughter of King Henry II of France
who married King Philip of Spain, of Mary Queen of
Hungary and Regent of Belgium. . . .

There are maps of the Duchy of Parma, and also
of Britain, both done in needlework: and a picture
which shows Juno, Pallas Athene, and Venus,
together with Queen Elizabeth. Beneath it are the
lines: Juno potens sceptris, et mentis acumine Pal-
las. . . . [etc][5]

This last portrait is unusual in that it remains in the
Royal Collection (it is included in this exhibition as
No. 9). The passage admirably conveys the range of
objects visible in the palace. Clearly the works of art
were not labelled with the names of artists and we
may doubt whether the servants in attendance were
able to supply this information. In place of labels,
however, there were inscriptions, not only identify-
ing sitters but supplying mottoes and maxims of the
kind so often incorporated in Tudor plasterwork and
stone carving. Portraits seem to have been the most
common subject – this has perhaps always been the
case in royal palaces – but there were other themes:
battle scenes, a painting of a cripple, a still life of
fruit, perhaps landscapes. The painting of the
goldsmith's wife may not have been a portrait, and
the legend attached to it is typical of those which
quickly grow up around paintings in collections of
this kind. Only slightly later, the Duke of Stettin-
Pomerania seems to have been informed that two
paintings of nudes which he saw in the palace were
portraits of ladies whom King Henry had 'enticed'
from their husbands.[6]

Like all royal palaces at the end of the sixteenth
century, Whitehall was well furnished with de luxe
diplomatic presents – globes, ships, models of
elephants and monkeys, mother-of-pearl objects.
Such artifacts were at once marvels of nature and
examples of modern ingenuity. In them both the great
nautical explorations and new imperial ambitions of
the age were often evoked. Such toys, gadgetry and
objets de vertu continued to be seen in the palace
under the Stuarts. John Evelyn in 1680 reported see-
ing 'divers curious clocks, Watches & Pendulo of
exquisite work, and other Curiosities' in the Privy
Lodgings at Whitehall. But what struck him most
were paintings by 'the greate Masters' as he called

them – Raphael, Titian and Holbein. 'An ancient
Woman, who made these lodgings cleane, & had all
the keyes, let me in at pleasure, for a small reward, by
the means of a friend.'[7]

By 1627 Whitehall Palace housed one of the
greatest collections of paintings in Europe. Rubens
was amazed and wrote to the great French scholar
Peiresc that he found 'none of the crudeness which
one might expect from a place so remote from Italian
elegance. And I must admit that when it comes to
fine pictures by the hands of first-class masters, I have
never seen such a large number in one place as in the
royal palaces and in the gallery of the late Duke of
Buckingham.'[8] The chief reason for this was the pur-
chase en bloc in the previous year of the picture gal-
lery of the Duke of Mantua, one of the great
collections of Europe, which included the series of
imaginary portraits of the Caesars by Titian, the
tapestry cartoons by Raphael and Mantegna's
Triumphs of Caesar, among many other works
(including those by Tintoretto, Bronzino, Fetti and
Cristofano Allori in this exhibition, Nos. 17, 25, 23).

A vivid picture of the enthusiasm for paintings felt
by King Charles I and Queen Henrietta-Maria is
found in the correspondence between the Pope's
nephew, Cardinal Francesco Barberini, and the papal
nuncio in London, Gregorio Panzani, in 1635 and
1636. The best presents for the king and queen would
be paintings, it was agreed, but there was a question
as to what sort of paintings would be most relished.
Panzani reported that he had spoken with the Floren-
tine painter Orazio Gentileschi, who worked for
Queen Henrietta-Maria (see No. 28), and surrep-
titiously asked him about the king:

He confirms that the King has a good nose in these
matters, and I believe that the works of Lanfranco,
of Spagnoletto [Ribera], and of the Caracci, would
not be displeasing to him as he has no works by
these as he has by the other famous painters. . . it
has come to the ears of the King that from the villa
of the Cardinal Ludovisi they are selling beautiful
pictures by Raphael, Correggio, Titian, and
Leonardo da Vinci, which since they are being
spoke of as being very beautiful, will without doubt
be very pleasing to the King.[9]

The Ludovisi paintings were in fact not available for
the King of England – they were eventually acquired
by King Philip IV of Spain. The Barberini gift finally
arrived on 30 January 1636. Panzani's report of the
event takes us again into a royal bedchamber:

The pictures came in time, because just as Father

Philip [the Queen's Confessor] brought the news to the Queen [Henrietta Maria] the King asked if the pictures were coming, and the Queen, to tease him, answered that they would not be coming any more. The King responded with great concern, why are they no longer coming; the Queen said, because they have already arrived; at which the King was very pleased. I then presented [the pictures] to the Queen, having them carried to her bed one by one, and she greatly appreciated them, and the room being full, all the principal ladies approved of the pictures. Especially pleasing to the Queen was that by Vinci, and that by Andrea del Sarto. . . . I said that Your Eminence had done his best to seek out the said pictures to serve Her Majesty and that now Your Eminence would be pleased, when he heard that they pleased Her Majesty. . . . She replied very courteously, thanking Your Eminence and repeating often that they pleased her greatly, but that she would not be allowed to keep them, because the King would steal them from her. . . .

The King came rushing to see the pictures the moment he was informed by the Queen that they had arrived and called Jones the architect, a great connoisseur of pictures, the Earl of Holland, and the Earl of Pembroke to be present. Immediately Jones saw them, he greatly approved of them, in order to study them better he threw down his riding cloak, put on his spectacles, and took hold of a candle and turned to inspect all of them minutely together with the King and accorded them extraordinary approval as the Abbé Duperron [the Queen's Almoner], who was present, has confirmed to me, and as the Queen reported to Father Philip, who was therefore very happy. . . .[10]

On the 6 February, the papal agent reported on the success that Cardinal Barberini's gift had achieved:

Jones, the King's architect, believes that the picture by [da] Vince is the portrait of a certain Ginerva Benci Venetiana, and he concludes this from the G, the B, inscribed on her breast. As he is very vain and boastful he repeats this idea often in order to show his great expertise of painting. He also boasts, that as the King had removed the note of the painters, which I had put on each picture, he guessed the names of almost all the artists. He greatly exaggerates their beauty, and says that they are pictures which should be kept in a special room with gilded and jewelled frames, and this he said publicly in the Queen's antichamber despite being a very stern puritan.[11]

The painting by Sarto which was so much admired is the fine portrait of a lady (Fig. 22), now catalogued as by Sarto's contemporary Domenico Puligo; the paintings by Giulio Romano, which the king was said to have especially liked, are now regarded as allegories painted by a North Italian artist in about 1530 and not of remarkable quality, but it would be arrogant to deny that the king or the queen or Inigo Jones possessed considerable connoisseurship, even if their discrimination did not match their enthusiasm. Panzani's reference to Jones's puritanism is of the utmost importance. These paintings were being presented to the king indirectly through the queen – the idea of presents passing directly from the Pope to the English king could have caused serious political disturbance. Many puritans must have been uncertain as to whether the sacred or the profane imagery, flowing into Whitehall from Italy, was the more offensive. Many of these paintings hung in a

Fig. 22 Domenico Puligo, *Portrait of a Lady*, The Royal Collection.

room between the Queen's Bedchamber and the private chapel. Puget de la Serre, who arrived in London in 1638 in the entourage of Henrietta-Maria's mother, Marie de Médicis, described it as:

> A gallery with openings on two sides through which one goes to the great chapel and to the Queen's [bed] chamber, thus a place intended for private promenading in which one might deliciously divert one's spirit with the number of rare pictures which are hung there. Among others one admires there the twelve Emperors by the hand of Titian. I say the twelve, even though the famous painter only did eleven, because Van Dyck [M. le Chevalier Vandheich] has depicted the twelfth for us [Vitellius/Otho], but so divinely that to merely admire it seems insufficient, because as he has brought Titian back to life in this work, the miracle of his industry puts it beyond value.[12]

De la Serre continued in the same manner, describing how moved he was by a painting of the Flood by Bassano, by a Death of the Virgin by Van Dyck and by a Tintoretto of the Pentecost. In his concluding remarks he describes the dominant impression made by the great portrait of the king, shown in armour and on horseback, which occupied one end of the room.

Leaving the building to admire the two gardens, de la Serre noted that the second, the so-called 'Orchard', was 'bounded along one side by a long covered gallery which is grilled in the front in which one can admire all the most rare marvels of Italy in a great number of stone and bronze statues.'[13]

The series of paintings of the Caesars by Titian (Fig. 23), the first works mentioned by de la Serre in this account, were among the greatest treasures of the Royal Collection. Having come from the Gonzaga collection in Mantua, they were perhaps reframed for Charles I, and presumably with Van Dyck's approval since he had completed the set. In any case we have a description of the frames in John de Critz's bill for painting and gilding them. They involved scrolls, swags of flowers, festoons of drapery and masks, probably a variation on the so-called Sansovino frame popular in late sixteenth-century Venice. De Critz made them (or perhaps restored them to) the colour of dark wood – a 'sadd walnutree culler' – with 'gould in oyle' applied 'in divers places'.[14]

Perhaps the most attractive of the rooms in Whitehall Palace where the paintings were displayed was the King's Cabinet Room, created not long before 1630. Here the small paintings were kept together with bronzes (including the series of statuettes after Giambologna presented to Charles's elder brother,

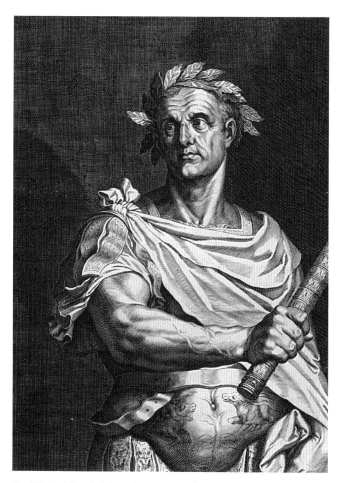

Fig. 23 Aegidius Sadeler, after Titian, *Julius Caesar*, c.1594, engraving, London, British Museum, Department of Prints and Drawings. Titian's series of the *Emperors* was destroyed by fire in Madrid in 1734.

Prince Henry, by the Grand Duke of Tuscany), gems, ivories and miniatures – seventy-five of them in all – which the Stuart court valued as much as the Tudors. Most of those not kept in jewelled mounts had turned ivory cases, and a group of miniatures of royal ancestors were assembled in the same frame, which may have been an innovation.[15]

Under the Commonwealth, Charles I's art collection was dispersed with only a few works, such as Raphael's tapestry cartoons and the bronze casts from the antique, retained as national treasures at Cromwell's express command.[16] After the Restoration in 1660 it was the smaller works of art, of the kind gathered in the Cabinet Room, which formed the basis of a new 'cabinet and closet of rarities'. John Evelyn took some of his relations there in the autumn of 1660 and found the following:

> The rare miniatures of Peter Oliver after Raphael, Titian & other masters, which I infinitely esteeme:

Also that large piece of the Dutchesse of Lennox don in Enamaile by Petito; & a vast number of Achates, Onyxes, & Intaglios, especially a Medalion of Caesar, as broad as my hand; likewise rare Cabinetts of Pietra Commessa; A Landskip of Needlework, formerly presented by the Dutch to K Charl: I.[17]

The miniatures by Peter Oliver, son of Isaac Oliver, who was the leading miniaturist after Nicholas Hilliard, were reduced copies of Old Masters. 'Petito', or Jean Petitot, the leading French enamellist of the mid-seventeenth century, had worked a great deal for the Stuart court in exile, many of his works being small versions of portraits by Van Dyck. The 'Achates' or agates, like the 'Onyxes', were not simply beautiful stones but miniature sculptures carved in relief with cameos, the face or figure in a stratum of one colour and the background in another. Intaglios were carved in negative like a seal. *Pietra commessa*, a marquetry of hard stones, often with a pictorial design, was chiefly produced by the grand-ducal workshops in Florence.

King Charles II had done his utmost to reassemble his father's collection, but much was irretrievable. By 6 December, when Evelyn returned to the palace with his brother and sister-in-law, he found that a splendid collection of paintings and sculpture was on display (including the portraits by Giulio Romano and Parmigianino included in this exhibition as Nos. 5, 18), which had been acquired from the Reynst family and presented to the king by the Dutch Government:

> Now were presented to his Majestie those two rare pieces of Drolerie, or rather a Dutch Kitchin, painted by <u>Douce</u> [Gerrit Dou], so finely as hardly to be at all distinguished from <u>Enamail</u>: I was also shewed divers rich jewells, and Christall Vasas: The rare head of <u>Jo: Belino</u>, <u>Titians</u> Master. The <u>Christ</u> in the Garden by <u>Hanib: Carracia</u>. Two incomparable heads of Holbein; the Q: <u>mother</u> in a <u>Miniature</u> as big as the life; an exquisite piece of Carving, 2 unicorns hornes, &c.[18]

In this account, as in the previous, it may seem strange to us how intermixed the paintings – whether miniatures or merely minutely detailed oil paintings – were with jewellery. But this was not at all unusual at this date. Painting was commonly studied together with the decorative arts. Visitors seem to have had easy access to the smallest, and often the most valuable, treasures in a princely collection (those most vulnerable to theft), and were allowed to handle cameos, miniatures and small sculptures, this being a

precondition for their appreciation. For reasons of security great museums cannot permit these liberties today, and it is no doubt for this reason that the sort of people who love and admire the masterpieces of Titian now generally take no interest whatever in ancient gems, something which would have astonished connoisseurs in the seventeenth century.

With the exception of the king's 'closet of rarities', the Palace of Whitehall did not make much of an impression, at least not on foreigners, with the exception of Inigo Jones's Banqueting Hall with its ceiling paintings by Rubens. It was rambling and the rooms were unfashionably low. Some beautiful rooms were, however, to be created there.

The most interesting commission received by a court artist under the Restoration, and one highly characteristic of King Charles II, is recorded by Lorenzo Magalotti, agent of Prince Cosimo de Medici, in his notes on the painter Lely.

> His profession is to make portraits, which he does very well. He has never been in Italy, but for all that one can say that his style is very good, being spirited, strong and tactile [*relievo*]. The King is having him do a very beautiful picture, which represents an Arcadia where all the most beautiful ladies of the court and of London will be depicted life size dressed as nymphs. I have seen the sketch, which is very beautiful. Lady Castlemaine did not wish to be in it saying that she would be mixed with so many women without a single man.[19]

Lely's interest in compositions of an Arcadian nature is evident from his *Concert* (London, Courtauld Institute of Art) and from his *Sleeping Nymphs* (London, Dulwich College Picture Gallery) of the late 1640s and early 1650s, but there is no record that he completed the project referred to here. It would seem to have been the germ for the 'Windsor beauties', an idea usually attributed to Anne Hyde, Duchess of York. This was a set of portraits, not a group portrait, and it was probably begun in 1662, the year in which Magalotti described the Arcadian sketch. Samuel Pepys saw the 'Duke of York's room of pictures [in Whitehall Palace] of some Maids of Honour, done by Lilly' on 21 August 1668 and declared them 'good, but not like'.[20] It was known as the White Room and was 'hung with white sarsanett, and over it blew mohair with silk fringe'. Here were exhibited not only Lely's portraits (which remain together at Windsor Castle), but also 'six narrow long pictures' (there are in fact seven) by Andrea Schiavone, placed 'under the great ones'.[21]

Perhaps partly because of the increasing menace of coal smoke, the asthmatic William III acquired and rebuilt a property to the west of London in Kensington. This new palace included a gallery built by Christopher Wren. The rooms were richly decorated with carvings in limewood by Grinling Gibbons, green velvet hangings and white damask curtains. The best paintings were concentrated here, together with other collections including a 'world of porcelain'.[22] Not long after it was completed the Palace of Whitehall was burnt to the ground in March 1698.

Though William and Mary made Kensington their principal London residence, they preferred to spend as much time as possible still further from London. Wren was therefore required to demolish Henry VII's rambling apartments at Hampton Court and rebuild them in a more respectably classical style. Meanwhile, as if realising how little time remained to her, Mary converted the Tudor water-gate at the south end of the privy garden into a riverside *maison de plaisir* or 'Water Gallery'. For this, imitating her mother at Windsor, she commissioned another set of portraits of 'beauties' from Godfrey Kneller, Lely's successor as court portraitist, who was knighted in 1692 after completing the series.[23] Celia Fiennes recorded her visit to Hampton Court some four years later, when building work on the main site was suspended due to Mary's death:

> The Water Gallery that opened into a ballcony to the water . . . was decked with China and fine pictures of the Court Ladyes drawn by Nellor; beyond this came several roomes and one was pretty large, at the four corners were littel roomes like closets or drawing roomes one pannell'd all with Jappan another with Looking Glass and two with fine work under pannells of Glass; there was the Queens Bath and a place to take boat in the house. . . .[24]

'Jappan' (Japanese laquer) and 'China' (oriental porcelain) were both new fashions and 'looking glass' was still a great extravagance.

When Celia Fiennes returned to Hampton Court almost a decade later, she was able to see the new interiors created there for King William by William Talman. She was far more interested in fabrics than in paintings, but it is clear that most of the rooms included paintings over the chimneypiece or as overdoors.

> You go into an anty-room hung with tapestry, thence into the Common Audience roome where was a throne and cannopy crimson damaske with gold fringe the form of the same round the roome; here was King Charles the Firsts picture on horse back over the mantlepiece; all the rooffes of the rooms are curiously painted with different storyes, out of this you enter the grand State Roome which has King Williams picture at length on the mantlepiece, fine pictures over all doores, and carvings in wood, the throne and cannopy here was scarlet velvet with rich gold orrice and window curtains; thence into the dineing roome where hangs in the middle a chrystall branch for candles, its hung with tapistry, I think its here the Queen of Bohemias picture is over the chimney piece, Sophia's mother [Elizabeth of Bohemia, mother of Electress Sophia, then heir to the throne and mother of George I], the window curtaines flower'd crimson damaske with gold fringe. . . .

From there one passed to the Drawing-Room, the Presence Chamber, the Dressing-Room and so to the private lodgings, which included the Queen's Closet:

> The hangings, chaires, stooles and screen the same, [were] all of satten stitch done in worsteads, beasts, birds, images and fruites all wrought very finely by Queen Mary and her Maids of Honour; from thence into a large long gallery wanscoated and pictures of all the Roman Warrs on one side, the other side was large lofty windows, two marble tables in two peers with two great open jarrs on each side each table. . . .
>
> Out of this into a long gallery, plain wanscoate without any adornment, which is for people to waite in . . . and here are doores that lead to the back stairs and to private lodgings; this leads at the end into the part that was design'd for the Kings side, into a noble gallery with curious pictures of the Scriptures painted by the Carthusion, the King of France offer'd 3000 pound apiece for them or indeed any money; here are green and white damaske window-curtaines and couches as the other was; this leads to roomes not finished.[25]

That Celia Fiennes was ignorant of painting is suggested by her record of Mantegna's *Triumph* simply as 'pictures of all the Roman Warrs', and is obvious from her reference to Raphael's tapestry cartoons as 'curious pictures of the scriptures painted by the Carthusion', but her story about the King of France probably has some basis in fact. In any case it is related by the connoisseur and collector Jonathan Richardson the Younger that Charles II was very tempted to accept an offer from Louis XIV to buy them.[26] King William's creation of a new gallery for the cartoons

The Seven Famous Cartons of Raphael Urbin Drawn at the Command of Pope Leo the 10.as Patterns for Tapestry: They were bought by K.Charles the first (at the Persuasion of S.P.P.Rubens) and brought from Flanders into England: afterwards K.William fix'd them in his Palace of Hampton: Court in the Gallery here Represented. In 1707. they were drawn and Engraven by Sim: Gribelin and by him most humbly Dedicated to Her Late Majesty —

SEMPER EADEM

ANNA REGINA.

Septem Tabulas Chartaceæ (Jussu Leonis X Pontificis Romani) a Raphaele Urbinate in Aulæorum Texturam pictæ, quas Rex Carolus I (Suasū P.P.Rubens Equitis) ex Flandriā in Angliam advehi jussit, et quas postea Rex Gulielmus Palatio suo Hampton-Court dicto in Pinacotheca hic repræsentata collocavit. Anno 1707. eas delineavit. Ærique incidit Sim.Gribelin et Seren.mæ Annæ Reginæ humilissime Dedicavit. S.G.inv.a sulp.t & excudit. 1720.

Fig. 24 Simon Gribelin, frontispiece to engravings of Raphael's Cartoons, London, British Museum, Department of Prints and Drawings.

represented the beginning of an important episode in their history. The gallery was devised by Wren and William Talman in 1699, out of what was formerly the King's Gallery in the part of Hampton Court Palace which had been built by Wren during the previous decade. Before this the cartoons had remained as strips kept in boxes, and were only assembled on special occasions.[27] The room is clearly illustrated in an engraving which shows the paintings hung above a high panelled dado (Fig. 24), exactly as if they were the fresco decorations in an Italian palace, but without reference to narrative sequence. Thought was, however, given to protecting them from fire, damp and light. It is not clear how easy access was, but later in the century it was claimed that King William's motives were very public spirited:

King William, although a Dutchman, really loved and understood the polite arts. He had the fine feelings of a man of taste, as well as the sentiments of a hero. He built the princely suite of appartments at Hampton-Court, on purpose for the reception of those heavenly guests. The English nation were

then admitted to the rapturous enjoyment of their beauties.[28]

This is certainly exaggerated; if 'the English nation' was frequently admitted it is unlikely that the Privy Council, under Queen Anne, would have met in the gallery in which the cartoons hung.

Claims may be made for King William as a man of taste, but no one has ever proposed that George I or George II had much feeling for the arts and a startling glimpse of the latter's attitude to the interior decoration of Kensington Palace is provided by Lord Hervey's *Memoirs*:

In the absence of the King, the Queen had taken several very bad pictures out of the great drawing-room at Kensington, and put very good ones in their places. The King, affecting, for the sake of contradiction, to dislike this change, or from his extreme ignorance in painting, really disapproving it, told Lord Hervey, as Vice-Chamberlain, that he would have every new picture taken away, and every old one replaced. Lord Hervey, who had a

mind to make his court to the Queen by opposing this order, asked if His Majesty would not give leave for the two Vandykes, at least, on each side of the chimney to remain, instead of two sign-posts, done by nobody knew who, that had been removed to make way for them. To which the King answered, 'My Lord, I have a great respect for your taste in what you understand, but in pictures I beg leave to follow my own. I suppose you assisted the Queen with your fine advice when she was pulling my house to pieces and spoiling all my furniture. Thank God, at least she has left the walls standing! As for the Vandykes, I do not care whether they are changed or not; but for the picture with the dirty frame over the door, and the three nasty little children, I will have them taken away, and the old ones restored; I will have it done to-morrow morning before I go to London, or else I know it will not be done at all.' 'Would your Majesty', said Lord Hervey, 'have the gigantic fat Venus restored too?' 'Yes, my lord; I am not so nice as your Lordship. I like my fat Venus much better than anything you have given me instead of her.' Lord Hervey then thought, though he did not dare to say, that if His Majesty had liked his fat Venus as well as he used to do, there would have been none of these disputations . . . though he knew the fat Venus was at Windsor, some of the other pictures at Hampton Court and all the frames of the removed pictures cut or enlarged to fit their successors, he assured His Majesty that everything should be done without fail.[29]

The 'gigantic fat Venus' was probably the *Venus and Cupid* by Palma Giovane or a version by his workshop.[30] The 'three nasty little children' have been supposed to be those of Charles I, painted by Van Dyck, but are perhaps more likely to be the children of the King of Denmark depicted by Mabuse.[31] The portraits by Van Dyck were of Kenelm Digby and the Villiers brothers, recorded as being taken to Kensington Palace in 1736, the date of this incident.[32] One of the aspects of the affair which is of some interest for the historian of taste is Hervey's reference to the alteration of the frames. These had presumably been designed – probably by William Kent or in his style – to match the new architecture of the Drawing-Room.

In Frederick, Prince of Wales, the son of George II, we suddenly encounter a member of the Royal Family with a keen interest in the visual arts. It is striking how strong an antiquarian flavour this interest had. Frederick was deeply fascinated by the collections of Charles I and in the art of that period – the Stuarts, or

at least the early Stuarts, assumed a romanticised character as soon as the threat which they represented to the House of Hanover began to recede. In 1749 Prince Frederick visited the artist and antiquarian George Vertue. He studied manuscript records of King Charles's collection, bought some drawings which Vertue had made after early royal portraits, consulted Vertue about tapestries which had belonged to Charles I, and summoned him to Carlton House in London:

> I waited on him – he & her Royal highness were at breakfast in a Pavillion in his Garden near the Park of St. James, near the Gate of the park . . . here he spoke much concerning the settlement of an Accademy for drawing & painting – and about painting & famous Artists in England formerly – about the Cartoons of Raphael Urbin, the paintings of Rubens in the banqueting house at Whitehall. . . .

Not long after this, Vertue was invited to Leicester House, London, where the prince kept his collection:

> Well says the Prince I have sent for you here to let you see some that I mostly value, then pointing to a piece of St Peter holding in his Armes the child Jesus, painted by Guido how do you think or like that picture of Guido . . . a piece most admirable, surely – I said, then turning to another of the same Great Master being a Lucretia at half figure, so beautiful strong clear & Natural, of the finest taste of that skillfullest artist Guido – I much admired – two paintings of Andra del Sarto for the design & rarity much to be admired so many others of sublime Masters antient and scarse none modern nor none very large in this closset but most pieces of great value & esteemation[33]

The *Lucretia* by Reni is the great painting of Cleopatra (No. 40). Not surprisingly, Frederick's eldest son, who ascended the throne as George III, possessed a far greater interest in art than did either of his predecessors, an interest that was much encouraged by his mother, by her favourite, Lord Bute, and also by his queen. In 1761, within two years of his accession, George III purchased Buckingham House for Queen Charlotte. On 25 May 1762 Horace Walpole noted how the other palaces were being 'stripped' to furnish it: the cartoons, for example, were removed there in December 1763 to be hung at a high level around the Great Room. (They were removed to Windsor Castle in 1787–8 and given their present Carlo Maratta frames.) It was partly to furnish this new palace that the king purchased the paintings (as well as drawings, books and gems) amassed by the

great dealer, collector and patron Joseph Smith, 'Consul Smith', in Venice.[34] Buckingham House was remodelled by Sir William Chambers in 1773 and plans for hanging the paintings, made in the following year, survive. They correspond to the hasty notes which Walpole made in 1782 and 1783 after a 'slight view'. These rooms were certainly not easily seen by the public.

> The Cartoons are in the great room [that is the Saloon, the first room in the Queen's apartments on the *piano nobile*], hung on light green Damask. The cieling, on which were the Poets & Sheffield Duke of Buckingham, who built the House, is effaced, & newly painted in the antique taste by Cipriani, as are two more cielings. In the Japan room is a large organ, & the great pictures from Kensington, of Charles Ist on the white horse, and He & his Queen and Children sitting [the 'Greate Peece', No. 14]. The Latter is a very poor copy. The horse's head in the other is fine

This is one of several instances in which Walpole complained about the unequal quality of the paintings and it is clear that considerations of symmetry had precedence in the arrangements. Walpole did not hesitate to praise some works, for instance a Holy Family by Andrea del Sarto in the Warm Room, with 'five figures, among whom St Catherine is the finest I ever saw of the Master, & the best-preserved; It is equal to Raphael.' This work is, in fact, a good copy. It came from Leicester House and was probably acquired by Prince Frederick, where Vertue had also admired it. Walpole frequently notices such provenances. As, for instance, in the same room: 'The virgin & Child appearing to a Friar, Carlo Maratti; bought of Mrs Edwin by the late Prince of Wales. Jacob stripping the Sticks to mark the Cattle, Guido Cagnacci; this was Lord Cholmondeley's; fine.' A room of special interest was the Queen's Dressing-Room. Here Walpole found the following:

> Six large frames . . . glazed on red Damask, holding a vast quantity of enamelled pictures, miniatures & Cameos, among which six or eight at least of Charles Ist. There are also the best of those that were in Queen Caroline's closet at Kensington, those that belonged to the late Duke of Cumberland, & the Isaac Olivers bought of Dr Meade by the late Prince; but in general, the Miniatures are much faded, having been & being, exposed to the light & Sun. There are also some modern Enamels by Meyer, & miniatures by Humphreys. . . .

It is clear from the plan that five of these frames were suspended from smaller seventeenth-century portraits, which were hung from two cords with bows at the rail. Downstairs were the king's apartments.

> In the Library & in the other rooms are many very fine Pictures, some very bad. Most were in the Royal collection before, or purchased by the late Prince, which were all good. A few very fine by the present King, & most the bad. Of the latter is a whole room by West, of which none have much merit but the Death of General Wolfe. There is another room of Vandyks, most copies; & another of very fine Landscapes. The Principal is a very large almost birdseye view of Flanders in a most masterly Style by Rubens, & one of his best Works. Another a Cottage or farm, very good; both brought by the present King. Three beautiful & most clear of Gaspar Poussin, & two or three Clauds, & some false Clauds

The idea of a landscape room was not new – a particularly fine example of such a room survives at Holkham Hall, Norfolk, and dates from a couple of decades earlier – but it is typical of the tidy mind of George III that he should have had one:

> The great hall is hung with views of Canalletti and Zuccherelli. Those of the former belonged to Mr Smith, Consul at Venice . . . These Canellettis are bolder, stronger & far superior to his common Works; & either done before he engaged with Mr Smith, or particularly for him[35]

Two examples of the spectacular Canalettos acquired from Smith are in this exhibition (Nos. 58, 59), together with a Ricci and a Vermeer (Nos. 57, 53).

Walpole may not be quite fair to George III, but it is certain that the king's interest in collecting Old Master paintings diminished once Buckingham House was properly decorated. The major commission given to West between 1769 and 1773 for a series of history paintings, mostly with antique subject matter but complemented by a copy of his celebrated *Death of Wolfe*, was an important encouragement to history painting and reflects perhaps the king's public role as patron of the Royal Academy, founded in 1768. It was repeated by other ambitious commissions from West for Windsor Castle,[36] among them *Edward III crossing the Somme* (No. 64), painted for the Audience Chamber in the late 1780s (Fig. 25).

Whereas the king's apartments in Buckingham House were elegant but unostentatious and unluxurious – he had an aversion to carpets – the queen's

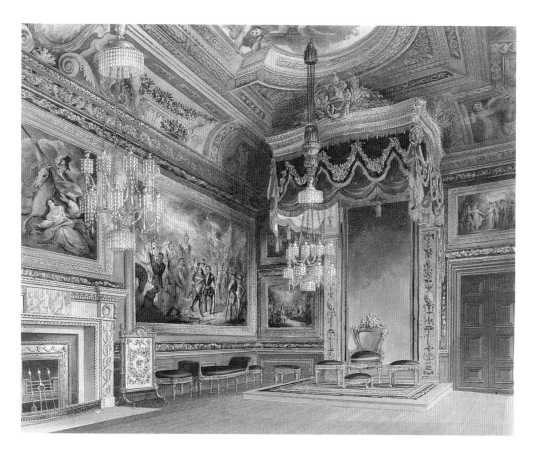

Fig. 25 C. Wild, *The King's Audience Chamber, Windsor Castle*, watercolour, Pyne, *The History of the Royal Residences*, vol. 1, 1819.

rooms were elaborately furnished. Whilst he collected clocks she acquired 'curiosities from every nation . . . the finest Dresden and other china, cabinets of more minute curiosities'.[37] These included fans, snuffboxes, Chinese ivory carvings, stuffed birds, shells, minerals and numerous jewels.

In 1783, the year following Walpole's visit to Buckingham House, the Prince of Wales (the future Prince Regent and King George IV) came of age and was allowed to take up residence in Carlton House, formerly a residence of Prince Frederick, his grandfather. It was rebuilt and refurbished in the most luxurious fashion and at enormous expense, and was then rebuilt and refurnished again and again until, having at last come to the throne, he 'tired of it' completely and resolved to turn Buckingham House into a palace – a conversion by his architect John Nash which was incomplete at his death in 1830.[38] That George IV was a great collector, that he had a passion for works of art which is comparable with that of Charles I, is undeniable, and there is evidence that he also possessed real discrimination; but there are times when his artistic appetite appears to border on gluttony, and it is shocking to dwell on what was destroyed almost as soon as it was created at both Carlton House and his

seaside pleasure house, the Pavilion at Brighton. 'He changes the furniture so often, that one can scarcely find time to catch a glimpse at each transient arrangement.'[39] No British prince ever acquired so many paintings; but it is also true that no other British prince has ever disposed of so many.

Paintings were bought as furniture – furniture of the 'rarest quality & consequence' such as those 'culled' for the prince in 1806 by Walsh Porter,[40] an eccentric figure who was a dealer, an entrepreneur and an interior decorator. By this date the prince's taste in Old Master paintings had come to settle almost entirely upon Dutch and Flemish pictures of the seventeenth century – paintings by Jan Steen (Nos. 54, 55) or Gerard Dou. Such works had been favoured as the wall furnishing of the most luxurious Parisian hotels of the eighteenth century, interiors which Carlton House was designed to outshine. By 1813 the prince had acquired a hundred Dutch paintings. Of these, however, forty were sold the following year, but only after the purchase of a further eighty-six from the Baring collection, including the Hondecoeter in this exhibition (No. 52). Acquisitions continued thereafter until the year of his death, made through and probably often on the advice of Lord

Yarmouth, Vice-Chamberlain of his Household (created 3rd Marquess of Hertford, 1822) and of Sir Charles Long (later Lord Farnborough).[41] Among the modern artists patronised by the prince the most important were probably Stubbs in the 1790s (No. 66), Wilkie and Lawrence. Wilkie (No. 68) worked in the manner of the Dutch and Flemish painters so well represented at Carlton House. Lawrence (No. 67) produced portraits that could match the great Van Dycks which had for so long been the most prominent artistic attractions of the royal picture collection. The most challenging commission that the prince is said to have given Lawrence was for a group portrait of himself with the Tsar of Russia and the King of Prussia – the allied monarchs. But this idea, like the group portrait of court ladies by Lely a century and a half earlier, was abandoned. Instead, Lawrence painted a series of full-length portraits of the allied monarchs and their commanders, which were eventually exhibited in the Waterloo Chamber at Windsor Castle.[42]

Lawrence's portraiture, with its theatrical glamour, its satin and velvet, complemented the opulent settings which the prince's architects and decorators devised at the Pavilion and Carlton House, and later

at Windsor and Buckingham Palace. One of the rooms at Carlton House, the Audience Room, must suffice to document this taste. It was known as the Blue Velvet Room, and its decoration can be seen from a watercolour of 1819 (Fig. 26). In it hung the great Rembrandt double portrait *The Shipbuilder and his Wife* and landscapes by Jan Both and Cuyp, all in new sumptuous gilt frames. The blue velvet was itself also framed in gold against a peach coloured ground and the richness and elaboration of the plaster ornaments in the coving, and the extent of hangings and pelmets, were unprecedented. The luxury is almost comically alien to the values of the hard-working couple in Rembrandt's painting. In style the room represents a version of Neo-classicism in which detail has multiplied and been overlaid with a Rococo exuberance. It contained porcelain, bronzes and cabinets as well as paintings, and it is obvious that access to a room such as this would have been very carefully controlled.

Nevertheless, a large percentage of the prince's paintings was shown to the public in an unprecedented manner through two exhibitions (in 1826 and 1827) organised by the British Institution, of which he was a patron. Loans of this kind were less painful for

Fig. 26 C. Wild, *The Blue Velvet Room, Carlton House*, watercolour, Pyne, *The History of the Royal Residences*, vol. 3, 1819.

the prince than for other collectors given the constant redecoration of his residences. But by 1816–17, 250 of his paintings were not hung and by 1826 all his paintings were in store.[43] Work on the great gallery at Buckingham Palace had begun.

A watercolour showing the palace gallery in 1843 (Fig. 27) makes a most instructive contrast with the Blue Velvet Room. The fact that the paintings are hung in tiers is not surprising – small paintings were certainly displayed in this way in Carlton House, and indeed it was the usual practice. But the crowding and especially the placing of some, presumably lesser, paintings above the large ones, as well as below them, suggests the way in which public collections such as London's new National Gallery were hung. The top lighting also suggests the preferred arrangements for public collections, as do the tablets identifying the pictures attached to the upper mouldings of the new, more or less uniform, frames. Rich furnishings and other works of art now no longer competed with the paintings. By this date Victoria had become queen. The paintings in the palace gallery were not those which she loved most; those bought by her and by the Prince Consort, for themselves or for each other, were hung separately in more intimate and domestic circumstances.

A good many royal pictures could be seen at Hampton Court. Mrs Jameson described the situation in 1842:

> Before the accession of William IV, in 1830, the number of state rooms open to the public was nineteen; the number of pictures about 200; since then, the pictures formerly at Kensington Palace, which used to be the great depository for all the old trash belonging to the crown, have been removed hither and being united with a great number of those which hung at Buckingham House and Windsor Castle before the late alterations, they form a gallery of about 750 pictures, distributed through twenty-four apartments. These are freely open to all visitors every day of the week, except Friday....[44]

Mrs Jameson also lamented the condition of the pictures. In the following year the queen inspected the palace and was 'thunderstruck and shocked . . . at the way in which the pictures, many fine ones amongst them . . . have been thrown about or kept in lumber rooms.' It was her intention to restore, redisplay and prevent 'pictures of the family, or ones of interest and value, from being thrown about again.' Her 'dearest Albert' would wish this done 'for he delights in these things.'[45]

The Prince Consort, to whom the queen deferred in all questions of taste, was an important collector of

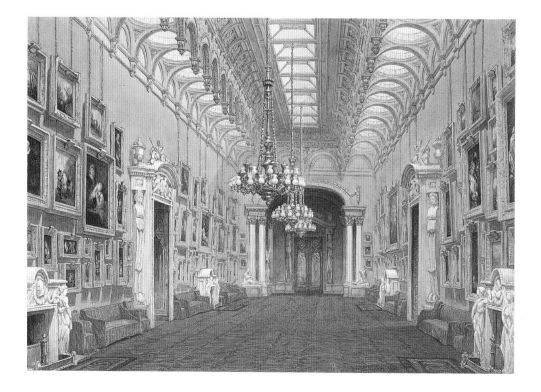

Fig. 27 Douglas Morison, *The Picture Gallery, Buckingham Palace*, The Royal Collection.

the work of Early Renaissance and late medieval painters, then known as 'primitives'. His Italian 'primitives' included several masterpieces such as those by Benozzo Gozzoli and Duccio (Nos. 82, 80). He also collected early German paintings (Nos. 83, 84, 86), a far more unusual choice in England. This taste reflected not only the interests of modern scholarship (these paintings were regarded as objects of study as well as delight) but also the enthusiasm of modern artists, especially the modern German artists, working in Italy. An incentive to buy paintings was supplied by the building, to Prince Albert's own design, of Osborne House on the Isle of Wight as a private residence for the prince and his queen (many of the finest paintings were hung in his Dressing-Room). Much was done in those years to protect royalty generally from public curiosity (alterations at Windsor Castle were made with this very much in mind), but Prince Albert's sense of public duty developed together with this desire for family privacy, and many of the primitives which had hung in his Dressing-Room were presented after his death, and in accordance with his wishes, to the National Gallery. That institution owed much to him, as did the South Kensington (now the Victoria and Albert) Museum, and he was also a vigorous promoter of the greatest loan exhibition of paintings ever mounted, the Art Treasures exhibition in Manchester in 1857.[46]

The Prince Consort's taste is well illustrated by the garden pavilion in the grounds of Buckingham Palace (Fig. 28), which he planned in 1842. It was decorated in the spring of 1843 and was ready for its first visitors the following year, but had to be dismantled in 1928 and can now only be studied in the splendid illustrations by Ludwig Grüner, Prince Albert's artistic adviser, who was its chief creator. The central octagon was decorated in the style of Raphael's Vatican *loggia*, with the lunettes painted by eight leading Royal Academicians (including Eastlake, Landseer, Leslie and Etty). Their subjects came from Milton's *Comus*, a source at once British (by a British poet and set in Britain) and classical (involving a quasi-Ovidian mythology). To one side was a smaller room painted in the Pompeian style and the other was decorated with subjects from Walter Scott. The Pompeian and Raphaelesque schemes were archaeological exercises. A passion for Raphael was highly characteristic of Prince Albert, who used Passavant's systematic catalogue of Raphael's works (the first true art-historical monograph) for ordering the drawings by Raphael at Windsor and for assembling a great photographic corpus of Raphael's work.[47] This passion clearly influenced the style of Dyce's *Virgin and Child* (No.

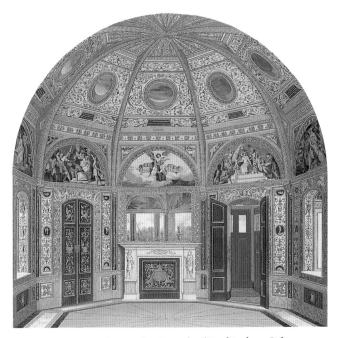

Fig. 28 *Garden Pavilion in the Grounds of Buckingham Palace: The Victoria Room*, from L. Grüner, *The Decoration of the Garden Pavilion in the Grounds of Buckingham Palace*, London, 1846.

90) which hung in the Queen's Bedroom, as it did the subject matter of Wittmer's painting (No. 93). But the pavilion reflected theories of art as well as scholarship – the central room reconciled ancient and modern, southern and northern, classical and romantic ideas found in the neighbouring rooms. Moreover, the whole scheme was public-spirited for it was intended to promote the revival of mural paintings, then so much under discussion in connection with the new Palace of Westminster.

Prince Albert's historical interests extended to the proper care of earlier royal collections. This is best seen in the Queen's Private Audience Chamber (Fig. 29), created in Windsor Castle in 1860–1. The elegant satinwood and marble panelling, divided by Raphaelesque grotesques, incorporates ormolu-framed vitrines behind which the royal miniatures and cameos were arranged. Above this were fifteen portraits of the Royal Family, painted nearly a hundred years earlier for George III by Gainsborough (these have since been replaced by Winterhalters). The frieze incorporated the heads of all the British monarchs from William the Conqueror to Queen Victoria, and in the coffering medallions of British saints.[48] The room is an illustrated history of British royalty, appropriate for its purpose as an audience chamber. But it is also an illustrated history of the taste of previous royal collectors, conducted in an antiquarian spirit which Vertue and Prince Frederick would have appreciated. The scheme, for all its pedagogy, has an elegance

Fig. 29 The Queen's Private Audience Chamber, Windsor Castle, c.1875–84, The Royal Collection.

comparable with the display of miniatures and cameos in previous centuries at Buckingham House and Whitehall Palace.

This anthology is based on the research of Dr Edward Chaney.

Notes:

1 A. F. Steuart (ed.), *Memoirs of Sir James Melville of Halhill 1535–1617*, London 1929, p. 94.

2 R. Strong, 'From manuscript to miniature' in J. Murdoch, J. Murrell, P. Noon, R. Strong, *The English Miniature*, London and New Haven 1981, pp. 25–84.

3 L. B. Salamon (ed.), *Nicholas Hilliard's Art of Limning*, Boston 1983, pp. 18–19.

4 G. von Bülow, 'Journey through England and Scotland made by Lupold von Wedel in the years 1584 and 1585', *Transactions of the Royal Historical Society*, IX (N.S.), 1895, p. 235.

5 G. W. Groos (ed.), *The Diary of Baron Waldstein*, London 1981, pp. 46–7.

6 G. von Bülow, 'Diary of the Journey of Philip Julius, Duke of Stettin-Pomerania, through England in the year 1602', *Transactions of the Royal Historical Society*, VI (N.S.), 1892, p. 23.

7 E. S. de Beer (ed.), *The Diary of John Evelyn*, 6 vols, Oxford 1955, IV, pp. 216–17.

8 R. S. Magurn (ed.), *The Letters of Peter Paul Rubens*, Cambridge (Mass.) 1955, p. 320.

9 R. Wittkower, 'Inigo Jones – Puritanissimo Fiero' in *Palladio and English Palladianism*, London 1983, pp. 211ff (translation by Edward Chaney).

10 Ibid.

11 Ibid.

12 Puget de la Serre, *Histoire de l'Entrée de la Reine dans la Grande Bretagne*, Paris 1775, pp. 42–4 (translation by Edward Chaney).

13 F. Haskell and N. Penny, *Taste and the Antique*, London and New Haven 1981, pp. 31–2.

14 H. Colvin (ed.), *The Kings Works*, 1963, IV, ii, p. 252.

15 Op. cit., p. 84.

16 A. MacGregor, 'The King's Goods and the Commonwealth Sale. Materials and Context' in A. MacGregor (ed.), *The Late King's Goods*, London and Oxford 1989, pp. 13–53.

17 Op. cit. in note 7, III, p. 260. For the Petitot portrait see the *Cata-logue of the collection of miniatures of J. Pierpont Morgan*, London 1906–8, pp. 56–9. For the cameo of Caesar (in fact the Emperor Claudius) see *Archaeologia*, XLV, 1880, pp. 6–9. For the needlework landscape see A. J. Loomie (ed.), *Ceremonies of Charles I: the Notebooks of John Finet 1628–1641*, New York 1987, p. 198.

18 Op. cit. in note 7, III, pp. 262–3.

19 A. M. Crino (ed.), *Lorenzo Magalotti Relazioni d'Inglilterra 1668 e 1688*, Florence 1972, p. 158 (translation by Edward Chaney).

20 O. Millar, *Sir Peter Lely*, catalogue of the exhibition held at the National Portrait Gallery 1978–9, nos. 11 and 25.

21 *Inventory of goods of James II, when Duke of York, at Culford Hall, 1671, and Whitehall, 1674*, Bodleian Library MS 891, fol. 7v.

22 For Kensington Palace see G. H. Chettle and P. A. Faulkner, 'Sir Christopher Wren and Kensington Palace', *Journal of the British Archaeological Association*, XIV, 1915; also op. cit. in note 14, V, pp. 183–91.

23 O. Millar, *Tudor, Stuart and Early Georgian pictures in the Collection of Her Majesty The Queen*, London 1963, 2 vols, I, nos. 351–8.

24 C. Morris (ed.), *The Journeys of Celia Fiennes*, London 1947, pp. 59–60.

25 Ibid., pp. 354–7.

26 J. Shearman, *Raphael's Cartoons in the Collection of Her Majesty The Queen*, London 1972, p. 147.

27 Ibid., pp. 148–9.

28 Wilkes speaking in the House of Commons on 28 April 1777, quoted ibid., p. 152.

29 R. Sedgwick (ed.), *Some Materials towards Memoirs of the reign of King George II by John, Lord Hervey*, 3 vols, London 1931, pp. 488–9.

30 J. Shearman, *The Early Italian Pictures in the Collection of Her Majesty The Queen*, Cambridge 1983, nos. 174 and 177.

31 L. Campbell, *The Early Flemish Pictures in the Collection of Her Majesty The Queen*, Cambridge 1985, no. 34.

32 O. Millar, op. cit. in note 23, I, no 153.

33 G. Vertue, Autobiographical Notes in *The Walpole Society*, XVIII, 1930, pp. 8–10.

34 [O. Millar], *George III as Collector and Patron*, anonymous introduction to the catalogue of the exhibition at The Queen's Gallery, Buckingham Palace 1974–5.

35 I. Toynbee, 'Horace Walpole's Journals of Visits to Country Seats', *The Walpole Society*, XVI, 1928, pp. 78–80; F. Russell, 'King George III's picture hang at Buckingham House', *Burlington Magazine*, August 1987, pp. 524–31.

36 H. von Erffa and A. Staley, *The Paintings of Benjamin West*, New Haven and London 1986, pp. 87–102.

37 E. J. Climenson (ed.), *Passages from the Diaries of Mrs Philip Lybbe Powys*, London 1899, p. 116.

38 *Carlton House: the Past Glories of George IV's Palace*, catalogue of an exhibition at The Queen's Gallery, Buckingham Palace 1991.

39 C. White, *The Dutch Pictures in The Collection of Her Majesty The Queen*, Cambridge 1982, p. LXI.

40 Ibid., p. LX.

41 Ibid., pp. LXI–LXXI.

42 K. Garlick, *Sir Thomas Lawrence*, Oxford 1989, pp. 21–2.

43 Op. cit. in note 39, p. LXVIII.

44 A. Jameson, *Handbook to the Public Galleries in and around London*, London 1842, p. 283.

45 O. Millar, *The Queen's Pictures*, London 1977, pp. 187–8.

46 J. Steegman, *Consort of Taste 1830–1870*, London 1950, pp. 233–56; F. Haskell, *Rediscoveries in Art*, London 1976, pp. 98–9.

47 L. Grüner, *The Decoration of the Garden-Pavilion in the Grounds of Buckingham Palace*, London 1846; [C. Ruland], *The Work of Raphael Santi da Urbino as represented in the Raphael Collection in the Royal Library at Windsor Castle, formed by H.R.H. The Prince Consort, 1853–1861, and Completed by Her Majesty Queen Victoria*, privately printed, 1876.

48 W. Ames, *Prince Albert and Victorian Taste*, London 1967, pp. 114–16.

The Catalogue

Editorial Note

REFERENCES

The principal references in the Literature sections are to the published catalogues of the Royal Collection, where citation of earlier literature and exhibition history can be found. Only the most important references to a painting, during or since the date of publication of the relevant catalogue, have been added, but subsequent exhibition histories are given in full. In all cases those exhibitions mounted by the Royal Collection in The Queen's Gallery, Buckingham Palace, are omitted. For those groups of pictures in the Royal Collection not yet officially catalogued, summary listings of Literature and Exhibitions are given.

Information that is specific to a particular catalogue entry is given in full in the Notes that follow. Bibliographical references in the catalogue entries are contained in the Literature sections and are abbreviated using the author-date system. These are given in full in the general bibliography.

MEDIA

All works are in oil, with the exception of the earlier Italian, Netherlandish and German schools where works are more usually in tempera. In each instance the support (canvas or panel) is given.

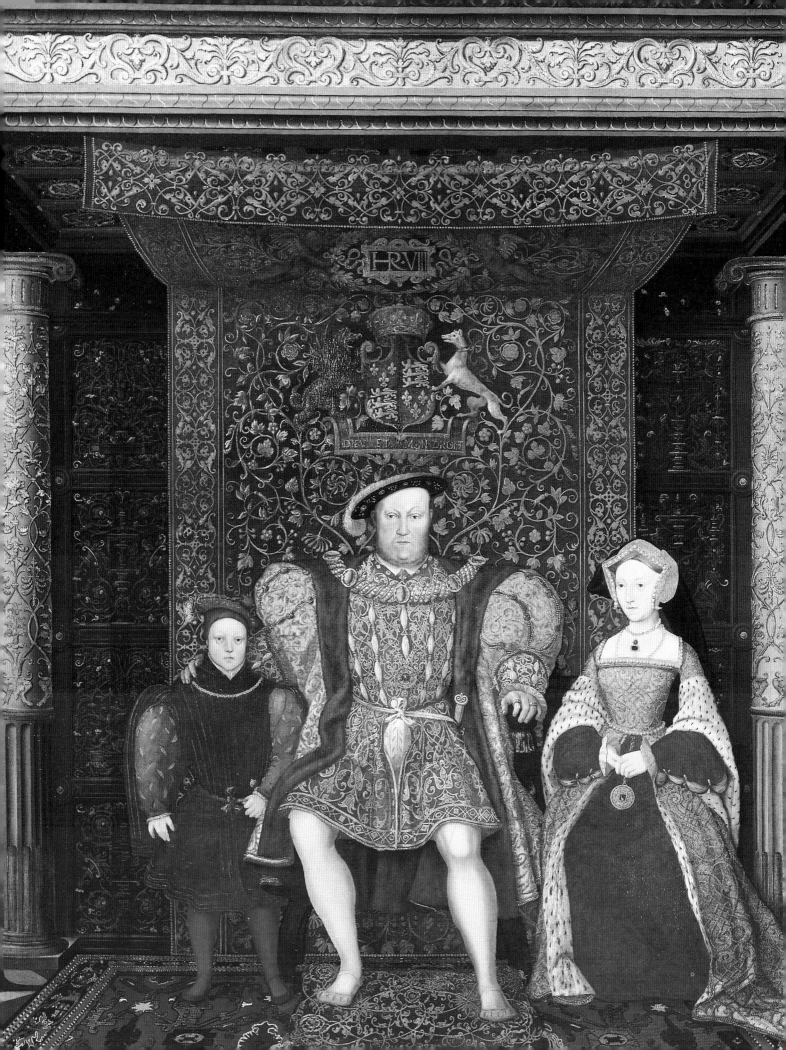

The Tudors and Stuarts

THE HISTORY of the Royal Collection in the modern sense begins with the Tudor dynasty. Henry VII (1485–1509) used the arts to reinforce his claim to the throne, and Henry VIII (1509–47) to demonstrate the continuation of the dynasty (No. 8), as well as to record changes in policy such as the Reformation (No. 6). Elizabeth I (1558–1603) preferred allegory (No. 9) to emphasise her position as queen, and the entertainments devised for her court (No. 10) reflect her intellect as much as the force of her personality. The most important artist at the Tudor court was Hans Holbein the Younger (Nos. 2, 3), German by birth and a major northern Renaissance figure, who divided his time between Switzerland and England.

The Stuarts nurtured the greatest royal collector of all: Charles I (1625–49). He inherited a love of art from his mother, Anne of Denmark, and was influenced by his elder brother, Henry, Prince of Wales, who was a noted patron but died in 1612 aged eighteen. Charles I's visit to Spain in 1623 in search of a bride enabled him, when still Prince of Wales, to see the collection inherited by Philip IV, and this undoubtedly served as an inspiration.

Charles I's achievement was to amass a collection that rivalled or surpassed those of the courts of France, Spain or Italy. His collection was formed rapidly within a period of twenty years, and finally numbered over 1,500 works, many of them of outstanding quality. He relied upon advisers and agents to seek out acquisitions, but his personal taste was the most important factor. Rubens at an early stage described him as 'the greatest amateur of paintings among the princes of the world.' The king was particularly fond of Venetian painting, especially the works of Titian. The purchase of the Gonzaga collection in Mantua in 1625–7 was the single most advantageous acquisition, as it included works by Mantegna, Leonardo da Vinci, Raphael, Titian, Correggio and Caravaggio. Many of these masterpieces were hung in Whitehall Palace.

OPPOSITE Unknown artist,
The Family of Henry VIII
(No. 8, detail).

JAN GOSSAERT, called Mabuse Active 1503; died 1532

Adam and Eve

1

Panel, 168.9 × 111.4 cm (66½ × 43⅞ in.)

THE STATES-GENERAL of Holland presented four paintings to Charles I in 1636, one of which was the *Adam and Eve* by Mabuse. Two of the other paintings were the front and back respectively of one wing of an altarpiece by Geertgen tot Sint Jans: *The Lamentation* and *Legend of the Relics of Saint John the Baptist* (Vienna, Kunsthistorisches Museum). These works originally belonged to the Knights of Saint John of Jerusalem at Haarlem and it is possible that the *Adam and Eve* came from the same source. The painting was sold in 1650 after the death of Charles I, but was recovered at the time of the Restoration. It has been suggested that John Milton, who was appointed Latin Secretary to Cromwell's Council of State in 1649, may have seen the work before it was sold, since the description of Adam and Eve in *Paradise Lost* (Book 4, lines 300–18) is fairly close.

This theme occurs at least nine times in Mabuse's painted and graphic oeuvre, but none of these renderings is dated. On grounds of style, however, the present painting would seem to have been undertaken after the *Neptune and Amphitrite* of 1516 (Berlin, Staatliche Museen) or the *Hercules and Deinara* of 1517 (Birmingham, Barber Institute of Fine Arts), and to have preceded the *Adam and Eve* dating from around 1525 (Berlin, Jagdschloss Grünewald). In general terms, as his career developed, Mabuse evolved compositions of greater complexity characterised by a repertoire of contorted poses with exaggerated anatomy and a vivid treatment of chiaroscuro. At the same time his technique became altogether freer. The *Adam and Eve* in the Royal Collection may date from around 1520.

Mabuse refers to a number of prints for the poses of Adam and Eve: Dürer's *Adam and Eve* of 1504, Jacopo de' Barbari's *Mars and Venus* and Marcantonio Raimondi's *Adam and Eve* after Raphael. The pose of Eve is perhaps more specifically related to Dürer's engraving known as *The Dream of the Doctor*, particularly the upper part of the body. Mabuse had visited Italy in 1508–9 and became a prime exponent of Northern Mannerism, a style that evolved principally from the cross-fertilisation of German and Italian art. Quite apart from the large scale of the painting, the prominence of the foreground figures is still further enhanced by the sudden drop down to the middle-ground, dominated by a fountain set in the Garden of Eden. Fanciful architecture of this kind is frequently found in Mabuse's work. He was also a remarkably fine painter of the nude. The treatment of the musculature may not be to modern taste, but it was undoubtedly inspired by classical sculpture. The handling of the hair, especially Eve's long tresses, which may have influenced Milton, was a speciality of the artist.

Supplementing the narrative of The Fall as recounted in the second and third chapters of Genesis is a certain amount of symbolism, which is illustrated in Mabuse's work: the two trees represent the Tree of Life and the Tree of Good and Evil, while the plants in the immediate foreground (columbine and sea holly) probably symbolise the contrasting emotions of the fear of God and the lust experienced by Adam and Eve in the Garden of Eden. Adam wears an apron of leaves, but Eve is still technically naked. Mabuse was concerned to paint an epitome of the theme and was therefore disposed to take liberties with the biblical text.

Literature: Campbell 1985, no. 33; Lowenthal 1990, under no. 2.

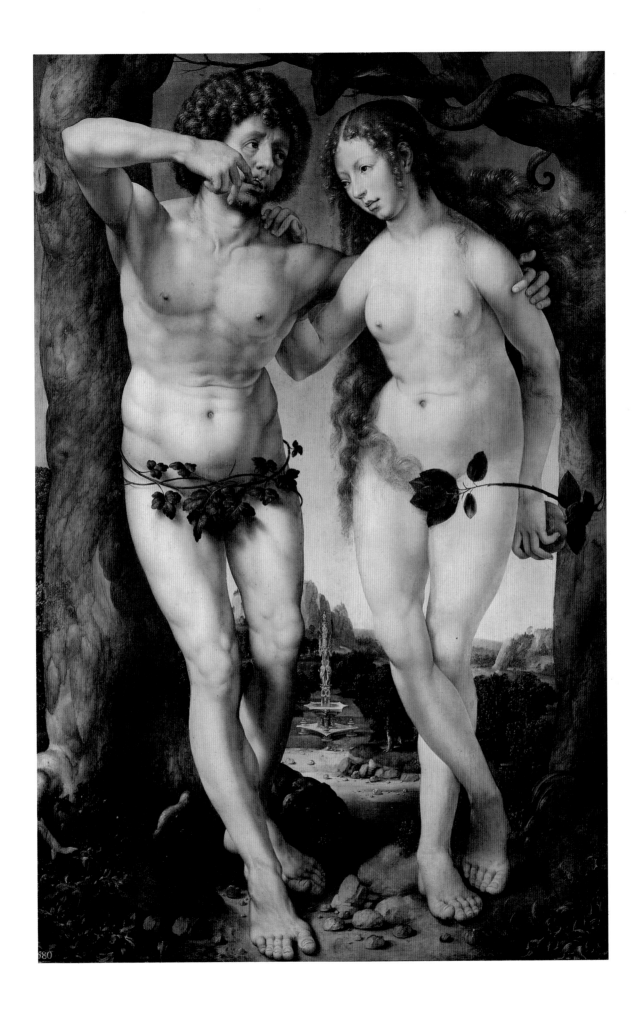

HANS HOLBEIN THE YOUNGER 1497/8–1543

2 'Noli me Tangere'

Panel, 76.8 × 94.9 cm (30¼ × 37¾ in.)
Cleaned 1991

SINGLE detached religious paintings by Hans Holbein the Younger are relatively rare in his oeuvre. However, having been trained by his father in Augsburg, Holbein did produce two large altarpieces during the early part of his career: the Oberried altarpiece of about 1520 (Münster, Freiburg-im-Breisgau) and the Passion altarpiece of about 1524 (Basle, Öffentliche Kunstsammlung), both designed in the traditional Gothic style with several compartments. The 'Noli me Tangere' is comparable with The Body of the Dead Christ in the Tomb dated 1522 (Basle, Öffentliche Kunstsammlung) to which it is close in date and in its own way no less dramatic.

The foreground is dominated by the two principal figures who surprise one another in front of the tomb depicted on the right.[1] Behind in the middle distance are two disciples, Saint Peter and Saint John, making their way to Jerusalem which can be espied in the valley below. On the left is Calvary where, unusually, the artist has shown more than three crosses. The scene is carefully composed, with the verticals established by the risen Christ and Mary Magdalen continued by the trees. The dialogue between the main figures is echoed by the poses of the two disciples, whose forms are contained in the space between the chief protagonists. As the disciples hurry away so they lead the eye down the hill and over the distant landscape. The fluid handling of the paint (some changes are visible around the door of the tomb and to the outlines of the Magdalen) and the firm drawing of the figures are characteristic of the younger Holbein, as is the precision with which the green sward in the foreground is rendered. Other features though, such as the sombre colours, the distinctive faces with high foreheads, long noses and small chins, the fast moving clouds seen between the trees, and the luminous interior of the tomb reveal the residual influence of the elder Holbein, as well as of Hans Baldung Grien and Hans Burgkmair.

The painting may well have been made in 1524, the year of Holbein's visit to France, or shortly afterwards. Rowlands contends that the Magdalen is dressed in the French fashion and that the ointment jar is recognisable as French faience. In addition, he argues that Holbein shows some knowledge of the style of Leonardo da Vinci and his followers, whose works were represented in the collection of Francis I at Amboise and Blois. Other works by Holbein of similar date (The Last Supper, Venus and Cupid, Lais of Corinth – all in Basle, Öffentliche Kunstsammlung) reveal Leonardesque elements which in the present painting are most evident in the tension between

Christ and Mary Magdalen, the fluency of their movements, and in the treatment of the landscape seen from above. It may be added that the face of the Magdalen is particularly reminiscent of the types painted by Andrea Solario, a follower of Leonardo da Vinci who worked in France from around 1507–11 (compare, for example, Solario's Salome with the Head of Saint John the Baptist – New York, Metropolitan Museum). On the other hand, it has been suggested on the evidence of the oak panel (oak was uncommon in France) that the painting was undertaken in Antwerp in 1526 as Holbein travelled to England.

However, there is some corroborative evidence that the painting was executed in France. The picture was not recorded in the Royal Collection until it was seen by John Evelyn in 1680 at Whitehall Palace. Yet it may be identifiable with a picture that hung in the bedroom of Henrietta Maria while in exile at Colombes until her death in 1669, when Charles II would seem to have acquired it. This implies that the painting could have remained in France since the sixteenth century. Evelyn's description of the painting is memorable: 'There is in the rest of the Private Lodgings contiguous to this, divers of the best pictures of the greate Masters, Raphael, Titian, etc. (& in my esteeme) above all the 'Noli me Tangere' of our B: Saviour to M: Magdalen, after his Resurrection, of Hans Holbeins, than which, in my life, I never saw so much reverence & kind of Heavenly astonishment, expressed in Picture.'[2]

Notes: 1 Saint John 20: 1–17. 2 The Diary of John Evelyn, ed. E. S. de Beer, IV, Oxford 1955, pp. 216–7.

Literature: Millar 1963, no. 32; Fletcher and Tapper 1983, pp. 89–91; Rowlands 1985, pp. 61–2 and 130, no. 17.

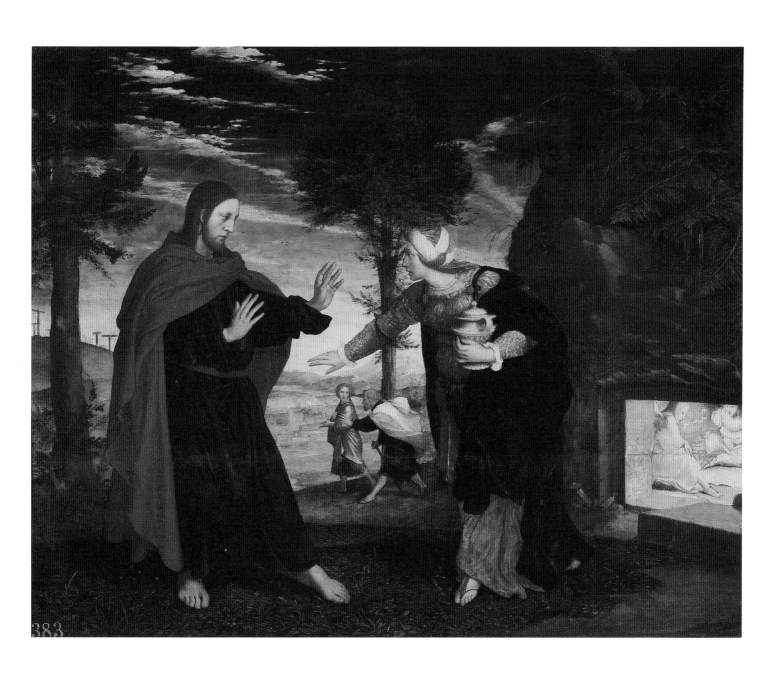

Portrait of Derich Born

3

Panel, 60.3 × 45.1 cm (23¾ × 17¾ in.)
Fictive inscription on the stone parapet below the ledge:
DERICHVS SI VOCEM ADDAS IPSISSIMVS HIC SIT/HVNC DVBITES PICTOR FECERIT AN GENITOR/DER BORN ETATIS SVÆ 23. ANNO 1533
[Here is Derich himself: Add voice and you might doubt if the painter or his father created him. Der Born aged 23, the year 1533]

HANS HOLBEIN THE YOUNGER returned to England in 1532 for a second and longer visit, marked by a series of portraits of German merchants in London's Steelyard community. The group formed part of the powerful Hanseatic League and its members were for the most part only based in London for a few years. Holbein painted the portraits of several merchants, not, as might well be assumed, for the decoration of the Steelyard Merchants' Hall, but most probably for their families left behind in Germany. (The success of these portraits, however, led the Steelyard Merchants to commission the allegorical paintings *The Triumph of Riches* and *The Triumph of Poverty* for their Hall.) The portraits are restricted to half-length compositions and the sitters are normally posed in

relation to a parapet or a table, looking directly out at the viewer and often identified by an inscription or some other internal clue. In this context the present inscription is of a type often found on portraits during the Renaissance. The wording might indicate an informal purpose for the painting. Although the exact number of the Steelyard portraits is not known, seven of the sitters can be firmly identified.

When seen in sequence the paintings reveal the development of Holbein's portraiture during the early 1530s, from the meticulous treatment of the still-life objects in *Portrait of George Gisze* (Berlin, Gemäldegalerie) to the more restrained composition of the present portrait. Here the barrier formed by the parapet is negated by the placing of the head in relation to the angle of the shoulders and by the sitter's jutting elbow. These devices help to define the position of the figure both within the picture space and with regard to the viewer. They can also be found in early portraits by Titian such as the *Portrait of a Man* (Fig. 30) and in the *Portrait of Baldassare Castiglione* by Raphael (Paris, Louvre). The precision of Holbein's brushwork incorporating the smooth modulation of the flesh tones, enhanced by the sharp light, the embroidery on the collar, and the foliage behind is remarkable. It has been suggested that the fig leaves behind the sitter in the present portrait are included for prophylactic reasons as opposed to being a personal symbol.

Derich Born was from Cologne and his mercantile activities are recorded between 1533, when he may already have been in England, and 1549. In 1536 he is documented as a supplier of harnesses at the time of the suppression of the Pilgrimage of Grace. Together with his brother, Johannes, Born was expelled from the London Steelyard in 1541 and he seems frequently to have been in financial difficulties even though he continued trading.[1]

The portrait has the brand of Charles I on the back, but it seems not to have been recorded in any of the inventories of the Royal Collection until the reign of Charles II. It may, however, be identifiable with a portrait of Derich Born recorded in 1655 as being in the collection of Thomas Howard, Earl of Arundel, a great admirer of Northern European painting. Charles I often gave paintings to Howard or exchanged pictures with him. This seems, therefore, to be a case of a picture having left the Royal Collection only to return later.

Notes: **1** Holman 1980, pp. 149–50.

Literature: Krummacher 1963, pp. 188–90; Millar 1963, no. 26; Markow 1978, pp. 44–7; Roberts 1979, p. 60; Holman 1980, p. 157; Rowlands 1985, pp. 83 and 139, no. 44.

Fig. 30 Titian, *Portrait of a Man*, oil on canvas, 81.2 × 66.3 cm, London, National Gallery.

LORENZO LOTTO c.1480–after 1556

4 Portrait of Andrea Odoni

Canvas, 104.1 × 116.6 cm (41 × 45⅞ in.)
Signed and dated lower left: *Laurentius Lotus/1527*

THE PORTRAIT is first recorded in the house of Andrea Odoni in Venice in 1532 by Marcantonio Michiel, who describes it as a likeness of the owner. Odoni (1488–1545) was a wealthy merchant who lived in a palazzo on Fondamenta del Gaffaro (between the Frari and Piazzale Roma). The palazzo was decorated on the outside with frescoes by Girolamo da Treviso, and according to Vasari (v, pp. 135–6) was a place for connoisseurs ('un albergo di virtuosi'). The painting clearly alludes to Odoni's cultural interests and his passion for classical sculpture. Several pieces, together with this portrait and even the coat that the sitter is wearing, are listed in the 1555 inventory of

goods belonging to Andrea's brother Alvise. Not all the sculpture shown in the portrait can be firmly identified. Some items may be casts and others recalled from memory, or invented by the artist. Odoni holds a terracotta statuette in the Egyptian style of Diana of the Ephesians. In the background on the right is a small Hercules *mingens*, probably a bronze, and the head in the right foreground relates to busts of the Emperor Hadrian. The left background is dominated by the figures of Hercules and Antaeus. Less positively identifiable are the standing male figure (perhaps Hercules), the female figure washing (Venus or Diana) in the right background, and the nude female torso (probably Venus) in the immediate foreground. It is apparent from the gesture, if nothing else, that the sculptures are not intended simply as an attribute of the sitter, but that a deeper significance is implied. A number of interpretations have been offered, such as the transitoriness of human life or the relationship between art and nature, but none of the proposals made so far is totally convincing. The statuette of Diana held by Odoni is clearly significant, and during the Renaissance this figure was equated with nature or earth. Lotto was particularly skilful at rendering a sitter's inner state of mind as reflected in pose, gesture and expression. Few of his portraits, however, combine psychological exploration with such an expansive treatment of the background.

The portrait was influential and its impact can be seen in the works of other artists like the *Portrait of a Man* by Parmigianino (London, National Gallery), the portrait of *Jacopo Strada* by Titian (Vienna, Kunsthistorisches Museum) and the *Portrait of a Collector* by Palma Giovane (Birmingham City Museum and Art Gallery). During the seventeenth century the painting was in Holland, where it was acquired by Gerard Reynst at the sale of the Lucas van Uffelen collection. Several of the pictures in the Reynst collection formed the basis of the gift made to Charles II in 1660 by the States-General of Holland to mark the Restoration. While in Holland, Lotto's composition, notably the broad gesture, seems to have been acknowledged by Van Dyck, as in the portrait of *Lucas van Uffelen* (Fig. 31), and by Rembrandt, as in *The Shipbuilder and his Wife* (Royal Collection).

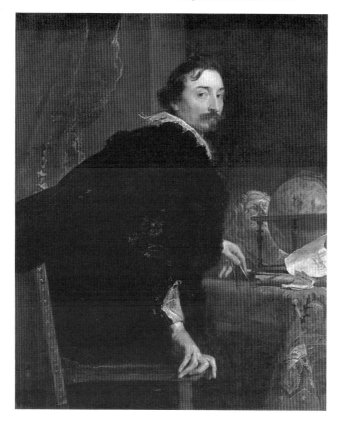

Fig. 31 Sir Anthony van Dyck, *Lucas van Uffelen*, oil on canvas, 124.5 × 101 cm, New York, The Metropolitan Museum of Art.

Literature: Shearman 1983, no. 143.

Exhibitions: London 1983–4, no. 46.

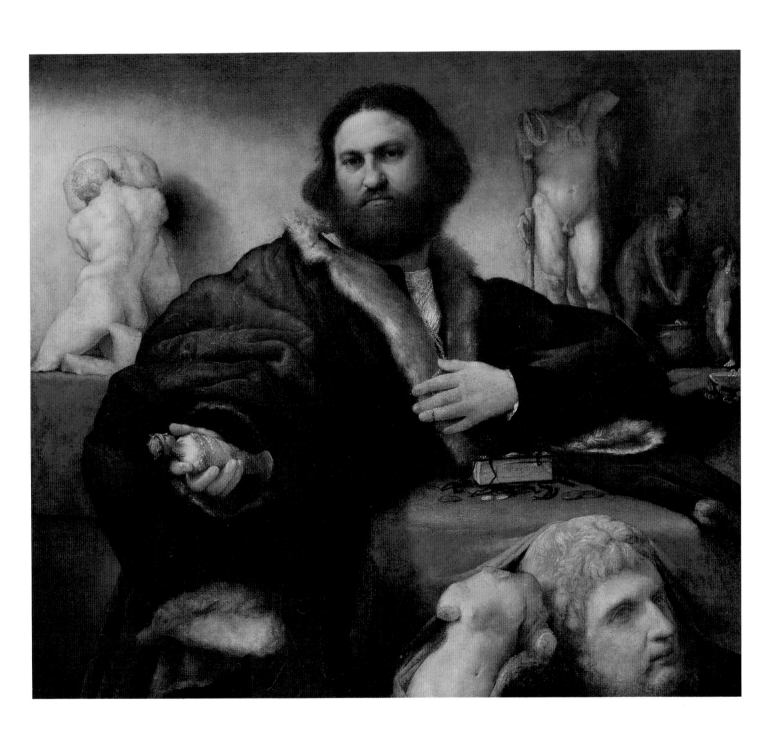

GIULIO ROMANO c.1499–1546

Portrait of a Woman traditionally identified as Isabella d'Este

5

Panel, 115.5 × 90.5 cm (45½ × 35⅝ in.)

THE ARTIST was a leading assistant of Raphael in Rome before being appointed court artist to the Gonzagas at Mantua in 1524. Apart from his skills as a painter, architect and designer, he has the distinction of being the only Italian artist referred to by name by Shakespeare.[1] The portrait was acquired by the States-General of Holland from the collection of Gerard Reynst for presentation to Charles II in 1660.

The painting was first recognised as a work by Giulio Romano and identified as a portrait of Isabella d'Este in the eighteenth century by the famous French connoisseur, Pierre-Jean Mariette. At the same time Mariette also observed the connection between the painting and a drawing for one of the figures in the right background, formerly in the Crozat collection and now in the Louvre. Although both the attribution and the identification have been challenged, there is a general consensus that the portrait is by Giulio Romano. The treatment of the architecture in particular is comparable with the backgrounds of the *Madonna della Gatta* (Naples, Capodimonte) and the *Virgin and Child* (Rome, Galleria Nazionale). In general terms, the composition reveals a debt to the *Portrait of Giovanna d'Aragona* (Paris, Louvre), which was probably designed by Raphael, but painted with the assistance of Giulio Romano.

The identification of the sitter has recently become the subject of discussion. Isabella d'Este (1474–1539), one of the foremost patrons of the arts in Renaissance Italy, married Giovanni Francesco Gonzaga, Marquis of Mantua, in 1490. She was notoriously reluctant to be painted and her personal iconography is severely limited. The principal images are two portraits by Titian: *Isabella d'Este in Black* (about 1534–6) and *Isabella d'Este in Red* (both in Vienna, Kunsthistorisches Museum). In these works, as well as in the famous drawing by Leonardo da Vinci dating from 1500 (Paris, Louvre) and a medal by Giancristoforo Romano of 1498[2], the face is round, the forehead low and the neck short. These are features that do not accord with the sitter in the present portrait. The age of the sitter also seems incompatible as Isabella d'Este would have been fifty when Giulio Romano arrived in Mantua. Furthermore, the knot patterns on the dress, often associated with the personal motif created for Isabella d'Este by Niccolò da Correggio in 1493, were a widespread fashion.

An alternative identification of the sitter with Margherita Paleologo (1510–66), who married Isabella

d'Este's son, Federico Gonzaga, the first Duke of Mantua, in 1531, has been proposed by Jane Martineau and supported by Rita Castagna and Anna Maria Lorenzoni. Contemporary descriptions suggest a closer likeness ('the skin white like snow, the face a little long with a nose like her father's') and there is an abundance of evidence for Margherita Paleologo's interest in clothes and ornaments. It has been suggested that the portrait was made at the time of her wedding, and that the veiled figure entering the room in the background is Isabella d'Este. The Marchesa is attended possibly by her other daughter-in-law, Isabella of Capua, and a nun, Margherita Cantelma, Duchess of Sora (died 1532). Although the documentary evidence is persuasive, final visual confirmation is lacking.

There are signs of a figure (perhaps a putto) in the upper left corner, which may indicate that the artist had used the panel on a previous occasion for a different composition. The elegant figure of the maid pulling back the curtain may have been inspired by the sculptural figures on early funerary monuments, for example, on the tomb of Cardinal de Braye (died 1282) by Arnolfo di Cambio (Orvieto, San Domenico).

Aspects of the composition, not least the intricate patterns of the dress, influenced an early work by Sir Edward Burne-Jones – *Sidonia von Bork*, 1860 (London, Tate Gallery).[3]

Notes: **1** *The Winter's Tale*, Act 5, scene 2. **2** G. Hill, *A Corpus of Italian Medals of the Renaissance before Cellini*, London 1930, I, no. 221. **3** *The Paintings, Graphic and Decorative Work of Sir Edward Burne-Jones 1833–1898*, exhibition catalogue, Hayward Gallery, London 1975–6; Southampton Art Gallery 1976; City Museum and Art Gallery, Birmingham 1976, no. 24.

Literature: Shearman 1983, no. 116; Castagna and Lorenzoni 1989, pp. 15–26; Campbell 1990, pp. 118, 185–90.

Exhibitions: London 1981–2, no. 110.

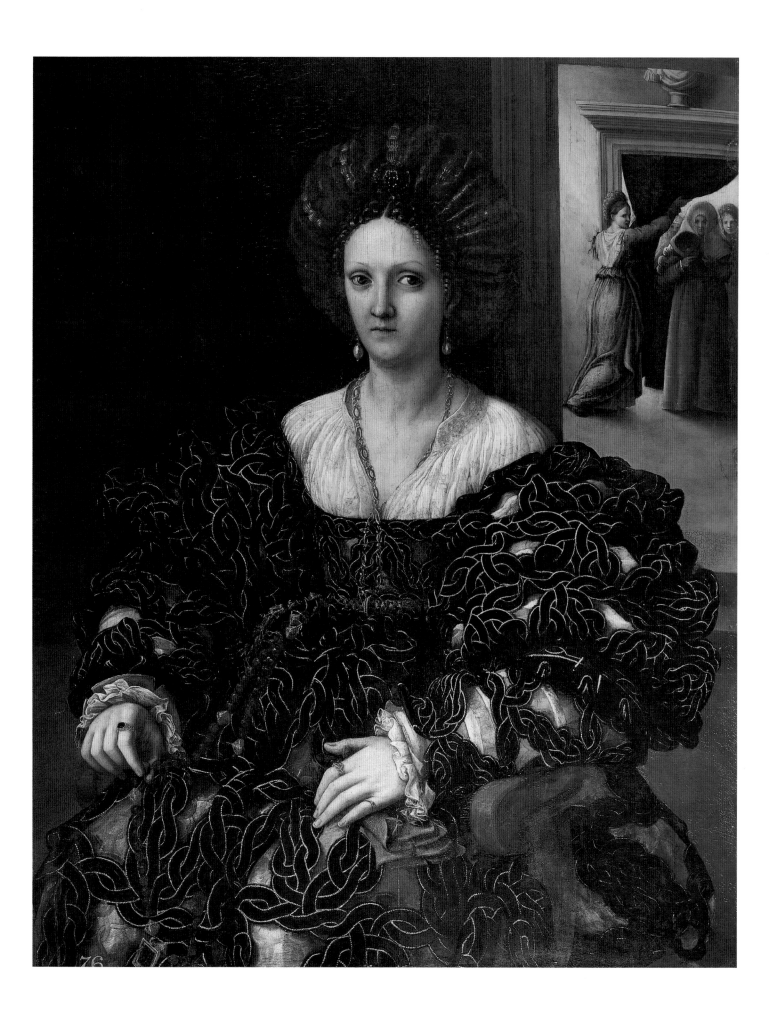

6 *A Protestant Allegory*

Panel, 68 × 84.4 cm (26¾ × 33¼ in.)

THE SUBJECT refers to the English Reformation, formally sanctioned by the Act of Supremacy of 1534, whereby Henry VIII broke away from the Church of Rome and was established as head of the Church of England. The painting was in the collection of Henry VIII who owned at least two other anti-papal pictures. The composition comprises a pope sprawling on the ground, flanked by two female figures representing avarice and hypocrisy, all of whom are being stoned by the four evangelists. On the ground in front of these figures are a cardinal's hat and a document with four seals (probably a Papal Bull). The city in the distance on the left may be Jerusalem. Above the city is a burning candle, which contrasts with another in the immediate foreground that has been extinguished by a cooking pan. These candles have been interpreted as symbolising respectively the true light of the Gospels and the false doctrine of Rome. Historically, the pope should be Paul III (1534–49), but the depicted likeness is closer to Julius II (1503–13). A specific identification may not have been intended.

The painting has been executed in grisaille with highlights in gold. The composition bears a striking resemblance to three identical woodcuts illustrating scenes of stoning in the Coverdale Bible of 1535 (Leviticus XXIV, Numbers XV, and Joshua VII), the first bible to be issued in English (Fig. 32). The tenor of the propagandist element in this picture is more commonly found in contemporary book illustrations, culminating in those made for the *Actes and Monuments* of 1536 by John Foxe. The pose of Saint Matthew resembles that of a figure in *The Stoning of Saint Stephen* (Genoa, San Stefano), an altarpiece of about 1521–3 by Giulio Romano, with whom Girolamo da Treviso may have worked when he was still in Italy.

The artist came to England sometime in 1538 and died in the siege of Boulogne in 1544, where he was serving as a military engineer. The picture is not listed in the royal inventory of 1542 and may therefore in theory be dated between 1542 and the artist's death.

Literature: Shearman 1983, no. 115; King 1989, pp. 151–2; Tafuri 1989, p. 57.

Fig. 32 *The Stoning of the Blasphemous Man, Biblia,* translated by Miles Coverdale, 1535, London, British Library.

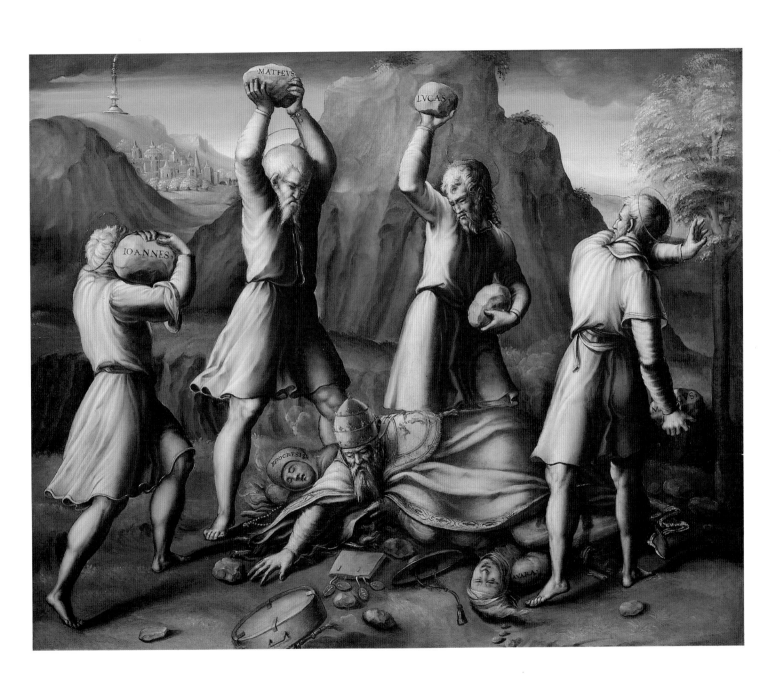

JACOPO BASSANO Active c. 1535; died 1592

7 The Adoration of the Shepherds

Canvas, 139.5 × 219 cm (54⅞ × 86¼ in.)

The Adoration of the Shepherds is an imposing composition dating from around 1544–5 and the time of the artist's early maturity. It was during this decade that Bassano painted a number of successful works on a large scale, which helped to establish him as a major artist of the Venetian school. Chronologically, the picture can be placed between *The Adoration of the Magi* (Edinburgh, National Gallery of Scotland) and *The Rest on the Flight into Egypt* (Milan, Ambrosiana). Another painting of the *Adoration of the Shepherds* in the Giusti del Giardino collection (Padua, Onara di Tombolo) appears to be slightly later in date, perhaps around 1550, but it has

Fig. 33 Albrecht Dürer, *The Nativity*, *The Little Passion*, 1511, woodcut, London, British Museum, Department of Prints and Drawings.

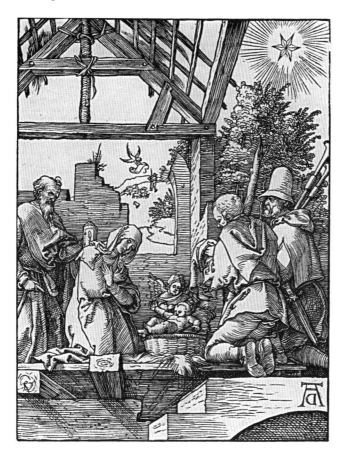

several compositional features in common with the present picture. Chief among these are the treatment of the architecture, the Virgin's expression of concern for the Child, and the figure of the shepherd who acknowledges the Holy Family by removing his headgear. These features appear to be derived from a painting of the same subject by Titian, the original of which was painted for the Duke of Urbino in 1532–4 and may be the ruined panel in the Palazzo Pitti, Florence. Interestingly, Charles I owned a version of this work by Titian, which is now at Christ Church, Oxford and in an equally parlous state. Bassano clearly knew of Titian's painting, but almost certainly through the woodcut by the Master I.B. (Giovanni Boitto), which he seems to have made use of in the 1530s. The composition follows the same direction as the print, which reverses Titian's painting. It is notable that Bassano often redeployed figures in his paintings so that the figure of Joseph in the present work is found in reverse in the *Rest on the Flight into Egypt* and the kneeling shepherd in the foreground is used in reverse in the *Adoration of the Magi*. Apparently, from quite an early date, the artist kept a stock of drawings in his studio for this purpose.

Apart from Titian, other influences have been cited in the context of Bassano's composition. The architectural features and the shepherd playing the bagpipes recall the woodcut of the Nativity in Dürer's *Little Passion* of 1511 (Fig. 33). On a general basis the naturalistic aspects of the composition are often compared with Netherlandish painting, particularly the work of artists such as Pieter Aertsen. Such observations perhaps over-emphasise the eclectic elements in Bassano's art when it is preferable to stress the scale of the work, the firm drawing, the warm colouring and the view of the artist's home town of Bassano del Grappa, seen in the background against the mountains. Iconographically, the broken elements of the classical architecture denote the passing of the Old Law in favour of the New Law symbolised by the Christ Child. Similarly, the tree prefigures the death of Christ on the cross.

The painting in all probability belonged to Charles I, who owned a number of distinguished Venetian pictures. It was sold at the time of the Commonwealth under Oliver Cromwell, and is next recorded in the Royal Collection during the reign of James II.

Literature: Shearman 1983, no. 16.

Exhibitions: London 1983–4, no. 5.

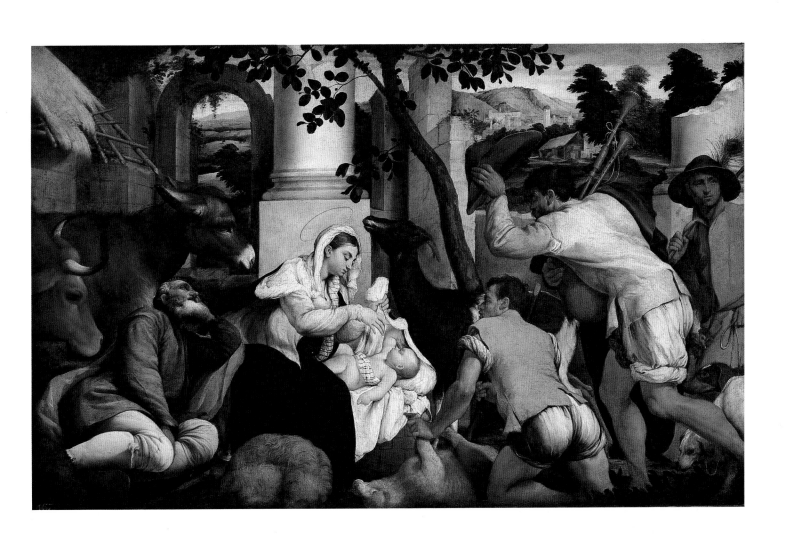

UNKNOWN ARTIST Active c.1545

8 The Family of Henry VIII

Canvas, 141 × 355 cm (55$\frac{9}{16}$ × 139$\frac{3}{4}$ in.)
Cleaned 1986–8, when two old additions made along the upper edge
of the canvas were removed

THE COMPOSITION is divided into three parts by the columns of a colonnade and in this respect resembles to a certain extent the format of an elaborate Renaissance altarpiece. The king is seated in the centre beneath a canopy of state with his third wife, Jane Seymour (c.1509–37) and Prince Edward, later Edward VI (born 1537). On the left is Princess Mary, later Mary I (born 1516), the king's daughter by his first wife, Catherine of Aragon, and on the right Princess Elizabeth, later Elizabeth I (born 1533), his daughter by his second wife, Anne Boleyn. The view through the arches is of the Great Garden at Whitehall Palace. The heraldic King's Beasts, carved in wood with gilt horns and set on columns, are prominently displayed amidst the flower beds, which are demarcated by wooden fencing and painted in the Tudor colours of white and green.[1] Through the archway on the left can be seen part of Whitehall Palace and the Westminster Clockhouse, balanced by a view through the archway on the right of the north transept of Westminster Abbey and a single turret of Henry VIII's Great Close Tennis Court. It is possible, as Strong (1987) suggests, that the colonnade under which the figures are placed reflects something of the interior design of Whitehall Palace. The two figures in the archways are members of the Royal Household, that on the right being the king's jester, Will Somers, who is represented in Henry VIII's Psalter in the British Library.[2]

The painting was probably made specifically for Henry VIII. The theme is primarily dynastic with considerable emphasis on the younger generation. As such it is comparable with the Whitehall Mural, painted by Hans Holbein the Younger in 1537 for the Privy Chamber at Whitehall Palace (destroyed by fire in 1698 and only known through copies made earlier in the seventeenth century) and the *Allegory of the Tudor Succession* of about 1570, attributed to Lucas de Heere, at Sudeley Castle, Gloucestershire. The picture reveals the influence of Holbein, not only in the portraiture but also in the classicising style of the architecture and the intricacy of the decorative motifs, so liberally highlighted in gold. Strong (1987) points out that the use of columns to divide up the composition might have been inspired by *The Healing of the Lame Man*, one of the set of tapestries designed by Raphael for the Sistine Chapel in Rome of which Henry VIII acquired his own set sometime before 1528. The likeness of Jane Seymour is posthumous and depends upon Holbein's portrait (Vienna,

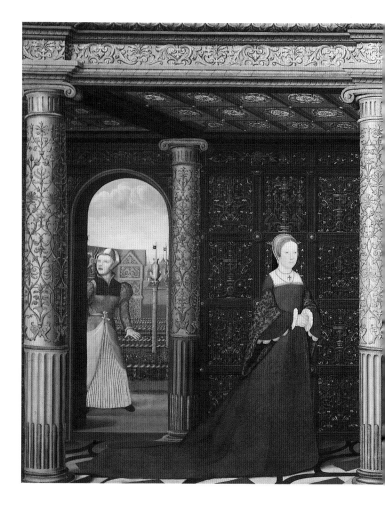

Kunsthistorisches Museum). The likenesses of the other main figures were presumably made from life. The suggested dating of around 1545 is based on the ages of the sitters, particularly of Prince Edward and Princess Elizabeth in comparison with the two portraits of them in the Royal Collection, now attributed to William Scrots.[3]

The painting is a key work dating from the period immediately after the deaths of Holbein in 1543 and Lucas Hornebolte in 1544.

Notes: **1** Strong 1979, pp. 34–7. **2** King 1989, p. 77, fig. 16.
3 Millar 1963, nos. 44, 46 and Strong 1969, p. 74, nos. 10, 11.

Literature: Millar 1963, no. 43; Strong 1963, no. 2, p. 53; Strong 1979, pp. 34–7; Strong 1987, p. 49.

Exhibitions: Hampton Court Palace, 1990–1, no. 3.

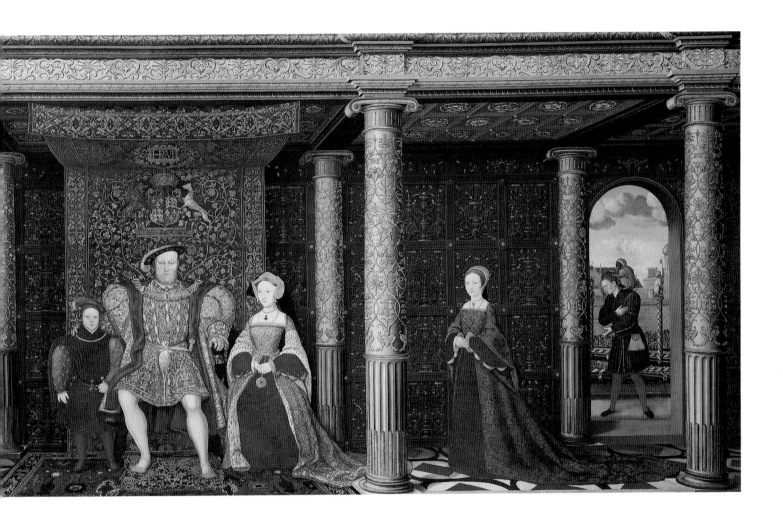

Elizabeth I and the Three Goddesses

9

Panel, 70.8 × 84.5 cm (27⅞ × 33¼ in.)
Signed in monogram and dated in the lower right corner: *1569/HE*
Inscribed on the frame in Latin: *IVNO POTENS SCEPTRIS ET MENTIS ACVMINE PALLAS/ET ROSEO VENERIS FVLGET IN ORE DECVS/ADFVIT ELIZABETH IVNO PERCVLSA REFVGIT/OBSTVPVIT PALLAS ERVBVITQ VENVS*
[Pallas was keen of brain, Juno was queen of might/The rosy face of Venus was in beauty shining bright,/Elizabeth then came/And, overwhelmed, Queen Juno took to flight;/Pallas was silenced; Venus blushed for shame][1]

ALLEGORY was a commonplace of court art in England during the reign of Elizabeth I. The present work is, in fact, the earliest known example of the painted allegories showing the monarch and as such is not particularly complex either in composition or allusion. The queen, wearing a crown and carrying the sceptre and orb, emerges from an elaborately decorated interior with her two ladies-in-waiting. Her dress is studded with jewels and embroidered with Tudor roses. Balancing this group are the three goddesses on the right with their attributes – Juno with a peacock, Minerva fitted with breastplate and helmet and carrying a standard, and Venus naked with Cupid disarmed. The queen plays the part of Paris, who in classical mythology awarded the golden apple to the goddess whom he judged to be the most beautiful, namely Venus. In this work, however, the queen advances towards the goddesses in a commanding manner and confounds them. Indications of concern are most apparent in the figure of Juno, who, having lost a sandal and dropped her sceptre, turns away from the queen. This conceit refers not only to Elizabeth I's abilities as a ruler, but also to her role as a woman as she is seen to combine the virtues of all the goddesses. According to Montrose, the marked contrast between the clothed queen and the naked Venus, the goddess of love, may be an allusion to the subject of matrimony, which preoccupied the court for so much of the reign, albeit with a changing emphasis as the queen continued to resist marriage. It is significant, therefore, that Juno, the goddess of marriage, should be the focal point of the composition, referring not only to this particular theme, but perhaps also to others more commonly found in Elizabethan literature, such as the contrast between court and country, or art and nature. Dominating the scene in the background on a hill is a view of Windsor Castle, in all probability the earliest painted view of it. On the far right is the chariot of Venus drawn by swans.

The attribution of the painting is unresolved. The monogram has been claimed as that of Lucas de Heere, Hans Eworth and Joris Hoefnagel, all painters who came to England as exiles from the Netherlands. The handling of the three goddesses certainly displays Mannerist tendencies. The artist is competent at the rendering of decorative detail and architectural ornamentation in the left half of the composition, and is equally successful in the treatment of the landscape that dominates the background on the right.

The painting is first recorded in the Royal Collection in 1600.

Notes: **1** The translation is from *The Diary of Baron Waldstein. A Traveller in Elizabethan England*, ed. G. W. Groos, London 1981, pp. 46–7.

Literature: Millar 1963, no. 58; Strong 1963, p. 79, no. 81; Strong 1969, pp. 144–5, no. 96; Yates 1975, p. 63; Montrose 1980, pp. 445–7; Strong 1987, pp. 65–9.

Exhibitions: Leicester and London 1965–6, no. 37.

Portrait of a Woman

10

Canvas, 217 × 135.3 cm (85¼ × 53¼ in.)
Cleaned and restored 1990–1
Inscribed twice on the tree: *Iniusti Justa querela* [A just complaint of
injustice] and *Mea sic mihi* [Thus to me my . . . [?tree was the only
hope]]; inscribed by the stag's head: *Dolor est medicina [e] d[o]lori*
[Grief is medicine for grief]
In a cartouche lower right is the following sonnet:

> The restles swallow fits my restles minde,
> In still revivinge still renewinge wronges;
> her Just complaintes of cruelty unkinde,
> are all the Musique, that my life prolonges.
>
> With pensive thoughtes my weeping Stagg I crowne
> whose Melancholy teares my cares Expresse;
> hes Teares in sylence, and my sighes unknowne
> are all the physicke that my harmes redresse.
>
> My onely hope was in this goodly tree,
> which I did plant in love bringe up in care:
> but all in vanie [sic], for now to late I see
> the shales be mine, the kernels others are.
>
> My Musique may be plaintes, my physique teares
> If this be all the fruite my love tree beares.[1]

ALTHOUGH the identification of the sitter remains
unknown, the attribution of the portrait to Marcus
Gheeraedts the Younger has been resolved on the basis of
the elaborate inscriptions. A similar type of calligraphy is
found on a number of works all by the same hand dating
from the 1590s. These accord with the style of painting
and the inscriptions on signed and dated portraits by the
artist which come from the later part of his career.
Gheeraedts was an important and popular painter of
Netherlandish origins who achieved success towards the
close of Elizabeth I's reign and was retained by Anne of
Denmark, the wife of James I.

Portrait of a Woman is a typical example of
Elizabethan allegorical portraiture. The symbolism, which
is clearly of some complexity, embraces the tree, the stag,
the flowers, even the birds and the sitter's costume. The
long-haired figure wears pearls attached to her wrist and a
pendant with a miniature around her neck. Her headdress
is derived from J. Boissard's *Habitus variarum orbis
gentium* (Antwerp 1581), where it is categorised as 'Virgo
persica' (Fig. 34). Gheeraedts refers to the same book for
his *Portrait of Thomas Lee* (London, Tate Gallery). The
inscriptions on the present work, especially the verses in
the cartouche to which those in Latin are related, allude
to the mood of melancholy that dominates the portrait,
but do not indicate the name of the sitter. Her pose is
hieratic and her stance somewhat unsteady, but there has
been an attempt to set the figure against a landscape as
opposed to an interior which is more usual in Gheeraedt's
work. The portrait has not survived in good condition and

the total effect is therefore not as grand as the artist's
famous *Portrait of Queen Elizabeth I*, known as the
Ditchley Portrait (London, National Portrait Gallery).

Arnold has posited that there might be a connection
between these three portraits and the *Sir Henry Lee with
his Dog* (The Ditchley Foundation, Oxfordshire). All are
inscribed with sonnets with identical calligraphy. The
other common factor is the country estate of Ditchley,
near Oxford, which was owned by Sir Henry Lee, Queen
Elizabeth's Master of the Armoury and former Champion
at the Tilt, who entertained the queen there in 1592.
Thomas Lee, a soldier of fortune, was Sir Henry's cousin.
On this basis, Arnold tentatively identifies the sitter here
as Anne Vavasour, a Gentlewoman of the Bedchamber
from 1580 who became Sir Henry Lee's mistress after
imprisonment in 1581 for bearing a child out of wedlock
(possibly the Earl of Oxford's). More detailed consider-
ation of the symbolism and further discussion about the
identification will be found in Strong (1992).

The *Portrait of a Woman* is recorded by the eighteenth-
century antiquarian, George Vertue, as once having the
royal cypher of Charles I on the back of the canvas.

Notes: **1** Vertue credits the verses in the cartouche to Edmund
Spenser, see Vertue 1931–3, pp. 48–9 and 1935–6, p. 77.

Literature: Millar 1963, no. 87; Strong 1969, no. 284 and pp. 350–1;
Arnold 1977, p. 100–5; Strong 1992.

Exhibitions: Hampton Court Palace 1990–1, no. 33.

Fig. 34 'Virgo persica', J. Boissard,
Habitus variarum orbis gentium,
1581, woodcut.

HENDRICK VAN STEENWYCK THE YOUNGER
Active 1604; died 1649

The Liberation of Saint Peter

Copper (irregular), 48.3 × 66 cm (19 × 26 in.)
Signed on the second step to the right: *HENRI. V. STEINICK*
Dated in centre: *1619*

THE SCENE is based on the account of Saint Peter's delivery from prison given in the Acts of the Apostles 12: 5–10:

> And when Herod would have brought him forth, the same night Peter was sleeping between two soldiers, bound with two chains: and the keepers before the door kept the prison. And, behold, the angel of the Lord came upon him, and a light shined in the prison: and he smote Peter on the side, and raised him up, saying, Arise up quickly. And his chains fell off from his hands.

> And the angel said unto him, Gird thyself, and bind on thy sandals. And so he did. And he saith unto him. Cast thy garment about thee, and follow me.

Steenwyck specialised in painting interiors with complicated perspectives. The subject of the liberation of Saint Peter was a particular favourite, partly because the narrative allowed him to exercise his penchant for night scenes. Numerous variants are known and there are more than six different versions in the Royal Collection alone. Of these the present painting is the earliest in date and the finest in quality. Although it is only first recorded during the reign of George III and cannot be firmly identified in earlier inventories, Charles I, like many of his contemporaries, appreciated Steenwyck's work for its intricate detail and careful finish. At least two of the versions in the Royal Collection were definitely in Charles I's collection and it is probable that the others were as well. Steenwyck worked in London from 1617 until around 1637, but he was more closely associated with his birthplace, the Netherlands.

Steenwyck often painted the architectural backgrounds of works in which the figures were depicted by collaborators, although this procedure was not necessarily followed here. The solid architecture with vaulted interiors, thick columns and heavy masonry can be made out in the flickering light of an oil lamp and the dying embers of a fire. The guards slumber in a variety of poses, their weapons laid aside, while Saint Peter and the angel make their escape. The tenebrist effect, which undoubtedly helps to create an atmosphere and heightens the sense of drama, may have been influenced by Adam Elsheimer.

Exhibitions: London 1972–3, no. 137.

12 An Old Woman: 'The Artist's Mother'

Panel, 61.3 × 47.3 cm (24⅛ × 18⅝ in.)

THIS PORTRAIT, together with two other Dutch pictures, was apparently given to Charles I by Sir Robert Kerr (1578–1654), presumably before 1633 when he was created Earl of Ancrum. It is possible that Kerr obtained the paintings while in Amsterdam on a diplomatic mission to express the king's condolences to the King and Queen of Bohemia on the death of their eldest son, Frederick Henry, who drowned in January 1629. The second painting has been identified as Rembrandt's early *Self Portrait* (Liverpool, Walker Art Gallery), which was sold from the Royal Collection in 1651 after the execution of Charles I. The third cannot be identified, but although at the time attributed to Rembrandt it was probably by Jan Lievens, who was Rembrandt's studio companion in Leiden during the 1620s. Kerr could have obtained these paintings either directly from the studio or indirectly through the Prince of Orange or his secretary, Constantin Huygens. The two identified pictures, if correctly attributed to Rembrandt, would have been the first works by the artist to enter an English collection.

Technical examination of the present work has revealed that Rembrandt reused a panel on which he had previously made a study of an old man, posed the other way up. This may have been intended as an evangelist with an attribute placed in the lower right (currently upper left) corner. The positioning of the head in the finished portrait is asymmetrical, which suggests that the panel has been cut down unevenly. There are indications of a previous oval frame similar to that containing the *Self Portrait* in Liverpool.

The same sitter appears in a number of early paintings by Rembrandt as well as in several etchings and a drawing, none of which is dated. In most of these the figure wears a hood. There is, however, no firm corroborative evidence for an identification with the artist's mother, Neeltge Willemsdr. van Suytbrouck (1568–1640). She was the daughter of a baker and married Harmen Gerritsz. van Rijn, a miller, in 1589. Of the eight children from the marriage Rembrandt was the seventh. Possibly the figure in this and the related works is too elderly to be a true depiction of the artist's mother, then aged sixty. Consequently, it has been argued that it is not so much a traditional portrait as a specific subject, such as a prophetess in the biblical sense. Significantly, the same figure is depicted by Gerrit Dou, who joined Rembrandt's studio as a pupil in 1628. On stylistic grounds, notably the small neat brushstrokes depicting the wrinkled skin and the even tonality, the date implied by its acquisition in Amsterdam by Sir Robert Kerr in

1629 is acceptable. Some writers, however, ignore that sequence of events, suggesting a date of around 1630/1, in which case the provenance has to be rethought. Yet others prefer an attribution to Rembrandt's studio companion, Lievens.

Literature: White 1982, no. 158; Corpus 1982, I, A32, pp. 315–21 and III, A32, pp. 839–40.

ARTEMISIA GENTILESCHI 1593–1652

13 *Self-Portrait as the Allegory of Painting*

Canvas, 96.5 × 73.7 cm (38 × 29 in.)
Signed on the table in the centre: *A.G.F.*

ARTEMISIA GENTILESCHI, the daughter of Orazio (see No. 28), was born in Rome. The chief formative influence on the style of her painting was her father, but after his departure for England in 1626 the only direct contact that she had with him was the few years she spent in London (1638–*c*.1641). Artemisia Gentileschi worked for long periods in Florence, Rome and Naples, as well as in Genoa and Venice. The style of Caravaggio with its emphasis on rich colouring and strong contrasts of light and shadow was deeply influential, but to this must be added knowledge of the work of Northern European artists active in Italy, and of regional differences in Italian art. While in London it is likely that Artemisia assisted her father just before his death with the painting of the *Allegory of Peace and the Arts under the English Crown* for the ceiling of The Queen's House at Greenwich (now in Marlborough House, London). It is evident that Charles I owned at least three paintings by her. The present work was sold after the execution of the king in 1649, but was recovered at the time of the Restoration. Yet it would appear that Charles I did not commission the *Allegory of Painting* directly from the artist. There are references in the correspondence between the artist and the famous antiquarian and collector Cassiano dal Pozzo (1588–1657) to a portrait which Artemisia painted for Dal Pozzo in 1630. This seems never to have been delivered to the patron and may indeed be the same painting referred to in a letter of 1637 as a self portrait. If the references in the extant letters are all to the present work and not, as has also been suggested, to two other pictures, then it is possible that the artist brought the painting with her to London. Alternatively, Charles I may have obtained the *Self Portrait* from another source through an agent.

The identification of the figure is confirmed by a contemporary medal of the artist and by a print by Jérôme David. The mode of the portrait, however, is allegorical and accords with the description of the personification of 'Painting' given in the *Iconologia* of Cesare Ripa (1611), where mention is made of a female figure with dishevelled hair, wearing a gold chain with a medallion in the form of a mask, and brightly coloured drapery. These attributes, however, have to be seen in conjunction with the pose: the figure is shown on a steep diagonal seen from below and is sharply lit from the left with the right arm raised in the act of painting. It has been argued that the artist, being a woman, was able to undertake a self portrait of greater significance than those of her male counterparts, who were often primarily concerned with extolling their social status. Taking advantage of the fact that 'Painting' was personified by a female figure, Artemisia Gentileschi has combined in her self portrait the theoretical and practical concepts of painting while at the same time drawing attention to her paradoxical status as a female artist in seventeenth-century society. The portrait demonstrates that intellectual allusion alone does not in itself make a painter, but that it must be combined with application.

Literature: Garrard 1989, pp. 85–8, 337–70; Levey 1991, no. 499.

Exhibitions: Leeds 1989, no. 8.

70

ANTHONY VAN DYCK 1599–1641

14 # Charles I and Henrietta Maria with their Two Eldest Children, Charles, Prince of Wales, and Mary, Princess Royal ('The Greate Peece')

Canvas, 298.1 × 250.8 cm (117$\frac{3}{8}$ × 98$\frac{3}{4}$ in.); these measurements include the additions made by Van Dyck at the top (31.7 cm, 12$\frac{1}{2}$ in.) and on the right (21.6 cm, 8$\frac{1}{2}$ in.)
Cleaned and restored 1976

THE ARTIST was appointed court painter to Charles I in 1632, and spent most of the rest of his life in England immortalising Stuart court life. This portrait was painted shortly after Van Dyck's arrival from Antwerp and was the first of a number of important commissions carried out for the king during the 1630s. Those on a similar scale are *Charles I on Horseback with M. de Saint Antoine* of 1633 (Royal Collection) and *Charles I on Horseback*, dating from around 1637 (London, National Gallery). Of these '*The Greate Peece*' hung in the Long Gallery in Whitehall Palace, presumably on an end wall, while *Charles I with M. de Saint Antoine* was painted for St James's Palace and *Charles I on Horseback* is first recorded at Hampton Court. *Charles I in Hunting Dress* (Paris, Louvre) was painted in 1635 for the king, but apparently was not retained for his own collection.

The present composition shows the Prince of Wales standing by his father while the Princess Royal (born on 4 November 1631) is held by her mother. On the left is a view of the River Thames with Parliament House, Westminster Hall and possibly the Clock Tower in the background. The painting is the first full-length family group that Van Dyck painted after leaving Italy in late 1627. As such it can be seen as a development of the Lomellini family group of about 1625 (Edinburgh, National Gallery of Scotland).

'*The Greate Peece*' is a landmark in royal portraiture and the advance is measured by comparing the painting with *The Family of Henry VIII* (No. 8). Charles I's connoisseurship is perfectly matched by the achievements of Van Dyck as court painter. Apart from technical skill, the artist's sophistication and innate artistic intelligence enabled him to surmount with apparent, but no doubt deceptive, ease the meritorious efforts of his immediate predecessors at the English court – Paul van Somer and Daniel Mytens. Van Dyck's output in England after 1632 was a spur to native art, lifting it onto an international level and continuing to be influential into the eighteenth century.

The compositional significance of the present painting is that while remaining an official portrait it admits a degree of informality. The trappings of state portraiture – the column and the looped curtain with the view of Westminster in the left background – are all in place, but the fact that the royal couple are seated and are seen to have a rapport with their children and pets, while the royal regalia is laid aside on an adjoining table, gives the picture an informal, animated air. The composition is, in essence, a royal conversation piece of a kind that was to be perfected by Johann Zoffany in the mid-eighteenth century.

The influences that are at work in such a painting reveal the true level of Van Dyck as an artist. Only Rubens and Velázquez treated royal sitters with such apparent nonchalance and insight, while the warm colours, the feeling for the texture of clothes and the dramatic sky bespeak a profound knowledge of Titian. A drawing in black chalk is clearly related to the composition and it may well have been made on the first occasion that the king sat for the artist.[1] It is interesting to note that the condition of the painting gave cause for concern as early as 1676 because Van Dyck had applied an unusual priming to the canvas.

Notes: **1** H. Vey, *Die Zeichnungen Anton van Dycks*, Brussels 1962, no. 205, as a copy.

Literature: Millar 1963, no. 150; Brown 1982, p. 163; Larsen 1988, I, pp. 295–6 and II, p. 320, no. 811.

Exhibitions: London 1982–3, no. 7.

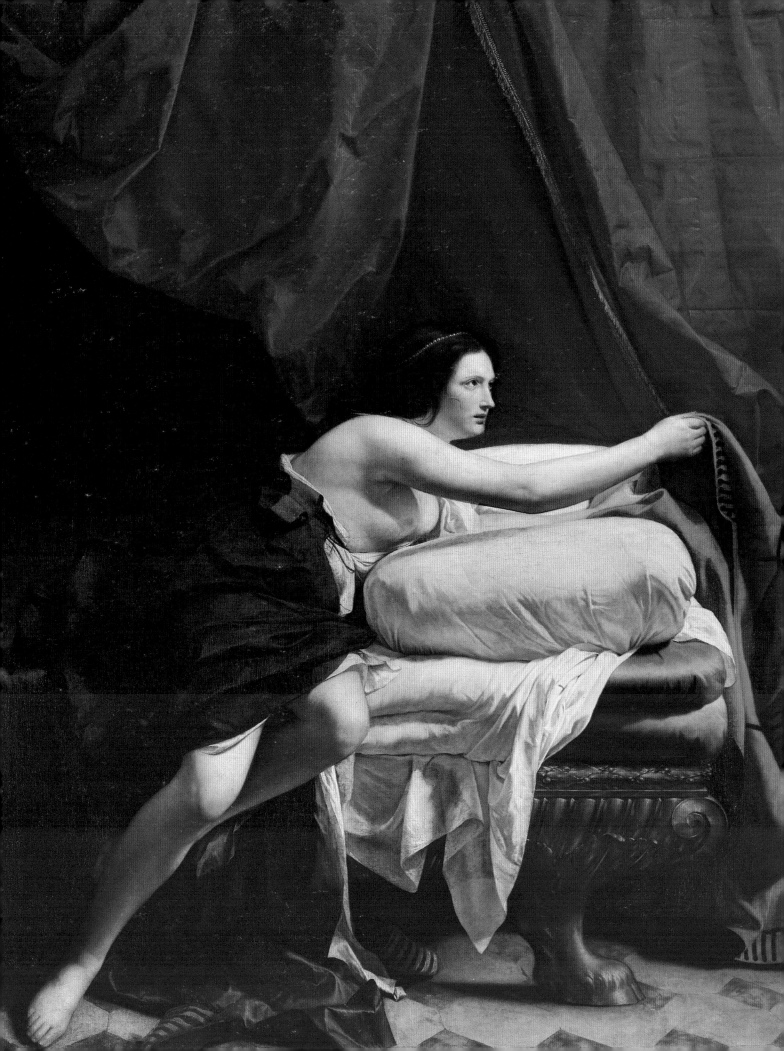

The Stuarts

THE FIRST HALF of the seventeenth century saw a remarkable concentration of works of art in London. Charles I was only one of a number of eminent collectors that included the Earl of Arundel, the Duke of Buckingham and the Marquess of Hamilton. One effect of Charles I's interest in art was to attract outstanding artists such as Rubens (No. 29) and his pupil Van Dyck (Nos. 14, 31, 41), whose paintings provide such a vivid and highly charged visual record of the Caroline court. On visiting London in 1629 Rubens referred to 'the incredible quantity of excellent pictures, statues and ancient inscriptions which are to be found in this Court.' The Catholic sympathies of Charles I's wife, Henrietta Maria, the daughter of Henri IV and Marie de' Medici, encouraged attempts, made principally by the Papacy, to engage the services of Italian (No. 28) and French (No. 30) artists at the English court.

The execution of Charles I in 1649 resulted in the confiscation of his collection by the Commonwealth, established by Oliver Cromwell, and its subsequent sale. Many masterpieces were thus acquired by leading French and Spanish collectors; others were bought by the connoisseurs and advisers who had assisted the king in forming the collection; and yet others were given to the king's creditors. The dispersal of the collection was a tragedy, and the sale accounts for the fact that many paintings once owned by Charles I are now in the great museums of the world.

Charles II (1660–85) inherited a much depleted Royal Collection, but several pictures were returned to the crown at the Restoration in 1660, and the king also received a generous gift of paintings from the States-General of Holland (Nos. 4, 5, 18). But his role as a collector should not be overlooked for he acquired a number of works on his own account (Nos. 20, 21, 22, 26). It was during his reign that the interior of Windsor Castle was redesigned with frescoes and carvings in the Baroque style. This new impetus was continued by James II (1685–88) who, like Charles II, maintained an interest in Italian and French art for religious reasons (No. 24), but at the same time encouraged the emergence of a British school of painting (No. 33). The change of religious emphasis at the accession of William III (1689–1702) and Mary II (1689–94) encouraged links with Holland, which equally affected the development of British painting (see No. 34). William III had a particular interest in the Royal Collection, dividing the pictures mainly between Hampton Court Palace and Kensington Palace, but he also removed a group of important works by artists like Van Dyck, Hans Holbein the Younger, Piero di Cosimo and Gerrit Dou to his palace at Het Loo. These paintings (some thirty-six in number) were reclaimed by Queen Anne on 3 August 1702, but without success, and they have for the most part remained mainly in Dutch public collections ever since.

OPPOSITE Orazio Gentileschi, *Joseph and Potiphar's Wife* (No. 28, detail).

LORENZO COSTA 1459/60–1535

15 Portrait of a Lady with a Lap-dog

Panel, 45.5 × 35.1 cm (17⅝ × 13¾ in.)

THE PORTRAIT can be dated on stylistic grounds to around 1500 on the basis of a comparison with the figures in the Ghedini altarpiece – the *Virgin with Four Saints* – of 1497 in the church of San Giovanni in Monte, Bologna. Such a dating also accords with the style of the costume which is notable for its detachable sleeves and elegant ties. The singing colours and transparent shadows denote Costa's Ferrarese origins and are characteristic of his early work. The high degree of finish, most apparent in the careful delineation of the strands of hair, the use of gold highlights on the dress, and the close observation of the numerous attachments (necklaces and headband), suggest that the portrait was not only an important commission, but also that the painter was susceptible to Flemish art, which he could have seen in the Este collection at Ferrara. It is a refined image of a type frequently found in north Italian courts at the turn of the fifteenth and sixteenth centuries. At least two copies of the portrait are known. The pose has certain affinities with the *Portrait of Cecilia Gallerani* – the mistress of Lodovico Sforza – by Leonardo da Vinci, which dates from the mid 1480s (Fig. 35).

Some scholars attempted to identify the sitter with Isabella d'Este, but this is no longer accepted, primarily because Costa did not begin to work for this important patron until 1504. It is possible that the likeness is of a member of the Bentivoglio family, who held sway in Bologna until driven from the city by Julius II in 1506. Works by Costa were commissioned by members of the family and later, on the recommendation of Antongaleazzo Bentivoglio, the artist played a prominent part in the decoration of Isabella d'Este's *studiolo* at the court of Mantua.

The left edge of the panel has been bevelled at the back and may therefore have originally been hinged. This suggests that the painting may have formed the right wing of a diptych, perhaps celebrating a marriage. The left side of the diptych is lost. In the context of a marriage the lap-dog would symbolise fidelity.

The painting is first recorded in the Royal Collection during the reign of Charles II.

Literature: Shearman 1983, no. 77.

Exhibitions: London 1981–2, no. 112.

Fig. 35 Leonardo da Vinci, *Portrait of Cecilia Gallerani*, oil on wood, 54 × 39 cm, Cracow, National Museum.

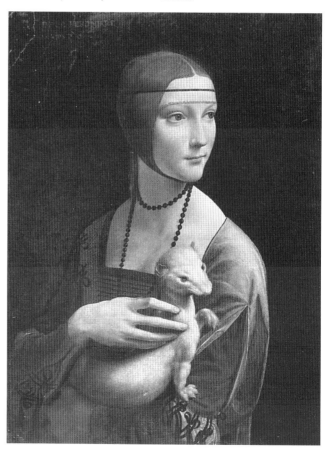

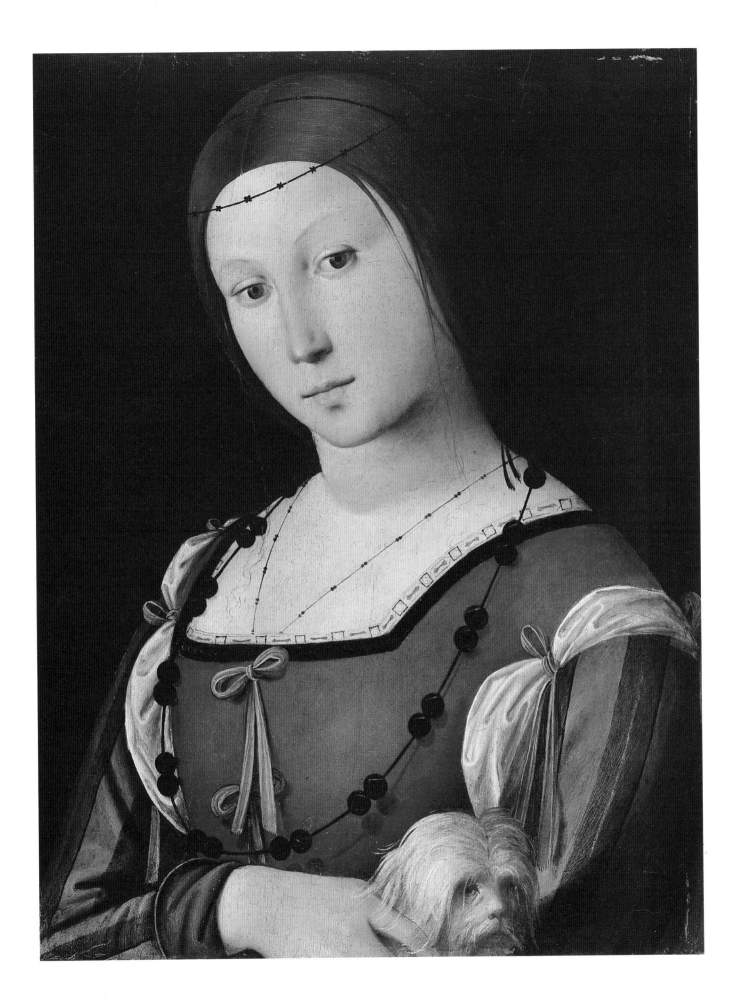

PALMA VECCHIO Active 1510; died 1528

16 *A Sibyl*

Panel (poplar), 74 × 55.1 cm (29⅛ × 21¾ in.)

THE PAINTING is a fine example of a type frequently
found in the work of Giorgione and Titian, by whom
Palma Vecchio was influenced. The sensuality of the
image is reinforced by the use of shallow diagonals to
place the figure in the composition, by the colours (light
green, cream white and straw yellow), and also by the
subtle play of light. The scale of the figure is somewhat
smaller than in the artist's related works, and the drapery
less fulsomely handled. These restraints suggest that the
picture dates from around 1520, preceding such paintings
as the *Flora* (London, National Gallery). Although many
of these works have specific subjects such as Lucretia or
Judith, or are allegorical, it is often the case that they are
disguised portraits of Venetian beauties of the day. This
conceit was continued, for example, by Sir Peter Lely in
the series of ten portraits known as the Windsor Beauties
in the Royal Collection, and it flourished again in the
nineteenth century with Rossetti and Burne-Jones. The
subject of the present painting is apparent from the
inscription in pseudo-Arabic on the cloth in the lower
left corner.

The picture was presented to Charles II by Edward
Montagu, first Earl of Sandwich (1625–72), an admiral
who began as a Parliamentarian but later played a
decisive role in restoring the monarchy. Samuel Pepys
was his secretary.

Literature: Shearman 1983, no. 180.

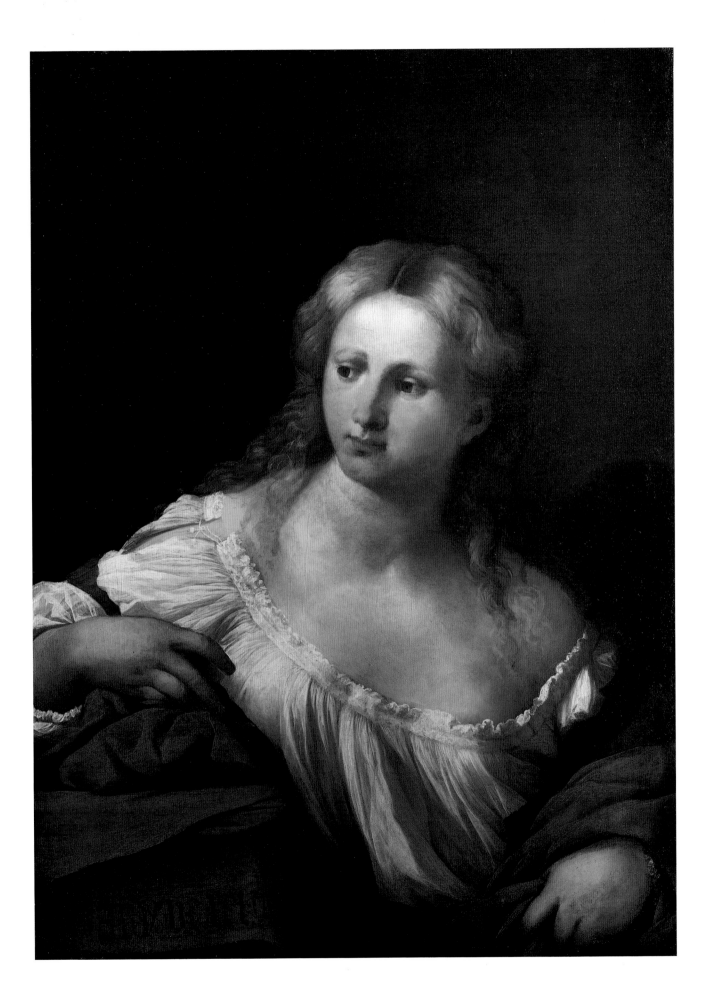

AGNOLO BRONZINO 1503–1572

17 Portrait of a Lady in Green

Panel, 76.7 × 65.4 cm (30¼ × 25¾ in.)

WILLIAM HAZLITT, writing in 1823, described the colours of the costume worn by the sitter in this memorable portrait as resembling 'the leaves and flower of the water-lily, and so clear'. The drawing and modelling are equally assured in the firm delineation of the features and the gentle modulation of light. The tilt of the head and the angle of the shoulders provide a distinctive characterisation for this unknown figure. Similar attention has been given to the costume with its slashed sleeves, puff shoulders, embroidered chemise and elegant headgear. The artist has combined the simplicity of form, attention to detail and high degree of finish often associated with his work. However, it lacks the abstract qualities of Bronzino's mature portraits which transcend a feeling of reality in favour of the metaphysical.

An attribution to Bronzino has not been universally accepted and some scholars have favoured an artist from north Italy, specifically from Emilia or Lombardy. The mitigating factor in such an argument lies in the costume which is not Central Italian in style. If the portrait is by Bronzino, then it must be early in date, between the *Portrait of a Lady with a Lap-dog* (Frankfurt, Städelsches Kunstinstitut) or the *Portrait of a Boy with a Book*, dating from the early 1530s (Milan, Castelio Sforzesca, Trivulzio collection), and the *Portrait of a Young Man with a Lute* (Florence, Uffizi) or the *Portrait of Ugolino Martelli*, dating from the mid-1530s (Berlin, Gemälde-galerie). It was at the beginning of this decade that Bronzino worked in Pesaro for the court of Urbino (1530–2) and it is possible that he took the opportunity to travel in Emilia, to places like Bologna, Ferrara or Modena. Alternatively, north Italian fashions could have been seen in the Marches, either at Urbino itself or in Pesaro, owing to the strong dynastic connections between Italian courts.

The portrait was almost certainly in the Gonzaga collection at Mantua, which was acquired by Charles I in 1625–7. In terms of both number and quality this was the most important acquisition of his reign.

Literature: Shearman 1983, no. 55.

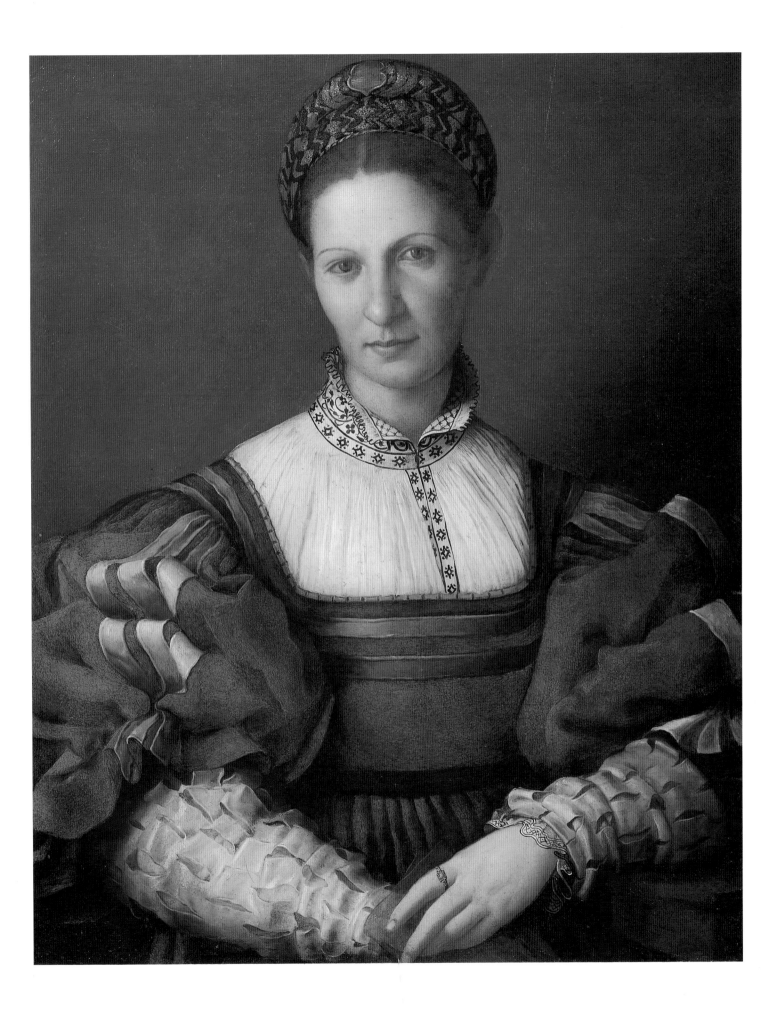

PARMIGIANINO 1503–1540

18 *Pallas Athene*

Canvas, 63.8 × 45.1 cm (25⅛ × 17¾ in.)
Inscribed on the plaque: *ATHENE*

PARMIGIANINO'S most important work survives in
Emilia, principally in the Rocca at Fontenellato and in the
church of Santa Maria della Steccata in Parma. He also
worked in Rome (1524–7), where he painted *The Vision of
Saint Jerome* (London, National Gallery), and at the end
of his life in Casalmaggiore, where he was exiled for fail-
ing to complete the decorations in Santa Maria della Stec-
cata begun in 1534. *Pallas Athene* would appear to be a
late work and is comparable in style with Parmigianino's
last altarpiece, *The Virgin and Child with Saint Stephen
and Saint John the Baptist* (Dresden, Staatliche Kunst-
sammlungen), painted for the church of San Stefano in
Casalmaggiore in 1539–40. The gracefulness of the style
evolved for the so-called 'Madonna with the Long Neck'
of around 1535 (Florence, Uffizi) gives way to a greater
sense of gravity in these late works, characterised by
slower, more ponderous rhythms and simpler composi-
tions. The warm flesh tones and the drapery that
resembles thin sheets of beaten metal are also hallmarks
of the artist's late style, although the elegant turn of the
head, the etiolated fingers and the delicate treatment of
the highlighted strands of hair evoke the earlier, more
poetic style. A preparatory drawing for the figure of Pallas
Athene is in the Pierpont Morgan Library, New York, and
three separate sheets of studies on a single Mariette
mount, relating to the design of the plaque on the arm-
our, were formerly in the Spector collection, New York.

The appearance of Pallas Athene complies with Ovid's
description in his *Metamorphoses* VI. The figure wears
armour but lacks the helmet and spear, perhaps because
the artist chose to emphasise the association with
wisdom and the arts as opposed to more warlike aspects.
The plaque indicated by the hand is reminiscent of an
antique cameo, but it is not a copy. The depiction of the
city and the winged figure of Victory flying with a palm
and an olive branch are references to Pallas Athene's suc-
cess over Poseidon concerning the ownership of Attica,
of which Athens was the capital.

First recorded in 1561 in an inventory of the collection
formed by Francesco Baiardo,[1] a friend and patron of
Parmigianino, the painting was acquired from Gerard
Reynst by the States-General of Holland for presentation
to Charles II in 1660.

Notes: **1** Dr David Ekserdjian (*pace* Shearman) has pointed out that
the dimensions given in the inventory in Parmese 'inches' or *oncia*
(0.16 × 10) equal 72 × 45 cm if 4.5 cm is taken as the standard
measurement for conversion. See A. E. Popham, 'The Baiardo Inven-
tory' in *Studies in Renaissance and Baroque Art presented to
Anthony Blunt on his 60th Birthday*, London/New York 1967,
pp. 26–9.

Literature: Shearman 1983, no. 186.

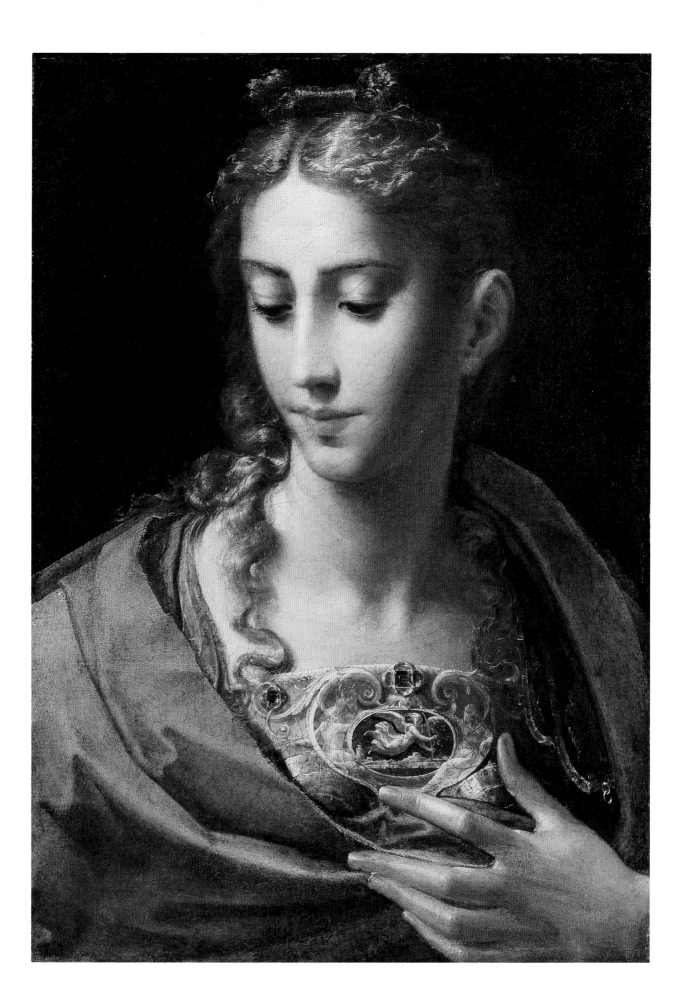

JACOPO TINTORETTO 1518–1594

19 *Esther before Ahasuerus*

Canvas, 207.4 × 273 cm (81⅝ × 107½ in.)
Cleaned 1990–1

THE SUBJECT of the picture is taken from the Book of Esther which exists in two versions: the first of Hebraic origin as part of the Old Testament and the second of Greek origin in the Apocrypha. It is the second more emotional account that seems to have been known to Tintoretto. He has depicted the dramatic moment (15: 2–16) when Esther, the Jewish queen of the Persian emperor, Ahasuerus, intervenes on behalf of her people in Persia who were threatened with death in a proclamation issued by the chief minister, Haman. Esther attended the court in regal dress in order to appeal to Ahasuerus. 'But as she was speaking, she fell fainting. And the King was agitated, and all his servants sought to comfort her' (15: 7). Ahasuerus stands on the left at the top of the flight of steps at the foot of which Esther kneels, supported by her entourage. Following this intercession and further deliberation Ahasuerus overrules Haman, who was himself hanged as a consequence of his ill-judged policy. The story of Esther was often treated as a prefiguration of the role of the Virgin in the Last Judgement.

On stylistic evidence the painting can be dated to the second half of the 1540s, close to the *Last Supper* of 1547 (Venice, San Marcuola) and the *Miracle of Saint Mark* of 1548 (Venice, Accademia). During the 1540s Tintoretto displayed a close interest in Central Italian art, particularly the works of Michelangelo and Raphael, which he probably knew through such secondary sources as prints. As a result Mannerist concepts were grafted onto the Venetian training that Tintoretto received in the workshop of Bonifazio de' Pitati. The tall swaying figures and operatic gestures bespeak Central Italian influence, while the warm flesh tones and rich colouring attest the artist's Venetian origins. The conflation of these two aspects became the basis of Tintoretto's mature style. The composition of *Esther before Ahasuerus* is dependent in a general sense upon the cartoon by Raphael of the *Sacrifice of Lystra*, a preparatory drawing for the tapestries in the Sistine Chapel, but the stooping figure on the far right fits more easily into the context of Raphael's *School of Athens* in the Stanza della Segnatura. According to Shearman, the male head at the right edge towards the back, looking out of the picture, may possibly be a portrait of Pietro Aretino, one of the greatest writers of the Renaissance, a friend of Titian and an early patron of Tintoretto. The scale of the painting accords with many of Tintoretto's undertakings dating from the 1540s including the scenes from the life of Saint Mark (Venice, Accademia) executed for the Scuola Grande di San Marco. The free handling of

Esther before Ahasuerus is also typical, and several changes were made to the figures by the artist as he worked on the canvas, creating the effect of improvisation. A second version, slightly later in date and basically a workshop production, is in the Escorial, near Madrid. The composition is extended on both sides and reveals some differences especially on the left around Ahasuerus, who is shown holding his sceptre. The painting in the Royal Collection was purchased by Charles I with the Gonzaga collection from Mantua in 1625–7.

Literature: Pallucchini and Rossi 1982, pp. 33 and 156, no. 129; Shearman 1983, no. 255.

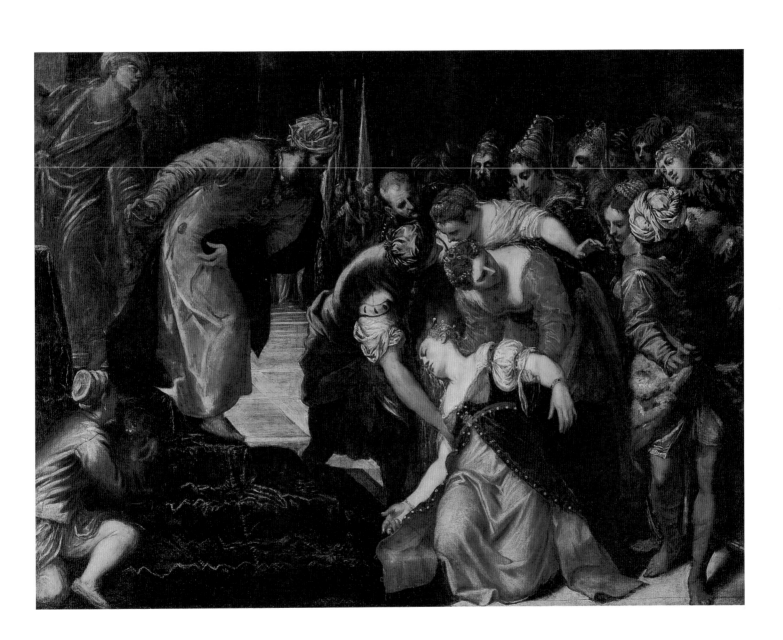

MARTEN VAN HEEMSKERCK 1498–1574

20 *The Four Last Things*

Panel, 68.6 × 152.4 cm (27 × 60 in.)
Signed lower left: *Martyn [sic] Van Heemskerck./.inventor*
Dated on the stone in the lower left corner: *1565*

THE SUBJECT is rare and conflates Death, Judgement, Paradise and Hell. It is based on Ecclesiasticus 38: 16–24. The theme, known colloquially as The Four Last Things, illustrates the plight of the individual at the time of the Last Judgement rather than the universality of the event itself. Thus, the emphasis lies to the left of the composition on a dying man who is surrounded by Faith, Hope and Charity. Christ, with the Virgin to the left and the Angel with the Sword and Saint John the Baptist to the right, is depicted in the upper right corner presiding over the resurrection of the dead in the centre and the damned on the right. The Four Last Things is a subject that is related to the eschatological tradition in fourteenth-century literature. It occurs as an item in the early catechism and during the Counter-Reformation in the *Spiritual Exercises* of Ignatius Loyola, which was widely consulted in the Spanish Netherlands where Heemskerck was resident in Haarlem. There is a distinguished rendering of the same subject in the form of a table-top by Hieronymous Bosch dating from around 1480 (Madrid, Prado).

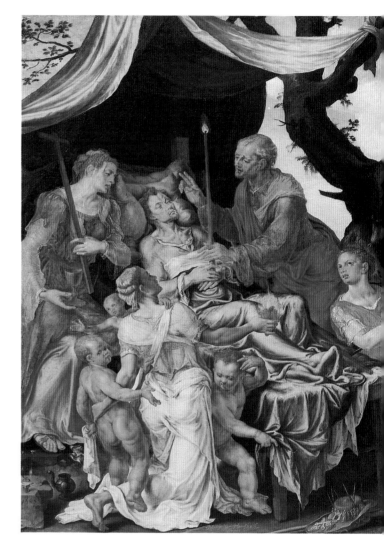

The present picture was commissioned together with a representation of *The Flood* (now lost) by Jakob Rauwaert (died 1597), the artist's pupil. Heemskerck has in part relied on certain visual sources, mainly prints, of related subjects by or attributed to Cornelis Anthoniszoon and Jörg Breu. His painting was in turn engraved, probably by Philip Galle, and published by Theodore Galle in 1569. A drawing made in reverse, corresponding only to the upper right of the painted composition, is at Chatsworth in the collection of the Duke of Devonshire.

The picture is mentioned in the *Het Schilder-boeck* by Carel van Mander (1604), by which time it was in the collection of Rudolf II in Prague. After the sacking of the city by Swedish troops in 1631 it passed into the collection of Queen Christina of Sweden. It appears that the painting was sold by Queen Christina in Brussels while travelling to Rome after her abdication in 1654. Subsequently acquired by the dealer William Frizell, it was sold to Charles II in 1662 (see also Nos. 21, 22, 26).

Literature: White 1982, no. 2.

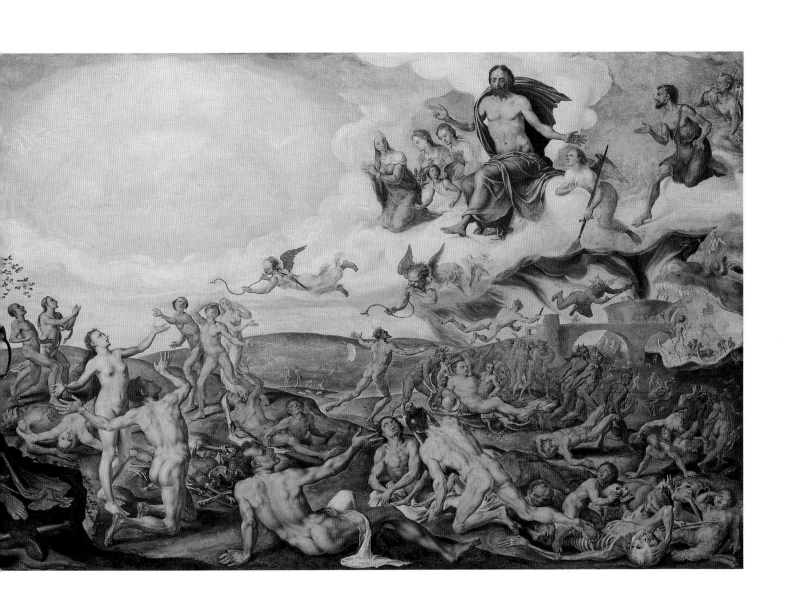

PIETER BRUEGEL THE ELDER Active 1551; died 1569

21 *The Massacre of the Innocents*

Panel, 109.2 × 158.1 cm (43 × 62¼ in.)
Signed lower right (only the tops of the letters visible after
trimming): *BRVEGEL*
Cleaned 1987–8

A NUMBER of versions exist of this work, four of which
have at one time or another been claimed as the original.
Apart from the present painting, the three other versions
previously in contention are in Bucharest, Vienna, and a
private collection in Japan (formerly belonging to Baron
Descamps, Brussels). The claim that the picture in the
Royal Collection is the original is made mainly on the
basis of the quality of the work revealed by recent
restoration. Its excellence is by no means limited to the
range of detail (note the icicles suspended from the eaves
and the footprints in the slush) but includes the sensitive
drawing of the figures, the vivid colours offset by the
white of the snow, the handling of the architecture, and
the internal rhythms that unify such a crowded composi-
tion. It is also apparent in the more general aspects,
namely the range of emotions elicited by the horror of the
massacre and the wintry setting that in its icy intensity
adds a note of harsh reality to the scene. The painting not
surprisingly was praised on two separate occasions by the
biographer and artist, Carel van Mander (1604). The com-
position, however, was altered at an early date, possibly
while in the collection of Rudolf II at Prague, for in an
inventory drawn up after the Emperor's death the subject
is described as the sacking or pillaging of a village. The
alterations chiefly involved substituting animals and bun-
dles of clothes for the small children. For the purposes of
the recent restoration it was decided to retain the
animals, partly on account of the early date at which the
changes were made, and partly because of the danger of
removing the remaining forms of the children below the
upper layers of paint. The picture was taken from Prague
by Swedish troops in 1648 and entered the collection of
Queen Christina of Sweden. After her abdication in 1654
she travelled to Rome, leaving some of her paintings in
the Netherlands. These were subsequently acquired by
the dealer William Frizell, who sold a large group of
pictures to Charles II in 1660. *The Massacre of the
Innocents* was the finest of eleven works with this par-
ticularly prestigious royal provenance (see also Nos. 20,
22).

The painting dates from around 1565–7. Although
dependent upon a biblical source (Saint Matthew 2:16),
Bruegel has set the scene in a Flemish village. A body of
horsemen rides down the street under instructions from
Herod to slaughter all the children of Bethlehem. The inn
where Jesus Christ was born is in the lower right corner.

The riders in the left foreground wearing red jackets are
legal officials, no doubt responsible for seeing that the
sentence is carried out. A herald, also on horseback and
wearing a tabard, is right of centre. It has been pointed
out that the winter of 1564–5 was extremely severe and
the conditions at that date seem to have inspired a num-
ber of snow scenes in Bruegel's oeuvre such as *The Hun-
ters in the Snow* dated 1565 (Vienna, Kunsthistorisches
Museum). In addition, the Feast of the Holy Innocents
falls on 28 December. The identification of Bethlehem
with a contemporary Flemish village suggests that the
artist may have implied some topical allusion to the
presence of Spanish troops in the Netherlands, whereby
the atrocities committed by the representatives of the
Roman Empire are equated with the occupying forces
of the Duke of Alba.

Literature: Campbell 1985, no. 9.

BELOW Pieter Bruegel the Elder, *The Massacre of the Innocents*.
OPPOSITE Detail.

ABRAHAM BLOEMAERT 1564–1651

22 *The Marriage of Cupid and Psyche*

Panel (circular), 61.6 cm (24¼ in.)

THE SUBJECT marks the climax of the story of Cupid and Psyche as recounted by Apuleius in *The Golden Ass* (Books 4–6). The theme became popular with artists during the Renaissance and was also frequently depicted in the seventeenth century (see Nos. 31, 44–47). The marriage of Cupid and Psyche took place in heaven on Mount Olympus after Psyche had endeavoured in vain to win back Cupid's love on earth by a series of ordeals set by Venus. The chief protagonists in this banquet of the gods are seated facing the viewer in the centre of the composition. Venus and Mars embrace with Vulcan to the left and Bacchus to the right. The immediate foreground is dominated by Neptune and Mercury, who conveyed Psyche to heaven in order for her to be reunited with Cupid. Jupiter and Juno are set further back in the picture space on the far right. Apollo, holding a lyre, can be faintly discerned top left, while Fame accompanied by putti blows a fanfare. The story of Cupid and Psyche was not always depicted simply as a narrative, but sometimes in broad philosophical terms as an allegory of carnal and spiritual love.

The composition of the painting is inspired by a large engraving of the *Marriage of Cupid and Psyche* by Hendrik Goltzius, made after a drawing of 1587 by Bartholomeus Spranger. The rectangular format of the engraving was favoured by Bloemaert for another version of the subject now at Aschaffenburg, Bavaria. This compositional dependency on Spranger's work is echoed in the similarity of style, which in turn suggests an early date of about 1595 for the painting. Bloemaert here provides a perfect demonstration of Mannerism in the complicated twisting poses, the severe foreshortening, the restless movement, and the dramatic gesticulation. These stylistic tendencies are given an added visual complexity by the circular format that was also often used by Goltzius for his prints of mythological subjects.

The painting formed part of a large group of pictures sold by the dealer William Frizell to Charles II in 1660. Of these, eleven were claimed by Frizell to have been in the collections of Rudolf II in Prague and Queen Christina of Sweden (see Nos. 20, 21), including the present picture. However, no such painting seems to have been listed in the inventories of the collections of either of these famous patrons of the arts and so Frizell's claim remains unconfirmed.

Literature: White 1982, no. 1; Lowenthal 1990, pp. 26–8.

CRISTOFANO ALLORI 1577–1621

23 *Judith with the Head of Holofernes*

Canvas, 120.4 × 100.3 cm (47¾ × 39½ in.)
Inscribed on the end of the bed lower right: *Hoc Cristofori Allori/Bronzinii opere natura/hactenus invicta pene/vincitur Anno 1613* [This [work is] of Cristoforo [sic] Allori Bronzino, hitherto unvanquished, [he] has almost been defeated by the labour [of] painting, in the year 1613]

Judith with the Head of Holofernes has been described as the most celebrated of all Florentine seicento pictures. It exists in numerous versions, the best known being that in the Palazzo Pitti, Florence, painted for Grand Duke Cosimo II. The primacy of the version in the Royal Collection, however, depends principally on the vividness of the characterisation, the freshness of colouring, and the numerous changes effected during the course of painting even after several preparatory drawings had been made. Many of these changes are visible to the naked eye and accord with early descriptions of Allori's working methods. By contrast, the version in the Palazzo Pitti is slicker and more self-assured as a result of following an established design.

The painting's reputation is derived from the autobiographical aspect of the treatment of the subject as recounted by Filippo Baldinucci (1625–96) in his *Notizie de' professori del disegno da Cimabue in qua*. Baldinucci records that Allori was essentially a libertine who was given to occasional bouts of piety. Regarding the subject of the present picture he states that the figure of Judith is a portrait of the painter's lover, Maria di Giovanni Mazzafirri (died 1617), known as 'La Mazzafirra', that the features of the servant are those of La Mazzafirra's mother, and that the head of the decapitated Holofernes is a self portrait of the artist. In essence, the composition commemorates an unhappy liaison and symbolises the suffering that Allori experienced at the hands of La Mazzafirra.

The story of the Jewish heroine Judith, who saves her townspeople the Bethulians by cutting off the head of the Assyrian general Holofernes, is recorded in the Book of Judith found in The Apocrypha. The subject was frequently represented, sometimes as a straightforward narrative, sometimes with an allegorical (usually political) significance. The double meaning in the painting by Allori is confirmed by a poem by Giovanbattista Marino (*La Galeria*, 1619), written in Paris where he saw one of the versions. Marino writes that Holofernes is killed twice, firstly by Cupid's darts and secondly by the sword. It is a theme that continues in literature certainly up to John Keats's *La Belle Dame sans Merci*. The female artists Lavinia Fontana and Artemisia Gentileschi depicted themselves as Judith, and there is an autobiographical ele-ment in the *Judith* by Jacopo Ligozzi of 1602 (Florence, Palazzo Pitti). Similar opportunities arose in the treatment of the subjects of David and Salome. Caravaggio, for instance, in the *David and Goliath* dating from 1605–6 (Rome, Galleria Borghese), used his own features for the head of Goliath. This last is a composition that Allori knew.

The painting probably formed part of the Gonzaga collection acquired by Charles I between 1625 and 1627.

Literature: Shearman 1983, no. 2; *Il Seicento fiorentino*, 1986–7, under no. 1. 72, pp. 189–91.

Exhibitions: London and Cambridge 1979, no. 1.

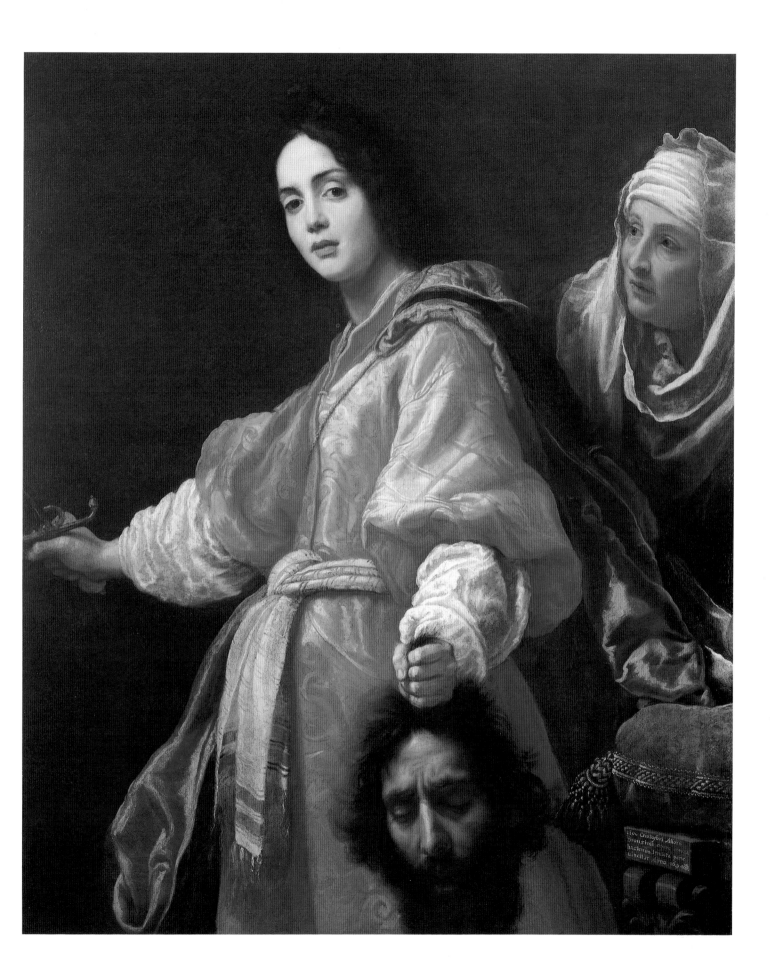

DOMENICHINO 1581–1641

24 *Saint Agnes*

Canvas, 213.4 × 152.4 cm (84 × 60 in.)
Cleaned and restored 1989–91

THE EARLY PROVENANCE of this altarpiece is not known, but it is first recorded in England in 1663, some forty years after it was painted. In 1663 the picture was hanging in the apartments of the Duchess of York in St James's Palace. James II's first Duchess was Anne Hyde (1637–71), the daughter of the courtier and historian Edward Hyde, Earl of Clarendon. Their marriage took place in 1660 and both had pronounced leanings towards the Catholic faith. It is possible, although not documented, that the altarpiece was sent directly from Italy as a gift for the Duke and Duchess of York, possibly by someone like Cardinal Francesco Barberini, who was keen to maintain links between Rome and the English court after the Restoration.

The painting can be dated around 1620 on the evidence of style. Comparisons may be made with the two large altarpieces of the *Madonna del Rosario* and the *Martyrdom of Saint Agnes*, both in Bologna (Pinacoteca), although in terms of scale and the drawing of the putto, *King David playing the Harp* (Versailles) provides a more suitable juxtaposition. All these works appear to have been painted in Bologna before Domenichino returned to Rome for his third extended stay in 1621. The relationship between the *Saint Agnes* and the two large paintings in Bologna is confirmed by a drawing at Windsor Castle which has on the recto a study for the *Madonna del Rosario* and on the verso one for *Saint Agnes*.

The painting is a fine example of what is known as Bolognese classicism, which evolved out of the late work of Annibale Carracci. Domenichino here combines harmonious colouring with purity of line. His ability as a landscape painter is only hinted at in the background of the composition. There is a certain resemblance between Saint Agnes and the figure of Saint Cecilia in the altarpiece of *Saint Cecilia with Four Saints* by Raphael (Fig. 36), which was painted for a Bolognese patron. The flying angel may be borrowed from the *Worship of Venus* by Titian (Madrid, Prado), which was in the Aldobrandini collection in Rome at the beginning of the seventeenth century. The classical vase and the low relief on the left symbolise the pagan world which Saint Agnes rejected in favour of Christianity. The relief shows a sacrifice which is perhaps an allusion to the saint's own martyrdom. The lamb held by the putto is the attribute of Saint Agnes. The uncovering of her remains in the church of Sant'Agnese fuori le mura in Rome in 1605 may have encouraged a revival of interest in her cult, of which this picture is almost certainly a product.

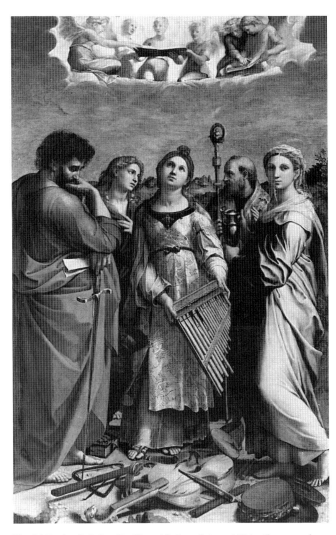

Fig. 36 Raphael, *Saint Cecilia with Four Saints*, 1514, oil on wood, transposed to canvas, 220 × 136 cm, Bologna, Pinacoteca Nazionale.

Literature: Levey 1991, no. 467.

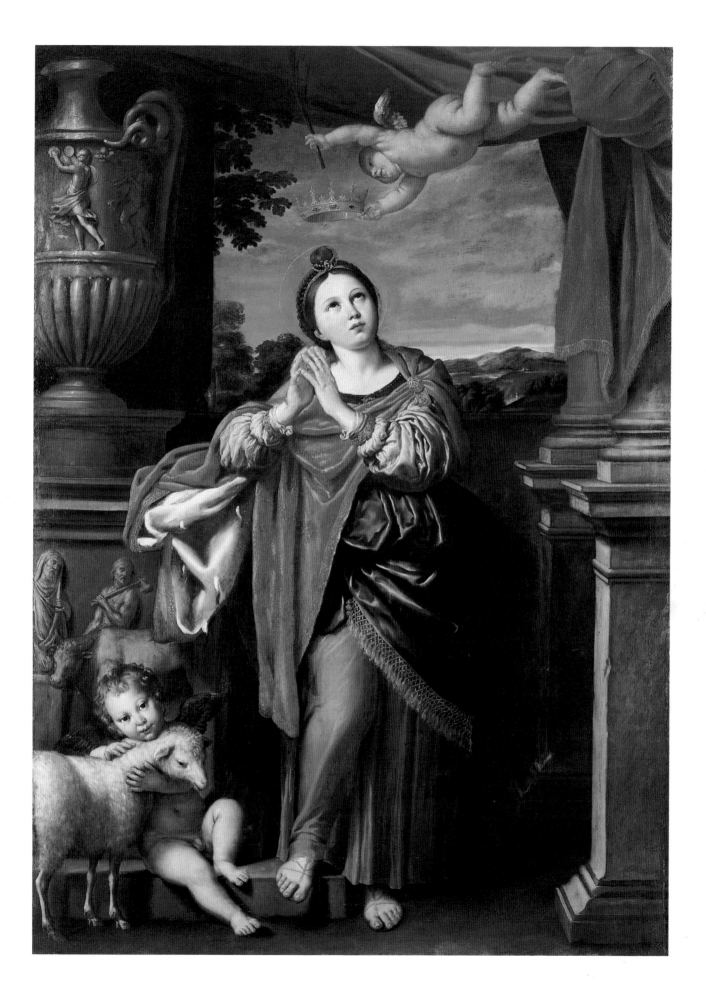

DOMENICO FETTI c.1589–1623

25 *David with the Head of Goliath*

Canvas, 153 × 125.1 cm (60¼ × 49¼ in.); the painting has been
extended once at the top and along the sides at a later date, with
yet further additions at the top and on the right
Cleaned 1990–1

FETTI was a peripatetic artist. Having been trained in
Rome by the Florentine painter, Lodovico Cigoli, he
worked at the court of Mantua from around 1613 and
towards the end of his life spent some time in Venice.
His principal patron was Duke Ferdinando Gonzaga at
Mantua and it was with the purchase of the Gonzaga
collection in 1625–7 that Charles I acquired a number
of works by Fetti. The artist was influenced by Venetian
painters, as well as by Elsheimer and Rubens. His
portraits and a series of small-scale pictures illustrating
parables, probably commissioned by Ferdinando Gonzaga,
are perhaps his best works. The artist's technique is dis-
tinctive, with rapid brushstrokes of pure colour applied as
highlights over broader areas of paint on canvases primed
with dark tones. Similarly, the poses of his figures and
the choice of viewpoints are often unusual.

David with the Head of Goliath almost certainly
formed part of the Gonzaga collection. A version of some
quality is in Dresden (Staatliche Kunstsammlungen) and
others are recorded. A date around 1620 has been sug-
gested, that is, before the artist moved to Venice in 1622.
The pose is somewhat reminiscent of the *Ignudi* by
Michelangelo on the ceiling of the Sistine Chapel in
Rome, and it is possible that the painting was meant to
be hung as an overdoor.

The present work depicts the story of David and
Goliath as recounted in the first Book of Samuel, 17:
48–51. The shepherd boy, David, defeats Goliath, the
champion of the Philistines, in single combat using a
sling with a stone. Afterwards David cuts off Goliath's
head using the giant's own sword. The body of Goliath is
visible on the left in the middle distance. Fetti cleverly
contrasts the large scale of the decapitated head and
sword with David's smaller body.

Literature: Levey 1991, no. 469.

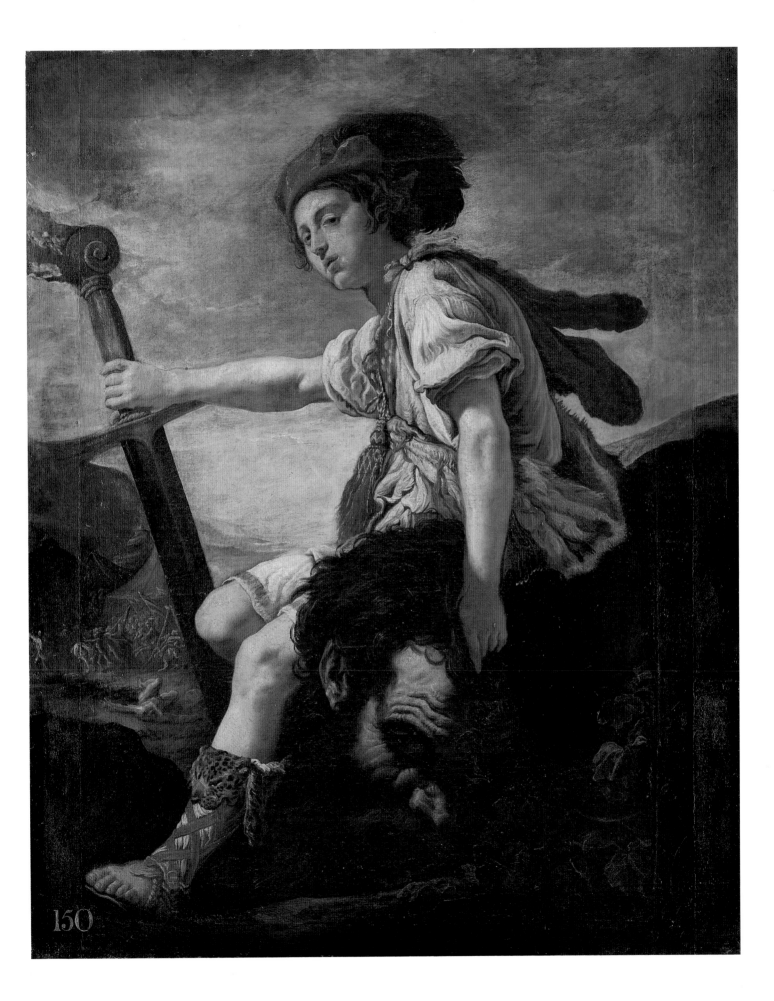

150

GEORGES DE LA TOUR 1593–1652

26 *Saint Jerome reading*

Canvas laid down on wood, 62.2 × 55 cm (24½ × 21⅝ in.)
Cleaned and restored 1972

CHARLES II seems to have acquired this painting in 1662 from the dealer William Frizell whom he saw in Breda just before the Restoration in 1660 (see also Nos. 20, 21, 22). At that time it was listed as 'St. Jerome wth [sic] spectacles of the manner of Albrecht Dürer'; it was not until 1939 that it was recognised by Kenneth Clark as 'a very bad de la Tour'. *Saint Jerome reading* is now regularly discussed in the literature on the artist, whose popularity has risen dramatically in recent years. Having been born in Lorraine where he passed most of his life, de la Tour's style reveals a commingling of Italian and Northern Caravaggesque influences which suggest, but do not necessarily prove, visits to Rome and the Netherlands. However, his style remains determinedly individual and was equally the product of local influences. He was a man of independent means and was appointed Peintre Ordinaire du Roi in Paris in 1639.

There is a limited number of signed or dated works in the artist's small oeuvre and only approximate indications (some controversial) for the development of his style.

Saint Jerome reading may be compared with the series of *Apostles* at Albi (Musée Toulouse-Lautrec), usually regarded as early works although not all autograph. The figures of Saint James the Less, Saint Philip and Saint Paul are particularly relevant. Also significant is a variant *Saint Jerome reading* in Paris, a copy after a lost painting by de la Tour, which is a more sophisticated composition with the figure seen from above and numerous objects comprising a still life in the foreground. A date of about 1621–3 has been suggested for all of these works, which herald the influence of Caravaggio.

Even allowing for the worn surface of the present painting, the chief characteristics of de la Tour's art can be discerned: the naturalistic rendering of hair and skin, the love of genre details such as the spectacles, the splash of saturated colour for the cardinal's robe and, above all, the mysterious light that illuminates the figure so powerfully. As a painter Georges de la Tour lifts the art of scientific observation onto a poetic level. It is not quite certain, for instance, to what degree the intense luminosity renders the paper transparent, but it helps to define the distance between the viewer and Saint Jerome in the picture space while providing a bright focal point on a vertical axis. The concentration that characterises Saint Jerome gradually envelops the viewer to the extent that the internal act of reading becomes synonymous with the external discipline of looking.

Literature: Thuillier 1973, p. 88, no. 20; Nicolson and Wright 1974, pp. 22–3 and 169, no. 18; Rosenberg and Macé de l'Epinay 1973, p. 112, no. 22; Nicolson 1979, p. 64.

Exhibitions: Paris 1972, no. 7.

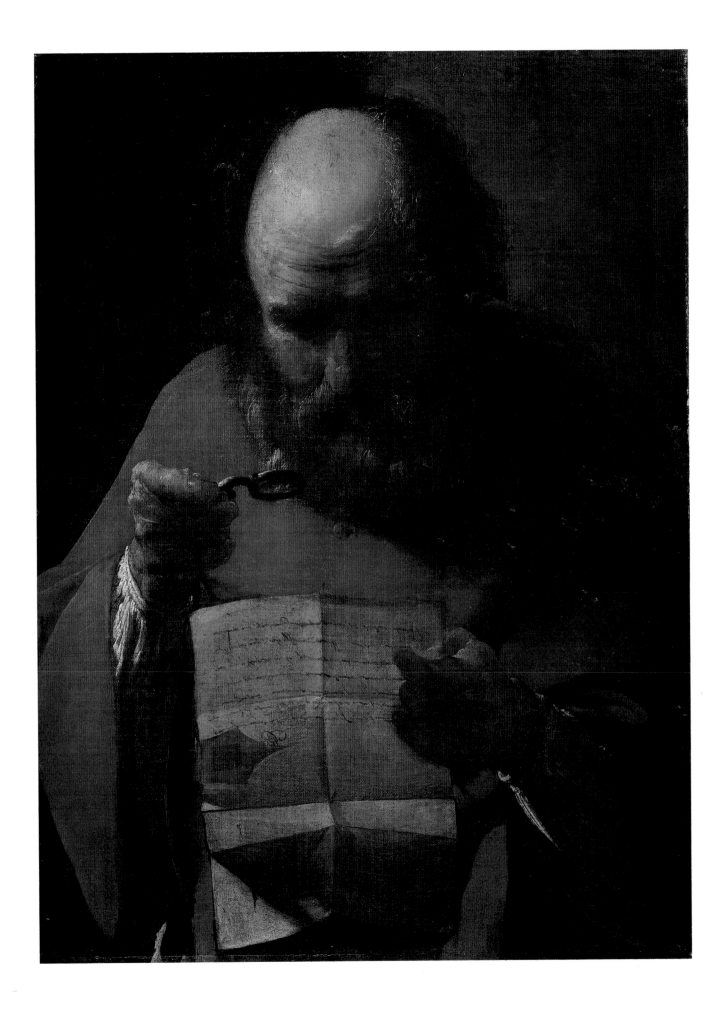

HENDRICK TER BRUGGHEN c.1588–1629

27 A Laughing Bravo with a Bass Viol and a Glass

Canvas, 104.8 × 85.1 cm (41$\frac{1}{4}$ × 33$\frac{1}{2}$ in.)
Signed upper left: *HTBrugghen fecit 1625* [*HTB* in monogram]
Cleaned 1989

THE ARTIST worked mainly in Utrecht, but spent about
ten years in Rome from about 1604–1614 where, like
several other Dutch painters, he became versed in the
style and subject matter of Caravaggio and his followers.
Ter Brugghen was, in fact, the first of the Dutch artists to
return to the north where, together with Baburen and
Honthorst, he helped to establish the tenebrist style.
Although no doubt based on one of the itinerant musi-
cians who travelled in the Netherlands at the beginning
of the seventeenth century, the subject is most probably
an allegory of the senses of Hearing (the bass viol) and
Taste (the glass). It is also possible that the artist is
illustrating the theme of *vanitas* whereby the brevity of
song is equated with a short life-span. A number of paint-
ings in ter Brugghen's oeuvre explore such subjects, but
only one other (known through a copy) includes a bass
viol. On the other hand, the model, the vividly coloured
costume and the cap are standard studio properties used
by the artist during the 1620s. Benedict Nicolson noted
the forced smile of the sitter, comparing it to 'that
thrown by the politician to his constituents' in 'a joyless
wish to please'. The breadth of the handling of the paint
contrasts with the drawing which is most fastidious.
An important element, however, is the treatment of the
light, which in its emotive power is decidedly
Caravaggesque, but in its descriptive qualities anticipates
later seventeenth-century Dutch painting.

Purchased by Charles I and sold after his execution, the
picture was in the possession of Sir Peter Lely at the time
of the Restoration and was returned to the Royal
Collection.

Literature: White 1982, no. 33.

Exhibitions: Birmingham 1989–90, no. 8.

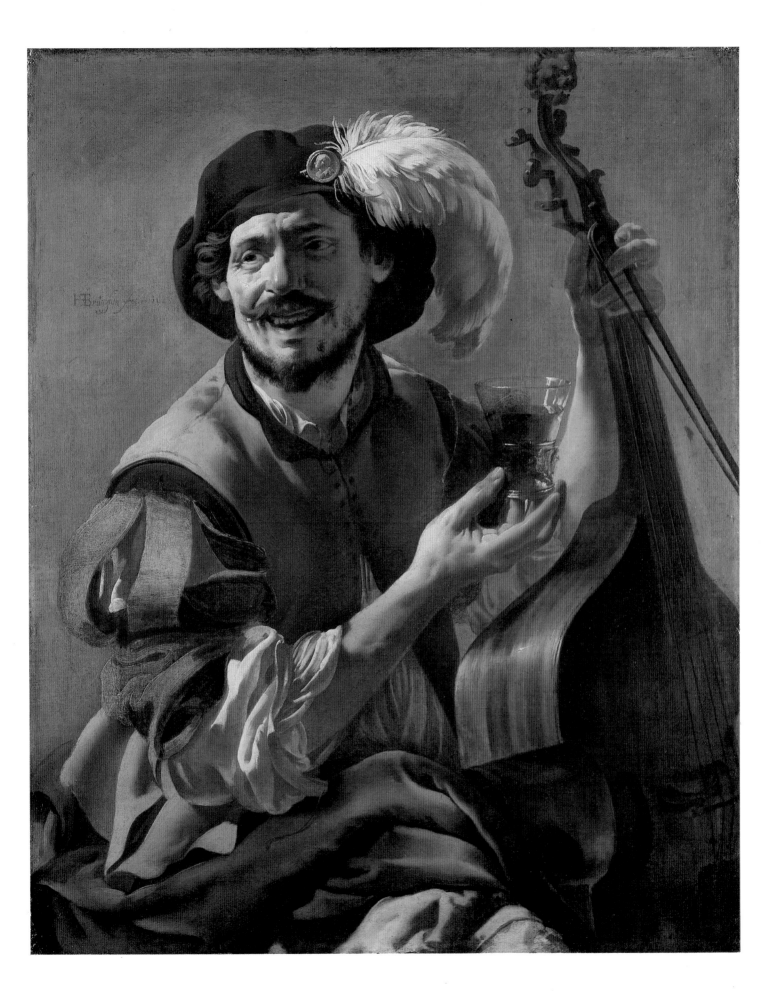

ORAZIO GENTILESCHI 1563–1639

28 Joseph and Potiphar's Wife

Canvas, 204.9 × 261.9 cm (79½ × 103⅛ in.)
Signed on the back of the original canvas: *HORATIUS – GENTILESCVS / FECIT*
Cleaned 1978–80

CHARLES I's success in attracting Northern European painters like Rubens and Van Dyck was not matched in the field of Italian painting. The question of inviting an Italian painter was complicated primarily by the political circumstances and by religious principles. Efforts were made, for example, to attract Guercino and Albani to the English court, but the former declined on the basis that England was officially a Protestant country and that the climate was too inclement, and negotiations with the latter came to nothing. Indeed, a similar situation pertained during the reign of Charles II when the only Italian artist at court was Guercino's nephew, Benedetto Gennari, an inferior painter who worked in England from 1674. Significantly, when Orazio Gentileschi came to England in 1626 his main employer seems to have been Charles I's wife, Henrietta Maria, the daughter of Marie de' Medici, who continued to profess her Catholic faith after her marriage in 1625. For the queen Gentileschi painted the ceiling of the Great Hall in The Queen's House at Greenwich – *Allegory of Peace and the Arts under the English Crown* (now in Marlborough House, London) – and other important pictures by him are recorded at Greenwich such as *The Finding of Moses* (given by Charles I to Philip IV of Spain in 1633) and *Joseph and Potiphar's Wife*. This last, although sold after the king's execution in 1649, was recovered for the Royal Collection at the time of the Restoration and sent to Henrietta Maria in exile in France at Colombes.

Gentileschi was born in Pisa, but early in life (1576/8) settled in Rome, where his style reflects the influence of a residual Mannerism that was soon to be swept away by the impact of Caravaggio. The artist left Rome for good at the beginning of the 1620s and is then recorded in Genoa in 1623 before moving northwards to Paris in 1624 and finally to England, where at first he worked for the Duke of Buckingham. Following Buckingham's assassination in 1628, Gentileschi became a fully-fledged court painter, indulging in diplomatic missions as well as painting. His presence in England was not widely welcomed and by 1633 he was trying to return to Florence, reminding the Grand Duke Ferdinand II in a letter that he had been out of Tuscany for fifty-five years. In spite of these efforts Gentileschi died in London.

The artist's work has only recently become the subject of close study. To a certain extent his paintings are self-consciously grand and display poor draughtsmanship.

Furthermore, the large scale that he so often favoured encouraged a rhetorical flourish that sometimes amounts to vacuousness. Yet many of his compositions are striking and linger in the memory – *Young Woman playing a Lute* (Washington, National Gallery of Art), *The Rest on the Flight into Egypt* (Birmingham City Museum and Art Gallery), *Lot and his Daughters* (Berlin, Gemäldegalerie) or *The Annunciation* (Turin, Galleria Sabauda). His style would seem to be based on a fusion between the realism of Caravaggio and the clarity of exposition demanded by the Counter-Reformation. It has also been argued that paintings like *Joseph and Potiphar's Wife* should be seen in the context of Caroline court art. The predilection for simplified, dramatic compositions and exaggerated gesture, together with the sharp contrast between exposed flesh and the texture of draperies, are paralleled in the plots of contemporary masques and poetry. Within court circles narrative pictures of this sort were possibly the province of Gentileschi, while Van Dyck concentrated at first on portraiture (see No. 41).

The story of Joseph and Potiphar's wife, which was popular in Florentine art of the early seventeenth century, is recounted in Genesis 39: 7–20. Potiphar was an Egyptian official ('captain of the body-guard') who bought Joseph from the Midianites. His wife found Joseph attractive, and after he was made comptroller of Potiphar's household she attempted to compromise Joseph but without success. 'And she caught him by his garment, saying, Lie with me: and he left his garment in her hands, and fled, and got him out.' Joseph was falsely accused on the basis of the garment and eventually imprisoned. The painting exhibits the strengths and weaknesses of Gentileschi's art in that the artist recognises the dramatic potential of the scene, but cannot quite sustain it on this large scale. Interestingly, a replica (New York, Paul Drey) which is smaller in size, is in the final analysis more compelling. On the other hand, the poses of the two figures, the handling of the draperies and the rich colours are memorable.

The results of a technical examination of the picture with some observations on Gentileschi's method of painting are published in the first issue of the *Bulletin of the Hamilton Kerr Institute of the Fitzwilliam Museum*, Cambridge 1988, pp. 99–104.

Literature: Levey 1991, no. 501.

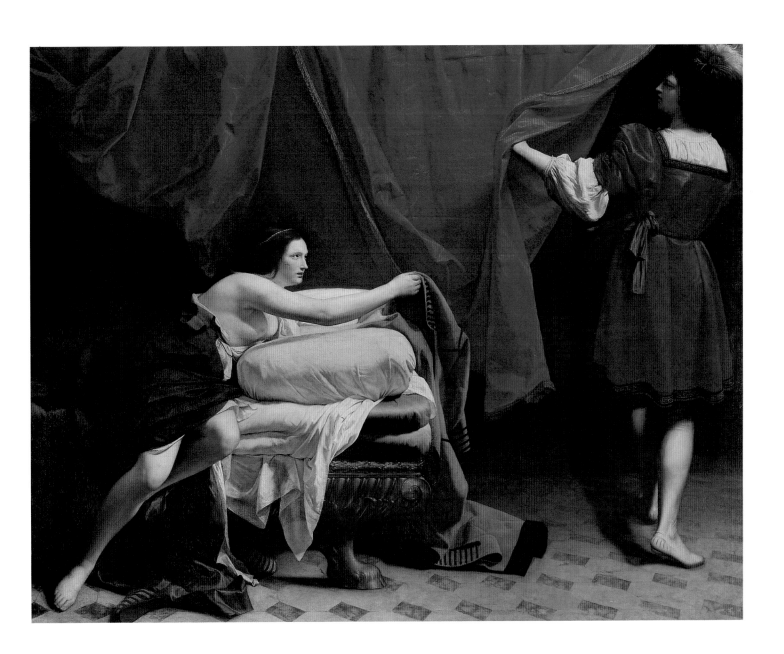

PETER PAUL RUBENS 1577–1640

29 # *Landscape with Saint George and the Dragon*

Canvas, 152.4 × 226.7 cm (60 × 89¼ in.); the original central section (irregularly cut) measured c.95.2/96.5 × 146 cm (c.37½ × 57 in.) before additions were made on the right (67.3 cm, 26³⁄₁₀ in.), at the top (20.3 cm, 8 in.) and along the lower edge (24.7 cm, 9³⁄₅ in.); on the left is an addition of 26.7 cm (10½ in.) and later a further section of c.8.9 cm (3½ in.) was attached along the lower edge

Saint George and the Dragon symbolises the close relationship established between Rubens and the court of Charles I. The subject honours the patron saint of England and of the Order of the Garter, founded by Edward III in 1348 (see No. 64). The features of Saint George are traditionally stated to be those of Charles I, while the figure of the Empress Cleodelinde is, according to the same tradition, intended to be Queen Henrietta Maria. The verdant landscape is also a form of flattery in so far as it is inspired by the English countryside. Indeed, the background was described by Croft-Murray as 'probably Rubens's single essay in English landscape.'[1] Some of the buildings are identifiable, although their contiguity is purely imaginary. On the left of the composition, for example, is the square church tower of St Mary Overy (now Southwark Cathedral) and to the right of this possibly the Banqueting House with Westminster Abbey before Hawksmoor's towers were added. Further down river on the right of the composition is an interpretation of Lambeth Palace.

The painting was no doubt begun while Rubens was in London between June 1629 and March 1630. During this time he stayed with Balthasar Gerbier, who acted as an agent to the Duke of Buckingham in the collecting of pictures. A letter of 6 March 1630, written by Sir Martin Stuteville to Joseph Mead (1586–1638), the biblical scholar, records that Rubens sent the work home to Flanders, 'To remain there as a monument of his abode & employment here.' However, the painting was acquired from the artist before 1635 by Endymion Porter for Charles I; it was then hung in Whitehall Palace. Although not mentioned in the sales following the death of Charles I, *Saint George and the Dragon* is next recorded in France in the collection of the Duc de Richelieu and then that of the Duc d'Orléans. When the Orléans collection was sold in London in 1798 the painting returned to England, and it was eventually acquired by George IV in 1814 from the dealer William Harris.[2] The picture was prominently hung in the Crimson Drawing Room on the Principal Floor of Carlton House, as can be seen in W. H. Pyne's

The History of the Royal Residences, 1819.[3]

The canvas was extended by the artist, evidently sometime between March 1630 when Rubens left England, and January 1635 when Endymion Porter returned from the Spanish Netherlands. These additions betoken extensive rethinking of the design. The original concept was to have been contained within the central section and is recorded in a drawing in Stockholm (National Museum).[4] This was preceded by a study in Berlin of motifs occurring in the right half of the composition.[5] These drawings show that the horseman on the right was at first balanced on the left by a woman standing with a child, forms which can still be discerned between the trunks of the two trees and which are even more obvious by X-ray.[6] They were omitted, however, when the composition was enlarged, possibly because they did not constitute a sufficiently strong counterpoint. The other elements of the composition, especially on the right, were merely rearranged on a broader scale. It is conceivable that some iconographical refinements were also made in order to sharpen the allegorical meaning. What remains of this central part is of good quality, particularly the flickering evening light and damp atmosphere so characteristic of the Thames Valley, and can be assigned to Rubens himself. The additions, however, are less adroitly handled and may have been left to studio assistants. Adler and Jaffé regard the painting as autograph throughout. The richness of Rubens's visual vocabulary and the diversity of his sources are apparent in *Saint George and the Dragon*. The initial composition, as observed by Burchard and d'Hulst,[7] perhaps relates to the engraving of the same subject by Lucas van Leyden.[8] The works of Pordenone, Titian, Polidoro da Caravaggio, Veronese and the Carracci family all inspired the artist in carrying out this political allegory which, in the context of the reign of Charles I, clearly has religious connotations with particular reference to Saint George.[9]

Notes: **1** Croft-Murray 1947, p. 89. **2** White 1982, p. LXVII, n. 241. **3** W. H. Pyne, *The History of the Royal Residences*, III, London 1819, pp. 20–2. **4** Adler 1982, figs. 98–9; Held 1986, p. 136, no. 172. **5** Adler 1982, fig. 100; Held 1986, pp. 138–9, no. 177. **6** Reproduced in Adler 1982, fig. 94. **7** Burchard and d'Hulst 1963, no. 145. **8** Reproduced in Adler 1982, fig. 96. **9** Strong 1972, pp. 59–62; Veevers 1989, pp. 187–91.

Literature: Croft-Murray 1947, pp. 89–93; Strong 1972, pp. 59–62; Millar 1977, pp. 631–2; Adler 1982, pp. 119–123, no. 35; White 1987, pp. 227–8; Jaffé 1989, no. 973; Veevers 1989, pp. 187–191.

Exhibitions: London, 1972–3, no. 84.

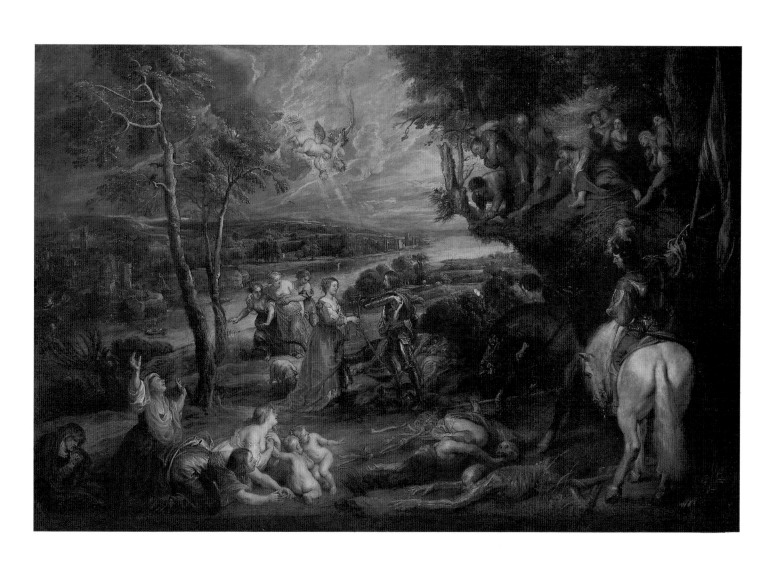

SIMON VOUET 1590–1649

30 *Diana*

Canvas, 102 × 141 cm (40 × 55½ in.)
Signed and dated on the quiver in the lower right corner: *Simon Vouet F. Paris 1637* [the date has previously been incorrectly read as 1627]

THERE IS NO documentary evidence that this picture belonged to Charles I, but the theorist Félibien claims that Vouet sent paintings to England for the king.[1] Certainly after the artist executed an allegorical ceiling decoration celebrating the marriage of Charles I and Henrietta Maria, which took place on 11 May 1625, such a contention seems perfectly plausible. The queen was the daughter of Marie de' Medici and the sister of Louis XIII, for whom Vouet worked as Premier Peintre du Roi on his return in 1627 from a ten-year period in Rome. The ceiling is lost, but it is known from an engraving made in 1639 and entitled *Allegory of Peace between England and France*, which, according to the inscription, was once at Oatlands Palace, a royal residence in Surrey used by Tudor and Stuart monarchs. Whether Vouet painted this ceiling while still in Rome, or retrospectively after his return to France, is not known.

The artist had been a leading painter in Rome and in 1624 was elected President of the Accademia di San Luca. His style there oscillated between the Caravaggesque, Roman baroque and Bolognese classicism. On his return to Paris he gained a reputation as a decorative artist, indulging in skilful displays of illusionistic painting including the ceiling of the principal room in the château at Colombes where Henrietta Maria lived from 1657.[2] Vouet was undoubtedly the most influential artist of his generation in France (*pace* Poussin who spent much of his life in Rome) and was active in establishing the Académie des Beaux-Arts in 1648, one year before his death.

Diana is in Vouet's late, more classical style. The idealised expression of the face with its widely spaced features, the languid gesture, and the slow, ponderous rhythms combined with the pale flesh tones and light colours of the drapery are typical of the artist's decorative work. The composition was originally oval, as seen in the engraving of 1638 by Vouet's son-in-law, Michel Dorigny (Fig. 37). With this knowledge the internal rhythms of the painting become more comprehensible, with the curve created by the reclining figure of the goddess of hunting continued in the muzzles of the two dogs pointing in opposite directions. Dorigny also engraved two other oval compositions in 1638, *Venus and Adonis* and *Mars and Venus*, which could have formed a series with the present painting. The pose is reminiscent of Venetian painting (for example, *Venus and Cupid* by Palma Vecchio – Cambridge, Fitzwilliam Museum). Vouet had visited Venice in 1612/13, but evidence of his interest in Venetian art resurfaces in several of the decorative schemes undertaken after 1627, especially in his masterpiece in the Hôtel Seguier, Paris. There is also an affinity with Primaticcio's work carried out at Fontainebleau for Francis I at the beginning of the sixteenth century, which was widely known through engravings.

Fig. 37 Michel Dorigny after Vouet, *Diana*, 1638, engraving, London, British Museum, Department of Prints and Drawings.

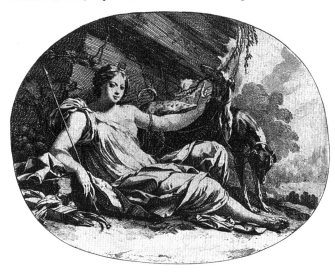

Notes: **1** A. Félibien, *Entretiens sur les vies et sur les ouvrages des plus excellens peintres anciens et modernes*, 1685–8. **2** J. Féray and J. Wilhelm, 'Une oeuvre inédite de Simon Vouet: le décor d'une chambre à alcôve du château de Colombes à la mairie de Port-Marly', *Bulletin de la Société de l'histoire de l'art français 1976* (1978), pp. 59–79.

Literature: Crelly 1962, pp. 125 and 166, no. 41.

Exhibitions: Paris 1990–1, no. 40.

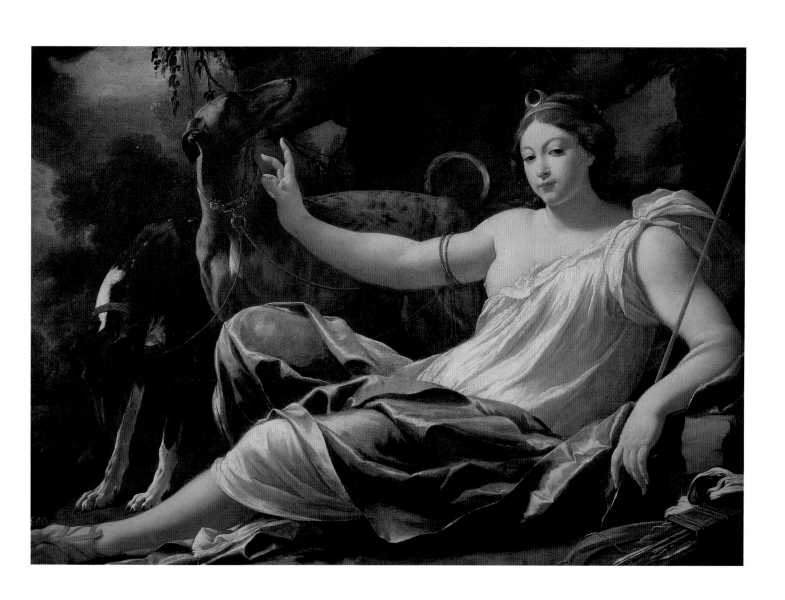

ANTHONY VAN DYCK 1599–1641

31 *Cupid and Psyche*

Canvas, 199.4 × 191.8 cm (78$\frac{1}{2}$ × 75$\frac{1}{2}$ in.); there are early additions at both the upper edge (9.5–10.8 cm, 3$\frac{3}{4}$–4$\frac{1}{4}$ in.) and the lower edge (c.5.7 cm, 2$\frac{1}{4}$ in.)
Cleaned and restored 1990

Cupid and Psyche is without doubt one of the most beautiful paintings undertaken by Van Dyck for Charles I. It is a late work, possibly dating from 1639–40, thinly painted throughout with several changes visible to the naked eye and some passages, particularly in the landscape, unresolved to the extent that the painting might not have been properly finished. Significantly, when first recorded in the Long Gallery at Whitehall Palace the picture was unframed. Both these factors might have some bearing on the circumstances of the commission. It has been suggested, for example, that the subject relates to the decoration of the Queen's Cabinet at Greenwich, which was initiated towards the end of 1639 by Rubens and Jacob Jordaens but was never completed – although a certain amount of preparatory material by Jordaens is recorded. Alternatively, the painting could have been made in the context of the celebrations for the marriage of Princess Mary to William II of Orange (April–May 1641).

The story of Cupid and Psyche (see Nos. 22, 44–47) was well known at the English court, as evidenced by John Milton's conclusion to *Comus* and by Shakerley Marmion's masque, performed in 1637 for the king's nephew, Prince Charles Louis (the Elector Palatine). The source is *The Golden Ass* by Apuleius (Books 4–6). Van Dyck has chosen the moment when Cupid discovers Psyche overcome by sleep after opening the casket which Venus had requested her to bring back, unopened, from Proserpine in Hades. This was one of the tricks set by Venus in Psyche's attempt to find Cupid. Compositionally, there is a kinship with paintings of Adam and Eve or the Annunciation. It is stated traditionally that Psyche's features resembled those of Van Dyck's mistress, Margaret Lemon.

Van Dyck's role as court painter seems primarily to have been directed towards portraiture, even though he was a supremely able painter of *poesie* in the Italian tradition. *Cupid and Psyche* is the only mythological composition known to survive from the time of the artist's full employment at the English court (after 1632). Bellori records that other mythological paintings were made[1] but these are now lost. This accounts for the long gap between the *Rinaldo and Armida* (Baltimore, Museum of Art), which the king commissioned in 1630 before the artist settled permanently in London, and *Cupid and Psyche*. In many ways the later painting may be seen as a summation of Van Dyck's art in this field. The composition successfully combines the artist's feeling for landscape with his understanding of the human form, both aspects being conveyed through superb draughtsmanship, here successfully conflated by the skilful use of diagonals. The sense of movement implied by Cupid's arrival contrasts with the stillness of Psyche asleep to create a tension that is the very essence of the picture, matching perfectly the contrast within the story itself between Beauty (Psyche) and Desire (Cupid). Such ethereal neo-Platonic ideals, which were open to various interpretations about love and the soul, were nurtured as part of the court life of Charles I and Henrietta Maria. Stylistically, the principal inspiration is Titian, whose pictures were such a major feature of Charles I's collection, but the highly charged poetic feeling, refined use of colours balancing warm and cold hues, and delicate modelling of human flesh that Van Dyck brings to the painting anticipate French Rococo art, especially the work of Watteau. In addition, it should not be forgotten that *Cupid and Psyche* was painted on the eve of the outbreak of the Civil War, so in many respects the choice of subject and the poetic intensity of the painting have a certain poignancy when seen in an historical context.

The painting was sold following Charles I's execution and was proposed in 1654 as a possible purchase for Cardinal Mazarin, but this was rejected on account of the price. The picture then came into the possession of Sir Peter Lely, who returned it to the Royal Collection at the Restoration in 1660.

Notes: **1** P. Bellori, *Le vite de' pittori, scultori et architetti*, 1672, p. 263.

Literature: Millar 1963, no. 166; Strong 1972, p. 62; Brown 1982, pp. 186–7; Larsen 1988, i, pp. 390–1 and ii, p. 409, no. 1043.

Exhibitions: London 1972–3, no. 109; London 1982–3, no. 58; Washington 1990–1, no. 85.

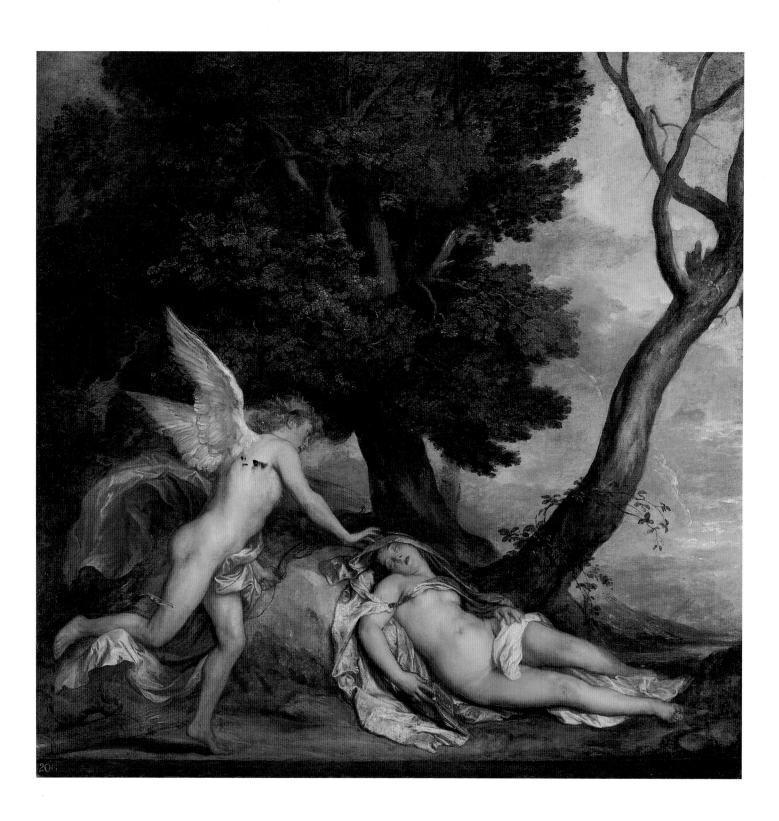

CARLO DOLCI 1616–1686

32 Salome with the Head of Saint John the Baptist

Canvas, 122.6 × 96.5 cm (48¼ × 38 in.)
Cleaned 1990–1

DOLCI was a painter of intense religiosity. His work was much sought after internationally during his own lifetime and his reputation reached its apogee during the eighteenth century, particularly in England. The meticulous finish, careful elaboration of detail and concentration of expression, especially in those compositions with single figures, are the hallmarks of a style that proved to be influential even in the late eighteenth century in the work, for example, of Jean-Baptiste Greuze.

The biblical source for the painting is Matthew 14: 6–11 or Mark 6: 21–8, where the daughter of Herodias danced for her stepfather, Herod, on his birthday. As a reward he promised her anything she wanted and, prompted by her mother, she chose the head of Saint John the Baptist, which she then carried to Herodias on a silver charger. The daughter subsequently became known in literature as Salome, and the theme was memorably treated in the nineteenth century by Richard Strauss and Oscar Wilde amongst others.

Dolci painted several versions of *Salome*. According to Baldinucci, the original version was painted, probably during the 1660s, for the Marchese Rinuccini in Florence and it proved to be the artist's most popular work, known through two other variants of good quality (Dresden, Staatliche Kunstsammlungen and Glasgow, City Museum and Art Gallery), which in turn spawned numerous copies. Of the three versions recorded by Baldinucci, the present painting is the second, which was acquired by Sir John Finch (1626–82) who gave it to Charles II. Finch was the English Resident at the court of the Grand Duke Ferdinand II in Florence from 1665 to 1670. He also gave Dolci's *Penitent Magdalen*[1] to Catherine of Braganza, as well as a *David with the Head of Goliath* (possibly in Milan, Brera). Of these only *The Penitent Magdalen* is dated (1670). It is likely that all three works, which were no doubt specially commissioned by Finch (Fig. 38) from the artist, date from the time that he served as Resident, although he might have first met Dolci in Florence in 1662–4. Finch spent much of his life in Italy, together with his friend Sir Thomas Baines (1622–80); both were trained as physicians and were closely associated with Cambridge University, where in 1660 Baines was appointed Gresham Professor of Music.

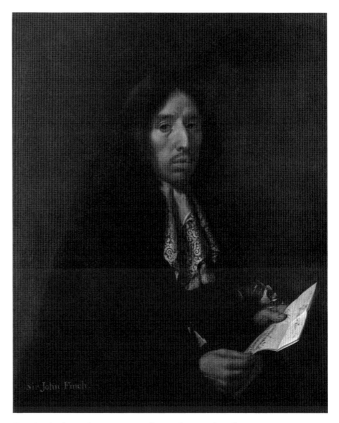

Fig. 38 Carlo Dolci, *Portrait of Sir John Finch*, oil on canvas, 87.2 × 70.8 cm, Cambridge, Fitzwilliam Museum.

Notes: **1** Levey 1991, no. 463.

Literature: Levey 1991, no. 464.

JOHN RILEY 1646–1691

33 *Bridget Holmes*

Canvas, 225.4 × 148.6 cm (88¾ × 58½ in.)
Signed (apparently strengthened): *I.R. PI^t.*
Inscribed lower left: *BRIDGET. HOLMES./ETA^S SUÆ:96. A:D:1686:*

THE NAME of the sitter and her advanced age are apparent from the inscription. Bridget Holmes was in fact a 'Necessary Woman' who lived to the age of one hundred. Her period of royal service began during the time of Charles I and continued into the reign of William III and Mary II. She is shown playing a game with a Page of the Backstairs.

Riley was appointed Principal Painter to William III and Mary II jointly with Sir Godfrey Kneller (see No. 34) in 1688. As a native-born artist he holds an important place in the development of English portrait painting and there is a line of descent that extends from him through Jonathan Richardson the Elder to Thomas Hudson, who was the first master of Sir Joshua Reynolds. Yet his official portraits were not always very convincing; a pupil, Thomas Murray, recorded Charles II's remarks on seeing his portrait: 'Is this like me? (oddsfish) then I'm an ugly fellow.'[1] By contrast, Riley seems to have had more success with less formal commissions. As Waterhouse observed, 'It is obvious that Riley was most at home below stairs.'[2] Indeed, two such portraits are known: *A Scullion* (Fig. 39) and *Katherine Elliot* (Royal Collection), the latter painted in conjunction with Johann-Baptist Closterman.

The present portrait is conceived on a monumental scale with all the props (notably the curtain and the vase with a relief of dancing nymphs) of fashionable portraiture, a view that runs counter to the social status of the sitter. It is possible that some satirical or moral comment was intended by this juxtaposition. The vase has been identified by Timothy Clifford as one occurring in a print of 1582 by Cherubino Alberti, after a fresco by Polidoro da Caravaggio on the façade of the Palazzo Milesi in Rome (Via della Maschera d'Oro). Reynolds also used the vase in the background of a number of portraits.[3] The subject of this portrait by Riley, as pointed out by Stewart, is comparable with certain contemporary Dutch paintings (for example, *An Interior with a Sleeping Maid and her Mistress* by Nicolaes Maes – London, National Gallery). The colouring of the portrait is characteristically rich, but the drawing is unusually accurate for this artist.

Notes: **1** Vertue 1935–6, p. 28. **2** Waterhouse 1962, p. 90. **3** Clifford 1976, figs. 4, 6, 9–10.

Literature: Millar 1963, no. 330; Clifford 1976, pp. 284–5; Stewart 1983, p. 32.

Fig. 39 John Riley, *A Scullion*, oil on canvas, 99.7 × 60.5 cm, Oxford, Christ Church.

SIR GODFREY KNELLER 1646–1729

34 Michael Alphonsus Shen Fu-Tsung (The Chinese Convert)

Canvas, 212.1 × 132 cm (83½ × 58 in.)
Signed and dated: *G. Kneller.fecit.A° 1687*

KNELLER shared with John Riley (see No. 33) the post of Principal Painter to William III and Mary II; previously he had received commissions from the courts of Charles II and James II and was subsequently to do so from the courts of Queen Anne and George I. He was knighted by William III in 1692 and granted a baronetcy by George I in 1715. Although born in Lübeck in Germany, Kneller received his training in Holland at Leiden and Amsterdam (under Ferdinand Bol and possibly also Rembrandt) from whence he went to Rome and Venice before coming to England between 1676 and 1679. His most sustained work for the English court was the series of portraits of fourteen naval commanders, painted with Michael Dahl for Queen Anne and Prince George of Denmark (the works were given by George IV to Greenwich Hospital in 1824), and the so-called Hampton Court Beauties, painted for Mary II. Both projects were inspired by similar undertakings by Lely during the reign of Charles II.

The sitter was born of Chinese Christian parents and came to Europe at the instigation of Father Philip Couplet, Procurator of the China Jesuits in Rome. After leaving Macao in 1681 they travelled together in Italy, France and England. Shen Fu-Tsung left England in 1688 for Lisbon where he entered the Society of Jesus. He died near Mozambique on his way back to China in 1691.

Shen Fu-Tsung seems to have been a well-known figure at the English court and his portrait was painted for James II. The first reference to the work is by the naval surgeon, James Yonge, who saw Shen Fu-Tsung at Windsor Castle in July 1687, describing him as 'a young, pale-faced fellow who had travelled from his country and become a papist (his picture being done very well like him in one of the King's lodgings).'[1] When James II visited Oxford in September 1687, Shen Fu-Tsung was the subject of conversation at the Bodleian Library, where the sitter had apparently helped to catalogue the Chinese manuscripts. On that occasion James II remarked that 'he had his picture to the life hanging in his roome next to the bed chamber.'[2]

The painting can be categorised either as a religious picture or as a portrait. The composition succeeds on the basis of the unaffected sense of design and the directness of the characterisation. The fact that the sitter looks upwards and away from the viewer suggests divine inspiration. According to Horace Walpole, 'Of all his works, Sir Godfrey was most proud of the converted Chinese at Windsor.'[3]

Notes: **1** *The Journal of James Yonge 1647–1721 Plymouth Surgeon*, ed. F. H. L. Poynter, 1963, pp. 199–200. **2** *The Life and Times of Anthony Wood . . .*, ed. A. Clark, III, 1894, pp. 236–7. **3** *Anecdotes of Painting*, ed. J. Dalloway and R. N. Wornum, II, 1888, p. 203.

Literature: Millar 1963, no. 348; Stewart 1983, pp. 29–30 and 229, no. 670.

Exhibitions: London 1971, no. 94; Berlin 1973, B 33.

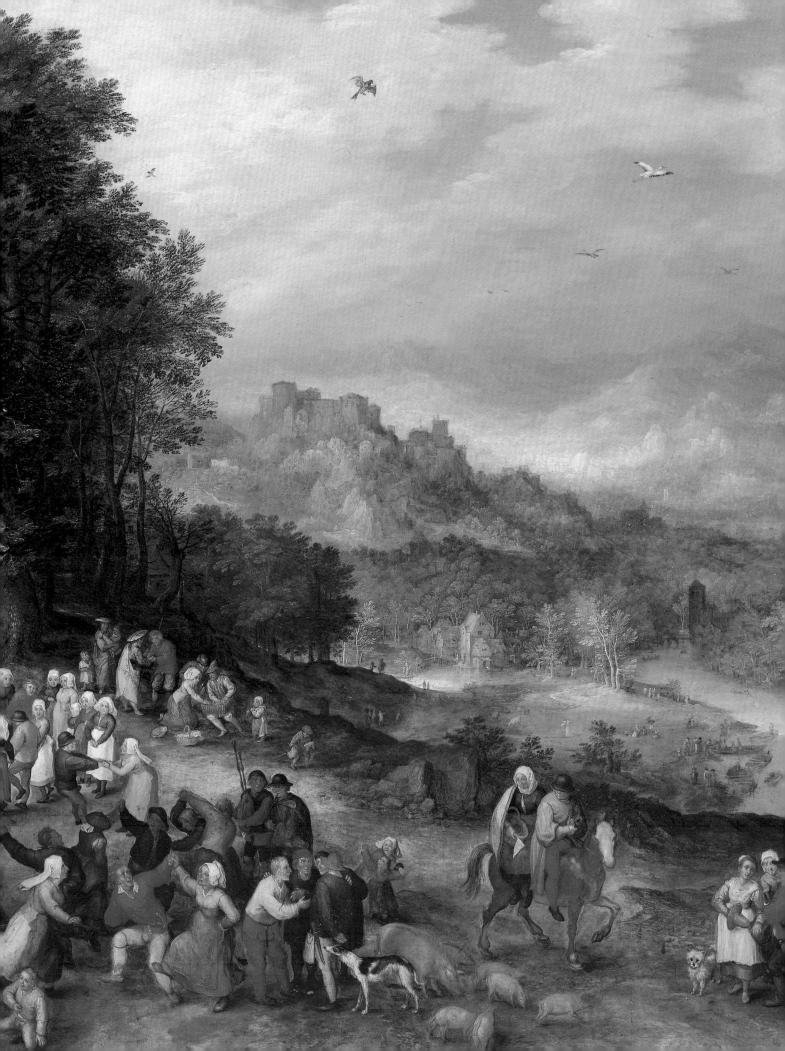

Frederick, Prince of Wales

FREDERICK, PRINCE OF WALES (1707–51), was the son of George II (1727–60). His father's love of the arts was limited and it would seem that he inherited his interest in painting from his mother, Caroline of Ansbach. Family relations between the early Hanoverians, however, were permanently strained to the extent that one set of political factions formed around the king and another around his son and heir, the Prince of Wales becoming the focus of an opposition party at Leicester House, his official London residence. While George II held writers and artists in contempt, Frederick enjoyed their company. He was painted by Philippe Mercier playing the cello and by Jacopo Amigoni holding Alexander Pope's translation of Homer. He encouraged contemporary French and Italian painters to work in London.

The antiquarian scholar, George Vertue, who in 1749 saw the Royal Collection in the company of Frederick, Prince of Wales, stated that 'no prince since King Charles the First took so much pleasure nor observations on works of art or artists.' Such comparisons are amply borne out by the additions made by the Prince of Wales to the collection. These were mainly seventeenth-century pictures including important examples of Flemish painting by Jan Brueghel the Elder (Nos. 35, 36), Rubens (Nos. 37, 38, 39), Van Dyck (No. 41) and David Teniers the Younger. Seventeenth-century Italian artists (Nos. 40, 44, 45, 46, 47) also interested him, as did painters of the French school of the same date (Nos. 42, 43). As a keen supporter of British art, he commissioned several paintings from the sporting artist, John Wootton (No. 48).

Frederick, Prince of Wales, took particular pleasure in paintings. He commissioned elegant frames (No. 48) to surround his pictures and concerned himself with restoration. The maiden voyage of the new State Barge, designed by William Kent, provided the occasion for a royal visit to Somerset House early in June 1732 where the king was able to see the collection being restored, accompanied by members of his family and 'a Set of Musick'.

OPPOSITE Jan Brueghel the Elder, *A Flemish Fair* (No. 35, detail).

JAN BRUEGHEL THE ELDER 1568–1625

35 *A Flemish Fair*

Copper, 47.6 × 68.6 cm (18¾ × 27 in.)
Signed and dated: *BRVEGHEL A 1600*

BOTH *A Flemish Fair* and *Adam and Eve in the Garden of Eden* (No. 36) can in all probability be identified with 'divers of the Brugels'[1] seen by the Earl of Egmont in the possession of George Bagnall. The paintings seem to have been acquired in Spain by Sir Daniel Arthur, whose widow married Bagnall. The antiquarian scholar, George Vertue, also saw the pictures in Bagnall's house in Soho Square, London, about 1740, but provides a longer description: 'a merry makeing or a fair many small figures. – Brueghel . . . its companion – a View of Eden. with all sorts of animals birds etc.'[2] Vertue states, incorrectly, that the paintings are in watercolour and, more importantly, adds later that they were 'sold to the Prince' (i.e. Frederick, Prince of Wales), to whom Bagnall also sold a number of other important paintings, including *Saint Martin dividing his Cloak* by Van Dyck and *Thomas Killigrew and (?) William, Lord Crofts* (No. 41). Payments were recorded for the two frames made for the pictures by Paul Petit on 13 January 1749. The frames were subsequently enlarged at the request of George IV. It would appear that during the eighteenth century the paintings were regarded as a pair, but discrepancies in date and size militate against such a description. Also, it is clear that the present painting is of a higher quality than *Adam and Eve*. Cabinet pictures of this type were much sought after by private collectors such as Cardinal Federico Borromeo, who first met Brueghel while in Rome in 1592–4 and then, as Archbishop of Milan, made the artist a member of his household for a short time. Borromeo remained a keen admirer of the artist's work and corresponded with him after his departure from Italy. The paintings by Brueghel from Borromeo's own collection are now in the Pinacoteca Ambrosiana, Milan.[3]

In his monograph on Brueghel, Ertz divides the numerous landscapes in the oeuvre into seven types on the basis of composition.[4] *The Flemish Fair* belongs to the fourth type or Nah-Fern-Landschaft (literally, 'near-far-landscape'), which the artist employed from 1600–19. Such compositions incorporate a specific scene in the foreground connected with an enclosed space, which in the present painting is a village dominated by a church, balanced on the other side by a distant view. Comparable pictures of this type listed by Ertz are *Landscape with a Pack Train* and *A Busy Country Road* (Munich, Alte Pinakothek). Brueghel's achievement is to have depicted a continuous landscape, with meticulously observed details on the left (note the birds visible in the branches of the trees) complemented by the superbly handled atmospheric blue tones that evoke a landscape of melting beauty on the right. The vigorous characterisation of the figures in the foreground recalls the work of the artist's father, Pieter Bruegel the Elder, but it is interesting to observe that several sections of society are represented and not just peasants.

Notes: **1** *Diary of the first Earl of Egmont*, III, London, 1923, p. 344. **2** Vertue 1937–8, p. 127. **3** See S. Bedoni, *Jan Brueghel in Italia e il Collezionismo del Seicento*, Florence/Milan 1983, pp. 89–146. **4** Ertz 1979, pp. 24–76.

Literature: Gerson and Ter Kuile 1960, p. 58; Wilenski 1960, 1, p. 515; Ertz 1979, pp. 47, 79, 81, 83, 86, 201 and 567, no. 60.

Exhibitions: London 1946–7, no. 275; London 1953–4, no. 353; Manchester 1965, no. 52.

JAN BRUEGHEL THE ELDER 1568–1625

36 *Adam and Eve in the Garden of Eden*

Copper, 48.6 × 65.6 cm (19⅛ × 25 13/16 in.)
Signed and dated: *BRVEGEL 1615*

THE ARTIST was the son of Pieter Bruegel the Elder (see No. 21). He specialised in flower painting and landscapes, many of which demonstrate a particular emphasis on animals, both domestic and wild. Jan Brueghel was a leading painter of the Antwerp school and held important administrative positions in the artistic hierarchy of the city. He was also appointed court painter to Archduke Albert and the Infanta Isabella in Brussels in 1609, but he continued to live in Antwerp. Brueghel collaborated with a number of fellow artists such as Joos de Momper, Hendrick van Balen, Pieter Neefs and Hendrick van Steenwyck (see No. 11), but, most importantly, with Rubens, who was a close friend (see Nos. 29, 37–39). A portrait by Rubens of Jan Brueghel with his second wife and two children, painted around 1613, is in the

Courtauld Institute Galleries (Somerset House, London).

Adam and Eve in the Garden of Eden is a typical example of Jan Brueghel's style. He painted the subject numerous times, in addition to which there are several replicas and copies.[1] The figures of Adam and Eve are placed characteristically to the back of the composition and it is appropriate to the theme that they are almost overwhelmed by their surroundings. Brueghel favoured works on a small scale, brought to a high degree of finish with carefully controlled brushwork, accurate drawing, and vivid colours. It is a highly decorative style, Mannerist in conception and miniaturist in execution. His feeling for landscape was heightened by extensive travel in Italy: Naples in 1590, Rome in 1592–5 and Milan in 1595–6. Later he travelled to Germany, also visiting Prague in 1604 and Spa in 1612. His studies of animals and birds were done from life from those kept in Brussels in the menagerie of the Infanta Isabella, whose interest in animals Rubens shared. His close working relationship with Rubens is evident in the treatment of the horse in the foreground of *Adam and Eve*. (Compare Rubens's *Riding School*, formerly in Berlin but destroyed in the Second World War, or the variant in the Royal Collection; Fig. 40.) The lion and lioness on the left are derived from the large composition by Rubens of *Daniel in the Lion's Den* of about 1613 (Washington, National Gallery of Art) which once belonged to Charles I, or from preparatory studies made for this painting (for example, Vienna, Albertina, or London, British Museum). Jan Brueghel often reused his studies of animals: in other versions of the theme of *Adam and Eve*, such as that in The Hague (Mauritshuis) for which Rubens painted the figures, or that at Budapest; in compositions like the *Family of Noah leading the Animals into the Ark*, also of 1615 (London, Apsley House), and its variants (Budapest and Earl of Verulam's collection). A version of the present composition – in reverse – is in the Doria Gallery, Rome. By comparison with a replica in the Duke of Northumberland's collection, dated 1613, it is an earlier work.

Like No. 35, the painting had entered the collection of Frederick, Prince of Wales, by 1749.

Fig. 40 Studio of Rubens, *A Study of Horsemen in Three Positions*, oil on panel, 35.9 × 66 cm, The Royal Collection.

Notes: **1** Ertz 1979, pp. 236–49.

Literature: Ertz 1979, p. 245.

Exhibitions: London 1946–7, no. 277; London 1953–4, no. 301; Norwich 1955, no. 5.

PETER PAUL RUBENS 1577–1640

37 Summer

Canvas, 142.8 × 222.8 cm (57½ × 89 in.); the central section of canvas measures 121.9 × 162.6 cm (47½ × 63⅖ in.) with additions on the left (c.31.7 cm, 12⅖ in.) and on the right (c.26 cm, 10 in.) with a further addition along the lower edge (c.20.9 cm, 8 in.)

THE PAINTING is a companion scene to *Winter* (No. 38), although it was only when both pictures were in the collection of Frederick, Prince of Wales, that they seem to have been treated as a pair. Yet, while both works were in the collection of George Villiers, 1st Duke of Buckingham (1592–1628; see No. 38), a contrast in seasons was acknowledged. Furthermore, a seventeenth-century writer, Edward Norgate, in his *Miniatura or The Art of Limning* (about 1648) referred to the present painting as 'Aurora, indeed a rare peece, as done by the Life, as [Rubens] himselfe told me *un poco ajutato*'.[1] Alternative titles for *Winter* and *Summer* may, therefore, once have been *Evening* and *Morning*, a premise continued in this century by Ludwig Burchard, amongst others.

X-ray examination reveals that the priming on all the additional pieces of canvas is identical, but differs from that of the central section of this work.[2] It appears that the design on the initial piece of canvas had not been fully resolved in all respects by the time the extra portions were added. The join on the left is on a line with the tall windswept trees, which seem to have been painted over the sky and therefore may be regarded as an adaptation of the original design, which most probably incorporated a clear view through to the horizon. On the right the design has been more radically changed as a result of the addition. A steep bank (still visible to the naked eye) originally closed the composition, but this was painted out so that the horizon could be extended in the upper half and a further group of farm buildings introduced in the middle distance. The addition along the lower edge allowed for the horse and cart in the immediate foreground. In effect, if the additions are discounted, the original composition remains an entity in its own right, but the changes alter the dynamics of the painting, placing greater emphasis on the peasants wending their way to market. Millar argues that the alterations, dating from the 1620s, also denote qualitative distinctions in so far as the 'distant landscape and the middle distance are very delicately and finely painted,' but that the additional areas 'are heavier and coarser in style'. On the basis of comparison with such works as *Landscape with a Cart crossing a Ford* (Leningrad, Hermitage), however, Millar does not regard any part of *Summer* as autograph. Adler disagrees and, following Burchard, favours a date around 1618, as opposed to the 1620s proposed by both Millar and Jaffé, who also regard the work as autograph. The

painting was engraved during the seventeenth century by T. van Kessel.

The composition of *Summer*, whatever its status as a painting, is distinguished. There is an emphasis on contrasting diagonals that reinforces the sense of movement begun by the figures in the foreground. The eye is plunged into the distance across a glorious landscape that is positively pantheistic in its celebration of nature (note the cow being mounted in the centre of the composition). Regardless of differences in scale and style, a telling comparison can be made between *Summer* and *The Flemish Fair* by Jan Brueghel the Elder (No. 35). Interestingly, it has been suggested that the composition of *Summer* depends upon a lost painting by Pieter Bruegel the Elder entitled *On the Way to Market*, only known today through an anonymous drawn copy in the Staatliche Graphische Sammlung, Munich.[3]

Notes: **1** Edward Norgate, *Miniatura or the Art of Limning*, ed. M. Hardie, 1919, pp. 46, 48. **2** Millar 1977, p. 632. **3** Adler 1982, fig. 70.

Literature: Millar 1977, p. 632; Adler 1982, pp. 88–92, no. 22; Jaffé 1989, no. 670.

PETER PAUL RUBENS 1577–1640

38 Winter

Canvas, 121.2 × 223.5 cm (47¾ × 88 in.); there is an early addition on the left (c.59.7 cm, 8⅝ in.)

IT IS APPARENT that both *Winter* and *Summer* (No. 37) were in the collection of George Villiers, 1st Duke of Buckingham (1592–1628), a close friend of Charles I and an important fellow collector. Both pictures can most probably be identified with items listed in the inventory of Buckingham's collection made in 1635, 'One winter piece' and 'A great Landskip' respectively,[1] and both were included in the Buckingham sale held in Antwerp in 1648. The paintings were reunited in the collection of Frederick, Prince of Wales, who had acquired them by September 1747 when an order was placed for two frames to be made. The antiquarian scholar, George Vertue, saw both pictures in Leicester House in 1749, describing them as follows: 'first Room or Anti Chamber. 2 large Landskapes by Rubens one the Summer – and country business represented and the other Winter – affairs – both large.'[2]

As constituted today, *Winter* and *Summer* differ in size and it seems that it was only while they were in the collection of Frederick, Prince of Wales, that the paintings were regarded as a pair. For the purposes of hanging the pictures together in Leicester House, *Winter* was considerably enlarged along the upper and lower edges. These additions were removed in 1959 and the canvas is now seen according to its original dimensions. The early addition on the left of the work was almost certainly made at the time the picture was painted. The join occurs behind the man leaning on a pitchfork, on a line with the basket. X-ray examination reveals that the priming of the two portions of canvas differs, denoting that they were not prepared at the same time.[3] Millar argues that there are visual discrepancies between the main part of the composition and the addition, namely, the view-point is higher on the left and the scale of the dog differs from that of the other animals.

Scholars have frequently debated the attribution of *Winter*. The central part of the composition, according to Millar, 'is rather coarse and heavy in drawing and in handling, lacking perhaps the nervous brilliance of Rubens's autograph touch,' whereas the technique of the left portion 'is thinner and more direct and shows a freedom more suggestive of Rubens himself.' In short, Rubens most probably designed the main part although he did not execute it; however, he was wholly responsible for both the design and execution of the addition. Adler regards the painting as autograph throughout. Similar differences of opinion have been expressed over the dating: Millar proposes the early 1620s as does Jaffé, while Adler,

following Burchard, suggests a date of around 1617.

Winter was engraved in the seventeenth century by P. Clouwet and in part by P. Pontius. The cart on the left appears in a drawing at Chatsworth,[4] which was made in connection with the paintings *Landscape with a Cart crossing a Ford* (Leningrad, Hermitage) and *The Prodigal Son* (Antwerp, Koninklijk Museum voor Schone Kunsten).

The composition is a landscape only in a general sense. It is in essence a farmyard scene set in a barn with a view beyond. Rubens combines anecdotal interest through the figures and the animals, but the eye soon moves from the barn to the cold snow-covered exterior. On the left, in a passage of great poetic intensity, snow drifts into the barn as though challenging the effectiveness of the fire in the foreground. The group huddled round the fire is reminiscent of scenes by Adam Elsheimer. It is interesting to compare the treatment of the cold in *Winter* with *The Massacre of the Innocents* by Pieter Bruegel the Elder (No. 21), an artist whom Rubens particularly admired.

Notes: **1** R. Davies, 'An inventory of the Duke of Buckingham's pictures, etc. at York House in 1635', *Burlington Magazine*, 10, 1907, p. 379. **2** Vertue 1929–30, p. 11. **3** Millar 1977, p. 632. **4** Adler 1982, fig. 76.

Literature: Millar 1977, p. 632; Adler 1982, pp. 86–8, no. 21; Jaffé 1989, no. 669.

Exhibitions: London 1953–4, no. 199.

BELOW Peter Paul Rubens, *Winter*. OPPOSITE Detail.

PETER PAUL RUBENS 1577–1640

The Holy Family with Saint Francis

Canvas, 189 × 214.5 cm (74$\frac{1}{2}$ × 84$\frac{1}{2}$ in.); additions of c.56.5 cm (22$\frac{1}{4}$ in.) at the top (now turned over the stretcher) and c.45–7 cm (17$\frac{3}{4}$–18$\frac{1}{2}$ in.) at the lower edge
Cleaned 1991

THE EARLIEST REFERENCE to the picture occurs in the Note Books of the antiquarian scholar, George Vertue, who records that in 1723 George I 'bought 6 Large paintings of Mr. Laws. Venus a dressing with her Nymphs of Guido. Andromeda of Guido. two other of Rubens & two besides for all which he paid 4000 pounds.'[1] The painting was hung over the fireplace in the Great Drawing Room at Kensington Palace where it was admired by Vertue.[2] Subsequently, during the reign of George III, the painting hung in the King's Drawing Room in Buckingham House,[3] and at the beginning of the nineteenth century it was taken to Windsor Castle and placed in the King's Drawing Room there. It is visible in the illustration of that room in W. H. Pyne's *The History of the Royal Residences* of 1819.[4]

These changes in location have had a bearing on the format of the painting, which has been extended at the upper and lower edges. The addition at the top edge (now turned over the stretcher) was made so that the picture would fit the wall space either in Kensington Palace or Buckingham House. The addition at the lower edge, however, was made while the work was still in the artist's studio as Rubens had decided to enlarge the composition.

Fig. 41 Peter Paul Rubens, *The Holy Family with Saint Francis*, oil on canvas, 176.5 × 208.6 cm, New York, The Metropolitan Museum of Art.

The work was evolved by Rubens in two stages. In the initial design of about 1626–8 the figures were depicted in three-quarter-length poses, possibly excluding the young Saint John the Baptist with the lamb, as evidenced by copies and a print by P. Spruyt. Later they were extended into full-length figures, with Saint John the Baptist and the lamb duly added. Exactly when these changes were made cannot be determined. A later variant of this second design, dated about 1630–5, is in the Metropolitan Museum of Art, New York (Fig. 41),[5] and a studio variant of this revised composition is in the California Museum of Art, San Diego. It is possible that the changes to the lower section of the painting in the Royal Collection were done in conjunction with the composition in New York, or even retrospectively in about 1635, but the stylistic evidence supports an earlier rather than a later date in this respect. With his usual facility Rubens also made further variations in a vertical format without the figure of Saint Francis: the *Holy Family with the Young Saint John the Baptist* (Private Collection) and the *Holy Family with Saint Anne* (Madrid, Prado), both dating from around 1630.[6] The stylistic distinctions between the painting in the Royal Collection and that in New York are reflected in differences of mood and interpretation of subject. The present composition has a formal reserve with the saint's pose matched by that of Joseph, whereas the Saint Francis in the composition in New York is more animated in his adoration, and is counterbalanced by the more thoughtful pose of Joseph. Both compositions, however, reveal Rubens's debt to Titian.

The recent cleaning of the painting in the Royal Collection has confirmed the outstanding quality of the figures, particularly the faces of the Virgin, the Holy Child and Saint Anne. The landscape is also impressive. There appears to be no great stylistic inconsistency between the main part of the composition and the addition along the lower edge, although it is certainly possible that the figures of Saint Francis and Joseph were partly repainted when their forms were extended and when the Saint John the Baptist and the lamb were added.

Notes: **1** Vertue 1933–4, p. 19. **2** Vertue 1931–2, p. 89. **3** F. Russell, 'King George III's picture hang at Buckingham House', *Burlington Magazine*, 129, 1987, pp. 526, 528–9. **4** Reproduced in W. H. Pyne, *The History of the Royal Residences*, I, London 1819, pp. 155–6. **5** W. A. Liedtke, *Flemish Paintings in the Metropolitan Museum of Art*, New York, 1984, pp. 40–6. **6** Jaffé 1989, nos. 988–9.

Literature: Rooses 1886, I, no. 234; Oldenbourg 1921, pp. 285, 466; Jaffé 1989, no. 881.

Exhibitions: London 1946–7, no. 291; London 1953–4, no. 170.

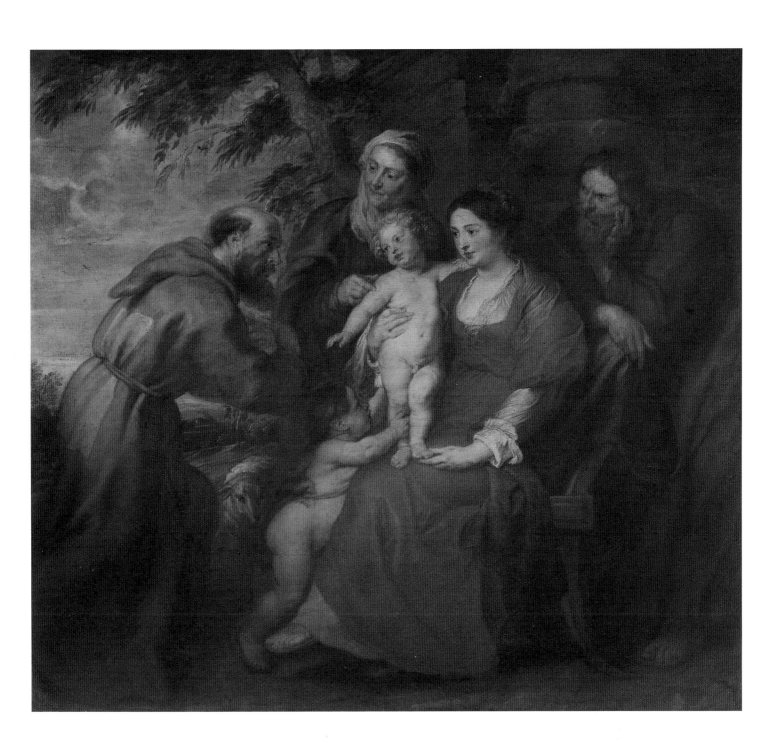

GUIDO RENI 1575–1642

40 *Cleopatra with the Asp*

Canvas, 113.7 × 94.9 cm (44¾ × 37⅜ in.)

THE ANTIQUARIAN SCHOLAR, George Vertue, who wrote a detailed description of the pictures in the collection of Frederick, Prince of Wales, at Leicester House, described this *Cleopatra* (which he wrongly identified as Lucretia) as 'so beautifull strong clear & Natural, of the finest taste of that skillfullest artist Guido'.[1] The painting was subsequently hung by George III over the mantelpiece in the King's Closet at Buckingham Palace as part of an arrangement of mainly seventeenth-century Italian pictures.[2]

The circumstances of the commission are slightly unusual. According to the Bolognese connoisseur, Malvasia,[3] the painting was one of four half-length figures undertaken in a competitive spirit for the Venetian merchant Boselli by Palma Giovane, Niccolò Renieri, Guercino and Guido Reni. Palma Giovane seems to have acted as the intermediary in the negotiations and, since he died in 1628, it can be deduced that the related paintings date from towards the close of the 1620s or the early 1630s. After Boselli's death, the *Cleopatra* passed into the collection of Renieri and shortly afterwards into that of Domenico Fontana. Several copies are known.

The subject of Cleopatra with the asp was popular during the seventeenth century and Reni evolved a number of half- and three-quarter-length interpretations. The sequence begins with the depiction of a more regal Cleopatra in Potsdam (Sanssouci), dating from about 1625–6, continues with the present painting, and is developed in those in Florence (Palazzo Pitti), London (Sir Denis Mahon's collection) and Rome (Capitoline Museum), all of which date from the late 1630s or early 1640s. A three-quarter-length composition was again chosen by the artist for his treatment of Lucretia and the Magdalen. In this *Cleopatra* Reni demonstrates his skill as a draughtsman in the foreshortening of the head seen from below, and his competence as a designer in his use of diagonals. There is also an abundance of skill in the portrayal of the expression, the modelling of the flesh, the swathes of drapery, and the use of fresh, light colours – pink and white – set against a dark background. All these elements are components of the classicism associated with the followers of Annibale Carracci, of which Reni was a leading exponent. It was a style for which he was universally admired both during his own time and in the eighteenth century, at the end of which his reputation waned. Reni's art was appreciated for its grace and finesse, the result of sound judgement and flowing brushwork.

The subject is taken from the *Lives of the Caesars* by Plutarch, in which Cleopatra's suicide in 30 BC is described.[4] Following Mark Antony's defeat by Octavian at the Battle of Actium, an asp was smuggled in to Cleopatra in a basket of figs. Her death resulted from its bite. Mark Antony also committed suicide.

Notes: **1** Vertue 1929–30, p. 10. **2** F. Russell, 'King George III's picture hang at Buckingham House', *Burlington Magazine*, 129, 1987, p. 529. **3** C. Malvasia, *Felsina Pittrice*, 2, 1678, p. 54. **4** Plutarch, 'Life of Antony', *Lives of the Caesars*, pp. 44–86.

Literature: Levey 1991, no. 576.

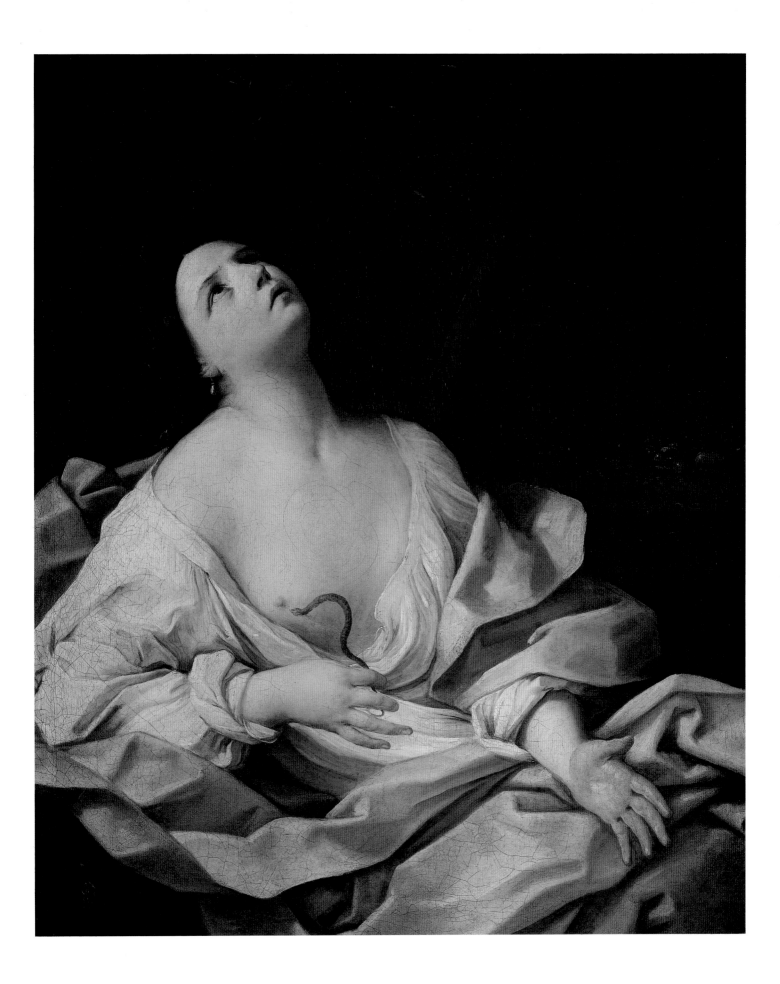

ANTHONY VAN DYCK 1599–1641

41 *Thomas Killigrew and (?) William, Lord Crofts*

Canvas, 132.7 × 143.5 cm (52¼ × 56½ in.)
Signed and dated: *A. van, Dyck, 1638*

VAN DYCK'S double portraits usually explore such themes as kinship or friendship, but the present painting depicts two figures united by grief. The circumstances in which the painting was undertaken and the elegiac mood created by the subtle monochromatic tones make this one of the most moving double portraits painted by Van Dyck. Thomas Killigrew (1612–83), a royalist poet, playwright and wit, is seated on the left looking out of the composition. The pose with the head supported by the hand is traditionally associated with melancholy. This state of mind in a man who was only twenty-six years of age was induced by the recent death of his wife, Cecilia Crofts. She died (possibly from plague) on 1 January 1638 after two years of marriage. He wears his wife's wedding ring attached to his left wrist by a black band. A silver cross inscribed with her intertwined initials is attached to his other sleeve. He holds a piece of paper on which there are drawings, possibly made with a funerary monument in mind. The other figure has been variously identified, but the most satisfactory suggestion is that he is William, Lord Crofts (c.1611–77), Killigrew's brother-in-law, who suffered a double loss at the beginning of 1638, since another sister, Anne, Duchess of Cleveland, died shortly after Cecilia. The paper held by Crofts is blank, but clearly it formed the basis for discussion between the two sitters – a discussion presumably meant to console, but from which Killigrew is distracted by grief. The mood of the picture, therefore, unifies the composition on one level, but so do the contrasting poses, with one figure seen from the front and the other from the back with the face turned in profile. There is also an allegorical link provided by the broken column, a symbol both of mortality and of fortitude. Killigrew's friendships with other poets are also significant for appreciating this portrait. Thomas Carew wrote a poem commemorating the marriage of Killigrew and Cecilia Crofts (29 June 1636), while Francis Quarles wrote an elegy on the deaths of the two sisters.[1] By showing the two sitters in conversation Van Dyck is demonstrating the sense of loss while also suggesting a means for its cure, since, according to contemporary literary convention, words had the power to heal the troubled soul. At the same time, in pictorial terms the device of depicting figures in the act of talking was a way of evoking their actual presence more effec-

tively (see, for example, the inscription on No. 3). The thematic and psychological interactions that characterise this double portrait are a supreme demonstration of Van Dyck's abilities as a portrait painter.

Van Dyck painted Killigrew on at least two other occasions.[2] A portrait by William Sheppard of Killigrew as an older man (1650) is in the National Portrait Gallery, London, and an image of Crofts can be found on the monument by Abraham Storey in Little Saxham Church, Cambridgeshire.

Like Nos. 35–36, this portrait appears to have been acquired by Sir Daniel Arthur in Spain, but by 1729 it was in the collection of George Bagnall, who had married Arthur's widow. Bagnall sold the picture to Frederick, Prince of Wales in 1748[3] and it was seen shortly afterwards at Leicester House, London, by George Vertue, the antiquarian scholar.[4]

Notes: **1** See Washington 1990–1, no. 84. **2** Larsen 1988, nos. 889, 890. **3** Vertue 1937–8, p. 127. **4** Vertue 1929–30, p. 11.

Literature: Millar 1963, no. 156; Larsen 1988, no. 891, p. 348; Wendorf 1990, pp. 100–1.

Exhibitions: Washington 1990–1, no. 84.

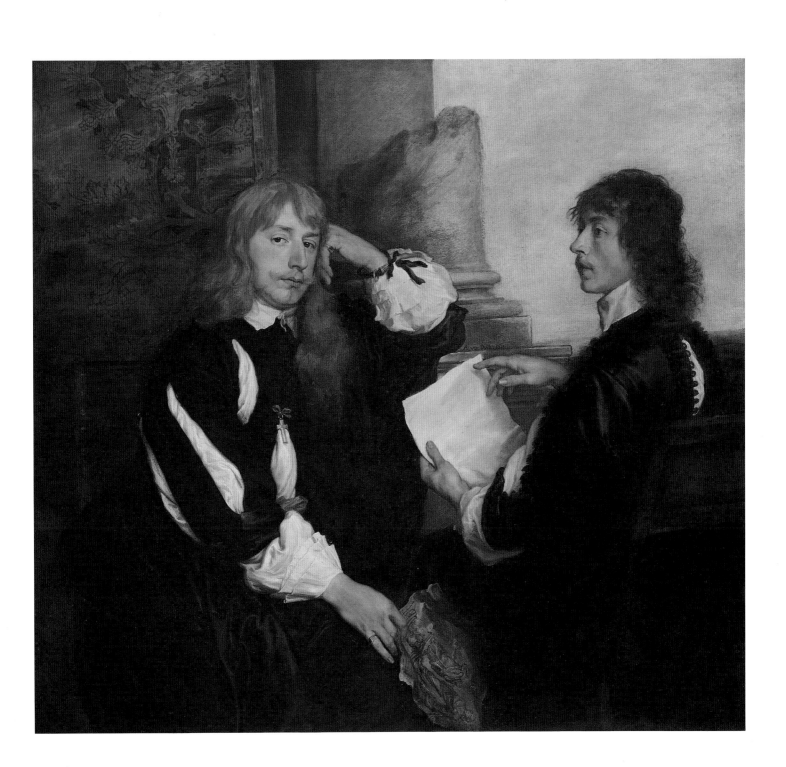

42 *Harbour Scene at Sunset*

Canvas, 74 × 99 cm (29 × 39 in.)
Dated on the bale carried by the man centre right: *1643*

THE COMPOSITION is in some respects related to a drawing (LV 19) in Claude's *Liber Veritatis* (Fig. 42), a drawn record kept by the artist himself of his finished paintings. The picture which LV 19 actually records is dated 1637 (Private Collection, England).[1] Although the present painting of 1643 is best described as an autograph replica of the earlier work, there are considerable differences between the two compositions. The round tower on the left of the earlier composition has been moved to the right, closer to the buildings seen on the shore, where it has been paired with another tower of similar design. The left edge of the later composition is dominated by two ships, balanced at the right edge by two porticoes instead of one. The man lying asleep in the foreground, who does not occur in LV 19 but is introduced into the painting of 1637, is retained in the present painting although the pose is reversed. The connections – albeit inexact – between this *Harbour Scene* and LV 19 have resulted in the painting being dated, by Röthlisberger in particular, to 1637, but cleaning in 1969 confirmed the authenticity of the date of 1643. Once this was established the stylistic distinctions evident between works of the 1630s and the 1640s could be confirmed. The deep ultramarine tone of the water, the overall

warmth of colour, and the more solid drawing of the figures, which, as a result, have a greater feeling of corporeality, are characteristic of the later decade. Comparison with the seaport scenes in the collections of the Duke of Northumberland and the Marquess of Bute, dating from 1637 and 1638 respectively,[2] or with the rendering in Florence (Uffizi), also of 1638,[3] reinforces these stylistic shifts. The picture in the Royal Collection was painted in the same year as *Coast View with Mercury and Aglauros* (Rome, Pallavicini collection)[4] and *Coast View with the Trojan Women setting Fire to their Fleet* (New York, Metropolitan Museum).[5] Three similar harbour scenes in the National Gallery, London, date from the 1640s and are comparable in style: *Seaport with the Embarkation of Saint Ursula*, *Seaport* of 1644, and *Seaport with the Embarkation of the Queen of Sheba* of 1648 – this last an inspiration to J. M. W. Turner.

Harbour scenes occur frequently throughout Claude's oeuvre. Usually depicted at sunset and populated by a full cast of staffage figures, busying themselves by loading and unloading ships or simply idling the day away in conversation, these compositions and the mood they created found favour with British collectors and were emulated by British artists.[6] John Wootton (No. 48) is one such example. The only firmly identifiable building in the present picture is the monumental gateway on the right next to the round tower. This is based on the Arcus Argentarium (Arch of the Silversmiths), dating from the third century AD at San Giorgio in Velabro, Rome, although it is seen in reverse and detached from the church. A view of this arch and the church occurs in an early drawing by Claude at Windsor Castle.[7]

The painting was most probably acquired by Frederick, Prince of Wales, although the first definite recording of the work does not occur until the reign of George III. The antiquarian scholar, George Vertue, saw '2 Claud Lorains' at Leicester House, but gives no titles.[8] Several copies of the composition are listed by Röthlisberger (1961).

Fig. 42 Claude Lorrain, *Harbour Scene* (LV 19), pen, grey-brown wash with white heightening on blue paper, 190 × 259 mm, London, British Museum, Department of Prints and Drawings.

Notes: **1** Röthlisberger 1975, no. 77. **2** Röthlisberger 1961, nos. LV 14 (1), LV 31. **3** Ibid., no. LV 28. **4** Ibid., no. LV 70. **5** Ibid., no. LV 71. **6** See D. Howard, 'Claude and English Art' in London, Hayward Gallery, 1969, pp. 9–10. **7** A. Blunt, *The French Drawings in the Collection of His Majesty The King at Windsor Castle*, London 1945, no. 56. **8** Vertue 1929–30, p. 11.

Literature: Röthlisberger 1961, no. LV 19; Kitson 1967, pp. 145–7; Röthlisberger 1975, no. 76; Kitson 1978, under no. 19.

Exhibitions: London 1969, no. 17.

EUSTACHE LE SUEUR 1616–1655

43 Caligula depositing the Ashes of his Mother and Brother in the Tomb of his Ancestors

Canvas, 167 × 143 cm (65¾ × 56¼ in.)

THE ARTIST was a pupil of Simon Vouet (see No. 30), but unlike his teacher he never left Paris. Le Sueur's style was based on Raphael and more immediately on Poussin. His best-known work is perhaps the series of paintings of the *Life of Saint Bruno*, dating from 1645–9 (Paris, Louvre). Although his style became increasingly classical, he retained a certain elegance in his draughtsmanship and use of colour.

There has been some confusion over the exact title of this imposing painting: *Nero depositing the Ashes of Germanicus* and the *Funeral of Poppaea* have both been suggested in inscriptions or commentaries to various engravings after the picture. The earliest source, however, Florent Le Comte's *Cabinet des singularitez d'architecture, peinture, sculpture et gravure* (1699–1700), refers to the picture as *Caligula depositing the Ashes of his Mother and Brother in the Tomb of his Ancestors*. There is good reason to believe that this is the correct title since Le Comte claimed to be basing his statement on information recorded in a studio book kept by the artist and retained by the Le Sueur family. The painting, together with another entitled *Lucius Albinus and the Vestal Virgins*, was commissioned for Claude de Guénégaud's residence in Paris in the rue Saint-Louis-au-Marais. Both are listed under the year 1647. The second painting is now lost, but it is recorded in a drawing in the Metropolitan Museum of Art, New York. The classical source for the present painting is Suetonius' *The Twelve Caesars*:

Gaius [Caligula] strengthened his popularity by every possible means. He delivered a funeral speech in honour of Tiberius to a vast crowd, weeping profusely all the while; and gave him a magnificent burial. But as soon as this was over he sailed for Pandataria and the Pontian Islands to fetch back the remains of his mother and his brother Nero; and during rough weather, too, in proof of devotion. He approached the ashes with the utmost reverence and transferred them to the urns with his own hands. Equally dramatic was his gesture of raising a standard on the stern of the bireme which brought the urns to Ostia, and thence up the Tiber to Rome. He had arranged that the most distinguished knights available should carry them to the Mausoleum in two biers, at about noon, when the streets were at their busiest[1]

Gaius Caesar, known as Caligula, the son of Germanicus and Agrippina, succeeded Tiberius as emperor in AD 37. Germanicus was the adopted son of Tiberius, who most probably had him poisoned owing to his growing popularity. The subject of Agrippina's return to Brundisium with the ashes of Germanicus was a popular theme with artists during the seventeenth and eighteenth centuries. Tiberius eliminated several members of Germanicus' family, but promoted Gaius of whom he said, 'I am nursing a viper for the Roman people and a Phaeton for the whole world.' The present subject is one that is rarely treated, whereas that of the companion painting, recounted by Livy[2] and others, can be found in fifteenth-century Florentine art and also in the work of Le Sueur's contemporaries, Jacques Stella and Sebastien Bourdon. The theme that unites these two paintings might be said to be piety, both private in the actions of Caligula and public in the altruism of Lucius Albinus. Such demonstrations of moral virtue were often chosen as subjects for French paintings during the middle decades of the seventeenth century, in conjunction with the philosophical creed of Stoicism that Nicolas Poussin, amongst others, professed. The intellectual and physical severity of this creed is reflected in the style of the painting with its stilted composition, visual clarity, carefully demarcated spatial intervals and purity of colour, quite apart from the archaeological exactitude sought for the setting. It has been pointed out that the painting was executed during the period when Poussin's second set of the *Seven Sacraments*, painted for Fréart de Chantelou, could be seen in Paris. The artist made a drawing of the high priest holding the urn (Private Collection, Paris).

The painting was seen by George Vertue in 1749 in Leicester House in the collection of Frederick, Prince of Wales. It was 'hung over the chimney, a painting of antient learned men & by Le Seur [sic] – a capital picture. . . .'[3]

Notes: 1 Suetonius, *The Twelve Caesars*, Gaius [Caligula] 15. 2 Livy, *History of Rome*, v, 40–2. 3 Vertue 1929–30, p. 11.

Literature: Mérot 1987, pp. 228–9, no. 77.

LUCA GIORDANO 1634–1705

44 *Psyche honoured by the People*

Copper, 57.5 × 68.9 cm (22⅝ × 27⅛ in.)
Cleaned 1976

THESE FOUR PAINTINGS form part of a series of twelve, illustrating incidents from the story of Cupid and Psyche as recounted at considerable length by Apuleius in *The Golden Ass* (Books 4–6). In general terms Apuleius tells how Venus sought to punish the young Psyche, whose beauty challenged even that of the goddess of love. Accordingly, Venus instructs Cupid to arrange for an unsuitable match for Psyche, but instead Cupid himself falls in love with her. He installs Psyche in his palace, but chooses to visit her only at night. Psyche's sisters, however, overcome by jealousy, maintain that her lover is in reality a monster. Her curiosity aroused, Psyche, although strictly forbidden to look at him, observes Cupid by the light of a lamp, but taken by surprise she allows oil from the lamp to fall on Cupid and so wakens him. To punish Psyche for her disobedience Cupid disappears. He is sought far and wide by Psyche, but in vain. Both Cupid and Psyche thus incur the wrath of Venus. Psyche then tries to win back Cupid's favour by performing numerous well-nigh impossible tasks set for her by Venus. These she undertakes successfully except for the last which involves the recovery of Persephone's casket from Hades.

Psyche's Parents offering Sacrifice to Apollo

Copper, 56.2 × 69.2 cm (22⅛ × 27¼ in.)
Cleaned 1977

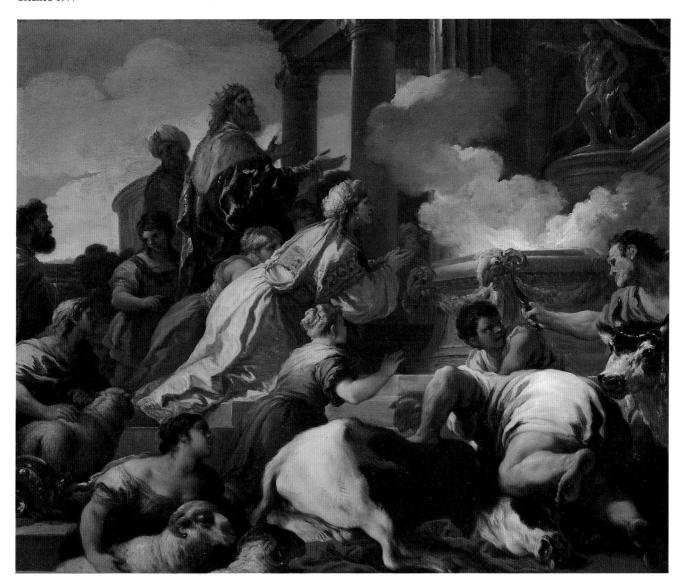

Although expressly told not to open it, Psyche is again overcome by curiosity and opens the casket only to find that it does not contain beauty, but a deadly sleep that overwhelms her. At this point Jupiter, encouraged by Cupid, takes pity on Psyche and consents to their marriage in heaven.

Even though the series by Giordano amounts to twelve scenes, the Neapolitan artist by no means depicts the narrative in full, and in this respect the series appears to have been left incomplete. The four scenes chosen here illustrate different parts of the story. *Psyche honoured by the People* and *Psyche's Parents offering Sacrifice to Apollo* are consecutive incidents from the beginning of the sequence. They refer respectively to the open acknowledgement of Psyche's beauty that provokes the initial jealousy of Venus, and the anxiety felt by Psyche's parents on suspecting that the goddess has been angered. *Psyche served by Invisible Spirits* illustrates her introduction to Cupid's palace, where she is attended by invisible spirits who invite her to bathe and to dine to the accompaniment of music. *Venus punishing Psyche with a Task (?)* was previously interpreted as *Psyche visited by*

Psyche served by Invisible Spirits

Copper, 57.8 × 68.9 cm (22¾ × 27⅛ in.)
Cleaned 1976–7

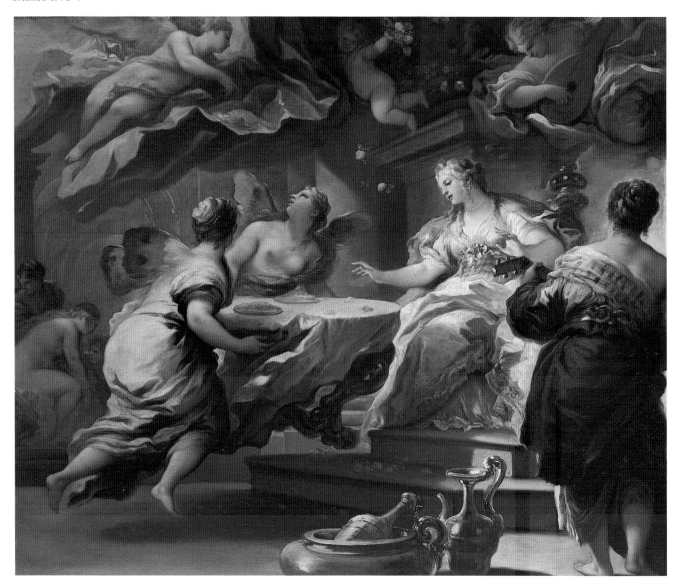

her Sisters, but Sir Michael Levey argues that the scene is more accurately identified as Venus setting Psyche a task in the attempt to find Cupid. The task in question may be that of procuring a flask of water from a stream running beneath a high mountain. Venus is the lightly clad figure in the middle pointing towards Psyche, whose own gesture indicates the mountain in the background. As such this scene is the last of those in the present series.

The story of Cupid and Psyche was open to several interpretations, some of which during the Renaissance were of a philosophical disposition, but it would appear

that Giordano has concentrated more on the narrative elements. The first composition (*Psyche honoured by the People*) is possibly derived from the sixteenth-century engraving of the subject by the Master of the Die, which forms part of an extensive and influential series of prints designed by Michael Coxie and illustrating Apuleius's text with a certain degree of literalness. Several of the subjects treated by the Master of the Die were not included by Giordano. An essential difference is that Giordano depicts Cupid as a youth rather than as a child.

The paintings are late works by the artist dating from

Venus punishing Psyche with a Task (?)

Copper, 58.1 × 68.9 cm (22⅞ × 27⅛ in.)
Cleaned 1977

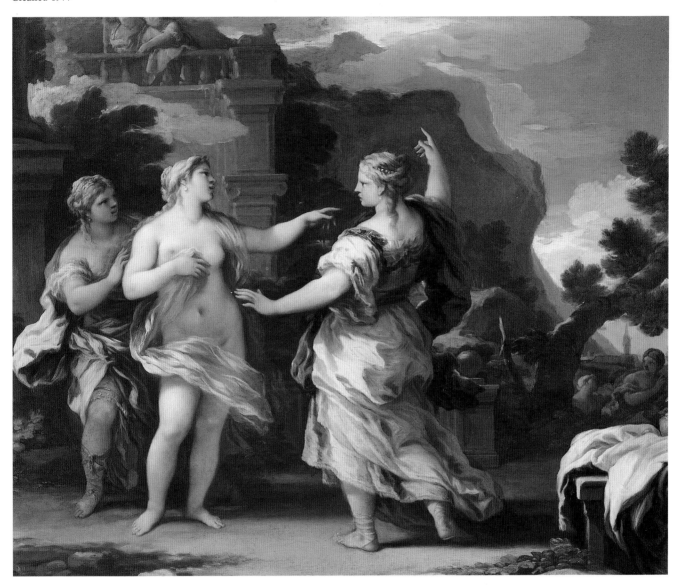

1692–1702, the years when he was in Spain at the court of Charles II. The fluidity of the brushwork, the sheer liquidity of the paint, the spirited inventiveness of the compositions, together with the delicate, refined colours are highly characteristic of Giordano at the height of his powers. The charm of the paintings is enhanced by the reduced scale which Giordano so often eschewed in favour of large decorative schemes. Essentially, as was the case in the context of Van Dyck (see No. 31), the story of Cupid and Psyche was a suitable subject for a court artist. The series may indeed have been painted for Queen Maria

Ana, the wife of Charles II of Spain, since they were apparently given by the queen to the Duc de Grammont after the death of the king in 1700. The pictures were included in the sale of the Grammont collection in 1715 and they are next documented in the collection of Jacques Meijers in Rotterdam. By 1737 they are recorded in the possession of Frederick, Prince of Wales, when a payment for frames was made to Joseph Duffour.

Literature: Levey 1991, nos. 502, 503, 506, 508.

JOHN WOOTTON c.1682–1764

The Shooting Party: Frederick, Prince of Wales, with John Spencer and Charles Douglas, 3rd Duke of Queensberry

Canvas, 88.9 × 74 cm (35 × 29⅛ in.)
Signed and dated: *JW/1740*

FREDERICK, PRINCE OF WALES, is shown seated, wearing hunting livery with the ribbon and star of the Order of the Garter. Two loaders can be seen behind him at the right edge of the composition, while John Spencer (1708–46) stands on the left holding a partridge behind his back. He was the father of the 1st Earl Spencer and the favourite grandson of Sarah, Duchess of Marlborough, whom he succeeded as Ranger of Windsor Great Park in 1744. Horace Walpole remarked on Spencer's early death in a letter of 20 June 1746 to Sir Horace Mann: 'Jack Spencer, old Marlborough's grandson and heir, is just dead, at the age of six or seven and thirty, and in possession of near £30,000 a year, merely because he would not be abridged of those miserable blessings of an English subject, brandy, small-beer, and tobacco.'[1] The Duke of Queensberry (1698–1778) quarrelled with George II and therefore, given the nature of Hanoverian politics, found favour with the king's son Frederick, Prince of Wales, becoming Gentleman of the Bedchamber (1733–51) and Captain-General of the Royal Company of Archers (1758–78). Later he served George III as Keeper of the Great Seal of Scotland. He was the patron of the dramatist John Gay.

Wootton was the foremost sporting artist, landscape and battle painter of early Georgian England. He was patronised not only by members of the Royal Family, but also by leading aristocratic families such as the Dukes of Beaufort, Devonshire, Newcastle and Bedford. Frederick, Prince of Wales, commissioned a number of hunting scenes from Wootton, and two battle scenes (*The Siege of Lille* and *The Siege of Tournay*) commemorating the Duke of Marlborough's campaigns during the War of the Spanish Succession (1689–1713); these were hung prominently in Leicester House. In addition, he acquired three important landscapes of the grounds of Park Place near Henley-on-Thames, an estate purchased by the Prince of Wales around 1738. Trained by the Dutch artist Jan Wyck, Wootton became an adroit painter of horses and dogs, but the landscapes in which he set his sporting scenes were influenced by Poussin, Gaspard Dughet and Claude. The style of Claude is apparent in *The*

Shooting Party, especially in the treatment of the sky and the trees.

A version of the picture exists at Drumlanrig in Scotland and was presumably painted for the Duke of Queensberry. It has a view of Windsor Castle in the background. Yet another version was sold in the artist's studio sale held on 12–13 March 1761.

The frame for the painting was made by Paul Petit (active about 1740–5) two years after it was delivered by the artist. Petit's bill is dated 6 October 1742: 'A Rich picture frame Carved with birds Richly Ornamented neatley repair'd [prepared] and Gilt in Burnished Gold to a picture of His Royal Highness painted by Mr Wootton . . . £21.' The frame is handsomely decorated with hunting trophies and equipment. At the top a lion's head supports the Prince of Wales's coronet and feathers, while below on the base rail a hawk stands astride a dead bird. A dead snipe and duck lie on the upper cornice, while hounds' heads emerge from the scrolls at the corners.

Notes: **1** *Horace Walpole's Correspondence*, ed. W. S. Lewis, vol. 19, London/New Haven 1954, p. 272.

Literature: Millar 1963, no. 547; Buttery 1987, p. 22.

Exhibitions: London 1974–5, no. 17; London 1984, no. L1; Washington 1985–6, no. 434.

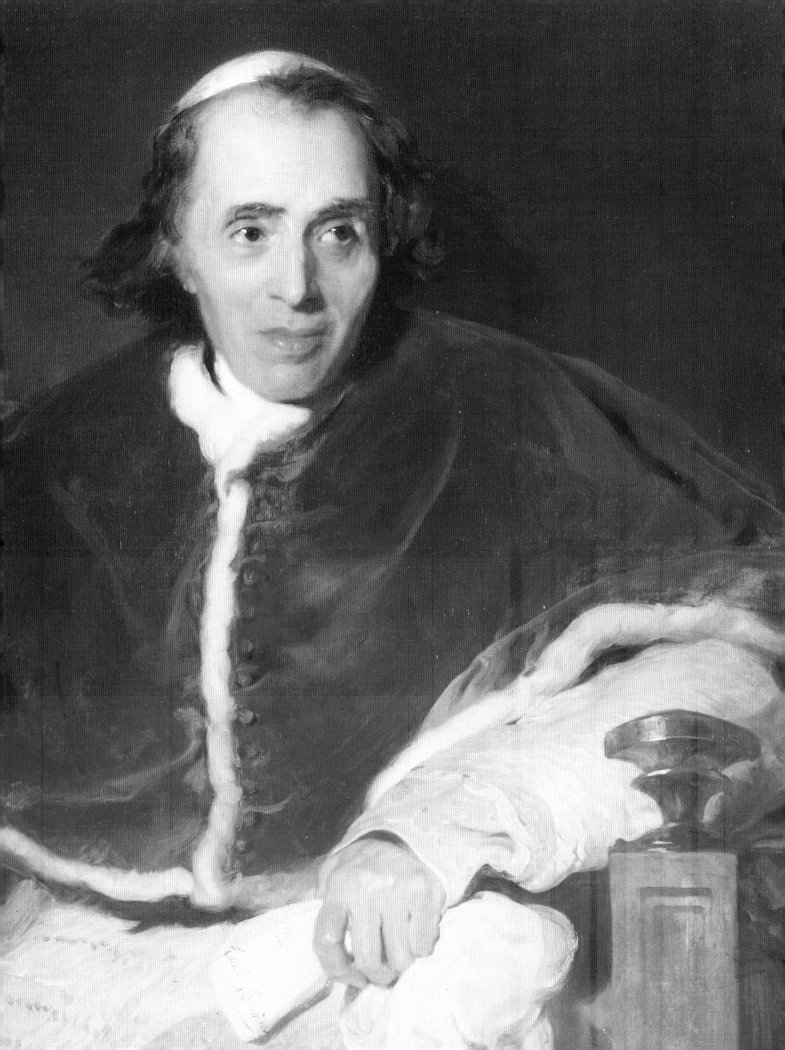

George III and George IV

GEORGE III (1760–1820) was a purposeful, but hardly a passionate, collector of paintings. His interests were broad – scientific instruments, clocks, books, music – and his appreciation of art must be seen as one of several activities. His wife, Queen Charlotte, was clearly an important influence in their shared admiration for Allan Ramsay (No. 60), Gainsborough (No. 63) and Johann Zoffany (Nos. 61, 62). The paintings were displayed for the most part in Buckingham House (later designated a Palace) and Windsor Castle. In both places Benjamin West (No. 64) devised extensive painted schemes based on historical and religious themes that suited George III's somewhat idealistic temperament. The single most significant acquisition of his reign was the purchase in 1762 of the collection formed in Venice by Consul Joseph Smith. This comprised a large group of over forty pictures by Canaletto (Nos. 58, 59) and a wide, although not comprehensive, representation of paintings by Venetian artists (No. 57). Smith's collection also included a small number of Northern paintings, one of them by Vermeer (No. 53).

By contrast with his father, George IV (1820–30) indulged in collecting works of art to a degree that can only be compared with Charles I. He was blessed with a sense of style and a zest for life that made him almost totally oblivious of extravagance, so that many of his purchases tended to be spectacular as opposed to shrewd. Like his parents, George IV admired Gainsborough and he continued to patronise British painters: Reynolds (No. 65), Stubbs (No. 66), Lawrence (No. 67) and Wilkie (No. 68). Many of the finest Dutch (Nos. 50, 51, 52, 54, 55) and Flemish (No. 49) paintings of the seventeenth century were added to the Royal Collection by George IV. He also obtained particularly choice examples of French seventeenth- and eighteenth-century paintings (No. 56).

George IV was not a pioneer in collecting terms, his taste being shared by several contemporary collectors, such as the Marquess of Hertford. However, the surroundings were unique: Carlton House, where he lived when Prince of Wales and then Prince Regent, but which he pulled down in 1827, Windsor Castle and Buckingham Palace. Both these last residences were redesigned for George IV with special provision for the display of pictures.

OPPOSITE Sir Thomas Lawrence, *Pope Pius VII* (No. 67, detail).

DAVID TENIERS THE YOUNGER 1610–1690

Peasants dancing outside an Inn

Canvas, 135.3 × 205.1 cm (53¼ × 80¾ in.)
Cleaned 1991

LIKE his grandfather, Frederick, Prince of Wales, George IV enjoyed the works of David Teniers the Younger. This particularly fine example, on a large scale and recently cleaned, was acquired by George IV as Prince of Wales in the saleroom. During the second half of the eighteenth century it was in the Lubbeling, Randon de Boisset (sold 1777) and Le Boeuf (sold 1782) collections before forming part of the collection of Henry Hope, which was sold at Christie's on 6 April 1811 (lot 58). The painting was hung, together with other distinguished Dutch and Flemish pictures, in the Bow Room on the Principal Floor of Carlton House, as can be seen in the illustration to W. H. Pyne's *The History of the Royal Residences* of 1819.[1] After Carlton House was pulled down in 1827 the painting was moved to Buckingham Palace, where it was hung in the Picture Gallery.

Teniers was born in Antwerp and was taught by his father. He was received as a Master of the Guild of Saint Luke in Antwerp in 1632/3, becoming its Dean in 1645/6, and in 1663 he became a founder member of the city's Académie Royale. For many years from 1651 Teniers worked in Brussels for the Governor of the Spanish Netherlands, Archduke Leopold-Wilhelm, and subsequently for his successor as Governor, Don Juan of Austria. Apart from his paintings, Teniers's duties as art adviser to Archduke Leopold-Wilhelm are best seen in the publication *Theatrum pictorium* of 1660, an illustrated catalogue of part of the Archduke's collection. Teniers made many of the small preparatory painted copies, prior to engraving (there are some in the Royal Collection and several in the Courtauld Institute Galleries, London), and oversaw the etchings for the catalogue. He spent five years in England from 1650 to 1655, apparently buying paintings as part of his activities as a dealer. Teniers was a man of considerable wealth, purchasing a country estate in 1662 and finally being ennobled in 1680. His first marriage was to Anne, the daughter of Jan Brueghel the Elder, but she died in 1656.

The painting, which would appear to date from the mid- or late 1640s, is essentially a genre scene of a type that had been pioneered by painters like Jan Brueghel the Elder (see No. 35), Frans Francken II and David Vinckboons. The broad characterisation of peasant types by Teniers is to some extent derived from Adriaen Brouwer, but the squat proportions of the figures, with their large heads and big feet, are typical of the artist's style. Not all the figures, however, are peasants. The couple in the left foreground, accompanied by a child and a dog, are bourgeois types. So too is the woman nearby being helped to her feet. Dress and coiffure suggest social distinctions that may give the painting extra meaning.[2]

The inn in the left half of the composition occurs again in a painting in Dresden, but the general layout of the composition with buildings on the left, a tree with or without a fence marking the centre, and a distant view on the right is a well-established format in Teniers's work (see, for example, *Feast in Harvest Time* in the Royal Collection). Otherwise it is the range of observation and contrasting actions that holds the attention. The bagpiper leaning against the tree, the man vomiting, the man near the centre leaning on his stick, the dancers, the woman looking out of the window of the inn are all memorable figures in a painting of varied emotions and changing rhythms. The figure helping the woman to her feet anticipates Watteau, who was a keen admirer of Teniers. Genre, landscape and still life are all combined in this composition, which provides abundant proof of the artist's skills.

Notes: **1** Reproduced in W. H. Pyne, *The History of the Royal Residences*, 3, London 1819, pp. 31–2. **2** See F. P. Dreher, 'The Artist as Seigneur: Chateaux and their Proprietors in the Work of David Teniers II', *Art Bulletin*, LX, 1978, pp. 682–703.

Literature: Smith 1831, III, no. 196.

PIETER DE HOOCH 1629–1684

50 *Cardplayers in a Sunlit Room*

Canvas, 76.2 × 66.1 cm (30 × 26 in.)
Signed with the artist's initials and dated lower right on the bench:
P.D.H./1658

Cardplayers in a Sunlit Room was painted in Delft where the artist is recorded in 1652, and where he remained until 1661. From these years date the first works in De Hooch's fully mature style. The move from Rotterdam, where he had lived previously, coincided with a change in subject matter and a new approach to composition. Where before the artist had been preoccupied with rustic settings, the paintings in Delft concentrate more on bourgeois society seen in the context of well-ordered and strikingly lit interiors or carefully observed outdoor scenes. These new developments in De Hooch's oeuvre were most probably inspired by local artists in Delft such as Carel Fabritius, Gerard Houckgeest and Emanuel de Witte, who were principally architectural painters interested in creating new illusionistic effects through the application of perspective. The *View of Delft* by Fabritius (National Gallery, London) stands as testimony to the form these early experiments took, just as *A Lady at the Virginals* by Vermeer (No. 53) shows the style brought to an unrivalled degree of perfection. De Hooch played a prominent part in the creation of the Delft school of painting. 'No earlier works had so successfully applied a cogent perspective system to the naturalistic representation of genre themes in secular spaces.'[1]

Several other paintings, also of outstanding quality, date from the same year as *Cardplayers in a Sunlit Room* including *A Girl drinking with Two Soldiers* (Paris, Louvre), *A Soldier paying a Hostess* (Marquess of Bute's collection) and *The Courtyard of a House in Delft with a Woman and a Child* (London, National Gallery). The mood of these pictures is calm and reflective, the actions of the figures restrained, and the rhythms languorous. There is a concentration on detail, as, for example, in the depiction of the playing cards, the raised glass and the broken pipe on the floor, in the lower right corner, which clearly absorbed the artist and enthrals the viewer. Such details help to create an atmosphere that is almost palpable in its freshness. The mother-of-pearl tone of the picture is enhanced by the use of pale colours against a grey ground, assisted by blending them with white. The view through from the shadowy interior to the sunlit courtyard in the middle distance allows De Hooch to exploit his skill in the handling of light as it falls over the different surfaces. This is particularly apparent in the rendering of the translucent curtains and the panes of glass, as well as the way in which light helps to define the forms of the figures. If the overall visual effect of the picture is one of a highly wrought finish, this is to some extent belied by the surprisingly broad handling of paint, particularly in the figures, and the almost matter-of-fact laying in of the squares on the tiled floor. Under-drawing is visible for the layout of the floor, and several compositional changes can be detected: for instance, the man drinking to the left of the group playing cards was originally given a hat.

Unlike certain Dutch paintings of this type (see No. 54) De Hooch seems to have made no use of symbolism. The painting hung high on the wall on the right surely does not have a hidden meaning, but the broken pipe and the playing cards are perhaps open to interpretation.

The painting remained in Holland until the early nineteenth century. In 1823 the dealer, C. J. Nieuwenhuys, stated that 'its novelty awakened the attention of collectors both in France and England.' Two years later it is first recorded in England. Finally, it was acquired by Lord Farnborough for George IV in 1827.

Notes: 1 Sutton 1980, p. 19.

Literature: White 1982, no. 85.

AELBERT CUYP 1620–1691

51 *The Negro Page*

Canvas, 142.8 × 226.7 cm (56¼ × 89¼ in.)

THE HOLDINGS of works by Cuyp in British collections are spectacular. The artist's popularity was established by the second half of the eighteenth century, when this painting is first recorded in England, and continued well into the nineteenth. George IV especially appreciated Cuyp's paintings and he acquired the seven examples that are in the Royal Collection. Leading collectors were particularly enthusiastic about those pictures painted after about 1642, when the artist came under the influence of painters in Utrecht like Jan Both, who had worked for several years in Italy. Cuyp's tight descriptive early style, nurtured by Jan van Goyen and Salomon van Ruysdael, now suddenly gave way to a broader, more effulgent style in which the landscape is soaked in a golden light. As William Hazlitt wrote in 1824 of Cuyp's *River Landscape* (London, Dulwich Picture Gallery), 'You may lay your finger on the canvas; but miles of dewy vapour and sunshine are between you and the objects you survey.'[1] This style reaches its climax during the 1650s when Cuyp created an imaginary landscape based on personal recollections of the North, but transformed by an appreciation of the South, particularly the Italian *campagna*, derived from other painters. A distant view, bathed in mist and the warm glow of a late afternoon light, proved irresistible to early collectors. *River Landscape with Horseman and Peasants* (London, National Gallery), which was

painted around 1655, is perhaps the finest example of Cuyp's mature style, but *The Negro Page*, dating in all probability from a few years earlier, is not far removed in quality. The types of the buildings, the hilly background and the lake are common to both paintings and may be a reflection of Cuyp's journey up the Rhine as far as Nijmegen and Kleve, near the German border, at the beginning of the 1650s.

Cuyp was economical with his motifs and several of those in *The Negro Page* recur in other paintings. For example, in *Huntsman halted* (Birmingham, Barber Institute of Fine Arts) Cuyp deploys similar horses, dogs and groom in a different composition. Dappled horses and negro pages are frequently found in other works by the artist of comparable date. The spaniel in the foreground of the present work is similarly posed in the painting of *Orpheus* (Marquess of Bute's collection). Some of the motifs are the subject of preparatory drawings either by Cuyp or his studio, such as the spaniel (Vienna, Albertina), the greyhound (Fig. 43) and the vegetation on the left (Paris, Lugt Foundation; London, British Museum, amongst others). The figure on the right facing the viewer has been tentatively identified as one of Cornelis van Beveren's sons, perhaps Willem (born 1624) who was appointed Bailiff and Dyke-Reeve of the Lande van Strien in 1648. This identification is based on the fact that his mount's horse brass is in the form of a fleur-de-lys, which suggests a connection with France (a knighthood was conferred on Cornelis van Beveren by the French king, Louis XIII).

Cuyp spent nearly all of his life in Dordrecht. His marriage in 1650 to Cornelia Boschman, the widow of a wealthy Regent, led to a decline in his artistic output as he devoted more time to a career in public life. His work was particularly appreciated by members of the Regent class in Dordrecht, and a recent essay by Simon Schama has emphasised the social mores that Cuyp seems deliberately to have cultivated in the paintings dating from the 1650s. These social distinctions are detectable in dress, the emphasis on equitation, the relationship of the figures to architecture and the prominence of servants.[2]

Fig. 43 Attributed to Cuyp, *Two Dogs Seated*, pen and sepia and washes of sepia and indian ink, 119 × 186 mm, London, British Museum, Department of Prints and Drawings.

Notes: **1** W. Hazlitt, *The Complete Works of William Hazlitt*, x, *Sketches of the Principal Galleries in England*, ed. P. Howe, London/ Toronto 1932, p. 19. **2** S. Schama, 'Dutch Landscapes: Culture as Foreground', in P. Sutton, *Masters of 17th-Century Dutch Landscape Painting*, exhibition catalogue, Amsterdam/Boston/Philadelphia 1987–8, pp. 80–2.

Literature: White 1982, no. 37.

MELCHIOR DE HONDECOETER 1636–1695

52 *Birds and a Spaniel in a Garden*

Canvas, 127.6 × 152.4 cm (50¼ × 60 in.)
Signed upper left on wall: *M. d'Hondecoeter*

THE ARTIST was born in Utrecht and lived for a short
time in The Hague before settling permanently in
Amsterdam in 1663. He was trained by his father,
Gijsbert de Hondecoeter, and by his uncle, Jan Baptist
Weenix, who had spent three years in Italy during the
1640s. Melchior de Hondecoeter specialised, like his
father, in painting animal and bird pictures, but the back-
grounds, usually comprising imaginary landscapes, are
more influenced by Weenix. Fidelity to subject matter
perhaps accounts for the lack of development in his style,
and dated works only occur after 1668, so that it is diffi-
cult to suggest a specific chronology for the undated
items that abound in his oeuvre. Hondecoeter frequently
repeated animals and poses in several pictures and it is
apparent, therefore, that he relied upon a pattern book of
motifs. His paintings proved to be popular with con-
temporaries as part of decorative schemes in country
houses, and by extension this accounts for his popularity
in eighteenth-century England.

The foreground is dominated by a fighting cock, a
tortoise, a crowned crane, a white hen with chickens and
a barking spaniel. In the middle distance are a hoopoe on
the left, a domesticated flying pigeon in the centre and a
cassowary just to the right of centre. Behind them can be
seen a peacock, a peahen and two flamingos. Hondecoeter
often showed animals entering the composition from out-
side the picture space in the manner of the fighting cock
on the left. Most of the birds and animals recur in other
pictures by the artist, but the high quality of the painting
throughout, the vivid colouring and the convincing
sense of movement do not suggest any intervention by
studio assistants.

The picture was acquired by George IV in 1814 when
he purchased the Baring collection, which was one of the
most distinguished holdings of Dutch paintings formed in
Britain at the end of the eighteenth century. The collec-
tion was made by the banker Sir Francis Baring, and
eighty-six pictures were sold by his son Sir Thomas Bar-
ing to George IV. From another source he obtained a
series of three paintings by Hondecoeter depicting the
estate and horses belonging to Johan Ortt at Nijenrode
Castle.[1] Such works by Hondecoeter reflect George IV's
interest in animals, as evidenced by the menagerie he
kept in Windsor Great Park, and are comparable with
the paintings he owned by George Stubbs (No. 66) and
Jacques-Laurent Agasse.

Notes: **1** White 1982, nos. 71–3.

Literature: White 1982, no. 69.

JAN VERMEER 1632–1675

53 *A Lady at the Virginals with a Gentleman*

Canvas, 73.3 × 64.5 cm (28$\frac{7}{8}$ × 25$\frac{3}{8}$ in.)
Signed along the lower edge of the frame of the painting on the
extreme right: *IV Meer* [*IVM* in monogram]
Inscribed on the underside of the lid of the virginals: *MVSICA
LETITIAE CO[ME]S/MEDICINA DOLOR[IS]* [Music is a companion
in pleasure, a remedy in sorrow]

THE GREATNESS of Vermeer is dependent upon the
economy of his style and the precision of his technique,
which served to create an enigmatic mood that has
become the hallmark of his mature paintings. This is, in
effect, what Gowing refers to as a 'studied obliquity of
theme'.[1] The apparent simplicity of the compositions,
which to a large extent rely on a limited number of
studio props,[2] and a restricted number of settings, belie
artifice. Indeed, the sophistication of his working
methods often involved technical aids such as the camera
obscura. The comparatively small number of works by
Vermeer that have survived (the oeuvre amounts to
thirty-four pictures) suggests a limited output, perhaps
resulting from a slow or deliberate technique. Although
Vermeer's paintings commanded respectable and
sometimes high prices during his lifetime, his reputation
was firmly based on the support of local patrons in Delft.[3]
The artist's fame today, however, is in essence a legacy
of the nineteenth century due mainly to the writings of
the French critic Théophile Thoré.[4] The provenance of
A Lady at the Virginals underscores the fluctuations of
taste to which Vermeer's work has been subjected. The
painting is first recorded in an anonymous sale held in
Amsterdam on 16 May 1696, which is believed to have
been the collection of Jacob Abrahamsz. Dissius. He was
a bookseller, who in 1680 had married Magdalena, the
daughter of Pieter van Ruijven and Maria de Kunijt,
patrons of Vermeer. The sale of 1696 included twenty-one
paintings by the artist, and the present picture is most
probably identifiable as lot 6: 'A young lady playing the
clavecin in a room, with a listening gentleman by the
same.'[5] It is next recorded in the collection of the Ven-
etian painter, Giovanni Antonio Pellegrini (1675–1741),
who worked in the Low Countries in 1716–18.
One year after Pellegrini's death the picture was duly
sold and acquired by Consul Smith.[6] When Smith's
collection was acquired by George III in 1762, the paint-
ing had an attribution to Frans van Mieris, which was in
all likelihood based on a misreading of the signature. This
attribution was maintained until 1866, when the correct
attribution was re-established in Thoré's monograph
of the artist.

There is general agreement that *A Lady at the Virginals*
dates from the 1660s, but it is difficult to be more exact.
The subject prompts comparison with Vermeer's *Concert
Trio* in Boston (Isabella Stewart Gardner Museum), but
the bolder, more dramatic use of perspective, emphasising
the longitudinal axis of the room, is closer to paintings of
the late 1660s such as *Lady writing a Letter with her
Maid* (Beit collection), *The Love Letter* (Amsterdam,
Rijksmuseum) and *The Geographer*, dated 1669 (Frank-
furt, Städelsches Kunstinstitut). This treatment of
perspective is typical of the style developed by painters
working in Delft during the 1650s (see No. 50).

The relationship between music and love as a theme
was frequently explored by Dutch seventeenth-century
painters with varying shades of meaning. Vermeer's sub-
ject matter is often understated, but at the same time
objects contained within the picture reinforce the mean-
ing, which in some instances is interpreted on a quasi-
philosophical basis. Thus, the two instruments – the
virginals and the bass viol – here signify the possibility
of a duet symbolising the emotions of the two figures.

Fig. 44 Andries Ruckers the Elder, a virginal, Amsterdam,
Rijksmuseum.

152

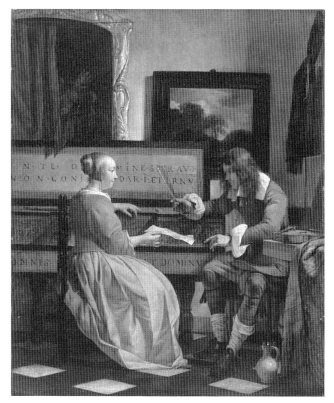

Fig. 45 Gabriel Metsu, *A Man and a Woman seated by a Virginal*, oil on wood, 38.4 × 32.2 cm, London, National Gallery.

OPPOSITE Jan Vermeer, *A Lady at the Virginals with a Gentleman* (detail).

Fig. 46 Jan Steen, *A Young Woman playing a Harpsichord*, oil on wood, 42.3 × 33 cm, London, National Gallery.

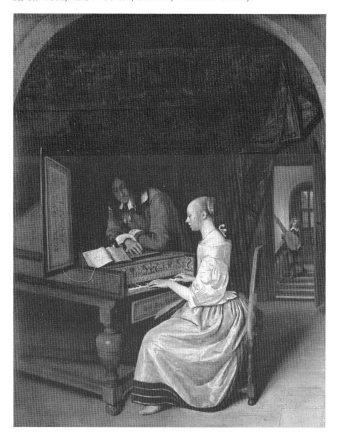

Similarly, the painting behind the man can be identified as *Cymon and Pero* (also known as *Roman Charity*) in which a daughter feeds her father, who has been imprisoned, from her own breast, a theme that clearly has connotations that are open to interpretation in the context of love. *Cymon and Pero* is in the style of a Dutch follower of Caravaggio (possibly Utrecht school), although the original has not been identified.[7] Interestingly, a painting of this subject is listed in the 1641 inventory of items belonging to the artist's mother-in-law, Maria Thins.[8] The keyboard instrument has been identified as being comparable with those built by Andries Ruckers the Elder. Examples with identical decorative devices on the lid, keywell and fallboard, as well as similar inscriptions, are in Bruges (Museum Gruuthuse), Brussels (Musée Instrumental du Conservatoire) and Amsterdam (Fig. 44). The lining paper on the keywell, decorated with flowers, foliage and sea-horses, also occurs on instruments depicted by Metsu (*A Man and a Woman seated by a Virginal*; Fig. 45) and Steen (*A Young Woman playing a Harpsichord*; Fig. 46), both in the National Gallery, London. There are specific sources for the patterns used on the lid[9] and the fallboard,[10] but no source for the pattern on the keywell has yet been discovered. The mirror above the woman reflects not only her head and shoulders, but also the artist's easel. The fact that there is a diminution in scale of the head in the mirror and that the image itself is slightly out of focus ('vitreous impressionism' is Gowing's phrase)[11] denotes the use of a camera obscura. However, while the box visible behind the easel in the reflection may indeed be a camera obscura, it may also be a paintbox.

The mood of this interior by Vermeer is created as much from the confrontation of the two figures as from the juxtaposition of mundane objects within a space precisely proportioned and subtly lit. As Gowing expressed it, 'there rests, as gentle as the air itself, an allegory of liberty and bondage, an allegory, as the inscription informs us, of the pleasure and the melancholy of love.'[12]

Notes: **1** L. Gowing, *Vermeer*, London 1952, p. 123. **2** For the inventory of the artist's possessions made after his death, see Montias 1989, Document 364, pp. 339–44. **3** Montias 1989, pp. 246–62. **4** Haskell 1976, pp. 86–90. **5** Montias 1989, pp. 363–4. **6** Vivian 1962, pp. 330–3. **7** See Philadelphia/Berlin/London 1984, no. 119, n. 40. **8** Montias 1989, pp. 122–3. **9** Balthasar Silvius, *Variarum Protractionum . . .*, 1554. **10** Francesco Pellegrino, *La Fleur de la Science de Pourtraicture*, 1530. **11** Gowing, op. cit., p. 124. **12** Ibid. p. 52.

Literature: White 1982, no. 119; Aillaud, Blankert, Montias 1986, pp. 18–20, 185, no. 16; Montias 1989, pp. 122, 192–3, 195, 201, 266.

Exhibitions: Philadelphia/Berlin/London 1984, no. 119.

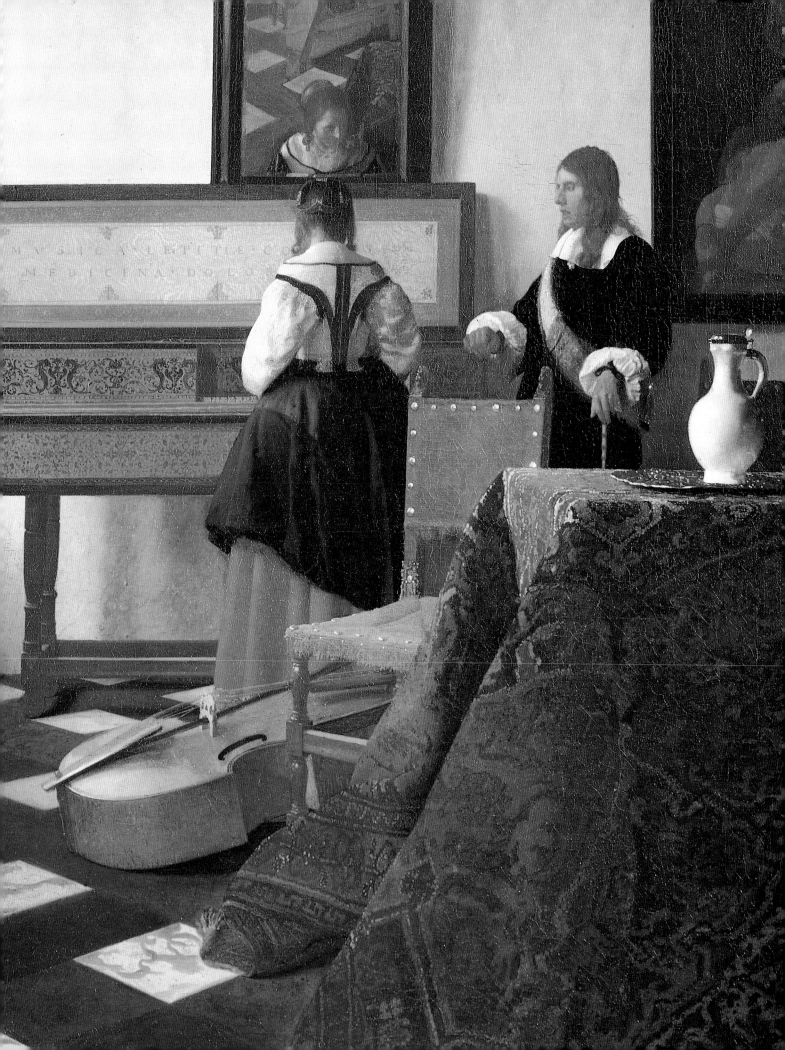

JAN STEEN 1625/6−1679

54 *A Woman at her Toilet*

Panel, 64.7 × 53 cm (25½ × 20 in.)
Signed on the left-hand column of the fictive architecture: *JSteen*
[*JS* in monogram]
Dated on the right-hand column: *1663*

GEORGE IV acquired seven of the eight paintings by
Steen in the Royal Collection and all of these are genre
scenes. As a result the collection lacks examples of the
artist's historical or religious works. *A Woman at her
Toilet* dates from the years when Steen was living at
Haarlem (1661–70) and it is a picture of outstanding
quality, notable for its neat style characterised by the
careful touch, precise drawing, wide range of colour and
meticulous attention to detail. Few of Steen's genre paint-
ings are as contemplative in mood or as highly charged in
meaning. The figure is seen through an elaborate archway
flanked by columns with Corinthian capitals set on tall
bases. Architectural features of this type are not repeated
in Steen's work, but can be found in paintings by Gerrit
Dou and Frans van Mieris the Elder, both of whom
worked in Leiden where Steen was born and where he
spent several years of his life. The arch is essentially a
framing device, which has its origins in Renaissance
manuscripts where it is also used in combination with
still-life motifs. Within the context of Dutch seventeenth-
century painting, however, the treatment of this composi-
tion and the style come close to Ter Borch and Vermeer.

The erotic elements in the painting are fairly clear. The
figure provocatively pulls on her stocking. She is
déshabillé and her room is untidy. The dishevelled bed-
clothes, the dog, the extinguished candle, the open jewel-
lery box festooned with pearls are all attributes used by
painters from the fifteenth century onwards to indicate
prostitution. Yet further allusions have been found in the
painting. For example, in seventeenth-century Dutch the
word for stocking was also used to describe the female
genitals and the word for shoe had similar connotations.
The still life in the foreground of a lute, a book of music,
a skull and a tendril of vine are references to *vanitas* or
memento mori, stressing the transitoriness of life. These
items are perhaps related to the weeping cherub over the
centre of the arch above and suggest that there might be a
wider meaning in the painting. Even here, though, the
broken lute string probably refers to the loss of chastity
and the tendril of vine need not necessarily have a reli-
gious significance when in secular iconography it is a
symbol of fertility or pregnancy.

Steen painted this subject again in a picture of approx-
imately the same date (Fig. 47), but the composition lacks
the archway and the *vanitas* still life in the foreground,
while the pose of the woman is more alluring.

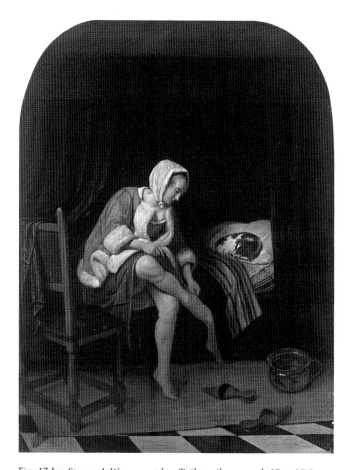

Fig. 47 Jan Steen, *A Woman at her Toilet*, oil on wood, 37 × 27.5 cm.
Amsterdam, Rijksmuseum.

Literature: White 1982, no. 189.

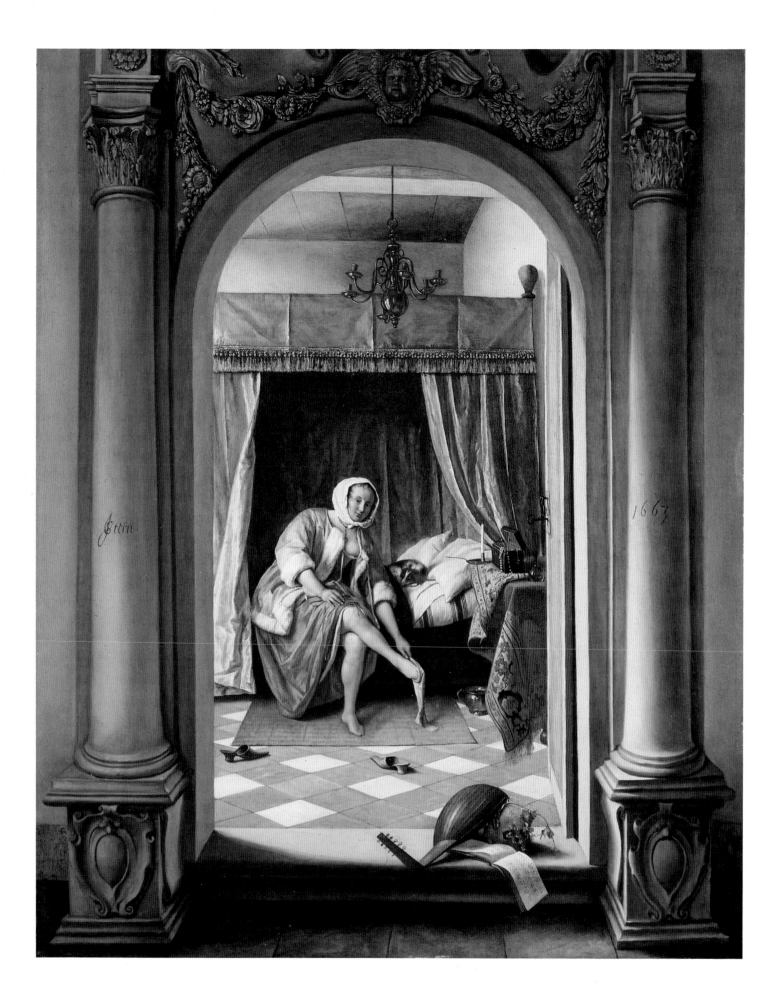

JAN STEEN 1625/6–1679

55 *Interior of a Tavern with Cardplayers and a Violin Player*

Canvas, 81.9 × 69.2 cm (32¼ × 27¼ in.)
Signed lower left corner: *JSteen* [*JS* in monogram]

THE MOOD of the painting is very different from
A Woman at her Toilet (No. 54) and it is of a type that
is more commonly associated with the artist, combining
broad characterisation with a skilful rendering of still life
and an accurate recording of light effects. The crowded
composition is based on an inverted triangle set at a
slight angle. The apex of the triangle, and the focus of the
composition is the violin player, who is often depicted by
Steen as a lone figure disengaged from the activities of
the rest of the company. Here the violinist is in conversa-
tion with a serving girl. The female figure playing cards
on the right, holding up an ace of diamonds, turns and
looks out at the viewer. This knowing glance and the
presence of a dog suggest that the woman is a prostitute.
The male figure laughing by the hearth on the left is in
all probability a self portrait. Steen was the son of a
brewer and opened his own tavern in 1672 towards the
end of his life. In the early literature the artist is often
stated as having led a profligate life, although there is no
definite evidence to prove this unless his paintings have a
strong autobiographical element. From the ceiling of the
tavern hangs a *belkroon* (a chandelier with a suspended
bell), decorated with a leafy branch. This sometimes
denotes a particular celebration, but such chandeliers are
frequently a feature of tavern scenes. The print on the
back wall, which shows a man on a charging horse, may
indicate that it is Prince's Day (15 November), the birth-
day of the Prince of Orange, the future William III, which
would, therefore, lend the picture a certain political
significance.

A date of about 1665–8 has been suggested for the
work, at which time the artist was living at Haarlem.

Literature: White 1982, no. 191.

Exhibitions: Philadelphia/Berlin/London 1984, no. 108.

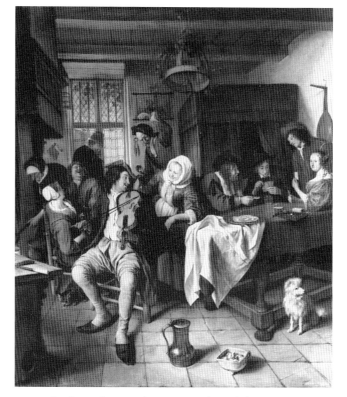

ABOVE Jan Steen, *Interior of a Tavern with Cardplayers and a Violin Player*. OPPOSITE Detail.

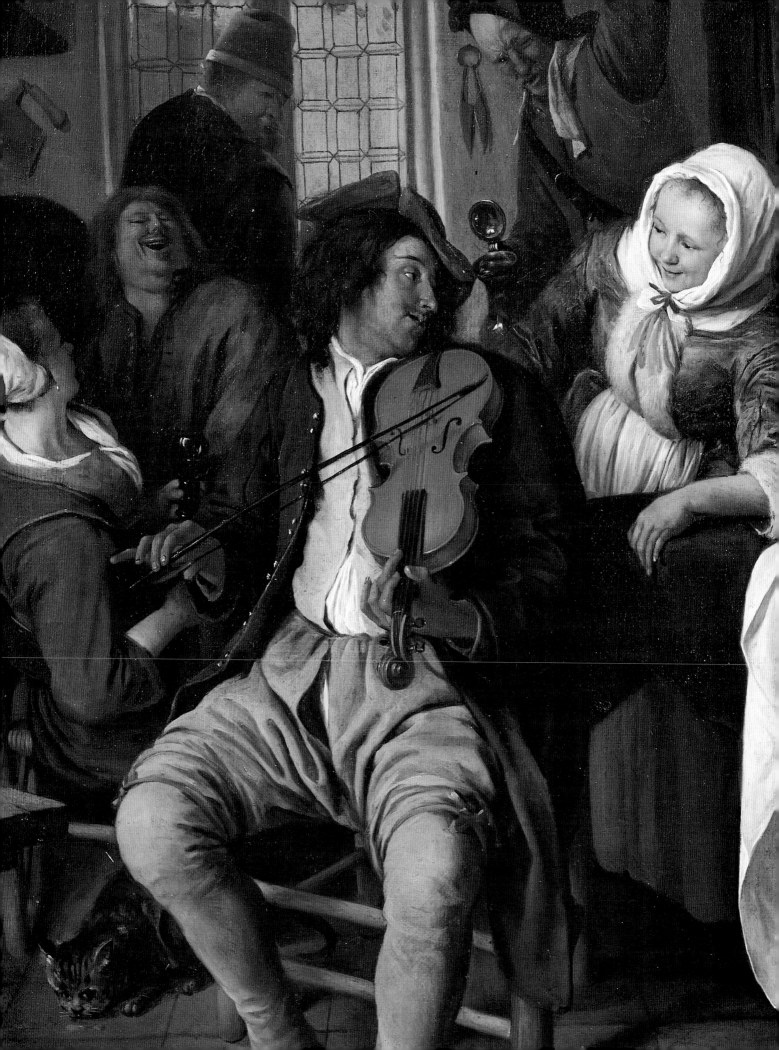

CLAUDE GELLÉE, called Le Lorrain 1600–1682

56 *Coast Scene with the Rape of Europa*

Canvas, 134.6 × 101.6 cm (53 × 40 in.)
Size of original painted surface, 131.4 × 98.4 cm (51¾ × 38¾ in.)
Signed and dated: *CLAVDE GILLE IVRI/ROMAE 1667*
Cleaned 1986–8

THERE ARE in all five painted versions of this subject by Claude dating from four different decades. The earliest is dated 1634 (Fort Worth, Kimbell Art Museum), followed by the second, dated 1647 (on loan to Utrecht, Centraal Museum), a third dated 1655 (Moscow, Pushkin Museum) and a fourth of 1658 (formerly in the collection of Simon Morison). The version in the Royal Collection, dated 1667, is the last in the series and in many ways marks the climax of the artist's treatment of the theme. This is admirably reflected in its heightened poetic sensibility and the sophisticated level of technical skills. Of the various compositions, that of 1634 is also recorded in an etching, while the others are included in Claude's *Liber Veritatis* (LV 111, 136 and 144), which served as an official drawn record made by the artist himself of his painted compositions dating from 1637 onwards. While the basic features of the design and iconography were established in the Fort Worth painting, changes or differences in emphasis occur in the others as Claude modified his style. It is also true to say that the version in Utrecht served as the basis for the later renderings, particularly in the greater spaciousness of the setting. There is a closer compositional affinity, however, between the painting in Moscow and the present picture, although small alterations in scale and in the number of figures and animals are apparent. For the painting in the Royal Collection Claude most probably referred back to the drawing of the Moscow version made for the *Liber Veritatis* (LV 136), although the picture itself remained in Rome in the collection of Fabio Chigi (1599–1667), who was elected Pope as Alexander VII in 1655 and was one of the artist's most important patrons. There is circumstantial evidence in the form of an inscription made by a later hand on the back of the drawing (LV 136) that the painting in the Royal Collection was made for Philippe de Graveron. An autograph drawing dated 1670, not from the *Liber Veritatis*, after the present painting is in the British Museum, London.[1]

The source for the story of the Rape of Europa is Ovid's *Metamorphoses* (II, 833–75). Jupiter, enamoured with Europa, the daughter of Agenor, changes himself into a white bull and mingles with the herd of cattle on the seashore where Europa and her maidens linger. Attracted by the beauty of the bull and not aware of Jupiter's transformation, Europa climbs onto its back and is abducted, eventually being carried out to sea. The description in Ovid is immensely poetic and Claude, by this time well versed in mythology and fully practised in its depiction, successfully expresses the beauty of the text in paint. The mood of the picture is established principally by the chief compositional features of trees, coastline, vessels and fortification judiciously placed within the picture space. The wide spatial intervals create a feeling of calm while quicker rhythms required for the narrative are concentrated in the foreground. The tonal values help to create an atmosphere charged with poetic feeling while the soft breeze wafting from the water is almost palpable. The overall beauty of the painting is enhanced by a number of felicitous details, both in terms of colour and of observation, in which Claude's painting matches Ovid's poetry. The care lavished on the draperies, the flowers and garlands, the waves lapping the sides of the vessels, and the down along the flanks of the cattle testify to the precision of Claude's art in creating a world that oscillates between quotidian experience and arcadian bliss.

The painting was in the collection of the Marquise de Baudeville, the grand-daughter of Philippe de Graveron, during the eighteenth century. It was bought for George IV at Christie's on 9 May 1829 at Lord Gwydir's sale (lot 81).

Notes: **1** Röthlisberger 1968, no. 1012.

Literature: Röthlisberger 1961, no. LV 136; Kitson 1973, p. 779; Röthlisberger 1975, no. 243; Kitson 1978, under LV 136.

Exhibitions: London 1969, no. 36; Washington/Paris 1982–3, under no. 15 and no. 48 bis respectively.

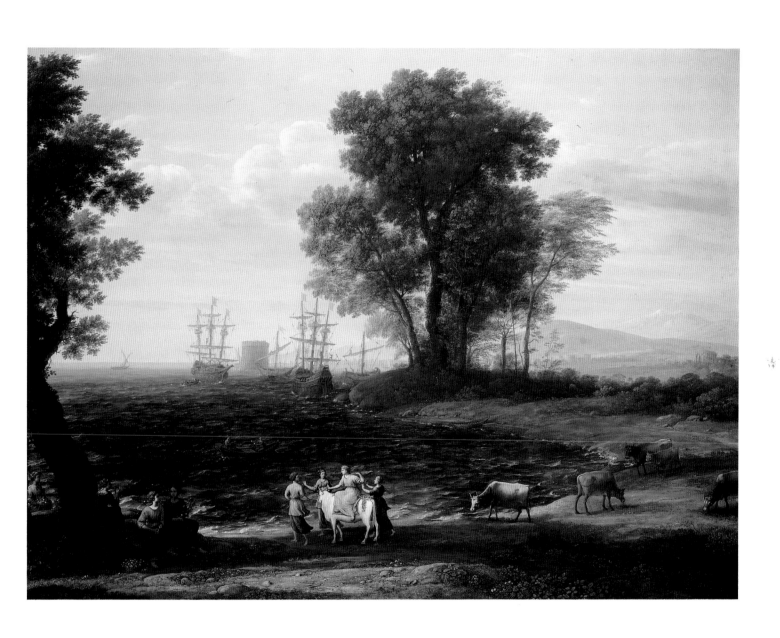

SEBASTIANO RICCI 1659–1734

57 The Adoration of the Magi

Canvas, 330.2 × 289.6 cm (130 × 114 in.)
Dated on the stone step: *MDCCXXVI*

THE ARTIST'S bold and colourful treatment of the theme (Saint Matthew 2: 9–11) is a link in Venetian painting between Paolo Veronese and Giovanni Battista Tiepolo. The composition is derived in its essentials from the altarpiece painted by Veronese in 1573 for the church of San Silvestro, Venice (now in the National Gallery, London) and anticipates the altarpiece painted by Tiepolo in 1753 for the monastery of Schwarzach in Franconia (now in the Alte Pinakothek, Munich). All three works are large, but the composition by Tiepolo differs from the others, which are almost square in format, by being compressed into a vertical.

The *Adoration of the Magi* was acquired by George III in 1762 from Consul Joseph Smith and formed part of a series of seven pictures of New Testament subjects. The related paintings are *Christ and the Woman who Believed*, *Christ and the Woman of Samaria*, *The Magdalen anointing Christ's Feet* (all still in the Royal Collection), *The Pool of Bethesda* and *The Woman taken in Adultery* (Ministry of Works, presently at Osterley House) and *The Sermon on the Mount*, which is lost. All these paintings, with the exception of the present work, illustrate scenes from Christ's ministry. Each was engraved in reverse by J. M. Liotard in 1742 as being in Smith's collection and a further written account of the series by the Abate Pietr' Ercole Gherardi of Modena was published in 1749. In addition, Smith possessed a considerable amount of the preparatory material, which was also acquired by George III in 1762. For the *Adoration of the Magi* alone sixteen drawings are preserved at Windsor Castle: two of these are studies for the whole composition and the rest are for groups, individual figures, or details (Fig. 48). What appears to be a *modello* is in the Princes Gate collection (London, Courtauld Institute Galleries).

The origin of the commission for this series of paintings is unknown. The size of the undertaking (the dimensions in each case are extremely large and there are fundamental changes in format) has caused the series to be associated with an unrecorded commission for the Royal House of Savoy in Turin, for whom Ricci worked during the 1720s. If this is correct, then it implies that the commission, for one reason or another, devolved upon Smith. On the other hand, the fact that he owned so much of the preparatory material in addition to the final paintings suggests that Smith could have commissioned these works privately, although it is not known how he would have arranged such a group of paintings in the Palazzo Mangilli-Valmarana where he lived in Venice. The existing evidence is circumstantial and open to interpretation. Thus, Levey stresses the significance of the iconography, suggesting that the scenes illustrating Christ's ministry formed part of the original commission, possibly intended for Turin, and that when these pictures came into Smith's possession he commissioned a seventh painting, namely *The Adoration of the Magi*, presumably to fit a particular location. The date on the painting could therefore represent the completion of the project. However, P. E. Gherardi, writing as early as 1749, suggested 1726–30 as the date for the series, as opposed to the earlier half of the 1720s. Given the scale of the works some allowance has to be made for stylistic distinctions that can occur over a period of time.

The painting demonstrates Sebastiano Ricci's role in the evolution of Rococo art in Venice, which reached its climax in the work of Tiepolo. The setting of *The Adoration of the Magi* is dramatic, the brushwork full of verve and panache and the colours bright. Several changes in the composition can be seen with the naked eye, especially in the centre. The artist travelled extensively in Italy and also worked in England from 1711/12 to 1716, returning home via France. He formed a partnership with his nephew, Marco (1676–1730), who, according to Gherardi, painted the architectural background to *The Adoration of the Magi* and the related pictures.

Literature: Levey 1991, no. 640.

Fig. 48 Sebastiano Ricci, *Two Heads*, black, white and coloured chalks on grey-blue paper, 288 × 418 mm, The Royal Collection.

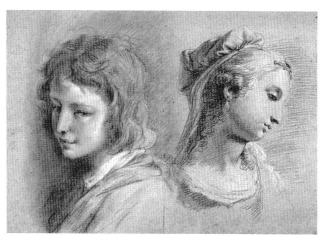

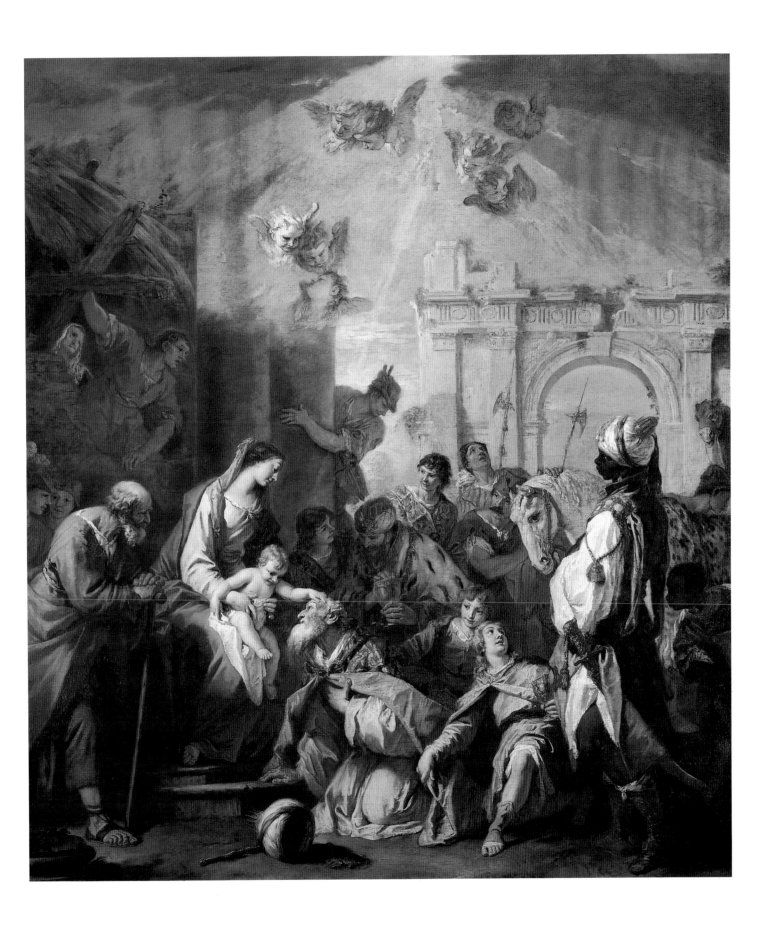

GIOVANNI ANTONIO CANAL, called Canaletto
1697–1768

Venice: The Piazzetta looking south-west towards S. Maria della Salute

Canvas, 172.1 × 136.2 cm (67¾ × 53⅝ in.)

THE PAINTING, together with five other views of the Piazza San Marco and the Piazzetta, forms part of a series commissioned from Canaletto by Consul Joseph Smith, who was the artist's most loyal patron. Smith, a merchant who lived in Venice, was not only an avid collector of Canaletto's work, but also arranged for the artist's paintings to be engraved and introduced him to potential clients. His collection, which included an incomparable group of paintings, drawings and prints by Canaletto, was sold to George III in 1762.

Fig. 49 Canaletto, *The Piazzetta looking towards S. Maria della Salute*, pen and brown ink over pencil, 233 × 182 mm, The Royal Collection.

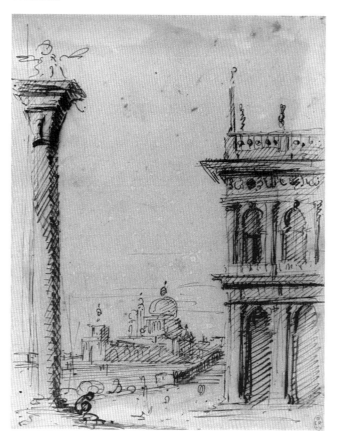

The early views of the Piazza San Marco and the Piazzetta, dating from before 1730, comprise four vertical compositions and two of horizontal format. Conceived as a series, it is almost certain that they were hung in one of the rooms in the Palazzo Mangilli-Valmarana on the Grand Canal where Smith lived. Only two of the paintings look out from the Piazzetta. The present example shows the view across the entrance to the Grand Canal with the Baroque church of Santa Maria della Salute, designed by Baldassare Longhena, and the Dogana in the background. Canaletto has made several major adjustments in the disposition of the proportions of the buildings and other architectural motifs. The placing of the column of San Teodoro has been altered and its height has been increased. The steps of the bridge, the Ponte della Pescheria, by the Biblioteca Marciana have been brought forward. Similarly, on the other side of the Grand Canal, the Dogana is positioned in too close proximity to the Salute. Comparison with the preparatory drawing (Royal Library, Windsor Castle, Parker 3; Fig. 49) shows that Canaletto originally included the column of San Marco on the left of the composition, but in the painting he omitted this in favour of a boat and instead inserted the column of San Teodoro by the Biblioteca Marciana. The balance of the composition is, therefore, heavily weighted to the right. These alterations to the spatial intervals and the amalgamation of viewpoints are highly characteristic of Canaletto's working methods. Such shifts of emphasis also confirm the likelihood that the paintings were made for a specific setting and that the compositions were closely discussed with the patron. Several changes (including the painting out of the column of San Marco) are visible to the naked eye. The paint is freely handled throughout, especially with regard to the figures in the lower right corner. The use made of mathematical instruments, mainly for drawing the outlines of buildings, is also apparent. The chiaroscural treatment of the light and the silhouetting of the buildings against the sky are the basis of the drama that characterises Canaletto's early style, especially in the paintings done for Consul Smith.

Literature: Constable/Links 1989, no. 146; Levey 1991, no. 383.

Exhibitions: New York 1989–90, no. 29.

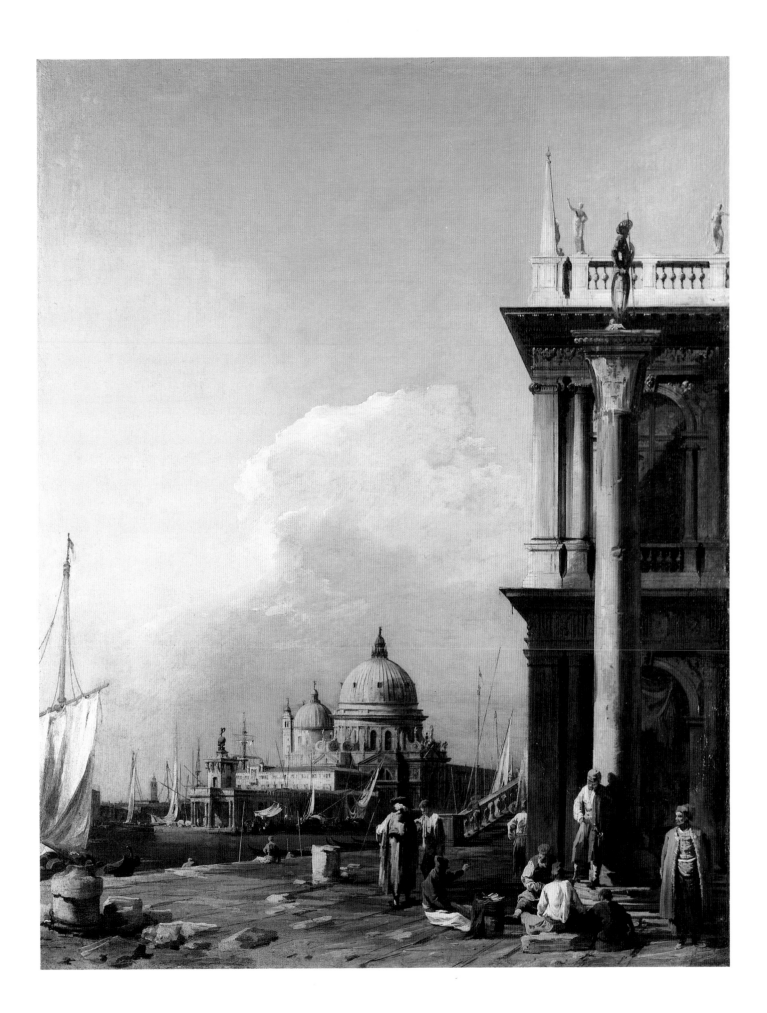

GIOVANNI ANTONIO CANAL, called Canaletto
1697–1768

59 *Venice: The Piazzetta looking north towards the Torre dell'Orologio*

Canvas, 172.1 × 134.9 cm (67¾ × 55⅛ in.)

THE PAINTING forms part of a series of six views of the Piazza San Marco and the Piazzetta, commissioned by Canaletto's most important patron, Consul Joseph Smith. The series was the first commission that Smith gave Canaletto and is fairly early in date, pre-1730. The scale of the six paintings is large and the style notable for the bold treatment of the light, the free handling of the figures, and the dramatic viewpoint. Presumably Smith ordered the paintings for a specific room in the Palazzo Mangilli-Valmarana on the Grand Canal where he lived, but exactly how they were displayed is not known. The collection formed by Consul Smith was sold to George III in 1762.

The buildings in this view of the Piazzetta can be readily identified. The Biblioteca Marciana designed by Jacopo Sansovino is on the left with the Campanile and Loggetta visible immediately behind. Across the Piazza is the Torre dell'Orologio with the east end of the Procuratie Vecchie extending to the left and the beginning of the Campo San Basso to the right. The façade of the Basilica di San Marco dominates the right side of the picture together with the column of San Teodoro. The figure in red, gesticulating in the foreground just to the left of centre, is a Procurator who appears to be attended by a secretary or notary. Once the buildings are identified, the degree to which Canaletto has conflated two separate viewpoints and altered the proportions in order to achieve a unified composition becomes apparent. Thus, the height of the Campanile is exaggerated and the projected distance between the viewer and the Torre dell'Orologio lengthened. Other changes include the positioning of the flagpoles and the column of San Teodoro. Most of these topographical adjustments (but not the positioning of the flagpoles) are apparent in the preparatory drawing (Royal Library, Windsor Castle, Parker 2; Fig. 50), which may have been made by the artist for discussion with his patron.

Horace Walpole was a firm admirer of Canaletto's early paintings which he described as 'bolder, stronger & far superior to his common Works.'[1]

Fig. 50 Canaletto, *The Piazzetta looking towards the Torre dell' Orologio*, pen and brown/brownish-black ink over pencil, 234 × 180 mm, The Royal Collection.

Notes: **1** 'Horace Walpole's Journals of Visits to Country Seats, etc', *Walpole Society*, 16 (1928), p. 79.

Literature: Constable/Links 1989, no. 63; Levey 1991, no. 381.

Exhibitions: New York 1989–90, no. 28.

ALLAN RAMSAY 1713–1784

60 *Prince George Augustus of Mecklenburg-Strelitz*

Canvas, 127 × 101.6 cm (50 × 40 in.)

ALLAN RAMSAY was official painter to George III and Queen Charlotte from the date of the accession in 1760, although technically he only succeeded John Shackleton as Principal Painter in Ordinary in 1767. By this date, however, he had already painted the State Portraits for which he is justly famous. Indeed, the success of the State Portraits was such that he was required to paint numerous replicas for most of the rest of his life. Ramsay was born in Edinburgh and his artistic abilities were brought to the attention of George III, when still Prince of Wales, by the 3rd Earl of Bute who served as mentor to the future king. Ramsay's style was influenced by two visits to Italy, the first between 1736 and 1738 in Rome and Naples and the second between 1754 and 1757 in Rome, but the compositions of his State Portraits, and above all the soft pastel colours, bespeak the influence of French painters such as Quentin La Tour, Jean-Baptiste Perroneau and Jean-Marc Nattier. It is significant that in the first instance Ramsay was appointed Principal Painter in preference to Sir Joshua Reynolds. Ramsay, like Gainsborough, established a good rapport with the Royal Family. However, he gave up painting around 1770 and devoted the rest of his life to writing essays and pamphlets on political subjects, becoming a friend of Samuel Johnson, who praised him highly for his literary merits.

Prince George of Mecklenburg-Strelitz (1748–85) was the younger brother of Queen Charlotte. The portrait was probably painted when the prince was in London between November 1768 and August 1769. He is shown wearing the uniform of an officer of Cuirassiers, a unit of the 4th Regiment of Austrian-Salzburg Dragoons or 'Serbellonis' of which he was later Colonel from 1778 to 1786. He attained the rank of Major-General in the Austrian army.

The portrait, which was presumably painted for Queen Charlotte, is a late work by Ramsay characterised by looser brushwork combined with the gentle colouring associated with the artist. The style recalls the antiquarian scholar, George Vertue's description of Ramsay's portraits being 'rather lick't than pencilld, neither broad, grand, nor Free, has more of the finished laboured uncertain.'[1] There is, however, a certain firmness in the drawing which attests to Ramsay's skill as a draughtsman, a facility apparent in his numerous drawings (Edinburgh, National Gallery of Scotland). The pale transparent flesh tones were the result of applying grey-green strokes over a red underpainting, while in the background the landscape appears to be veiled in mist. It is a romantic portrait with a mood of quiet heroism. The evenness of the paint, the muted light, the silvery tone, the attention to detail, and the quite outstanding rendering of different textures create a feeling of calm that is in contrast with Prince George's love of soldiering. The head and shoulders have been painted on a separate piece of canvas that has been set into a larger piece, a practice much favoured by the artist.

Notes: 1 Vertue 1933–4, p. 96.

Literature: Millar 1969, no. 1000.

JOHANN ZOFFANY c.1733–1810

61 ## The Tribuna of the Uffizi

Canvas, 123.5 × 154.9 cm (48⅝ × 61 in.)

THE PAINTING has become one of the most celebrated images of eighteenth-century taste. Zoffany shows a group of connoisseurs and members of the nobility admiring works of art in the Tribuna, the principal room of the Uffizi in Florence, which was the most famous gallery in the world during the eighteenth century. The Tribuna had been built by Francesco de' Medici in 1585–9 to a design by Bernardo Buontalenti as a showcase for the most precious items in the Medici collection. Although Zoffany has depicted the architectural features of the Tribuna with a fair degree of accuracy, he has rearranged the works of art and in some cases altered their scale. In fact, he has also incorporated a number of paintings from that part of the Medici collection housed in the Palazzo Pitti, as well as including several additional pieces of sculpture. The painter thus successfully gives the gallery a more crowded and undoubtedly richer appearance than it had during the eighteenth century, and by this means has facilitated his rendering of the complicated sightlines of the room and the perspectival inlaid marble decoration of the floor. The setting is therefore somewhat idealised, but it remains a perfectly accurate representation of the significance of the Tribuna for eighteenth-century connoisseurship, with its emphasis on the antique, the High Renaissance, the Bolognese school and Rubens.

Zoffany painted the picture in Florence expressly for Queen Charlotte, beginning in 1772. Much of the composition was completed the following year, but the artist continued working on it intermittently until late in 1777, making changes some of which are now only visible by X-ray. Notable among these changes is the inclusion of a self portrait on the left of the composition, where the artist has shown himself peering round the unframed canvas of the *Virgin and Child* by Raphael. For this purpose, it is almost as if the painter has abandoned his easel, partly visible in the lower right corner of the picture, and walked across or around the back of the room to partake in the discussion. The figures in the picture, all of whom are identifiable (Fig. 51), fall into three groups: those on the left between the sculptures of *Cupid and Psyche* and *Satyr with the Cymbals*; those in the foreground, right of centre, gathered around the *Venus d'Urbino* by Titian; and those on the right around the *Venus de' Medici*. These portraits were meticulously painted by Zoffany and won widespread admiration, although apparently not from George III and Queen Charlotte, who claimed that such recognisable figures were inappropriate to the scene. In essence, however, Zoffany has amalgamated the traditional subject of a gallery view, much exploited by

Flemish painters in the seventeenth century, with the conversation piece evolved by British painters during the eighteenth century, although recently other more cryptic levels of meaning have been sought in the picture.

Royal patronage enabled the artist to have the *Venus d'Urbino* by Titian taken down from the wall for copying after the Grand Duke of Tuscany (Ferdinando I) had specifically decreed that the picture had been copied too much and should not be moved again for such a purpose.

Correspondingly, there are one or two references in the picture to the Royal Collection: the *Virgin and Child* by Raphael, held by the artist, was a work that was offered to George III by Earl Cowper (this is the Niccolini-Cowper Madonna, now in the National Gallery of Art, Washington) and the *Samian Sibyl* by Guercino, seen at the lower edge of the composition, is a pendant to the *Libyan Sibyl* by the same artist bought by George III in the 1760s.[1]

The Tribuna of the Uffizi is a technical *tour de force*. The attention to detail and texture involves not just the portraits, but also the copies after the works of art nearly all of which are identifiable (see Key). Controlled brushwork and careful application are the hallmarks of Zoffany's style, and they are seen at their best in this famous picture without any of the loss of verve that such a long and elaborate undertaking might have forced upon the artist.

Notes: **1** Levey 1991, no. 521.

Literature: Millar 1969, no. 1211; Paulson 1975, pp. 138–48; Pressly 1987, pp. 96–7.

Exhibitions: London 1977, no. 76.

OPPOSITE Johann Zoffany, *The Tribuna of the Uffizi* (detail).

Fig. 51 Key

Portraits

1 George, 3rd Earl Cowper (1738–89), Prince of the Holy Roman Empire. A distinguished collector and devoted lover of Florence.
2 Sir John Dick (1720–1804), Baronet of Braid. British Consul at Leghorn, 1754–76. He is wearing his badge as a Baronet of Nova Scotia and the ribbon and star of the Russian order of St Anne of Schleswig-Holstein; he was nominated 'Chevalier' of the order on 25 March 1774 and received the ensigns early in 1775.
3 Other Windsor, 6th Earl of Plymouth (1751–99). He was in Florence in January, February and June 1772.
4 Johann Zoffany.
5 Charles Loraine-Smith (1751–1835), second son of Sir Charles Loraine, 3rd Bt. He left Florence with Mr Doughty (16) on 14 February 1773.
6 Richard Edgcumbe, later 2nd Earl of Mount Edgcumbe (1764–1839).
7 Mr Stevenson, companion to Lord Lewisham (8) on his travels.
8 George Legge, Lord Lewisham, later 3rd Earl of Dartmouth (1755–1810). Lord of the Bedchamber to the Prince of Wales, 1782–3; Lord Chamberlain, 1804–10. He embarked on a tour of the Continent with Mr Stevenson in July 1775. They were in Florence on 2 December 1777.
9 *Called* Joseph Leeson, Viscount Russborough, 2nd Earl of Milltown (1730–1801). His presence in Florence is only reported in the *Gazzetta Toscana* of 8 August 1778, after Zoffany's departure; and the figure does not

agree in age or appearance with the portrait by Batoni (1751) in the National Gallery of Ireland.
10 Valentine Knightley (1744–96), of Fawsley. He is probably the Knightley who was in Florence in November 1772; and could well be the Knightley who left Florence in March or April 1773.
11 Pietro Bastianelli, a *custode* in the Gallery.
12 John Gordon. The *Gazzetta Toscana* reported on 2 July 1774 that a *sig. Gordon* was in Florence; he was probably identical with *Monsieur Godron Uffiziale Inghilese*, reported in Florence on 13 August 1774.
13 George Finch, 9th Earl of Winchilsea (1752–1826). Gentleman of the Bedchamber, 1777–1812; Groom of the Stole, 1804–12. He was in Florence from December 1772 to late March 1773.
14 Mr Wilbraham (see below, No. 21).
15 Mr Watts. He was reported in Florence on 2 January 1773.
16 Mr Doughty. He was in Florence in February 1773 and left with Loraine-Smith (5) on 14 February.
17 Hon. Felton Hervey (1712–73), ninth son of the 1st Earl of Bristol. Equerry to Queen Caroline of Ansbach and Groom of the Bedchamber to William, Duke of Cumberland. He was in Florence early in September 1772.
18 Thomas Patch (*c*.1725–1782). Painter of caricatures and topographical views. Active in Florence from 1755 until his death.
19 Sir John Taylor (*d*.1786). Recorded in Rome in 1773; perhaps also the Taylor who was

in Florence in November 1772.
20 Sir Horace Mann (1706–86). Famous as the friend and correspondent of Horace Walpole. Early in 1738 he was assisting the British Resident at the court of the Grand Duke of Tuscany and in 1740 he succeeded to the post; he stayed at Florence for another 46 years, as Resident, 1740–65, Envoy Extraordinary, 1765–82, and Envoy Extraordinary and Plenipotentiary, 1782–6. He received the Order of the Bath in 1768.
21 T. Wilbraham. The two gentlemen of this name (see above, No. 14) were perhaps two of the sons of Roger Wilbraham of Nantwich: Thomas (*b*.1751), George (1741–1813) or Roger Wilbraham (1743–1829). The two Mr Wilbrahams are reported in Florence by Lord Winchilsea (13) between December 1772 and 16 February 1773.
22 James Bruce (1730–94). The famous African traveller; he was in Florence in January 1774.

Paintings

23 Annibale Carracci. *Bacchante.*
24 Guido Reni. *Charity.*
25 Raphael. *Madonna della Sedia.*
26 Correggio. *Virgin and Child.*
27 Sustermans. *Galileo.*
28 Unidentified. Conceivably the old copy (in the Uffizi) of Rembrandt's *Holy Family* in the Louvre.
29 School of Titian. *Madonna and Child with Saint Catherine.*
30 Raphael. *Saint John.*
31 Guido Reni. *The Madonna.*
32 Raphael. *Madonna del Cardellino.*
33 Rubens. *Horrors of War.*
34 Franciabigio. *Madonna del Pozzo.*

35 Holbein. *Sir Richard Southwell.*
36 Lorenzo di Credi. *Portrait of Verrocchio;* now described as a portrait of Perugino by Raphael.
37 Now attributed to Niccolò Soggi. *Holy Family.*
38 Guido Reni. *Cleopatra.*
39 Rubens. *The Painter with Lipsius and his pupils.*
40 Raphael. *Leo X with Cardinals de' Medici and de' Rossi.*
41 Pietro da Cortona. *Abraham and Hagar.* Now in the Kunsthistorisches Museum, Vienna.
42 School of Caravaggio. *The Tribute Money.*
43 Cristofano Allori. *The Miracle of Saint Julian.*
44 Unidentified. *Roman Charity.*
45 Raphael, 'Niccolini-Cowper' *Madonna,* formerly at Panshanger and now in Washington.
46 Guercino. *The Samian Sibyl.*
47 Titian. *The Venus of Urbino.*
Of these Nos. 24, 25, 27, 29, 33, 38, 39, 42, 43 and 46 are now in the Palazzo Pitti, Florence.

Statues

48 The *Arrotino* or *Scita Scorticatore.*
49 *Cupid and Psyche.*
50 *The Satyr with the Cymbals.*
51 *Hercules strangling the Serpent.*
52 *The Wrestlers.*
53 *The Venus de' Medici.*

Objects on the Floor

54 South Italian or Apulian *cratere,* 4th century B.C.
55 Etruscan helmet.
56 The Etruscan Chimera.
57, 58, 59 Roman *lucernae.*
60 Egyptian Ptahmose, XVIIIth dynasty.
61 Greek bronze torso.
62 Bust of Julius Caesar.
63 Silver shield of the Consul Flavius Ardaburius Aspar.
64 Bronze head of Antinous.
65 South Italian *cratere.*
66 Etruscan jug.
67 South Italian *situla.*
Nos. 54, 55, 56, 60, 61, 63, 64, 65, 66, 67 are in the Museo Archeologico, Florence; No. 57, is in the Bargello, Florence; and No. 62 in the Uffizi, Florence.

Objects on the Shelves

(Many remain unidentified)
68 Bust of 'Plautilla'.
69 Small female head.
70 Head of Tiberius in jaspar, on gold mount of the sixteenth century.
71 Bust of 'Annius Verus'.
72 Bust of an unknown boy, the 'Young Nero'.
73 Bronze figure of Hercules.
74 Small Egyptian figure.
75 Bronze *Arion* by Bertoldo di Giovanni.
No. 75 is in the Bargello, Florence; Nos. 69, 70, 74 are in the Museo degli Argenti, Florence; No. 73 is in the Museo Archeologico, Florence; and Nos. 68, 71, 72 are in the Uffizi, Florence.
76 Octagonal table made by Ligozzi and Poccetti, now in the Opificio delle Pietre Dure, Florence.

Johann Zoffany, *The Tribuna of the Uffizi* (No. 61).

JOHANN ZOFFANY c. 1733–1810

62 *Prince Ernest Gottlob Albert of Mecklenburg-Strelitz*

Canvas, 125.7 × 100.3 cm (49½ × 39½ in.)

ZOFFANY was born near Frankfurt-am-Main and in 1760 travelled to England, where he won success as a painter of conversation pieces and theatrical scenes. He was extensively patronised by George III and Queen Charlotte, although he had no official connection with the court. Zoffany was nominated personally by George III in 1769 for membership of the newly founded Royal Academy, where he exhibited between 1770 and 1800. The artist was absent from England for two long periods: firstly in Italy from 1772 to 1778 and secondly in India from 1783 to 1789.

Sir Ellis Waterhouse wrote: 'It is not surprising that George III should have shown an appetite for the work of a painter who was both a German and a limner of domesticity,'[1] and it is true that some of Zoffany's most captivating work was done for the Royal Family, for example, *Queen Charlotte and her Two Eldest Sons* of 1771. Like the conversation pieces, many of the single portraits are imbued with a surprising degree of informality implied more by the pose than the finish, which is always meticulous. Both qualities are apparent in the portrait of *Prince Ernest Gottlob Albert of Mecklenburg-Strelitz*, where the sitter leans nonchalantly against a chair and looks away from the viewer. The figure is sharply lit from the right, but set against a dark background. The coiffure, the facial features and the uniform are all carefully and precisely modelled, but in such a way that the technical skill heightens the effect of the characterisation.

Prince Ernest of Mecklenburg-Strelitz (1742–1814) was the youngest brother of Queen Charlotte. He is depicted in Hanoverian military uniform, wearing the ribbon and star of the Polish Order of the White Eagle. He was a keen soldier and in 1788 George III appointed him General of Infantry in the British Army. The portrait was probably painted for Queen Charlotte in the spring of 1772 as the sitter had returned to Hanover by May. He is also depicted standing on the right of the group portrait of *Queen Charlotte with Members of her Family* (Fig. 52).[2]

Fig. 52 Johann Zoffany, *Queen Charlotte with Members of her Family, c.* 1772, oil on canvas, 105.1 × 127 cm, The Royal Collection.

Notes: **1** Waterhouse 1962, p. 219. **2** Millar 1969, no. 1207.

Literature: Millar 1969, no. 1208.

THOMAS GAINSBOROUGH 1727-1788

Johann Christian Fischer

Canvas, 228.6 × 150.5 (90 × 59¼ in.)

JOHANN CHRISTIAN FISCHER (1733–1800) was an outstanding musician. He was born in Germany at Freiburg-im-Breisgau and played for a time in the court band at Dresden before entering the service of Frederick the Great. On coming to London, where he is first recorded on 2 June 1768, he became a member of Queen Charlotte's Band and played regularly at court. His performance of Handel's fourth oboe concerto during the Handel Commemoration at Westminster Abbey in 1784 gave particular pleasure to George III. Regardless of such successes, he failed in 1786 to secure the post of Master of the King's Band. He collapsed in 1800 while playing in a concert at court and died shortly afterwards.

Fischer was a composer and virtuoso oboist. His two-keyed oboe is visible on the harpsichord-cum-piano against which the musician leans. Fanny Burney praised the 'sweet-flowing, melting celestial notes of Fischer's hautboy,' but the Italian violinist Felice de' Giardini (1716–93) referred to Fischer's 'impudence of tone as no other instrument could contend with.' In the portrait on the chair behind Fischer is a violin, on which he was apparently also an accomplished performer although only in private. The harpsichord-cum-piano, made by Joseph Merlin who came to London from the Netherlands in 1760 and established a successful business in the production of pianofortes, presumably refers to his abilities as a composer, as no doubt do the piles of musical scores.

This portrait of *Johann Christian Fischer* stands as testimony to Gainsborough's own love of music. The artist preferred the company of actors, artists, dramatists and musicians to that of politicians, writers or scholars, and was himself a talented amateur musician in addition to being a painter. Gainsborough once wrote to William Jackson: 'I'm sick of Portraits and wish very much to take my Viol da Gamba and walk off to some sweet Village when I can paint Landskips and enjoy the fag End of Life in quietness and ease.'[1] Yet some of his finest portraits are of musicians and include, in addition to that of Fischer, the composer *Karl Friedrich Abel* (San Marino, Henry E. Huntington Library and Art Gallery) and *Johann Christian Bach* (Bologna, Museo Civico, Bibliografico Musicale). These two portraits date from the late 1770s, whereas that of *Johann Christian Fischer* was exhibited at the Royal Academy in 1780.

Gainsborough seems to have known Fischer while he was still living in Bath (Fischer moved permanently to London in 1774). As early as 1775 Fischer evinced an interest in the artist's elder daughter Mary (1748–1826), whom he married at St Ann's Church, Soho, on 21 February 1780. The wedding was agreed to reluctantly by Gainsborough, who, although he admired Fischer as a musician, perhaps hoped that his elder daughter might make a better marriage, and lodged doubts about the musician's character. He wrote to his sister on 23 February 1780: 'I can't say I have any reason to doubt the man's honesty or goodness of heart, as I never heard anyone speak anything amiss of him; and as to his oddities and temper, she must learn to like as she likes his person, for nothing can be altered now. I pray God she may be happy with him and have her health.'[2] The marriage did not last and Mary gradually became insane.[3] Whatever tensions Gainsborough might have been experiencing with regard to Fischer's relationship with his daughter, Gainsborough's portrait is masterly in its compositional sophistication, use of colour and sympathetic characterisation. It is clear, however, that the likeness has been painted over another portrait which will no doubt be revealed by X-ray. The portrait came into the Royal Collection indirectly. It appears to have been painted for Willoughby Bertie, 4th Earl of Abingdon (died 1799), a radical politician and a talented amateur musician, but was sold by his successor. Eventually it was acquired by Ernest, Duke of Cumberland, who in 1809 presented it to his brother, the Prince of Wales (later George IV). Both were admirers of Gainsborough's work.

Notes: **1** *Gainsborough Letters*, 1963, no. 56, p. 115. **2** Ibid., no. 40, pp. 85–7. **3** Belsey 1988, p. 29.

Literature: Millar 1969, no. 800; Hayes 1975, pp. 14–15 and 220, no. 95; Wilson 1977, pp. 109–10.

Exhibitions: London 1977, no. 10; London 1980–1, no. 126.

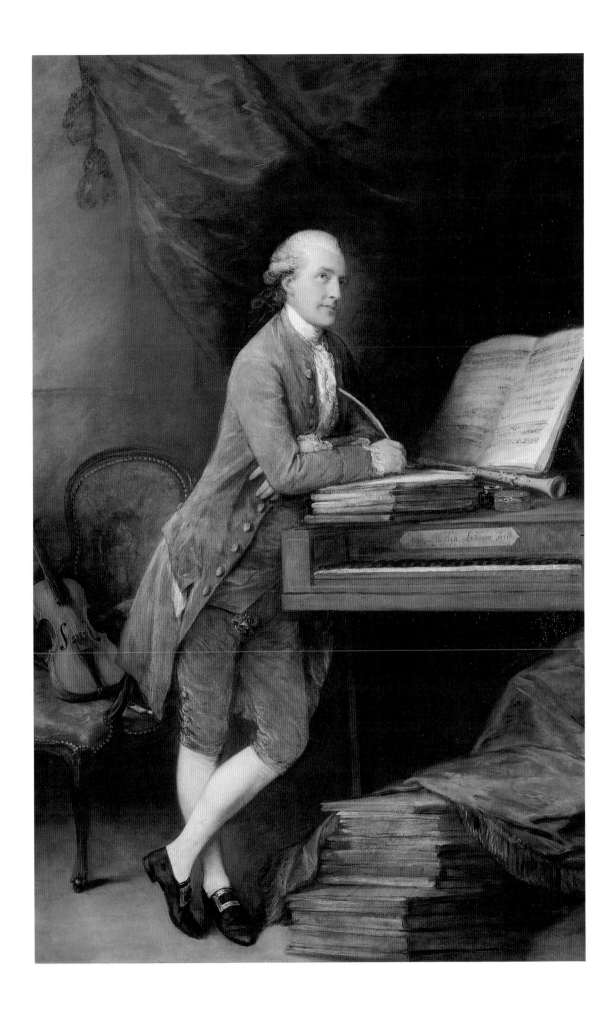

64 *Edward III crossing the Somme*

Canvas, 137.2 × 149.9 cm (54 × 59 in.)
Signed and dated: *B. West. 1788*
Cleaned 1988–9

THE American artist, Benjamin West, arrived in England in 1763, after spending three years in Italy. He quickly gained the patronage of George III, for whom he became Historical Painter in 1772 carrying out a number of projects, especially at Windsor Castle, involving classical, historical and religious subjects. West was a founding member of the Royal Academy of Arts in 1768 and succeeded Sir Joshua Reynolds as President in 1792.

A series of eight paintings illustrating events from the reign of Edward III was commissioned from West by George III to decorate the Audience Chamber at Windsor Castle. The task took three years to complete from 1786 to 1789, but the arrangement was dismantled by George IV during the mid-1820s when much of Windsor Castle was redesigned by Jeffry Wyatville. However, a view of the Audience Chamber with the pictures still in place is included in W. H. Pyne's *The History of the Royal Residences* of 1819 (Fig. 25, page 38).[1] The present painting was double-hung on the left of the throne balancing *The Burghers of Calais* on the right, positioned above the door.

The series illustrates Edward III's campaign in northern France during the summer of 1346. *Edward III crossing the Somme* is the first in the sequence and shows an incident preceding the Battle of Crécy, when the king was trying to cross the River Somme at Blanche Tache, near Abbeville, in order to escape the French army. Edward III encountered and engaged a part of the French force under Godemar de Faye, the outcome of which, like the Battle of Crécy itself, was dependent upon the skill of the English archers seen in the upper right of the composition. The king is on horseback just to the right of centre and the figures accompanying him can be identified with the aid of a key provided by the artist for George III. An oil sketch of the composition is in the Santa Barbara Museum of Art, California (Fig. 53).

A subject taken from medieval history was an unusual choice for this date. According to West's earliest biographer, John Galt, it was George III who, 'recollecting that Windsor Castle had, in its present form, been created by Edward the Third, said, that he thought the achievements of his splendid reign were well calculated for pictures, and would prove very suitable ornaments to the halls and chambers of that venerable edifice.' In addition to his military prowess, Edward III had also been the founder of the Order of the Garter that is so closely associated with Windsor Castle. The paintings by West must be seen, therefore, as part of a revival of interest in the Middle Ages that was being pioneered by antiquarians such as Joseph Strutt[2] and Francis Grose,[3] to whose works the artist clearly referred for details of the arms, armour, and dress. For the historical narrative the primary sources in English were an early translation of the *Chronicles* (1325–1400) of Jean Froissart[4] and the *History of England* (1754–62) by David Hume. West's work showed that ideal truth could be sought in themes unrelated to antiquity, and his lively treatment of such subject matter reveals his innovative qualities as an artist.

Fig. 53 Benjamin West, *Sketch for Edward III crossing the Somme*, 1788, oil on canvas, 43.5 × 55.2 cm, Santa Barbara Museum of Art.

Notes: **1** W. H. Pyne, *The History of the Royal Residences*, 1, 1819, pp. 166–7. **2** Joseph Strutt, *Honda Angel-cynnan or, A compleat View of the Manners, Customs, Arms, Habits etc. of the Inhabitants of England, from the Arrival of the Saxons till the Reign of Henry the Eighth*, 1774–6. **3** Francis Grose, *Treatise on Ancient Armour and Weapons*, 1786. **4** J. Froissart, *Chronicles*, English translation 1523–5, chapter CXXVII.

Literature: Millar 1969, no. 1158; Strong 1978, pp. 79–85; Girouard 1981, pp. 19–20; Erffa and Staley 1986, pp. 192–3, no. 56.

Exhibitions: Baltimore 1989, no. 32.

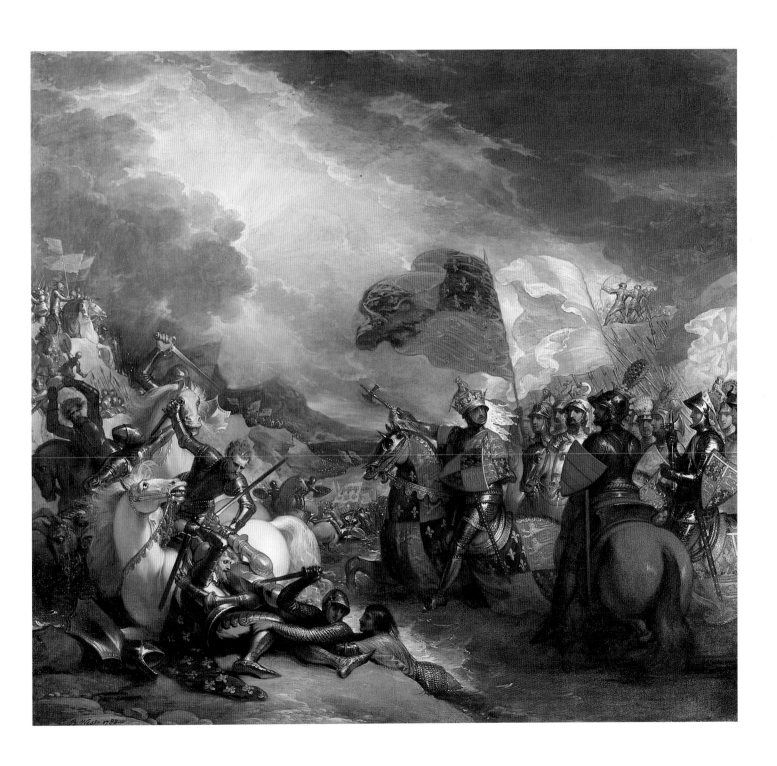

SIR JOSHUA REYNOLDS 1723–1792

65 *Francis Rawdon-Hastings, 2nd Earl of Moira and 1st Marquess of Hastings*

Canvas, 240 × 147.9 cm (94½ × 58¼ in.)

THE PORTRAIT was painted for Frederick, Duke of York, at whose sale it was acquired by George IV for £72 9s. (Christie's, 7 April 1827, lot 107). According to the artist's pocket-book, the work was begun in June–July 1789. It was still in progress in September when a newspaper report commented on 26 September 1789: 'Lord Rawdon's *head* is done – and, what is extraordinary with Sir Joshua, in two sittings. The figure, drapery, and landscape are sketched out, and in their first colour – so may be safely as well as easily finished.'[1] A record of payment exists dated May 1790, when the portrait was exhibited at the Royal Academy. An engraving was issued in 1792. Evidence of changes made by Reynolds can be seen in the outline of the hat and the arrangement of the curtain wrapped around the tree, while the initial painting of the sky can be detected beneath the trees in the middle distance and in the far landscape.

Reynolds had the keenest intelligence of any painter working in eighteenth-century Britain. His appointment as the first President of the Royal Academy in 1768 was as much a reflection of his intellectual powers as of his abilities as an artist, as indicated by the Discourses on Art addressed to the students of the Academy between 1769 and 1790. In addition, a considerable amount is known of his working practices over the years owing to the survival of many of his pocket-books, quite apart from knowledge of his personality and conversation as recorded in James Boswell's *Life of Johnson* (1791). Yet, with all those advantages, Reynolds failed to please George III and Queen Charlotte. Although he was granted the position of Principal Painter to the King in 1784 in succession to Allan Ramsay, it was said that 'The King and Queen could not endure the presence of him; he was poison to their sight.'

This portrait of the Marquess of Hastings (1754–1826) dates from near the end of the artist's life when his eyesight (like his hearing) had begun to fail. Indeed, a note in his pocket-book of 13 July 1789 records that his eye 'began to be obscured', and it seems likely that this portrait was one of the last he painted with a sitter in front of him. Yet, Reynolds, in spite of such difficulties, created with seeming ease an heroic image. The tall figure posed against a tree is framed by the swirling smoke of battle echoed by the twisted curtain. His sword and hat are silhouetted against the background. The stance, with the right leg thrust forward and the hand

raised to the chin as though in conversation, suggests a certain confidence in the face of danger. The figure is alert but dignified.

The Marquess of Hastings is shown wearing the undress uniform of a Colonel and ADC to George III, the rank he held from 1782 until 1793. He was a soldier and statesman close to both the Prince of Wales and the Duke of York. His military service was undertaken in America during the War of Independence, in Brittany and the Netherlands. Appointed Master of Ordnance (1806–7), he was also made Governor of Bengal from 1813 to 1822 and Governor of Malta in 1824. He died at sea. Reynolds's portrait of *George IV when Prince of Wales with a Page* (now at Arundel Castle, Sussex) was presented to the Marquess of Hastings by the Prince of Wales as a mark of friendship in 1810.

Notes: **1** Quoted in A. Graves and W. V. Cronin, *A History of the Works of Sir Joshua Reynolds*, II, London 1899, p. 784.

Literature: Millar 1969, no. 1023.

Exhibitions: London 1986, no. 153.

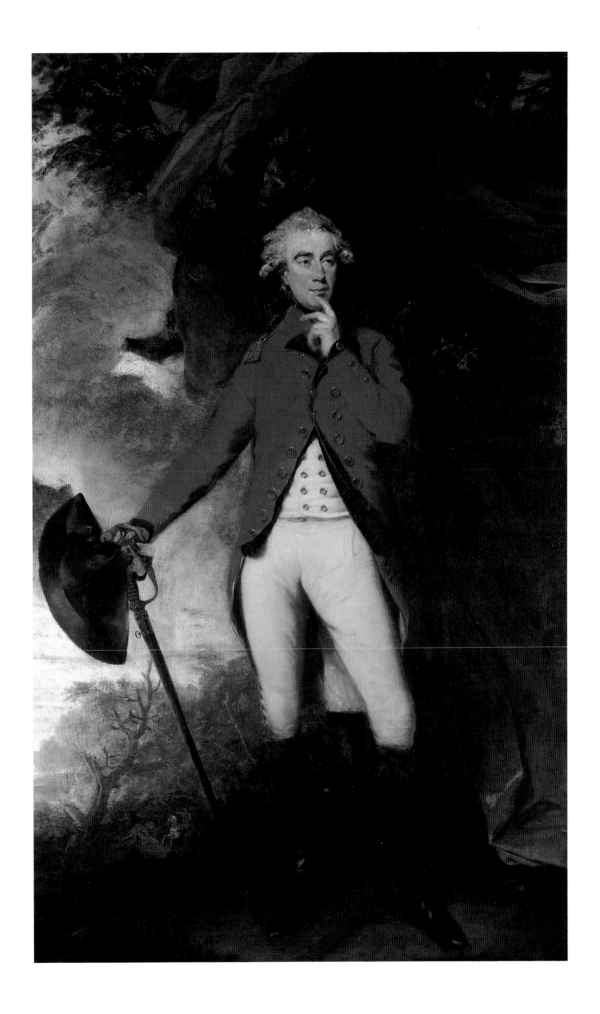

GEORGE STUBBS 1724–1806

William Anderson with two Saddle-horses

Canvas, 102.2 × 127.9 cm (40¼ × 50⅜ in.)
Signed and dated lower centre: *Geo: Stubbs p:/1793*

THERE ARE eighteen paintings by Stubbs in the Royal Collection, all of which were almost certainly commissioned by George IV, or else acquired by him. Seventeen of these date from the early 1790s when Stubbs seems to have been particularly busy on behalf of his royal patron, to the extent that many of his pictures are recorded as being in store at Carlton House. A bill dated 14 February 1793 for frames made by Thomas Allwood reads: 'To Carving & Gilding eight Picture frames of half length size for sundry Pictures painted by Mr Stubbs. all of one pattern.' This is endorsed by Stubbs and the amount charged was £110 16s. 0d. The frame around the present picture is one of those made by Allwood.

William Anderson began as helper and hack-groom to George IV, when Prince of Wales, from 1788 to 1800, but he was appointed head groom in 1804 and finally Groom of the Stables in 1812. He wears royal livery – a scarlet coat with blue hat, collar and cuffs. The real subject of the painting, however, is not so much Anderson as the two chestnut horses of which George IV was particularly fond. A letter of 15 April 1790 from the Prince of Wales to his sporting companion, Sir John Lade, states: 'I have driven every day of late the chestnut horses wh. go better than any horses I have belonging to me.'[1] The prince himself is shown riding a chestnut horse in a portrait by Stubbs, painted two years before the present painting (Royal Collection).[2]

William Anderson with two Saddle-horses is a painting of outstanding quality. The composition is deceptively simple with the overlapping flanks of the two horses, silhouetted against the sky, fused in a memorable pattern. The emphasis throughout is on the horizontal and the only firm vertical is Anderson himself, rigid in the saddle of the leading horse. The languorous rhythm of the horses in the foreground of the picture is offset by the large expanse of sky, which takes up as much as three-quarters of the canvas, and by the flat rolling landscape contained within the remaining quarter. Stubbs achieves a moving, almost poetic, balance within the picture which should not be seen simply as an exercise in design. The artist uses his knowledge of anatomy in the depiction of the horses and there is a surprising variety of observation in the treatment of the clouds, the glimpse of the sea on the left, the copse and the burdock plants in the right fore-ground. The sea suggests that Anderson is shown riding near Brighton, a resort which the Prince of Wales first visited in 1783 and where he leased property in 1786 that was by degrees enlarged, originally by Henry Holland and then John Nash, to become the Royal Pavilion. The town became highly fashionable and had the added advantage of having a racecourse. In 1807–8 a stable block was added to the Pavilion with room for fifty-four horses. Domestic accounts record that Anderson was billetted in Brighton for twelve days in 1793 in addition to his work at Windsor. The second horse in the painting has presumably been saddled for the Prince of Wales.

Notes: **1** *The Correspondence of George, Prince of Wales, 1770–1812*, ed. A. Aspinall, II, London 1964, p. 247. **2** Millar 1969, no. 1109.

Literature: Millar 1969, no. 1110.

Exhibitions: London 1984–5, no. 133.

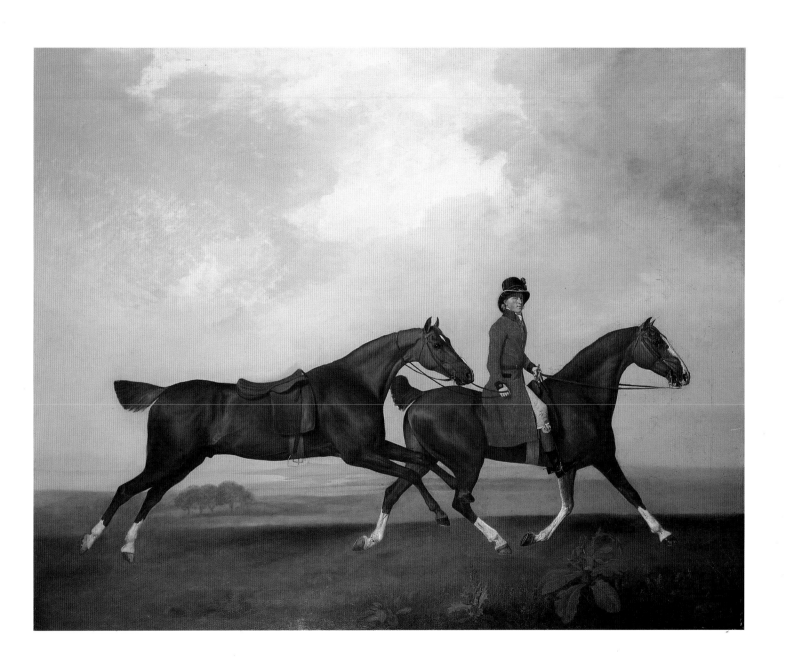

SIR THOMAS LAWRENCE 1769–1830

67 *Pope Pius VII*

Canvas, 269.2 × 177.9 cm (106 × 70 in.)

PIUS VII (1742–1823) was the most famous Pope of the nineteenth century; he was also the most widely recognised man in that century, apart from Napoleon I. Born Luigi Barnaba Chiaramonti, he was elected Pope in 1800. Although he was present at Napoleon's coronation in Paris in 1801, Pius VII later excommunicated him and was captured by the French three years later and held at Fontainebleau until 1814. He is noted for his essentially passive resistance to the French emperor, epitomised by the Concordat of 1801 between France and the Papacy, but it was nonetheless a policy that was tenaciously and effectively pursued. After the final defeat of Napoleon in 1815, Pius VII was identified with the emerging nationalist movement in Italy – the Risorgimento – and the renewal of catholicism in Europe. By concentrating on restoring the buildings of Rome and by consolidating the famous collections in the city so recently pillaged by Napoleon, Pius VII enabled Rome to become the spiritual and cultural capital of Europe.

Lawrence was commissioned to paint the Pope by George IV, when still Prince Regent, as part of a series of portraits of those European heads of state, soldiers and diplomats associated with the downfall of Napoleon. The project was begun by Lawrence in 1814, but the twenty-five or so portraits preoccupied him for the rest of his life and, indeed, some remained unfinished at his death. Originally, it was intended to hang the portraits in Carlton House, but after this was pulled down in 1826 it was decided to create the Waterloo Chamber in Windsor Castle, which was part of the large rebuilding programme in the Castle undertaken by Jeffry Wyatville. Owing to the king's own death in 1830, the contents of the Waterloo Chamber were actually installed by William IV.

Lawrence travelled extensively in Europe – to Aix-la-Chapelle, Vienna and Rome – in order to obtain sittings for the portraits. He was in Rome from May to December 1819, staying in the Quirinal Palace, and between 18 May and 21 September he painted Pius VII and his personal adviser, Ercole, Cardinal Consalvi, whose portrait is also included in the Waterloo Chamber. With both sitters Lawrence felt an immediate rapport. A version of his portrait of *The Prince Regent in Garter Robes* was sent to Pius VII by George IV after the artist returned to London. It is still in the Vatican, Rome.

Pope Pius VII has every reason to be called Lawrence's masterpiece and it was recognised as such during the artist's lifetime. Lawrence wrote on 25 June 1819, 'No picture that I have painted has been more popular with the friends of its subject, and the public . . . and, according to

my scale of ability, I have executed my intention: having given him that expression of unaffected benevolence and worth, which lights up his countenance with a freshness and spirit, entirely free (except in the characteristic paleness of his complexion) from that appearance of illness and decay that he generally has when enduring the fatigue of his public functions.'

Pius VII is shown on the papal throne, or *sedia gestatoria*, on which he was carried in procession. His coat-of-arms with his motto PAX are visible on the finials of the throne. He holds a paper in his left hand marked *Per/Ant°. Canova*, who was appointed Prefect of the Fine Arts in Rome by Pius VII and created Marchese d'Ischia. In the background on the left is a view of the unfinished Braccio Nuovo, built to house some of the finest antiquities in the Vatican collections – the Apollo Belvedere, the Laocoön and the Torso Belvedere are visible. The setting is, therefore, as important as the characterisation, but above all there is the sheer brilliance of Lawrence's sense of colour and brushwork, as, for example, in the depiction of the pope's hands or his slippers raised on the stool. The significance of this portrait of Pius VII is only fully grasped if it is appreciated that Lawrence was working in a well-established tradition extending from the portraits of Julius II by Raphael (London, National Gallery), Paul III by Titian (Naples, Capodimonte) and Innocent X by Velázquez (Rome, Doria-Pamphili). Lawrence was not overwhelmed by these inevitable comparisons and his achievement is such that he can be accorded a prominent place alongside these outstanding portrait painters.

Literature: Millar 1969, no. 909; Levey 1975, pp. 194–204; Olson 1986, pp. 77–93; Garlick 1989, p. 253, no. 650.

Exhibitions: London 1979–80, no. 38.

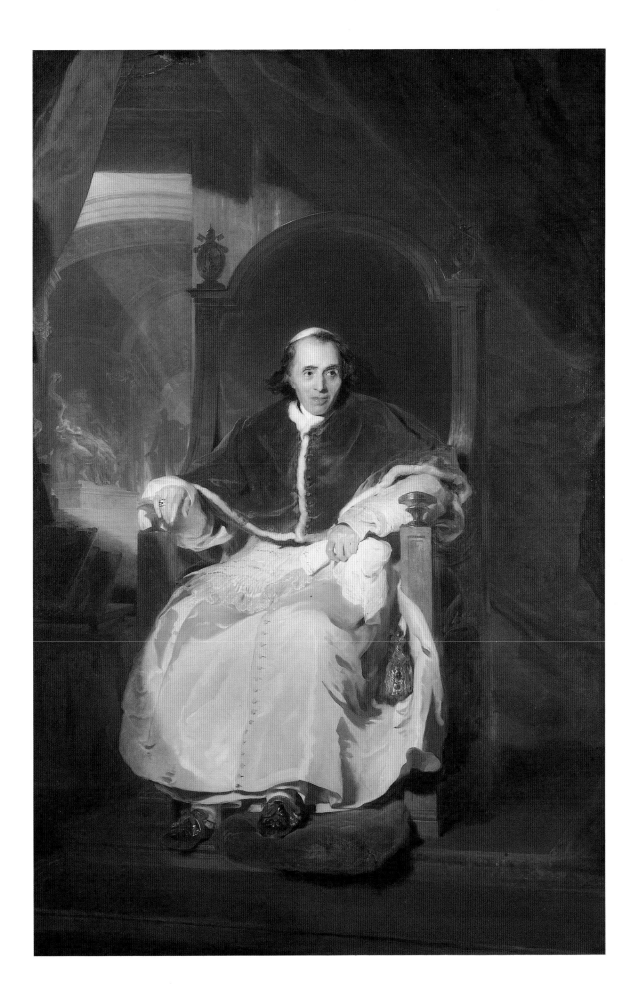

SIR DAVID WILKIE 1785–1841

68 The Defence of Saragossa

Canvas, 94 × 141 cm (37 × 55½ in.)
Signed and dated: *David Wilkie. Madrid 1828*

THE ARTIST had a distinguished career within royal circles, succeeding Sir Henry Raeburn as Limner to George IV for Scotland in 1823 and Sir Thomas Lawrence as Principal Painter to the king in 1830. He held this second post during the reigns of William IV and Queen Victoria, but it was George IV who particularly admired Wilkie's genre subjects and history paintings and he acquired works in both categories.

The Defence of Saragossa forms part of a group of four paintings purchased by George IV in 1829–30 and still in the Royal Collection. The other paintings are *The Spanish Posada: a Guerilla Council of War*, *The Guerilla's Departure* and *The Guerilla's Return*. Of these *The Spanish Posada* and *The Guerilla's Departure* were painted while the artist was in Madrid between October 1827 and May 1828. The present painting appears to have been unfinished since Wilkie wrote to his sister on 31 March 1828: 'I am now proceeding with my *third* picture for the season . . . The Defence of Saragossa This picture all my kind friends wish I could have finished here, but the tour to the south, and my anxiety to have these pictures early in London, prevents me.' These three pictures were exhibited at the Royal Academy in 1829, by which time George IV had seen the sequence of paintings and commissioned a fourth subject, *The Guerilla's Return*, which was exhibited at the Royal Academy the following year. Of the four paintings the king preferred *The Spanish Posada*, although the present painting is undoubtedly the most striking of the group. A compositional drawing for *The Defence of Saragossa* with some variations is dated 29 November 1827 (Fig. 54).

The four paintings illustrate a decisive moment in the development of Wilkie's style. His early reputation had been based on genre pictures, mainly of scenes from Scottish life painted in the tradition of Teniers or Ostade, but an extended visit to the Continent in 1825–8, prompted by illness and the need for fresh inspiration, enabled the artist to study the works of major European painters, encouraging him to undertake more expansive historical subjects such as *The Defence of Saragossa*. Here the bolder composition – conceived on a larger scale – the vigorous handling and fresher colouring are clearly evident. These new aspects of Wilkie's style were derived from his attentive examination of works by Titian, Rubens, Velázquez and Murillo while on the Continent and particularly in Spain.

The subjects of the four pictures acquired by George IV were inspired by the Spanish insurrection against Napoleon's occupying force. The Spanish defiance of the French is a theme widely recorded in contemporary prose and poetry, partly as a result of the role played by the Duke of Wellington in the Peninsular War of 1808–14. Of the paintings by Wilkie three are imaginary, but *The Defence of Saragossa* is based on a specific incident when the French laid siege to the city from June to August 1808. The composition depicts the Spanish guerilla leader, Don José Rebolado Palafox y Melci (1775–1847), and the Augustinian friar, Father Consolacion, who together have aimed the gun on the French column at the Convent of Santa Engracia, near the Portillo Gate. The moment shown is that when Agostina Zaragoza, the wife of the gunner dying in the lower left corner, seizes the lighted match and fires the gun at the encroaching forces. Wilkie was able to study the head of Palafox from life while he was in Madrid (Palafox was also painted by Goya [Madrid, Prado]). The priest, Boggiero, another hero of the Spanish resistance, is seen writing a dispatch on the left. Wilkie also discussed his ideas for these pictures with Delacroix in Paris on his return journey from Spain. Indeed, *The Defence of Saragossa* has been described by one writer as 'this country's answer to Delacroix's *Liberty at the Barricades*'.[1] The heroine of the picture, known thenceforth as the Maid of Saragossa, became a celebrity in Europe, and Byron extols her heroism in the first canto of *Childe Harold's Pilgrimage* (stanzas 54–9).

Notes: **1** D. B. Brown, *Sir David Wilkie. Drawings and Sketches in the Ashmolean Museum, Oxford*, London 1985, p. 9.

Literature: Millar 1969, no. 1180; Altick 1985, p. 438.

Exhibitions: Raleigh/New Haven 1987, no. 30.

Fig. 54 Sir David Wilkie, *Study for the Defence of Saragossa*, 1827, watercolour, 180 × 230 mm, Blackburn Museum and Art Gallery.

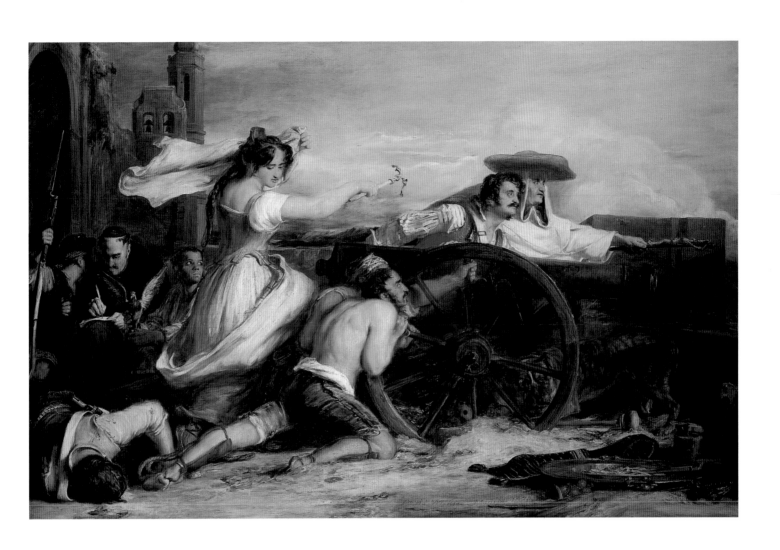

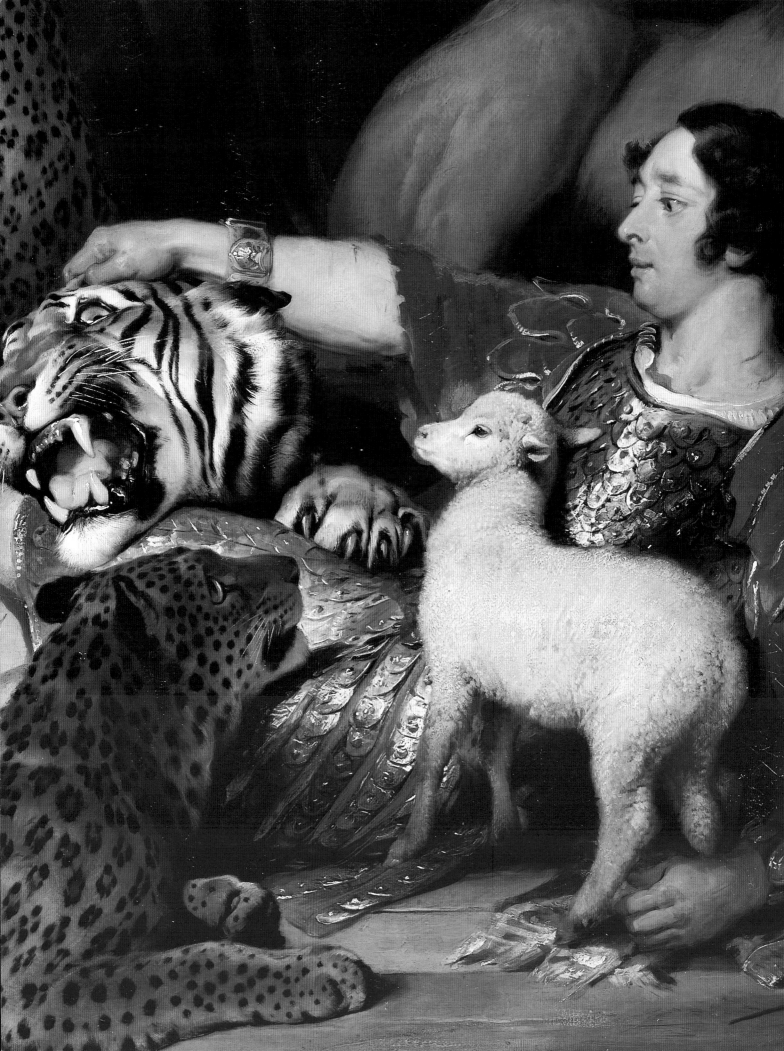

Queen Victoria and Prince Albert (1)

QUEEN VICTORIA (1837–1901) and Prince Albert (from 1857 Prince Consort) approached art in a strictly practical way. The most detailed inventory of the Royal Collection ever made was undertaken in 1857 by Richard Redgrave as Surveyor of The Queen's Pictures; limited access was granted to the pictures, which were often lent to exhibitions; and catalogues were published. The influence of Prince Albert is evident in all of this and he played an active role in formulating official policy towards the promotion of the arts in Britain, advocating a closer relationship with education and the manufacturing industries. Both Queen Victoria and Prince Albert drew and painted, as well as taking a serious interest in the history of art.

Queen Victoria was a fervent and occasionally critical supporter of contemporary British painting. She often visited the annual exhibition at the Royal Academy where she saw work by artists like Frith (No. 74), Holl (No. 76), Paton (No. 75), Roberts (No. 72) and Butler (No. 77), whose paintings have a strong narrative content based on contemporary scenes and sometimes related to specific events.

Certain painters were patronised by Queen Victoria and Prince Albert over a long period, and by the queen alone after the Prince Consort's death in 1861. Landseer specialised in animal painting (No. 69) and scenes inspired by the Scottish Highlands (No. 70); Swoboda recorded the queen's interest in India (No. 79); Winterhalter and the Danish artist, Tuxen (No. 78), painted those special family occasions that punctuated the latter part of the queen's life with such daunting regularity. Before the end of the reign, however, photography had asserted itself as a challenge to traditional painting.

OPPOSITE Sir Edwin Landseer, *Isaac van Amburgh* (No. 69, detail).

SIR EDWIN LANDSEER 1803–1873

Isaac van Amburgh and his Animals

Canvas, 113 × 174.6 cm (44½ × 68¾ in.)
Inscribed on the back with the name of the artist and title
Dated on the back: *1839*
Cleaned 1990–1

LANDSEER was greatly admired as a painter of animals and to a certain degree his reputation rests on such pictures. Indeed, it was as an animal painter that he first came to the attention of Queen Victoria in 1836. Landseer's particular skills lay not just in accurate drawing (based on his early experience of dissection) and a convincing rendering of the characteristics of animals, but also in his ability to incorporate them into compositions. This was done in such a way that their presence often buttressed the narrative – if it was not historical – with a moralising or allegorical dimension. Interestingly, when the present picture was engraved by J. Scott it was entitled *Dominion*.

Queen Victoria shared Landseer's fascination with animals. Isaac van Amburgh was an American lion-tamer of Dutch extraction whose performances at theatres like Drury Lane and Astley's enthralled Londoners. The queen visited Van Amburgh's display at least five times during the first two months of 1839, much to the consternation of the actor, William Macready, who later became manager of Drury Lane. 'One can never see it too often,' she recorded in her *Journal* on 29 January 1839. During the same period she observed Landseer's progress on the painting. The compositional feature that struck Queen Victoria most forcibly was the positioning of the viewer inside the cage with the spectators visible through the bars. Van Amburgh reclines in the cage surrounded by a tiger, a lion, a lioness and two leopards. He wears a coat of mail, presumably not as a form of protection but perhaps, judging by the footwear, as a form of costume (part Roman and part medieval). There are scratches on the skin of his right forearm and on his neck. The sheen on the coats of the animals reveals Landseer's superb technique, as in the balance between the underpaint and the highlight on the lioness, or the spots visible beneath the top layer of paint on the two leopards. Next to Van Amburgh is a lamb which no doubt heightened the drama of the performance, but it might also be seen as a biblical reference, as in the late work *The Lion and the Lamb* of 1871 (Johannesburg Art Gallery).

The lion behind Isaac van Amburgh brings to mind the four bronze lions that were commissioned from Landseer towards the end of his life for the base of Nelson's column in Trafalgar Square. The original commission was given to the artist in 1857, but it preoccupied him for ten years and the lions were unveiled in January 1867.

Literature: Millar 1992, no. 410.

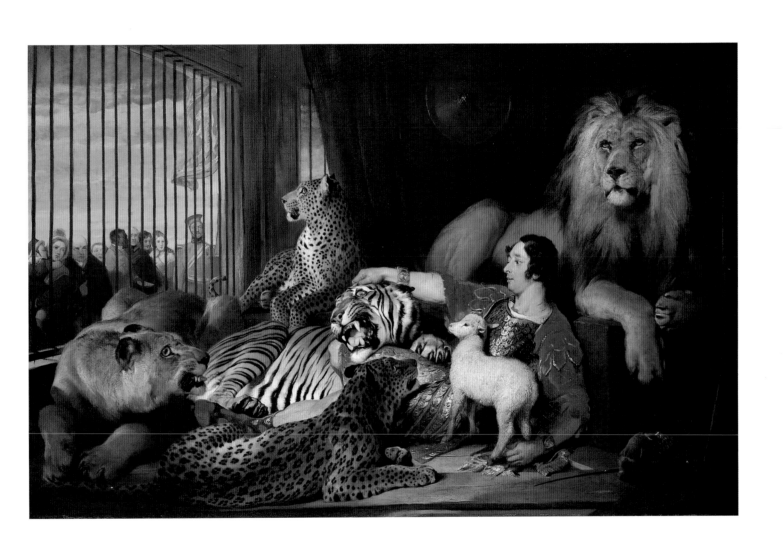

SIR EDWIN LANDSEER 1803–1873

70 The Sanctuary

Canvas, 61.3 × 152.7 cm (24⅛ × 60⅛ in.)

ONE of Landseer's main sources of inspiration was the Highlands of Scotland, which he first visited in 1824. The history of the Highlands, the landscape and the wild life, as well as the lives of the people, dominated his work for several decades. This intensified after Queen Victoria and the Prince Consort visited the Highlands for the first time in 1842. Balmoral Castle was leased in 1848 and subsequently bought in 1852. *The Sanctuary* was exhibited at the Royal Academy in 1842 and acquired by William Wells, who was one of Landseer's chief patrons and a close friend of the artist. The picture was purchased by Queen Victoria from Wells for £215 as a birthday gift for Prince Albert on 26 August. The queen lent it to the Exposition Universelle in Paris of 1855, which she attended while in France with Prince Albert as the guest of Emperor Napoleon III.

The setting is Loch Maree, a lake twelve miles long in the county of Ross and Cromarty on the west coast of Scotland. A stag has swum across the loch. Its course is evident in the curving line of wash in the water, which forms a diagonal that is countered by another established by the ducks, which have been disturbed by the approach of the stag and fly towards the sunset. It is dusk and Landseer has skilfully combined the dying sunlight with a suggestion of emerging moonlight, thus creating an ethereal effect. There is an evenness of tone throughout the composition, although the artist has used a wide range of colours – blue, orange, red, pink, brown and purple. The highlights in the water and the drops falling from the flanks of the stag are particularly luminous.

The Sanctuary is the first of the deer paintings by Landseer that has symbolic overtones. The subject was inspired by a poem entitled *The Stricken Deer* by a friend of the artist, William Russell, which was published in the catalogue of the Royal Academy exhibition.

> See where the startled wild fowl screaming rise
> And seek in marshalled flight those golden skies.
> Yon wearied swimmer scarce can win the land,
> His limbs yet falter on the water strand.
> Poor hunted hart! The painful struggle o'er,
> How blest the shelter of that island shore!
> There, whilst he sobs, his panting heart to rest,
> Nor hound nor hunter shall his lair molest – *Loch Maree.*

It is clear from these lines that the stag has escaped death and has come to rest in this silent, still landscape. The picture is notable for 'its sublime and mystical conception of nature' and 'its recollection of violence in tranquility'.[1]

Notes: **1** R. Ormond, *Sir Edwin Landseer*, exhibition catalogue, Philadelphia Museum of Art and the Tate Gallery, London 1981, pp. 170–1, no. 121.

Literature: Millar 1992, no. 428.

JOHN MARTIN 1789–1854

71 *The Eve of the Deluge*

Canvas, 142.9 × 218.4 cm (56¼ × 86 in.)
Signed and dated: *J. Martin 1840*

JOHN MARTIN had humble beginnings in Newcastle-upon-Tyne as a herald painter to a coach-builder, and then in London as a painter on china and glass, but he later achieved a great success with his highly imaginative paintings of scenes from a variety of literary sources, particularly the Old Testament. Many of these pictures were executed on a vast scale and were frequently visionary in conception. The impact of Martin's paintings was also enhanced by his use of vivid contrasts in colour, which served to emphasise the grandeur and other-worldliness of his compositions, and the varying thickness of the paint surface. Sir David Wilkie remarked of Martin in a letter of 16 February 1821 to Sir George Beaumont that 'although weak in all those points in which he can be compared with other artists, he is eminently strong in what no other artist has attempted.' Apart from his paintings Martin was also a prolific illustrator and engraver, as well as a practising urban engineer. Owing to its grand scale, elaborate architecture and cataclysmic subject matter, Martin's work has influenced modern cinema as evidenced in films by D. W. Griffith, Cecil B. de Mille, William Wyler and Francis Ford Coppola.[1]

The artist gave drawing lessons to Princess Charlotte, the daughter of George IV, and after her marriage to Leopold, King of the Belgians, he was appointed Historical Landscape Painter. He also hoped to become Historical Painter to William IV and to Queen Victoria, whose coronation he depicted (London, Tate Gallery), but without success. However, it was while Prince Albert was visiting Martin's studio that he saw one of the artist's major works, *The Deluge* (the second version of 1834, present whereabouts unknown),[2] and suggested that the artist paint the related themes – *The Eve of the Deluge* and *The Assuaging of the Waters* – in order to make a series. It would seem, however, that the artist himself had already developed the idea for such a sequence.[3]

The subject of *The Eve of the Deluge* is ultimately based on Genesis 6: 5–8, in which God despairs of man's wickedness on earth and decides to destroy him with the single exception of Noah. The figures on the promontory in the foreground are the patriarchs. The seated figure with a white beard is Methuselah, who is surrounded by the family of Noah. Methuselah instructs Noah to open the scroll written by his father, Enoch, so that he can compare the signs in the sky (sun, moon and comet) with those on the scroll. The fact that they match ordains the end of the world and this results in Methuselah's death. The figures hurrying up the slope include those described in the Bible as 'giants in the earth in those days'. In the middle distance, under the trees on the right, is a group of revellers representing the antediluvian age. Their behaviour has no doubt undermined God's confidence in man. Ravens, a symbol of ill omen, circle overhead. The ark, which Noah was instructed to build in order to save himself, his family and the animals, is visible on a distant promontory in the background on the right. Both *The Eve of the Deluge* and *The Assuaging of the Waters* were exhibited at the Royal Academy in 1840, and *The Eve of the Deluge* was acquired by Prince Albert the following year for £350. The composition is based upon a mezzotint illustrating John Galt's *The Ouranoulogos or The Celestial Vision* of 1833, where the description also perfectly matches the painting. *The Assuaging of the Waters* is now in San Francisco Museum of Fine Arts.

Martin published his own account of these three paintings in a pamphlet entitled *The Deluge* of 1840. This shows that his sources were fairly recondite, extending beyond the historical and the religious to the cosmological and the eschatological, including Byron's *Heaven and Earth*. 'Altogether the three paintings amount to a history of the world, summarized in the terms of documentary mythology and dioramic episodes, compressed into three scenes – evening, midnight and daybreak.'[4] It is possible that he might have seen the Great Comet (also known as Napoleon's Comet) of 1811–12 and the return of Halley's Comet in 1835.[5] Both J. M. W. Turner and John Linnell painted this same subject at a later date (c.1843 and 1848 respectively). The composition by Turner is in the National Gallery of Art, Washington, and that by Linnell in the Cleveland Museum of Art.

Notes: **1** For some preliminary observations, see W. Feaver, *John Martin*, Oxford 1975, pp. 211–13. **2** Reproduced in colour by Feaver, op. cit., pl. IV. **3** Ibid., p. 231, n. 20. **4** Ibid., p. 161. **5** R. M. Olson, *Fire and Ice. A History of Comets in Art*, New York 1985, pp. 86–7.

Literature: Millar 1992, no. 489.

DAVID ROBERTS 1796–1864

72 *A View in Cairo*

Canvas, 91.4 × 69.9 cm (36 × 27½ in.)
Signed and dated: *David Roberts. 1840*

THE ARTIST visited the Near East in 1838–9, travelling extensively in Egypt and the Holy Land. Having begun his career as a house-painter and a painter of stage scenery, first in Scotland where he was born and then in England, Roberts established a reputation as a topographical artist during the 1820s, concentrating mainly on European views. The visit to the Near East was, according to Roberts's friend and first biographer, John Ballantine, the 'great central episode of his artistic life'.[1] Indeed, he returned with 272 drawings, a panorama of Cairo and three sketchbooks filled with motifs, which was enough material to 'serve me for the rest of my life'.[2] The drawings either formed the basis of paintings, or else were published as a series of prints entitled *The Holy Land, Syria, Idumea, Arabia, Egypt and Nubia*, published in three volumes between 1842 and 1849 with the lithographs executed by Louis Haghe. This was 'the first accurate topographical record of the Holy Land to be published in England.'[3] It would seem as though the prints outweighed the significance of the paintings, but, in fact, Roberts produced more paintings of the Near East than of any other area he visited. The popularity of these paintings was in part due to their quality, but it was also

Fig. 55 David Roberts, *Gate of Metwalis, Cairo*, 1843, oil on wood, 76.1 × 62.8 cm, London, Victoria and Albert Museum.

as a result of the growing interest in the Holy Land and the neighbouring countries associated with the Bible. This interest increased during the 1830s at the same time as travel became easier in these areas.[4] Roberts was thus able to capitalise on this situation. His views are not simply accurate records of the appearance of buildings. Genre elements are introduced as he himself became interested in the social mores of these different countries.[5] The few biblical narratives, inspired by Old Testament subjects, that were painted by Roberts before he went to the Holy Land were conceived by contrast in the manner of John Martin.

A View in Cairo was acquired by Queen Victoria in 1840 for £105 after being exhibited at the Royal Academy. The composition is closely related to plate no. 6 in *Egypt and Nubia, from Drawings made on the Spot by David Roberts RA*, vol. III, 1849, which shows some differences in the architecture on the left and substantial changes to the figures. The view is towards the Gate of Zuweyleh (colloquially known as Mutwalli or Metwalis), over which tower the minarets of the mosque of Sultan Mu'ayyad Shaykh. The entrance to the mosque itself is on the right. Roberts also made a painting of the interior, for which he had to have special permission.[6] The artist was working in Cairo from 21 December 1838 to 7 February 1839. On 28 December he made 'two drawings of the gate of Bab Zuweyleh, with its minarets' and on 9 January he made 'an oil-sketch of the mosque of Metwalis'. A painting of the Gate from the other side is in the Victoria and Albert Museum, London (Fig. 55). It was purchased in 1843 by John Sheepshanks, also for £105.[7]

Roberts painted *The Bridge at Toledo* and *The Fountain on the Prado, Madrid* for Queen Victoria in 1840 as presents for Prince Albert. Both pictures are still in the Royal Collection,[8] together with two paintings recording the opening of the Great Exhibition of 1851.[9] The artist left an absorbing account of royal patronage being exercised in connection with his paintings of the Great Exhibition.[10]

Notes: **1** John Ballantine, *The Life of David Roberts RA*, Edinburgh 1866, p. 231. **2** See B. Llewellyn, 'Roberts's Pictures of the Near East', in H. Guiterman and B. Llewellyn, *David Roberts*, Oxford 1986, p. 69. **3** J. Pemble, *The Mediterranean Passion. Victorians and Edwardians in the South*, Oxford 1987, p. 58. **4** Ibid., pp. 46–8, 55–60, 182–96. **5** Ballantine, op. cit., pp. 103–14. **6** Guiterman and Llewellyn, op. cit., no. 145. **7** Ibid., no.146. **8** Millar 1992, nos. 585–6. **9** Ibid., nos. 587–8. **10** See H. Guiterman, 'Roberts on Royalty', *Turner Studies*, 10, 1990, pp. 44–50.

Literature: Millar 1992, no. 584.

WILLIAM EDWARD FROST 1810–1877

73 *L'Allegro*

Canvas, 96.5 × 71.1 cm (38 × 28 in.)
Signed and dated: *WE Frost 1848*

THE PAINTING was inspired by lines 11–16 of the poem *L'Allegro* by John Milton:

> But come, thou Goddess fair and free,
> In heaven yclept Euphrosyne,
> And by men, heart-easing Mirth,
> Whom lovely Venus at a birth
> With two sister Graces more
> To ivy-crowned Bacchus bore

Euphrosyne is the figure in the middle playing a tambourine. She is flanked by the 'two sister Graces more'. *L'Allegro* was written by Milton in conjunction with *Il Penseroso*, and both poems explore contrasting themes that had been essayed by neo-Platonists during the Renaissance: the former describing the active life and the latter the contemplative. *L'Allegro* and *Il Penseroso* date from about 1630 and are in Milton's early lyrical style.

The painting was commissioned by Queen Victoria on the basis of a larger picture entitled *Euphrosyne*, which had been exhibited at the Royal Academy in 1848. The composition is not an exact replica of the larger painting and only repeats the central group. In fact, *Euphrosyne* had originally been painted for Elhann Bicknell as a replacement for another picture by Frost, *Una among the Fairies and Wood-Nymphs*, based on Edmund Spenser and dating from 1847, which Bicknell had commissioned but had ceded to Queen Victoria. Frost's *L'Allegro* was intended as a birthday present for Prince Albert on 26 August 1848. It was commissioned in May and therefore had to be executed at considerable speed. Frost succeeded in completing the picture in time and was paid £157 10s. A preparatory study in watercolour is known and the artist painted a replica. The queen herself made a copy of part of the composition in watercolour.

Themes from John Milton's oeuvre achieved great popularity during the nineteenth century.[1] They exerted a particular fascination for Queen Victoria and Prince Albert. The Garden Pavilion at Buckingham Palace was decorated by frescoes illustrating scenes from *Comus*, involving artists such as William Etty, Charles Eastlake, William Dyce, Charles Leslie, Thomas Uwins, Daniel Maclise, William Ross, Edwin Landseer and Clarkson Stanfield. The decorations were commissioned in 1842–3, but the Garden Pavilion was pulled down in 1928 and the scheme is only preserved in the colour engravings published by Ludwig Grüner in 1846, with a text by Anna Jameson.[2]

The poems *L'Allegro* and *Il Penseroso* proved to be influential not only with poets, but also with artists. It has been calculated that during the nineteenth century over eighty British paintings can be associated with these poems and, in fact, they proved to be more popular than *Comus*. The depictions of *L'Allegro* and *Il Penseroso* do not usually illustrate specific lines from the poems, rather the contrasting moods and overall themes. J. C. Horsley, for example, combined both subjects in a single painting commissioned by Prince Albert in 1850 as a Christmas present for the queen (Royal Collection). Frost specialised in Miltonic subjects, succeeding Henry Howard in this capacity, and he alone exhibited fifteen paintings based on *Comus*, *L'Allegro* and *Il Penseroso* at the Royal Academy between 1845 and 1871, by which time the fashion for these subjects had begun to wane.[3] The artist was strongly influenced by Etty, who was renowned for his depiction of the female nude. The poem *L'Allegro*, in particular, provided the artist with considerable scope for the treatment of this subject.

Notes: **1** M. Pointon, *Milton and English Art*, Manchester 1970, especially pp. 174–244. **2** See D. Farr, *William Etty*, London 1958, pp. 95–8, and Pointon 1970, pp. 208–17. **3** Altick 1985, pp. 364–72.

Literature: Millar 1992, no. 246.

WILLIAM POWELL FRITH 1819–1909

Ramsgate Sands: 'Life at the Sea-Side'

Canvas, 76.8 × 154.9 cm (30¼ × 61 in.)

FRITH painted some of the most popular narrative pictures of England in the nineteenth century, including *Derby Day* of 1858 (London, Tate Gallery) and *The Railway Station* of 1862 (Egham, Royal Holloway and Bedford New College). *Derby Day*, like Elizabeth Thompson's *The Roll Call* (No. 77), was so well received when it was exhibited at the Royal Academy in 1858 that extra precautions were taken to protect it from the crowds. The success of such pictures not only enhanced the artist's reputation, but also benefited him financially when the compositions were engraved for wider distribution. *'Life at the Sea-Side'* was in fact Frith's first attempt at a subject depicting contemporary life and manners. The painting was exhibited at the Royal Academy in 1854, where it was seen by Queen Victoria and Prince Albert, but bought by the dealers Messrs Lloyds for £1,000. The queen acquired the picture later in the year from Messrs Lloyds for the same sum.

'Life at the Sea-Side' was inspired by Frith's holiday at Ramsgate in 1851. He started making studies of various groups of figures, culminating in an oil sketch now in the collection of the Dunedin Public Art Gallery Society. The painting itself was begun in the spring of 1852, but progress was slow and the work continued into 1853. Frith returned at least twice to Ramsgate in order to refresh his memory, particularly regarding the details of the buildings in the background. For many of his compositions the artist often relied on photographs, but on this occasion these proved to be unsuccessful and he had to depend solely on drawings.

A full account of the evolution of the painting is given by Frith in *My Autobiography and Reminiscences*, published in 1887.[1] 'The variety of character on Ramsgate Sands attracted me – all sorts and conditions of men and women were there. Pretty groups of ladies were to be found reading, idling, working, and unconsciously forming themselves into very paintable compositions.' An intriguing aspect of the painting is that the artist has positioned himself a short distance out at sea looking towards the shore. Facing the viewer, therefore, is a cross-section of Victorian society with Ramsgate as a backdrop. The buildings are identifiable as follows from left to right: the Clockhouse in the Pier Yard of Ramsgate Harbour, the Royal Hotel, the Obelisk in the Pier Yard erected in honour of George IV's visit in 1821, the Committee Rooms of the Ramsgate Harbour Trustees, the castellated Pier Castle, and, extending from that point at right-angles, Kent Terrace. Behind are Albion House and further to the right Wellington Terrace surmounting the East

Cliff. At the foot of East Cliff are the bathing machines and in the centre below Kent Terrace is Barling & Foat's Baths, while on the left is the Stone Yard. The figures on the sands are predominantly holiday-makers and entertainers. Amongst the latter can be made out a performing hare, a group of minstrels, a troop of white mice, a seller of toys, a Punch and Judy show, and a team of donkeys. The tide is clearly coming in and the figures will soon be disturbed. As a painting the crowded com-

position resembles a novel 'to be read rather than seen in terms of form and colour.'[2] As a social document it records Victorian society enjoying a new-found leisure at a popular seaside resort, which is also featured at an earlier date in two novels by Jane Austen – *Pride and Prejudice* and *Mansfield Park*. Queen Victoria herself took a holiday in Ramsgate in 1835, but contracted typhoid, a memory that does not seem to have detracted from her appreciation of Frith's picture. A description of the seaside at Ramsgate is given by Charles Dickens in 'The Tuggs at Ramsgate', published in *Sketches by Boz* (1835–6): it makes an interesting comparison with Frith's painting.

Notes: **1** W. Frith, *My Autobiography and Reminiscences*, London 1887, I, pp. 243–67. **2** M. Levey, *Painting at Court*, London 1971, p. 189.

Literature: Millar 1992, no. 242.

SIR JOSEPH NOËL PATON 1821–1901

75 ## 'Home': The Return from the Crimea

Panel, 71 × 57.5 cm (27$\frac{15}{16}$ × 22$\frac{5}{8}$ in.)
Signed in monogram and dated: *NP 1859*

THE ARTIST was appointed Queen Victoria's official Limner for Scotland in 1864 and was knighted on 26 March 1867. He began his career as a designer of textiles in Paisley, but studied at the Royal Academy Schools in 1842–3 where he met S. C. Hall, the editor of the influential *Art Journal*, and the artists Richard Dadd and John Everett Millais. Paton's early reputation rested on his paintings of literary themes (for example, *The Quarrel* and *The Reconciliation of Oberon and Titania*, both National Gallery of Scotland, Edinburgh) in which a predilection for fairies is evident, as well as a strong sense of design. His pronounced interest in spiritual or allegorical, as opposed to religious or historical, subject matter was partly derived from his father, who, apart from being a Fellow of the Society of Antiquaries of Scotland, was fascinated by the work of William Blake and eventually adopted the religio-scientific views of Emanuel Swedenborg. Paton in fact painted an important composite triptych for the Prayer Room at Osborne House, Isle of Wight, which was installed in 1885 but given to the Parish and Churchwardens of Anmer church, near Sandringham in Norfolk, by Queen Mary in 1921.

Queen Victoria particularly admired the artist's drawing, which was the basis of a meticulous style that was otherwise characterised by a thin application of paint and somewhat bleached colouring.

In answer to John Ruskin's rallying call for artists to eschew traditional history painting, Paton undertook two paintings of contemporary subjects: '*Home*' in the context of the Crimean War (1854–6) and *In Memoriam* (Private Collection) relating to the Indian Mutiny (1858). '*Home*' depicts the return from the Crimea of a Corporal in the Scots Fusilier Guards. He has been wounded in the head and has lost his left arm. The Crimean medal, awarded by Queen Victoria in 1855 to all those who fought in that war, is worn on his uniform and below the chair is a trophy – a Russian helmet lying beneath the soldier's stick. The mother weeps over his shoulder, while his wife kneels and embraces him. A small child sleeps in the cot. The open Bible on the table indicates the source of the family's strength in the soldier's absence. The subject is treated as domestic genre although, like *The Roll Call* by Elizabeth Thompson (No. 77), the painting can also be interpreted as an implied criticism of the war. Indeed, the anti-heroic sentiments that might be said to dominate the picture incurred some criticism in reviews of the 1856 Royal Academy exhibition,[1] where the work had a profound effect on the public.

Queen Victoria commissioned this reduced replica in 1856 for a sum of £400 and gave it to the Prince Consort at Christmas, 1859. When Ruskin saw the main version at the Royal Academy he criticised the muted colour ('He should for this spring paint nothing but opening flowers, and, in the autumn, nothing but apricots and peaches').[2] Significantly, it is known from correspondence that Paton tried to remedy this deficiency by heightening the effect of the firelight and deepening the shadows in the background. The detailed style and the elaborate technique (Paton has used a non-absorbent white ground) is akin to paintings by the Pre-Raphaelites. Recent examination has revealed that the painting has never been varnished and that the original glazes are intact.

Notes: **1** J. Hichberger, *Images of the British Army. The Military in British Art 1815–1914*, Manchester University Press 1988, pp. 159, 170–1. **2** Academy Notes, 1856, reprinted in *The Works of John Ruskin*, Library Edition, ed. E. T. Cooke and A. Wedderburn, XIV, London 1904, pp. 50, 156–7.

Literature: Millar 1992, no. 541.

FRANK HOLL 1845–1888

'No Tidings from the Sea'

Canvas, 71.4 × 91.4 cm (20⅛ × 36 in.)
Signed and dated: *FRANK HOLL. 1870*

FRANK HOLL died aged forty-three from overwork. He made his name as a painter of rather sombre scenes of everyday life, often with tragic themes such as *Her First Born* (Sheffield City Art Galleries) and *Gone* (London, Geffrye Museum), both of 1877, or *Newgate: Committed for Trial* of 1878 (London, Royal Holloway and Bedford New College). The first of these treats the subject of maternal grief, the second emigration, and the third that of imprisonment. Such paintings fall into the category of social realism, but Holl nearly always stresses the humanitarian aspects. His daughter, Ada Reynolds, described her father as possessing 'a somewhat morbid strain, or, rather, an unconscious preference for the graver, greyer aspect of life.'[1] The subject matter is matched by a preponderance of dark shadows and subdued colours, which lend his compositions an appearance of unrelieved gloom. Holl, however, was a superb draughtsman and came from a family of skilled engravers. He himself made illustrations for the *Graphic* from 1871, finding many of his subjects in the East End of London. (The *Graphic* was one of Van Gogh's prime sources of inspiration when he lived in London during the mid-1870s.) During the second part of his career Holl became a successful portrait painter. Beginning in 1879 he often painted as many as twenty portraits a year in a conscientious manner. It was this intensity of commitment that brought about his early death.

'No Tidings from the Sea' shows the interior of a fisherman's cottage in the early morning after a storm. The seated woman has been out all night looking for her husband who is now presumed dead. There are two small children: a daughter who clings to the skirts of an elderly woman and a small boy asleep on the floor with a toy boat beside him. The painting is based on a scene witnessed by the artist in the coastal village of Cullercoats in Northumberland.[2] The picture was exhibited at the Royal Academy in 1871, where there were no less than five other paintings by different artists depicting incidents in the life of the fishing community of Cullercoats. Such subjects had only been painted intermittently by English artists during the middle decades of the nineteenth century, but they were to reach a climax with the Newlyn school during the 1880s and 1890s. 'No Tidings from the Sea', however, was painted shortly after Holl's visit to the Continent, where he had admired works by the Dutch painter, Jozef Israels, whose style and treatment of subject matter this painting emulates. The twisted pose of the young woman, distraught with grief, which dominates the centre of the composition, is memorable.

The painting was commissioned by Queen Victoria in 1870 at a cost of £105. The queen had seen and admired another picture by Holl in the Royal Academy exhibition of 1869, *The Lord gave and the Lord hath taken away; blessed be the name of the Lord*. She wanted to obtain this picture, but it had been acquired by the collector, Fred Pawle, who refused to cede it. As a result, the artist was given a special commission for another painting.

Notes: **1** A. M. Reynolds, *The Life and Work of Frank Holl*, London 1912, p. 59. **2** Ibid., pp. 83–5.

Literature: Millar 1992, no. 341.

Exhibitions: Manchester/Amsterdam/New Haven 1987–8, no. 65.

ELIZABETH THOMPSON, LADY BUTLER 1846–1933

77 *The Roll Call: Calling the Roll after an Engagement, Crimea*

Canvas, 92.7 × 183.8 cm (36½ × 72⅜ in.)
Signed and dated under a cypher: *Eliz. Thompson/1874*

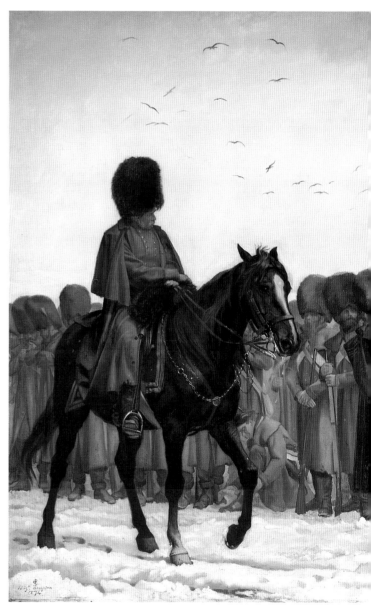

The Roll Call was one of the most popular paintings in the nineteenth century and when it was exhibited at the Royal Academy in 1874 the crowds were so great that special arrangements had to be made to protect it. A similar set of circumstances had only occurred twice before when *Chelsea Pensioners* by Sir David Wilkie and *Derby Day* by W. P. Frith were exhibited in 1822 and 1852 respectively. The success of *The Roll Call* made the artist's reputation, and Elizabeth Thompson remained the foremost painter of military subjects of her day. Following its popularity at the Royal Academy, the painting was subsequently shown in Newcastle-upon-Tyne, Leeds, Birmingham, Liverpool and Oxford. In the first location the picture's arrival was heralded by men with sandwich-boards reading '*The Roll Call* is coming'.

The scene was inspired by the Crimean War of 1854–6, when a British and French alliance was formed to defend Turkey from invasion by Russia. The wintry conditions suggest an identification with the Battle of Inkerman, which was fought on 5 November 1854 in fog and rain (as opposed to snow), and there is some supplementary evidence to support this association even though the art-ist chose not to be so specific. At Inkerman the 3rd Bat-talion of Grenadier Guards (a force of some 650) lost 104 officers and men killed, with an additional 130 casualties. According to Captain George Higginson, who is the adjutant depicted on horseback on the left of the com-position, only about 200 men responded at roll call. Elizabeth Thompson's purpose, however, was to paint an archetypal image of the Crimean War and, indeed, the painting was 'the first time that such a vital image of the soldier's own experience of war had appeared in Britain.'[1] The mood is sombre and the imagery uncompromising. Yet it would be a mistake to interpret *The Roll Call* as an anti-war picture. Rather, it served to draw attention to the plight of brave soldiers in the aftermath of battle at a time when it was widely recognised that the British army was in need of reform. The reforms initiated during the 1870s were seen in the light of the army's performance during the Crimean War, and it is not surprising that the artist painted similar scenes, such as *Balaclava* (Manches-ter City Art Gallery) and *The Return from Inkerman* (Hull, Ferens Art Gallery), dating from 1876 and 1877 respectively.

The treatment of *The Roll Call* is derived in the main from French military painting, in the first instance from Jean-Louis-Ernest Meissonier and also from con-temporaries like Edouard Detaille and Alfonse de Neuville. The composition resembles a relief in its lack of depth, and the artist's close attention to detail is evident at all the preparatory stages. Soldiers who had fought in the Crimea were consulted and reference was

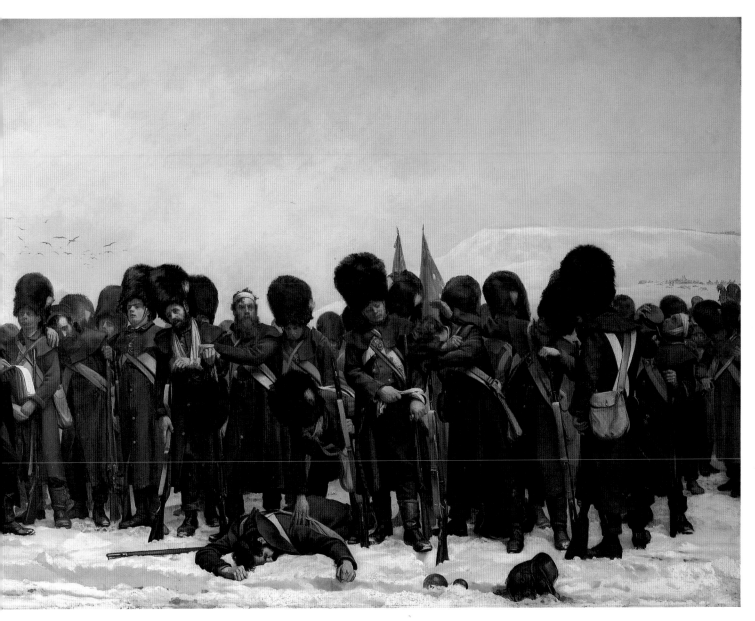

no doubt made to illustrations published at the time in *The Illustrated London News*, as well as to the official history by A. W. Kinglake (1863–87).

The picture was commissioned by the industrialist, Charles Galloway, at a cost of £126. Both Queen Victoria and the Prince of Wales greatly admired the painting and Galloway eventually ceded it to the queen in May 1874, much to the chagrin of the Prince of Wales.

Notes: **1** P. Usherwood and J. Spencer-Smith, *Lady Butler Battle Artist 1846–1933*, London 1987, p. 35.

Literature: Millar 1992, no. 185.

78 *The Family of Queen Victoria in 1887*

Canvas, 165.7 × 226.1 cm (65¼ × 89 in.)
Signed and dated: *L. Tuxen 1887*

THERE ARE twenty-seven paintings in the Royal Collection by the Danish artist, Laurits Tuxen, whose work for the English court extended across the reigns of three monarchs: Queen Victoria, Edward VII and George V. Tuxen studied in the Academy in Copenhagen and also in France and Italy. Much of his career was spent abroad, working at the British and Russian courts, but he became governor of one of the Free Schools of Art in Copenhagen from 1882 to 1906 and was appointed professor at the Academy there from 1909 to 1916. The paintings by Tuxen in the Royal Collection commemorate special occasions and tend to be formal set pieces, often incorporating numerous figures. They are skilfully executed with a refined sense of colour and a high finish. Although Tuxen's reputation rested on portraiture, his range was much wider and included history painting as well as landscapes.

The Family of Queen Victoria in 1887 was commissioned by the queen to commemorate her family at the time of the Golden Jubilee. The figures are shown in the Green Drawing Room in Windsor Castle. A bronze bust of the Prince Consort, who had died in 1861, is visible on the mantelpiece. The figures, summarised by Queen Victoria as 'myself, with my children, children-in-law, & grandchildren', can be identified with the aid of a key (Fig. 56). Tuxen was given the commission on the basis of his painting *The Family of Christian IX of Denmark* of 1883 (Frederiksborgmuseet). The composition was prepared with a series of drawings and oil sketches,[1] but the position of individual figures brought out family tensions and rivalries. Tuxen worked well in advance so that before the whole family had gathered at Windsor for the celebrations in May he had laid in the background of the picture and established the positions of the sitters. Work continued on the painting at Osborne House, Isle of Wight, later in the year and it was completed by December. The artist was paid £1,000. All the subjects were painted from life and the picture is notable for the accuracy and liveliness of its portraits and for the freshness of its colouring.

The Family of Queen Victoria in 1887 is an important dynastic image, perhaps the most significant of the queen's long reign. Compositionally it is akin to the more elaborate *sacra conversazione* of early Renaissance art. Indeed, as Queen Victoria wrote in a letter dated 6 May 1887 to the Duke of Connaught, 'It is not to be stiff & according to *Etiquette*, but prettily grouped.' Tuxen achieved this effect admirably by representing an important moment in history as an informal family gathering.

OPPOSITE Laurits Tuxen, *The Family of Queen Victoria in 1887* (detail).

Notes: **1** Tuxen 1990, nos. 54–6.

Literature: Millar 1992, no. 786.

Exhibitions: Frederiksborg 1990, no. 53.

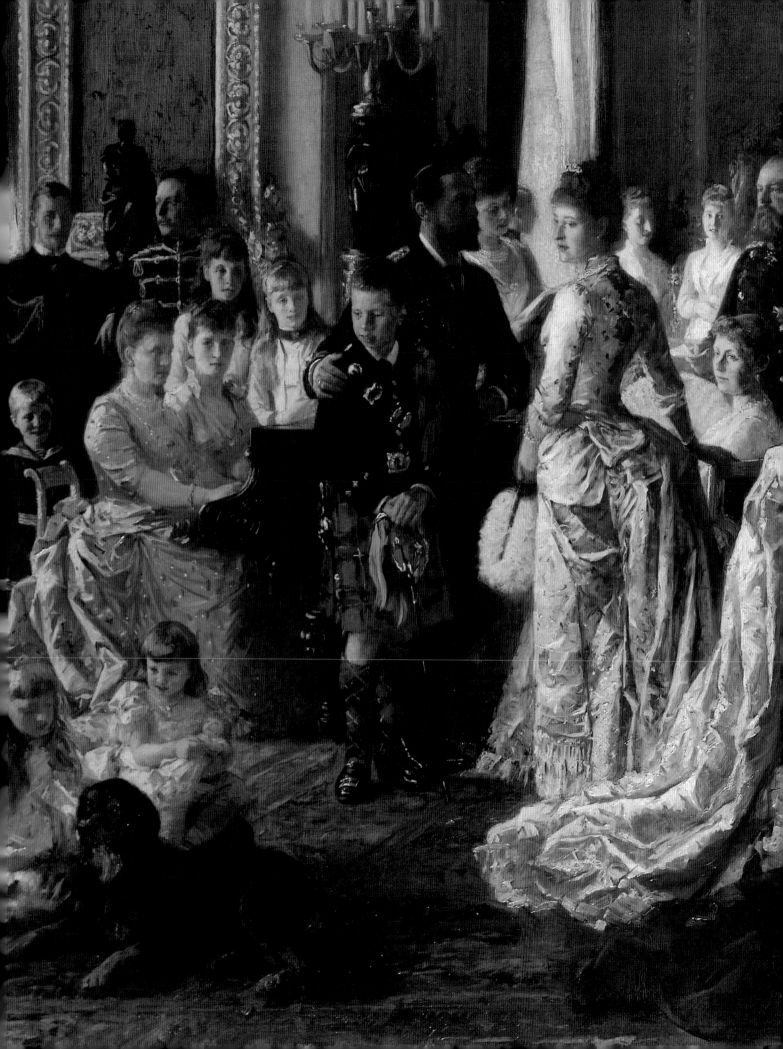

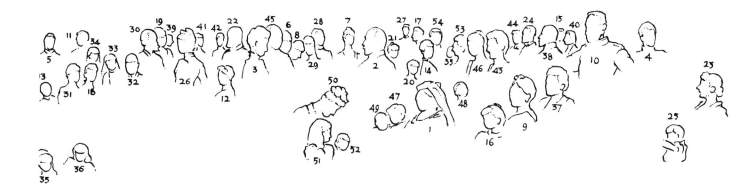

Fig. 56 Key

1 Queen Victoria
2 Prince of Wales
3 Princess of Wales
4 Prince Albert Victor of Wales
5 Prince George of Wales
6 Princess Louise of Wales
7 Princess Victoria of Wales
8 Princess Maud of Wales
9 Crown Princess of Germany
10 Crown Prince of Germany
11 Prince William of Prussia
12 Princess William of Prussia
13 Prince Frederick William of Prussia
14 Hereditary Princess of Saxe-Meiningen
15 Heriditary Prince of Saxe-Meiningen
16 Princess Feodore of Saxe-Meiningen
17 Prince Henry of Prussia
18 Princess Irene of Hesse
19 Princess Victoria of Prussia
20 Princess Sophie of Prussia
21 Princess Margaret of Prussia
22 Grand Duke of Hesse

23 Princess Louis of Battenberg
24 Prince Louis of Battenberg
25 Princess Alice of Battenberg
26 Grand Duchess Elizabeth of Russia
27 Grand Duke Serge of Russia
28 Hereditary Grand Duke of Hesse
29 Princess Alix of Hesse
30 Duke of Edinburgh
31 Duchess of Edinburgh
32 Prince Alfred of Edinburgh
33 Princess Marie of Edinburgh
34 Princess Victoria Melita of Edinburgh
35 Princess Alexandra of Edinburgh
36 Princess Beatrice of Edinburgh
37 Princess Helena, Princess Christian of
 Schleswig-Holstein
38 Prince Christian of Schleswig-Holstein
39 Prince Christian Victor of
 Schleswig-Holstein
40 Prince Albert of Schleswig-Holstein
41 Princess Victoria of Schleswig-Holstein
42 Princess Louise of Schleswig-Holstein

43 Princess Louise, Marchioness of Lorne
44 Marquess of Lorne
45 Duke of Connaught
46 Duchess of Connaught
47 Princess Margaret of Connaught
48 Prince Arthur of Connaught
49 Princess Patricia of Connaught
50 Duchess of Albany
51 Princess Alice of Albany
52 Prince Charles Edward, Duke of Albany
53 Princess Beatrice, Princess Henry of
 Battenberg
54 Prince Henry of Battenberg
55 Prince Alexander of Battenberg

OPPOSITE Laurits Tuxen, *The Family of
Queen Victoria in 1887* (No. 78).

210

RUDOLF SWOBODA 1859–1914

79 'A Peep at the Train'

Canvas, 90.5 × 55.9 cm (35⅝ × 22 in.)
Signed: *Rudolf L. Swoboda*

'A Peep at the Train' is the title used on the official invoice, dated 15 August 1892, when the artist was paid £145. However, Swoboda has inscribed on a label attached to the back of the frame an alternative title, *Waiting for the Train . . . Madras*. The painting was exhibited at the Royal Academy in 1892 as '*A Peep at the Train – India*' and was hung in the New Wing Corridor (now called the Durbar Corridor) at Osborne House, Isle of Wight.

The composition shows a group of children in the company of an old man, positioned by the barrier near a railway line. A village is in the background. A small section of the railway line is visible in the lower left corner. The layout of the composition is particularly effective in so far as the figures are seen behind the barrier at a slight distance from the viewer, who is positioned on the near side of the railway line. This is a case of the observer being observed – a visual device exploited by painters such as Degas. The foreground of the picture is therefore dominated by the strong pool of shadow cast by the figures and the barrier, which sharpens the sunlight and so intensifies the feeling of heat. The paint is very opaque, almost to the point of suggesting the dust of India, and the surface has never been varnished. The picture remains a telling image of the country, painted nearly twenty years after Queen Victoria had been proclaimed Empress of India in 1877. Although the queen never travelled to the sub-continent, she was fascinated by it and took a particular interest in its people and the conduct of British policy there.

Swoboda was a Viennese artist who had been recommended to Queen Victoria by the portrait painter, Heinrich von Angeli. He travelled extensively, but in the context of the Royal Collection he is noted for the large series of specially commissioned portraits of Indians, several of whom were the queen's own personal servants forming part of her Household from the late 1880s. Some of the portraits were painted in London on the occasion of the Colonial and Indian exhibition of 1886 and at the time of the Diamond Jubilee in 1897, but many were painted independently for the queen, beginning with those executed on a visit the artist made to India at the queen's expense in 1886–8. The portraits are fairly small in size (on average 27.9 × 17.8 cm, 11 × 7 in.) and from the first were hung in the Durbar Corridor at Osborne House, Isle of Wight. Queen Victoria appreciated them not only for their quality, but also because Swoboda made a reasonable charge for his work. On a wider basis they are comparable with contemporary late nineteenth-century photographs of Indians (for example, *The People of India*, 1868–75), undertaken in a spirit of scientific investigation.[1]

Notes: **1** See Christopher Pinney, *The Raj, India and the British 1600–1947*, London 1990, pp. 252–63, especially 254–6 and no. 346.

Literature: Millar 1992, no. 731.

Queen Victoria and
Prince Albert (2)

PRINCE ALBERT encouraged Queen Victoria to appreciate early Italian and German painting. He was, in fact, one of the first collectors in Britain to buy such pictures and many of them were hung in his Dressing Room and Writing Room in Osborne House, Isle of Wight. The revival of interest in primitive Italian and German painting arose partly as a result of the recognition of its significance for the development of art in general, and partly as a result of its availability after the Napoleonic wars, which had led to the sequestration of so much ecclesiastical property (Nos. 80, 81, 82). The paintings by Dyce (Nos. 90, 91), who was profoundly influenced by the art of the German Nazarene artists and played a part in the revival of fresco painting in Britain so zealously supported by Prince Albert, Wittmer (No. 93), Winterhalter (No. 92) and Waldmüller (No. 94) consciously reflect earlier styles, compositions and themes. Similarly, the literary sources for the paintings by Frost (No. 73) and Maclise (No. 89) can be related to an historicist approach.

The largest group of early paintings owned by Prince Albert was acquired almost by default. A German collector, Prince Ludwig Kraft Ernst Oettingen Wallerstein, negotiated a private financial loan with Prince Albert in 1847 and deposited his collection of German, Italian and Netherlandish paintings in London as surety. The pictures were put on exhibition in Kensington Palace in 1848 but, since no buyer was found, the whole group passed to Prince Albert (Nos. 84, 85, 87). After the Prince Consort's death in 1861, and in accordance with his wishes, Queen Victoria presented twenty-five of these pictures to the National Gallery, London (Nos. 95, 96), where some of them can be seen today in the Sainsbury Wing.

OPPOSITE Daniel Maclise,
A Scene from 'Undine'
(No. 89, detail).

DUCCIO Active 1278; died 1319

Triptych: The Crucifixion with the Virgin Mary and Saint John the Evangelist and other scenes

Panels, centre: 44.9 × 31.4 cm (17⅝ × 12⅜ in.); left and right wings: each 44.8 × 16.9 cm (17⅝ × 6⅝ in.); spandrel (now detached) over the centre panel: 13.9 × 34.9 cm (5½ × 13¾ in.)

THIS IMPORTANT TRIPTYCH was acquired by Prince Albert in 1846, together with the *Madonna dell'Umiltà with Angels*, then thought to be by Fra Angelico but now attributed to a follower of that artist.[1] Both works were hung in Prince Albert's Dressing-Room and Writing-Room at Osborne House, Isle of Wight, where several other early paintings were also grouped (Fig. 20, page 26). The price of £190 paid for these two works indicates the relative indifference with which early Italian art was still regarded towards the middle of the nineteenth century. Prince Albert was one of only a small number of collectors in Europe who favoured such paintings at this date.[2] The triptych was apparently acquired in Siena by an established dealer, Johann Metzger (died 1844), who specialised in early Italian paintings. His son, Ludwig, had by 1846 sold it to Prince Albert in Florence through the artist, Ludwig Grüner, who acted as an adviser to Queen Victoria and Prince Albert. Probably before it became part of the Royal Collection the triptych had been dismantled and put in a heavy gothic frame, which was removed when it was cleaned in 1930. After this the triptych was displayed in a shadow box with a simpler frame. This, too, was considered to be inappropriate and the present reconstruction of the triptych was devised in 1988, although further thought has since been given to the angle at which the two wings should be positioned in order to make proper visual sense of the architecture.

The painting is a portable triptych of a type that was fairly widely produced in Italy during the early fourteenth century, essentially for private worship. For the purposes of travel the wings would have closed inwards covering the centre panels and lying flush with the raised spandrel above the inner moulding. The backs of the wings were most probably painted with imitation marble or porphyry, perhaps with decorative motifs, as opposed to narrative scenes. The creation of a work of art of this kind was due to a combination of craftsmanship and painterly skills. Some of the finest surviving examples are Florentine or Sienese in origin. The triptych in the Royal Collection is comparable with examples in the National Gallery in London, the Museum of Fine Arts in Boston, the Pinacoteca in Siena, and the Fogg Art Museum in Cambridge, Massachusetts, all of which, according to varying degrees of attribution, are associated with Duccio or his workshop. The exact attribution of the present triptych is unsettled owing to the multiplicity of hands at work not only in Duccio's workshop as a whole, but even on the surface of individual paintings. Contrary to the opinions of some modern authorities, the centre panel in particular is of a quality worthy of Duccio himself. The same might almost be said of the lower scenes in each of the wings, certainly in their design even if the actual execution reveals evidence of assistants (for example, the gold decoration on the cloth of honour behind *Christ and the Virgin Enthroned*, lower right). The inconsistencies apparent in the architecture of *Annunciation* (top left) or the design of the two thrones are not unknown in Duccio's own work, as revealed in the *Maestà* of 1308–11 (Siena, Museo dell'Opera del Duomo) with which this triptych is comparable in date or possibly slightly earlier.

The iconography of the panels is also significant. Paradoxically, the inner religious consistency is derived from the unusual combination of scenes, especially the pairing of enthroned figures in the lower sections of the wings. The enthronement of the Virgin twice (top left and lower right), for instance, suggests a temporal sequence before and after Christ's death as represented in the centre. The *Annunciation* (top left) is comparable with the relevant scene (now in the National Gallery, London) from the *Maestà*, whereas both *Saint Francis receiving the Stigmata* (top right) and *Christ and the Virgin Enthroned* (lower right) recall frescoes in the Upper Church of St Francis, Assisi (the former in the nave from the *Life of Saint Francis* and the latter, earlier in date and by Cimabue, in the transept). These connotations and the treatment of the crucifixion in a devotional, as opposed to a narrative sense, imply a Franciscan origin for this triptych. The quantity of blood depicted in the central scene (some of it removed in an earlier restoration) is an unusual feature in a work on this scale.

Notes: **1** Shearman 1983, no. 252. **2** See Haskell 1976, pp. 45–70.

Literature: Shearman 1983, no. 86.

BERNARDO DADDI c.1300–1348

The Marriage of the Virgin

Panel, 25.5 × 30.7 cm (10 × 12⅛ in.)

THE PANEL originally formed part of the high altarpiece painted by Bernardo Daddi during the 1330s for the church of San Pancrazio, Florence. Nearly all of the remaining parts of the altarpiece are preserved in the Uffizi, Florence. The design of the altarpiece was fairly elaborate, with panels ranged in three tiers extending downwards from the main field into the predella below and terminating above in a series of gabled pinnacles. The principal section shows the *Virgin and Child Enthroned* with three full-length saints on either side (*Saints Pancrazio, Zenobius and John the Evangelist* to the left and *Saints John the Baptist, Reparata and Miniato* to the right). The predella comprises scenes from the early life of the Virgin, of which the present panel is the sixth in the narrative sequence. It has even been suggested that the altarpiece had a second predella (now dispersed in various collections) with scenes from the life of Saint Reparata positioned below those illustrating the early life of the Virgin, but this seems very unlikely. The scale of the altarpiece was no doubt inspired by the multi-tiered high altarpieces painted by the Sienese artist, Ugolino di Nerio, for the churches of Santa Maria Novella and Santa Croce, Florence, both of which can be dated before the San Pancrazio altarpiece. It is notable that all the predella panels still attached to the altarpiece in the Uffizi have rounded tops set into cusped frames, which indicates that *The Marriage of the Virgin* has been fairly extensively cut at the top. Each of the other predella panels measures 50 × 38 cm (19⅝ × 15 in.). The exact circumstances by which this single panel from the predella became detached are not known. It is apparent that the altarpiece began its peregrination as early as the end of the fourteenth century when San Pancrazio was rebuilt for the first time. By the second half of the eighteenth century, after much further reconstruction, the altarpiece had been dismembered and moved to the abbot's apartment in the monastery attached to the church, which was suppressed in 1808. Shortly afterwards the altarpiece was transferred to the Uffizi. However, *The Marriage of the Virgin* was then given in exchange to the local dealer, Luigi Marzocchi, in 1817 and was subsequently acquired by Johann Metzger (died 1844), a dealer of German origin resident in Florence. Metzger's son, Ludwig, sold it through the artist Ludwig Grüner to Queen Victoria in 1845 who, in turn, gave it to the Prince Consort the following year. Even though cut down, *The Marriage of the Virgin* is undoubtedly the best preserved of the predella panels. A few of the elements from the pinnacle panels are also missing, the most significant losses being those above the *Virgin and Child Enthroned*.

As a Florentine painter Daddi was undoubtedly influenced by Giotto. His figures therefore have a monumentality and dignity worthy of that master, but Daddi was also aware of contemporary Sienese painting, especially the works of Ambrogio and Pietro Lorenzetti, which invested his style with a lyricism and an incandescent sense of colour that give his smaller panels a remarkable intensity. The artist is seen at his best in works on this compact scale, especially in the portable triptychs of which several examples have survived (Florence, Museo del Bigallo; Altenburg, Lindenau Museum; London, Courtauld Institute Galleries; New York, Metropolitan Museum of Art and Siena, Pinacoteca). It is now recognised that these works introduced what has been called 'the miniaturist tendency' into Florentine painting, a style that prevailed until just after the middle of the century with the emergence of Andrea Orcagna. Daddi, therefore, holds a position of singular importance in the development of Florentine art.

The textual sources for *The Marriage of the Virgin* are the apocryphal Book of James (or Protoevangelicum), known as the Infancy Gospel, 8–9,[1] or, alternatively, *The Golden Legend* by Jacobus de Voragine.[2] According to these sources, each of the suitors for the hand of the Virgin brought a rod to the Temple to be placed on the altar. Of these it is Joseph's rod that flowers and onto which the Holy Spirit descends, thus indicating that he has been chosen to marry the Virgin. In Daddi's panel the dove can be seen perched on the top of Joseph's rod while the disappointed suitors break their rods over their knees as the marriage takes place.

Notes: **1** M. R. James, *The Apocryphal New Testament*, Oxford 1955, p. 42. **2** Under 8 September, 'The Nativity of the Blessed Virgin Mary'.

Literature: Shearman 1983, no. 79; Offner 1990, pp. 268–70.

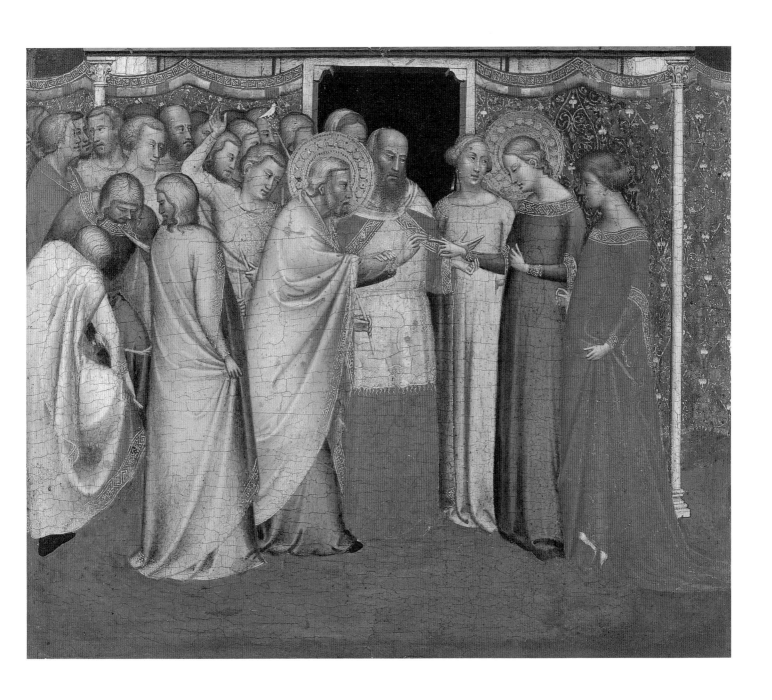

82 *The Fall of Simon Magus*

Panel, 24.3 × 34.5 cm (9⅝ × 13⅝ in.)

THE MAIN SECTION of the altarpiece, to which this panel was once attached as part of the predella, is in the National Gallery (Fig. 57). It shows the Virgin and Child enthroned with angels and six saints: John the Baptist, Zenobius and Jerome to the left and Peter, Dominic and Francis to the right. The altarpiece was painted for the Compagnia di Santa Maria della Purificazione e di San Zanobi, known as the Compagnia di San Marco, which was affiliated to San Marco in Florence. The contract for the altarpiece is immensely detailed. It was signed by Gozzoli on 23 October 1461 and adumbrates not just the various parts of the altarpiece, but also the artist's obligations as regards the frame, the gilding and the quality of the pigments to be used. The work was to be finished by 1 November 1462. Gozzoli does not appear to have defaulted, but there are, nonetheless, certain discrepancies between the contract and the finished work. One of these includes the number and the subjects of the predella panels. There were to have been seven in all, six of them illustrating incidents from the lives of the saints in the main part of the altarpiece. The subject of the seventh panel was not stipulated, but it can reasonably be

assumed that, since the Confraternity was dedicated to the Virgin, it would have been a scene from the Virgin's life. Five predella panels are known. In addition to the present panel, they are as follows: *A Miracle of Saint Dominic* (Milan, Brera), *A Miracle of Saint Zenobius* (Berlin, Gemäldegalerie), *The Dance of Salome and the Death of Saint John the Baptist* (Washington, National Gallery of Art) and *The Purification of the Virgin* (Philadelphia, Museum of Art). No scenes illustrating the lives of Saint Jerome and Saint Francis appear to have survived and, since the dimensions of the five known panels fit the main panel, it is likely that the remaining two were never painted. The scenes were placed below the respective saints so that *The Fall of Simon Magus* was positioned to the right of the centre predella panel, which was presumably *The Purification of the Virgin*.

San Marco was a Medici foundation, and the high altarpiece of the church had been painted by Fra Angelico in about 1440. It is hardly surprising, therefore, that Angelico's chief assistant and pupil, Gozzoli, should have been commissioned to paint the altarpiece of the Compagnia di San Marco. Gozzoli was by this time an established Medicean artist in his own right, having undertaken in 1459 the frescoes of *The Journey of the Magi* in their private chapel in the Palazzo Medici-Riccardi in Florence, and from 1468 onwards working for them in the Campo Santo, Pisa. Gozzoli was an adroit narrative painter who was conversant with, although not always an able exponent of, the latest advances in Renaissance art. His colouring is always fresh and the predella panels to this particular altarpiece are amongst his finest works on a small scale. *The Fall of Simon Magus* is a subject taken from *The Golden Legend* of Jacobus de Voragine and it involves a contest between a sorcerer at the court of the Emperor Nero and Saint Peter. Nero is seen enthroned on the left while Saint Peter and Saint Paul are on the right. Simon Magus, endeavouring to prove his magical powers, attempts to launch himself from a wooden tower towards heaven, but even though supported by demons his experiment fails and he falls to the ground.

The Compagnia di San Marco was suppressed in 1802, but the predella may already have been detached by that date. For instance, *The Fall of Simon Magus* was owned by the important collector and authority on Italian art, William Young Ottley, who was in Italy in 1791–8. It was subsequently bought by Prince Albert in 1846.

Literature: Shearman 1983, no. 132.

Fig. 57 Benozzo Gozzoli, *The Virgin and Child Enthroned among Angels and Saints*, oil on wood, 161.9 × 170.2 cm, London, National Gallery.

Apollo and Diana

83

Panel, 83.8 × 56.5 cm (33 × 22¼ in.)
Signed with the image of a winged serpent

CRANACH, like his contemporary Albrecht Dürer, was a dominant figure in German Renaissance painting. The influence of both artists was pervasive, although Cranach had the advantage of outliving Dürer by as much as thirty years. At the start of his career he was active in Munich and Vienna, but in 1505 he became court painter to Duke Friedrich the Wise of Saxony. Cranach held this position under two successive Electors until 1547, and again from 1550 until his death. The court was based at Wittemberg until the Elector Johann Friedrich went into exile in

Augsburg (1547–52). After his return the Elector preferred to live in Weimar. Cranach carried out a wide range of duties as court artist including the decoration of the palace, but he was granted a coat-of-arms in 1508 and became wealthy, holding public office several times. The mark or signature of a flying snake that occurs on this panel and many others (see No. 86) was derived from his coat-of-arms. Cranach was also a prolific engraver and book illustrator with an interest in publishing, particularly in Reformation literature. He was a close friend of Martin Luther and his family, whose portraits he painted frequently, although, like many other artists in Germany during these years, he retained Catholic patrons such as Cardinal Albrecht of Brandenburg, Elector of Mainz.

The subject of Apollo and Diana was treated on two other occasions by Cranach (Brussels, Musée des Beaux-Arts and Berlin, Gemäldegalerie). There are considerable differences between the three compositions, although in each case Apollo stands and Diana is seated on a stag. The painting in Brussels and the present work show Apollo about to shoot an arrow, whereas in the painting in Berlin (1530) he is without a quiver and merely holds three arrows in the same hand as the bow. The composition with Apollo aiming is comparable with the engraving by Dürer of about 1505 (Fig. 58), or with the print by Jacopo de' Barbari. The figure of Diana holding her right foot with one leg crossed over the other is reminiscent (although reversed) of the famous antique bronze known as the *Spinario*.[1]

The painting in the Royal Collection reveals all the main characteristics of Cranach's art. The tautness of the style, the fluency of the drawing of the nude, the love of greens and blues offsetting the lighter flesh tones, the detailed rendering of foliage and the carefully observed landscape replete with a perilously balanced castle on a distant crag and peaceful reflections in calm waters, these are the hallmarks of his finest works, and, it has to be admitted, also of his studio. The intensity of the style is matched by the studied care of the composition and by the clarity of the image.

The painting was bought in 1846 by Prince Albert through his adviser Ludwig Grüner from Friedrich Campe, a collector in Nuremburg.

Fig. 58 Albrecht Dürer, *Apollo and Diana*, woodcut, London, British Museum, Department of Prints and Drawings.

Notes: **1** Haskell and Penny 1981, no. 78.

Literature: Friedländer and Rosenberg 1978, p. 122, no. 271A.

Exhibitions: London 1946–7, no. 140; Manchester 1961, no. 86.

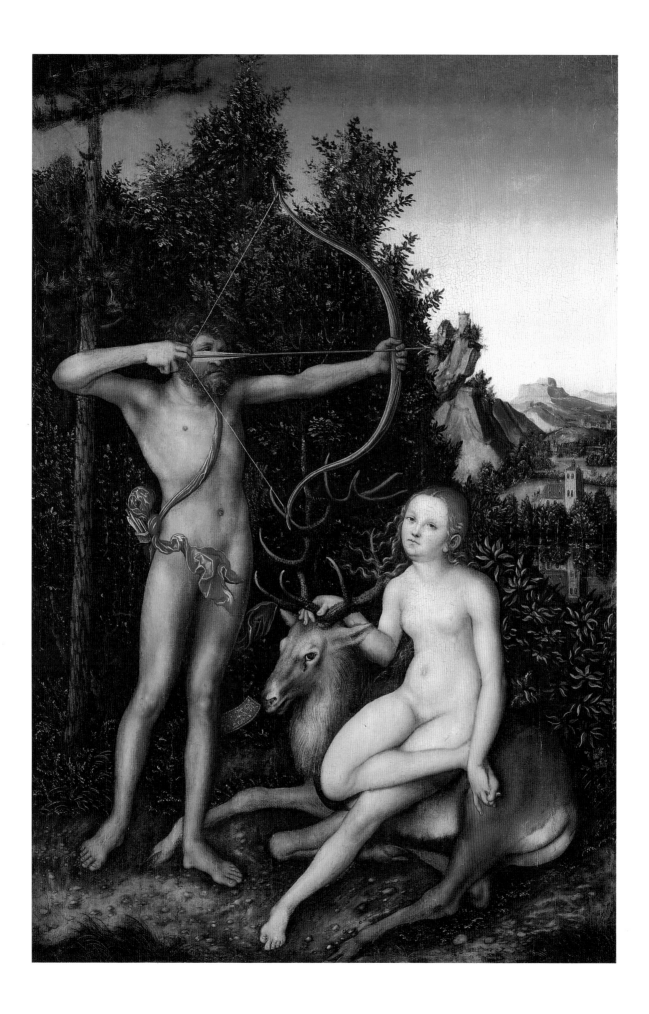

HANS BALDUNG GRIEN 1484/5–1545

84 *Portrait of a Young Man with a Rosary*

Panel, 51.4 × 36.8 cm (20¼ × 14½ in.)
Dated: *.ANNA DÑI.1509.*

THE ARTIST is one of the most original and creative figures of the German Renaissance. Born in the village of Schwäbisch-Gmund in south-west Germany, his family established close connections with Strasbourg. It was here that Baldung worked for most of his life, apart from four years in Nuremburg spent in Dürer's workshop (1503–*c*.1507) and five years in Freiburg-im-Bresgau (1512–17) where he painted his masterpiece, *The Coronation of the Virgin*, for the high altar of the Münster. Baldung was a prolific artist and his oeuvre comprises numerous prints and designs for book illustrations and stained-glass, as well as paintings and drawings. He was the most individual of Dürer's assistants and his style and treatment of colour are remarkably expressive. The range of subject matter in Baldung's work matches his technical dexterity: religious and mythological themes, in addition to a fascination for witches, are vividly, almost shockingly, handled. In achieving this emphatic style, Baldung was influenced by Grünewald, Cranach, and artists of the Danube school. It is clear that he was inspired by the spirit of the Reformation and this encouraged an element of dualism in his work, most evident during the 1520s. Strasbourg was sympathetic to Reformist ideas and the artist himself was buried in the Protestant cemetery.

Portrait of a Young Man with a Rosary is an early work; it is, in fact, the first dated portrait in Baldung's oeuvre, painted on his return to Strasbourg two years after *The Martyrdom of Saint Sebastian* (Nuremburg, Germänisches Nationalmuseum). The style, combining linearity with a perfectly controlled understanding of the liquidity of paint, is clearly dependent upon Dürer, especially his portraits including that of Burkhard von Speyer in the Royal Collection, painted while Dürer was in Venice from 1506 to 1507. However, the liveliness of the almost quixotic characterisation is typical of Baldung. At the upper edge in the centre, as part of the signature, is an image of an owl attacking a bird on a branch, which perhaps symbolises the conflict between good and evil or day and night. This piece of symbolism should perhaps be seen in the context of the rosary held by the sitter.

The painting was part of the collection of Italian, German and early Netherlandish pictures formed by Prince Ludwig Kraft Ernst von Oettingen Wallerstein (1791–1870), which Prince Albert accepted as surety for a financial loan in 1847. The collection was put on display in Kensington Palace in 1848 in order to encourage a buyer, but this ploy failed and so the pictures came into the possession of Prince Albert. In 1863 Queen Victoria presented twenty-five of the best paintings to the National Gallery, London, in memory of the Prince Consort and in accordance with his wishes (see Nos. 84, 96). Like several other paintings in the Oettingen Wallerstein collection, *Portrait of a Young Man with a Rosary* previously belonged to Count Joseph von Rechberg (1769–1833).[1]

Notes: **1** See Campbell 1985, pp. XLVIII–XLIX.

Literature: Oettinger and Knappe 1963, pp. 43 and 120–1, no. 5; Osten 1983, pp. 20 and 54–5, no. 8.

Exhibitions: Karlsruhe 1959, no. 9; Manchester 1961, no. 77.

The Adoration of the Kings

Panel, 48.2 × 38.9 cm (18$\frac{15}{16}$ × 15$\frac{1}{4}$ in.)

THE ARTIST was active principally in Antwerp, but it is possible that he visited Rome and certain that in 1535 he was in Constantinople. He died in Brussels. On an official basis he seems to have worked as painter to Mary of Hungary and Charles V. Certainly his diversity suggests that he fulfilled the role of court artist, for his oeuvre includes not only paintings and drawings, but also designs for tapestries and stained-glass, sculpture and architecture. In connection with this last discipline he translated the treatises of Vitruvius and Serlio. He was also a publisher, a profession that culminated in a series of woodcuts based on his experiences in Turkey and published posthumously with the title *Ces Moeurs et Fachons de faire des Turcs* (Antwerp, 1553).

The *Adoration of the Kings* is a relatively early work that can be dated to about 1530 if compared with the *Last Supper* of 1530 in Liège, where the head of the disciple seated second from the right is directly comparable with Saint Joseph. The style reveals Mannerist touches: for example, the turning figure of Saint Joseph and the up-turned head of the ox eating hay on the left, or the hem of the drapery worn by the second king, Melchior, on the right, and the fluttering pennant held by the soldier. The outstretched hands of the Christ Child is a charming observation, but at the same time it prefigures the crucifixion. The influence of Italian art commingles in Pieter Coeck's work with northern elements, as in the series of paintings of the *Last Supper*, based on the fresco in Milan by Leonardo da Vinci. There is in this *Adoration of the Kings*, however, a certain kinship with Dürer's woodcut of the same subject in the *Life of the Virgin* of 1511. The broken arches that dominate the background are a representation of the Basilica Maxentius, or Temple of Peace, in the Forum at Rome. According to *The Golden Legend* of Jacobus de Voragine, the Basilica Maxentius, which housed a statue of Romulus, 'on the night of Our Lord's birth crumbled to the ground.'[1] This building, usually in a state of ruin, is often depicted in scenes of the Nativity for the purposes of representing the passing of the Old Law in favour of the New Law introduced with the birth of Christ.

The painting was formerly in the collection of Count Joseph von Rechberg (1769–1833) and Prince Ludwig Kraft Ernst von Oettingen Wallerstein (1791–1870) before being ceded to Prince Albert in 1847 (see Nos. 84, 87).

ABOVE Pieter Coeck van Aelst, *The Adoration of the Kings*. OPPOSITE Detail.

Notes: **1** Jacobus de Voragine, *The Golden Legend*, ed. G. Ryan and H. Ripperger, New York 1941, p. 48, under 'The Nativity of our Lord'.

Literature: Campbell 1985, no. 21.

86 # The Judgement of Paris

Panel, 50.2 × 34.9 cm (19¾ × 13¾ in.)
Signed with the image of a winged serpent, lower left corner

The Judgement of Paris, like *Apollo and Diana* (No. 83), reveals Cranach's interest in those classical themes which so attracted Renaissance artists both north and south of the Alps. Of these two subjects it is the *Judgement of Paris* that engaged his attention most fully. Twelve different versions of the theme are known. The paintings in Copenhagen (Statens Museum), Basle (Öffentliche Sammlung) and Karlsruhe (Staatliche Kunsthalle) are dated 1527, 1528 and 1530 respectively. A version on permanent loan to the Wallraf-Richartz Museum, Cologne, is considerably earlier in date (about 1512/14), but it is to a later grouping dating from after 1537 that the present work belongs, together with paintings in Gotha (Landesmuseum) and Berlin (Bode Museum). All these versions include the same compositional elements, but there are considerable differences in the arrangement and poses of the figures. The picture in the Royal Collection differs markedly from the others only in the respect that it lacks a distant landscape: here the hedge closes off the composition and Cranach accordingly arranges his figures as in a frieze. The artist ran a busy workshop in which his two sons, Hans and Lucas, were active and it is sometimes difficult to determine the division of labour.

Paris is seated by a stream. He wears armour and his horse peers round the tree through the hedge. Mercury, who holds an orb inscribed with the word *MONET* (presumably from the Latin), attends Paris while the three goddesses – Venus, Minerva and Juno – await his decision. Venus is most probably the goddess seen from the back turning to look at the viewer, for it is at this figure that Cupid in the clouds above aims his arrow. Interestingly, Cranach has not relied upon strictly classical sources for his depiction of the Judgement of Paris. Instead, he appears to have been dependent upon bastardised medieval interpretations of the story, such as the *Historia destructionis Troiae* by the thirteenth-century writer Guido degli Colonne. According to this account, Paris is not a shepherd but a hunter. He loses his way in a thicket and so tethers his horse to a tree before falling asleep. Mercury appears to Paris while he sleeps and introduces him to the three goddesses, demanding that he gives a judgement as to who is the fairest. Paris agrees to do this only if the goddesses undress, which they duly do.[1] Some of these texts were illustrated, so Cranach, who was a prolific engraver and book illustrator with an interest in publishing, was well placed to draw upon both the visual and the textual traditions of interpreting the classics in Northern Europe. Comparison with

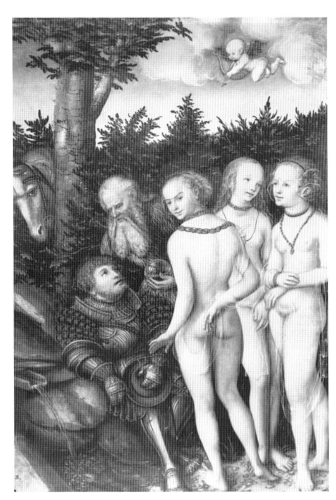

ABOVE Lucas Cranach the Elder, *The Judgement of Paris*.
OPPOSITE Detail.

No. 9 shows to what extent the subject of the Judgement of Paris was open to interpretation.

Notes: **1** See Koepplin and Falk 1976, 11, pp. 613–31, nos. 528–42.

Literature: Friedländer and Rosenberg 1978, p. 151, no. 409A.

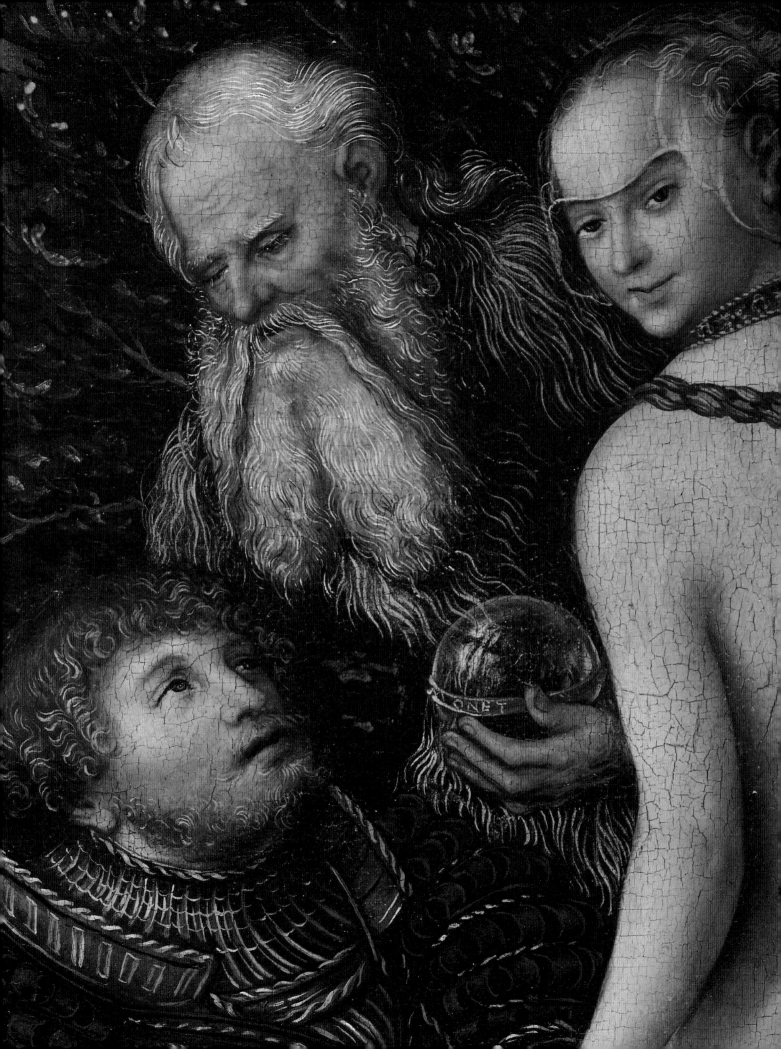

87 *The Nativity*

Panel, 35.7 × 28.9 cm (14$\frac{1}{16}$ × 11$\frac{3}{8}$ in.)
Signed in the lower left corner in monogram: *GB*
Inscribed on the banderole: *Gloria in exelsis deo*[1]

THE ARTIST derives his name from the monogram that
appears on the present panel. He has been tentatively
identified as Guillaume Benson, the son of the artist
Ambrosius Benson, but further proof is needed before
such an identification can be fully accepted. From the
style it is apparent that the painter was active in Bruges
during the mid-sixteenth century. The composition is
derivative, stemming ultimately from the *Nativity* that
forms the centre panel of the triptych attributed to
Gerard David (New York, Metropolitan Museum of Art),
which can itself in general terms be related back to the
Adoration of the Shepherds by Hugo van der Goes in
Berlin (Staatliche Museum). David's composition was
evidently much appreciated, since it is also echoed in
works by many of his followers or associates: Ambrosius
Benson (attributed to; Leningrad, Hermitage), 'Adriaen
Ysenbrandt' (Antwerp, Meyer van den Bergh Museum)
and the Master of the Female Half-Lengths (Strasbourg,
Musée des Beaux-Arts). The style of the Monogrammist
G.B. is closely modelled on that of 'Ysenbrandt', of whom
he seems to have been a follower. The facial type of the
Virgin, for example, is closer to those paintings accredited
to the name of 'Ysenbrandt' than to the figures of
Ambrosius Benson. It is, in fact, just this kind of observa-
tion that calls into doubt the identification with Guil-
laume Benson. The symmetrical composition, the flying
angels with the figures carefully positioned in relation
to the buildings, and the precision in the handling of
architecture, draperies and facial features reveal the
heritage of Gerard David, but in a somewhat debased
way. The artist displays more charm than skill.

The painting is first recorded in the collection of Count
Joseph von Rechberg (1769–1833), but was acquired from
him by Prince Ludwig Kraft Ernst von Oettingen Wal-
lerstein (1791–1870) whose collection passed in 1847 to
Prince Albert (see Nos. 84, 85).

Notes: **1** Saint Luke 2: 14.

Literature: Campbell 1985, no. 56.

SIR EDWIN LANDSEER 1803–1873

88 *Queen Victoria and Prince Albert at the Bal Costumé of 12 May 1842*

Canvas, 142.6 × 111.8 cm (56⅛ × 44 in.)

THREE fancy-dress balls were held at Buckingham Palace by Queen Victoria and Prince Albert, each in a different style. At the first on 12 May 1842 the principal figures appeared as Edward III (1312–77) and Queen Philippa (1314?–69). The second, on 6 June 1845, was in early Georgian dress and the third, on 13 June 1851, in the style of the Restoration. *The Times* of 14 May 1842 (pp. 6–7) observed: 'Her Majesty's fancy dress ball on Thursday night was a scene of such brilliance and magnificence, that since the days of Charles II, with the solitary exception of one fête given in the reign of George IV, there has been nothing at all comparable to it in all the entertainments given at the British Court.'

Landseer has painted Queen Victoria and Prince Albert in the Throne Room on the occasion of the fancy-dress ball of 1842, standing beneath a specially designed Gothic canopy decorated with purple velvet hangings. Two chairs of state are visible behind the figures and above their heads on the cloth of honour is emblazoned the coat-of-arms of Edward III, combining French and English quarterings. It was from this alcove that Queen Victoria and Prince Albert greeted over 2,000 guests. Members of the Royal Household were expected to appear in costumes dating in style from the reign of Edward III, while the guests were encouraged to wear costumes of any period or country. The setting for the ball and the design of the costumes were entrusted to James Robinson Planché, who was an authority on the history of dress, as evidenced by his encyclopaedic book *History of British Costume* (1834), as well as a dramatist and a herald in the College of Arms. In 1843 he published an illustrated account of Queen Victoria's first *bal costumé* held the previous year. This reveals that, in addition to assisting in the current revival of interest in medieval history, the making of the costumes and accoutrements had helped to revive the declining weaving industry based at Spitalfields and thus offset unemployment. The ball was also reported in *The Illustrated London News* (14 May 1842) and many of the costumes were illustrated in C. and L. Martin's *Dresses worn at Her Majesty's Bal Costumé* (1842). Dancing (mainly quadrilles) was somewhat restricted owing to the nature of the footwear.[1]

The costumes worn by Queen Victoria and Prince Albert were designed by Vouillon and Laure with the guidance of Planché. For the sake of accuracy reference was made to the relevant monuments in Westminster Abbey. The queen's costume was based upon the effigies of Philippa of Hainault and her daughter Blanche de la Tour (died in infancy 1342), while that for Prince Albert was derived from the effigy of Edward III. The preparations for the ball generated almost as much excitement as the occasion itself. Queen Victoria wrote to her uncle Leopold, King of the Belgians, on 19 April 1842, 'I am quite bewildered with all the arrangements for our *Bal Costumé*, wh. I wish you cd see; we are to be Edward III & Queen Philippa, & a gt number of our Court to be dressed like the people in those times, & very correctly, so as to make a grand Auzfug – but there is such asking, and so many silks & Drawings & Crowns, & God knows what, to look at, that I, who hate being troubled about dress, am quite *confusé*.' Landseer began his painting at the time of the ball, but, as was so often the case with this artist, progress was delayed and the picture was not finished until 1846.

The decision that Queen Victoria and Prince Albert should appear as Edward III and Queen Philippa was no doubt connected with the fact that the king was the founder of the Order of the Garter (see No. 64), but in general the fascination for the Age of Chivalry was already fairly widespread. The famous medieval tournament staged in adverse weather conditions by Archibald Montgomery, 13th Earl of Eglinton, in August 1839[2] had preceded the *bal costumé* of 1842, but both events are symptomatic of a serious revival that also had its lighter moments.

Notes: **1** M. Girouard, *The Return to Camelot. Chivalry and the English Gentleman*, London/New Haven 1981, pp. 112–14. **2** Ibid., pp. 90–110.

Literature: Millar 1992, no. 390.

DANIEL MACLISE 1806–1870

89 *A Scene from 'Undine'*

Canvas, 44.5 × 61 cm (17½ × 24 in.)

THE SUBJECT is based on a moment in a romantic German novel entitled *Undine*, written by Friedrich de la Motte Fouqué,[1] which was first translated into English in 1818 and became almost as popular with artists in England as Goethe's *Faust*.[2] The incident painted by Maclise occurs in chapter IX, where the young knight, Huldbrand, accompanies his bride, Undine, back home through the forest. The priest, Father Heilmann, who has just performed the marriage ceremony, follows behind and is visible beneath the branch of the tree. Ahead is the dark and sinister apparition, Kuhleborn, the spirit of the waters and the uncle of Undine. Huldbrand draws his sword on Kuhleborn and then strikes him, whereupon the spirit of the waters is transformed into a waterfall. Clearly the painting illustrates the forces of good, represented by the newly married couple, overcoming the power of evil, symbolised by the looming figure of the water god. The narrative element of the picture is aligned on a diagonal, which is contained within a bower populated by elves, goblins and water-nymphs associated with the surrounding forest. 'The picture is a pantheistic hymn to the sensuality of nature, concealed by the overtly heroic theme of the subject.'[3]

The composition is a triumph of design with the main elements of the story formed by an ornamental border of considerable intricacy. Maclise used other such borders for several of his book illustrations including those for *The Chimes* by Charles Dickens of 1844 and *Irish Melodies* by Thomas Moore of 1845. A contemporary critic writing in *The Times* in 1844 (7 May), when the painting was exhibited at the Royal Academy, referred to 'that stiffness of outline and exuberance of invention that characterizes one of the German border engravings.' Maclise has indeed here relied on German sources for the decorative features, and was clearly influenced by German illustrators such as F. A. M. Retzsch, E. Neureuther and J. B. Sonderland.[4] There was, in addition, a vogue for fairy painting inspired in part by the publication of Grimm's *Fairytales* in 1824 and Crofton Croker's *Fairy Legends* in 1825, but there were precedents also in the work of Henry Fuseli and William Blake. An outstanding work in this tradition is Richard Dadd's *Fairy-Feller's Masterstroke* (1855–64), once owned by the poet Siegfried Sassoon and now in the Tate Gallery, London.

Undine was acquired from the artist by Queen Victoria and presented to Prince Albert on his birthday, 26 August 1843. No doubt the German influence in the picture would have appealed to the prince. Dickens wrote in a letter to his American friend, Cornelius Conway Felton, on 1 September 1843, 'He [Maclise] is in great favour with the Queen, and paints secret pictures for her to put upon her husband's table on the morning of his birthday, and the like. But if he has a care, he will leave his mark on more enduring things than palace walls.'[5] There are two other paintings of literary subjects by Maclise in the Royal Collection, *Scene from 'Gil Blas'* and *Scene from 'Midas'*, both acquired by Queen Victoria in 1839.[6]

Maclise was of Irish origin and in 1827 he came to London, where he almost immediately gained recognition as a portrait draughtsman, drawing numerous likenesses for *Fraser's Magazine*. He painted historical and literary subjects, several as frescoes for the Palace of Westminster. Maclise formed close friendships with the novelists Charles Dickens and William Makepeace Thackeray as well as his compatriot, the poet Thomas Moore, and the politician Benjamin Disraeli. With all of these he shared an ebullience of character and a sense of humour, but this later gave way to melancholy and pessimism.

Notes: **1** 1st edn in German, 1811; 1st edn in English, 1818; with numerous subsequent editions. **2** See W. Vaughan, *German Romanticism and English Art*, New Haven/London 1979, pp. 106–18. **3** R. Ormond, *Daniel Maclise 1806–1870*, Arts Council of Great Britain, London 1972, no. 80. **4** Vaughan, op. cit., chapters IV and V. **5** *Letters of Charles Dickens*, 3, 1842–3, ed. M. House, G. Storey, K. Tillotson, Oxford 1974, pp. 547–51. **6** Millar 1992, nos. 484–5.

Literature: Millar 1992, no. 486.

90 *The Virgin and Child*

Canvas, 80.6 × 58.4 cm (31¾ × 23 in.)
Signed in monogram and dated: *WD 1845*

THE *Virgin and Child* was exhibited at the Royal
Academy in 1846, having been acquired by Prince Albert
for £80 during the previous year. Queen Victoria, who
first saw the painting in Buckingham Palace on 9 August
1845, described it in her *Journal* as 'a most beautiful pic-
ture of the Madonna & Child by Dyce, quite like an
Old Master and in the style of Raphael – so chaste and
exquisitely painted.' This is a perfectly valid piece of
criticism which can also be applied to an earlier painting
(possibly dating from 1838) of the same subject in the
Tate Gallery, London, and to the variant of the present
design in the Castle Museum, Nottingham. It is conceiv-
able that the composition in Nottingham, which is on
slate, was made in preparation for the present picture, but
there are nonetheless pronounced differences, as in the
background and its relationship to the figures, and the
lack of a kerchief covering the Virgin's head. The under-
lying subject of the Virgin and Child in the Tate Gallery
is maternal affection, whereas the compositions in the
Royal Collection and Nottingham concentrate more on
religious devotion.[1] All three paintings have composi-
tional affinities with Raphael, particularly works such as
the *Madonna del Granduca* (Florence, Palazzo Pitti), the
Madonna Tempi (Munich, Alte Pinakothek) and the large
'*Cowper Madonna*' (Washington, National Gallery of Art,
Mellon Collection). Dyce made a number of preparatory
studies for the *Virgin and Child* and in a surprisingly
wide variety of media – drawings, watercolours, oil and
apparently even fresco, although this last item may be the
painting on slate in Nottingham. All this preparatory
material was sold at the sale following Dyce's death
(Christie's, 5 May 1865). The pleasure that the *Virgin and
Child* gave to Queen Victoria and Prince Albert resulted
in the commission a year later of *Saint Joseph* to form a
pair. This was finished in 1847 and was thought by Prince
Albert to be finer than the *Virgin and Child*. Both pictures
were hung after Prince Albert's death in the Queen's Bed-
room at Osborne House, Isle of Wight. The queen herself
made a copy in pastel of the *Virgin and Child*.

Dyce was an important figure in the Victorian art world
and he shared with Prince Albert a concern for the public
role that art should play in society, both as regards edu-
cation and design. He held several influential positions,
including Superintendent of the School of Design in
London from 1837 to 1843; from 1844 he was Professor
of Fine Art at King's College, London University. He
was also closely involved in 1853 with proposals for the
development of the National Gallery, London, giving

Fig. 59 Julius Schnorr von Carolsfeld, *Madonna and Child*, 1820,
oil on canvas, 74 × 62 cm, Cologne, Wallraf-Richartz Museum.

Saint Joseph

Canvas, 79.1 × 54.6 cm (31⅛ × 21½ in.)

evidence to a Parliamentary Select Committee, but publishing his forthright suggestions separately. *The Vision of Saint Bernard* by Filippo Lippi was one of the paintings he recommended for purchase by the National Gallery.

As an artist Dyce was influential in his support for the revival of religious subject matter in art and for fresco painting. In both these areas he was affected by his visit to Rome in 1825 (and later in 1827–8, 1832 and 1845–6) where he established contact with German Nazarene artists like Frederick Overbeck and Julius Schnorr von Carolsfeld. Dyce thus formed a vital link between the Nazarenes in Germany and the Pre-Raphaelites in Britain. The *Virgin and Child* and *Saint Joseph* are both works that in their simplicity of design, purity of outline and restricted colour are comparable with paintings by Overbeck and Schnorr von Carolsfeld (Fig. 59). Dyce also became involved with several major joint commissions for frescoes, principally the Garden Pavilion at Buckingham Palace (1842–3) and the Palace of Westminster, where his main achievement was the Queen's Robing Room in the House of Lords (1847 onwards). In between these two projects he painted the fresco *Neptune assigning to Britannia the Empire of the Seas* for Prince Albert on the staircase at Osborne House. Ironically, he is today perhaps best known for two paintings in oil: *Titian's First Essay in Colour* (Aberdeen Art Gallery) and *Pegwell Bay: A Recollection of October 5 1858* (London, Tate Gallery). Dyce was an artist of omniverous interests extending from ecclesiology through geology to musical composition, specifically in connection with the Motett Society, which he established in 1844.

Notes: **1** W. Vaughan, *German Romanticism and English Art*, London/New Haven 1979, p. 199.

Literature: Millar 1992, nos. 227–8.

FRANS XAVIER WINTERHALTER 1805–1873

92 *The First of May 1851*

Canvas, 106.7 × 129.5 cm (42 × 51 in.)
Signed and dated: *F. Winterhalter 1851*

ALTHOUGH Queen Victoria appointed British artists to the post of Principal Painter, the efforts of Sir David Wilkie, Sir George Hayter and James Sant were supplemented by the work of certain European painters brought to the queen's attention. Such was the case with Winterhalter, who was born in Germany, but had an extremely successful career as a fashionable portrait painter based at the leading European courts. He was essentially a peripatetic artist of a truly international status who, with the help of studio assistants, had by the end of his life amassed a considerable financial fortune. First recommended to Queen Victoria by Louise, Queen of the Belgians, Winterhalter came to England in 1842 and subsequently worked regularly for the queen and her family over the next two decades. Queen Victoria had a very high opinion of Winterhalter, admiring particularly his ability to capture a likeness and his fresh, invigorating colour. In addition, the painter's dexterous brushwork and high finish were also praised, although doubts were quite rightly expressed about the accuracy of his drawing. Together with Landseer (see No. 88), Winterhalter provides a vivid record of Queen Victoria's court and he was responsible for many of the more important and lasting images of the queen and the Prince Consort. His achievement is in many respects comparable with Van Dyck's images of the early Stuart court.

The First of May 1851 is a cryptic title for a painting that shows the aged Duke of Wellington presenting a casket to his one-year-old godson, Prince Arthur, Duke of Connaught, who is supported by Queen Victoria. Behind these figures and forming the apex of a pyramidal composition is Prince Albert, half looking over his shoulder towards the Crystal Palace in the left background. Both the Duke of Wellington and Prince Albert are dressed in the uniform of Field Marshal and wear the Order of the Garter. In addition, Prince Albert wears the badge of the Golden Fleece. The painting derives its title from the fact that both the Duke of Wellington and Prince Arthur were born on 1 May, which was also the date of the inauguration of the Great Exhibition in Hyde Park. The Crystal Palace was the principal building in the Great Exhibition to which Prince Albert made such an important contribution. Queen Victoria recorded in her *Journal* that on 1 May 1851 the Duke of Wellington in fact gave a gold cup to Prince Arthur, as opposed to a casket, and received from him, as depicted here, a nosegay.

The painting was commissioned by Queen Victoria, but Winterhalter clearly encountered some difficulties in devising an appropriate composition. In the queen's words, he 'did not seem to know how to carry it out' and it was Prince Albert 'with his wonderful knowledge and taste' who gave Winterhalter the idea of using a casket. As regards the composition, and to a certain extent the iconography, the painting resembles an Adoration of the Magi, and, indeed, is not unlike works of that subject by sixteenth-century Italian painters such as Paolo Veronese.

Prince Arthur (1850–1942) was Queen Victoria's third son. As befitted a godson of the Duke of Wellington, he pursued an active military career, distinguishing himself during the Egyptian campaign of 1882, and was promoted to the rank of Field Marshal in 1902. Subsequently he was made Governor-General of Canada (1911) and retired from public life in 1928.

Literature: Millar 1992, no. 827.

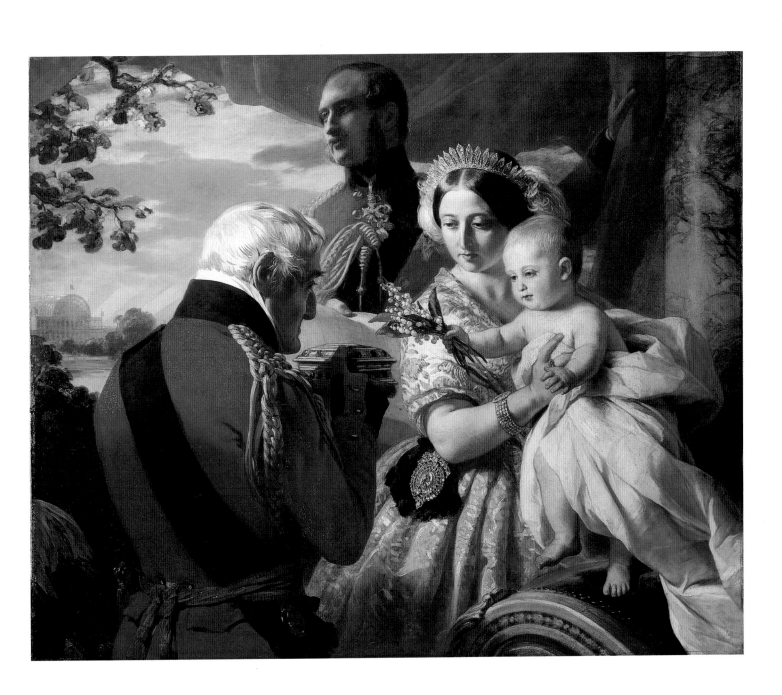

JOHANN MICHAEL WITTMER 1802–1880

93 # *Raphael's first sketch of the 'Madonna della Sedia'*

Canvas, 98.7 × 74.6 (38$\frac{7}{8}$ × 29$\frac{3}{8}$ in.)
Signed and dated: *M. Wittmer, f. 1853*

THE LIVES of famous artists became a popular subject for painters during the nineteenth century. This was partly the result of a serious revival of historical interest that influenced the discipline of art history during the middle decades of the century, and partly the result of the Romantic preoccupation with the workings of artistic genius.[1] Raphael was an obvious choice, since his undoubted success as a painter could be spiced with a rich variety of biographical details, including not only his dealings with powerful patrons but also his own personal relationships both as an infant prodigy and as a young man who died at the height of his creative powers. All these aspects of Raphael's life are encapsulated, for example, in the set of engravings published by Giovanni Riepenhausen in *Vita di Raffaello da Urbino disegnata ed incisa . . . in XII tavole*, published in Rome in 1833.[2]

The particular episode of Raphael painting the *Madonna della Sedia* seems to have a German origin. Sir Ernst Gombrich has demonstrated that the incident shown in the painting was first recounted in a children's book by Ernst von Houwald, published in 1820.[3] This records a legend whereby a hermit, on being attacked by a pack of wolves, escaped into the branches of a tree from which he was eventually rescued by a vintner's daughter. In gratitude the hermit prophesied that both the tree and the girl would be immortalised. After several years the daughter married and had two children. The tree was felled and its timber used for wine barrels. While walking through the countryside Raphael saw the young mother with her two children and, overcome by their beauty, felt impelled to paint them. On discovering that he had left his painting materials behind, he drew the group in chalk on the bottom of one of the wine barrels, thereby immortalising both the tree and the girl as the hermit prophesied. It also provided a totally specious explanation for the discovery of the tondo as a format for painting. Lithographs by August Hopfgarten dating from 1839[4] and by Achille Devéria dating from 1838[5] attest the popularity of the subject, which was considerably enhanced by the status of the original painting by Raphael, widely regarded as one of the most admired pictures in the world. A painting of the same subject by an Italian artist, Dionigi Faconti, in Turin (Galleria Civica d'Arte Moderna) achieved some success as a result of the artist's own early death in 1865,[6] but, otherwise, not many painted renderings are known. Wittmer has set the scene of his painting near Rome, since the Colosseum can be seen through the loggia on the left. The picture was apparently engraved.

Wittmer was born in northern Bavaria and trained as a goldsmith before entering the Academy in Munich in about 1820. He was a pupil of Johann Peter von Langer and Peter Cornelius, whom he assisted in painting the frescoes in the Glyptothek in about 1825. For several years he lived and worked in Italy (1828–32) before travelling in Sicily, Greece and Asia Minor. The main influences on his style were the Nazarene painters whom he met in Rome, namely Friedrich Overbeck and Johann Koch, whose daughter he married in 1838. He was essentially a history painter, but later in life he painted a number of altarpieces. The present painting was purchased by the Prince Consort in 1853. Two other paintings by the artist, *Aesop* and *Ossian*, are recorded at Osborne House, Isle of Wight, at an early date.

Notes: **1** F. Haskell, 'The Old Masters in Nineteenth-Century French Painting', in *Past and Present in Art and Taste. Selected Essays*, New Haven/London 1987, pp. 90–115. **2** See *Raffaello: elementi di un mito*, Biblioteca Medicea Laurenziana, Florence 1984, no. 1. **3** See E. Gombrich, 'Raphael's "Madonna della Sedia"', in *Norm and Form. Studies in the Art of the Renaissance*, London 1966, pp. 65–6. **4** Reproduced in Gombrich, op. cit., fig. 108. **5** Reproduced in A. Devéria, *Hommage à Raphael. Raphael et l'art francais*, Paris, Grand Palais, 1983–4, no. 274. **6** See *Raffaello: elementi di un mito*, no. 18.

Literature: Osborne 1876, II, p. 346.

FERDINAND GEORG WALDMÜLLER 1793–1865

94 *The Grandmother's Birthday*

Panel, 71 × 57.8 cm (28 × 22¾ in.)
Signed and dated: *1856*

WALDMÜLLER was the most important Austrian painter
of the Biedermeier period during the first half of the
nineteenth century. Within his lifetime he established a
reputation in America, and there was a major exhibition
of his work in London in 1862. He was proficient in most
aspects of painting – miniatures, landscape, portraits and
genre. His career within the art establishment was suc-
cessful, but not without controversy. Appointed Professor
at the Academy in Vienna in 1829, he was an advocate of
realist painting and of reform, which led to his temporary
dismissal from the post from 1857–64. Nonetheless,
Waldmüller was an effective teacher, an influential the-
orist, and an immensely popular artist within Viennese
society and at court. His success as a painter stemmed
from his powers of observation, from his measured style
and his wholly sympathetic treatment of subject matter.
The accumulation and faithful recording of detail led to
an idealism based on the subject matter itself, as opposed
to one imposed upon it by an outside order, this being a
vital distinction between eighteenth- and nineteenth-
century art.

The Grandmother's Birthday was given to Queen Vic-
toria by the Prince Consort on the queen's birthday, 24
May 1857. Another picture by Waldmüller, *The Surprise*
of 1853, was given to the Prince Consort by the queen at
Christmas 1857, but it is no longer in the collection. It
would be hard to find an artist who combined to such a
high degree those aspects of art that they both so appreci-
ated. Rustic genre was the last theme that Waldmüller
essayed. The subjects he chose extolled the moral virtues
of rural life, or, as here, the joys of family life. The care
taken over the rendering of garments, the still life and the
surroundings is offset by the radiance of the figures'
expressions, reinforced by their gestures which create a
circular composition of great tenderness. Waldmüller was
well-versed in the tradition of the Old Masters and the
composition has affinities with several paintings by
Raphael of the Holy Family – the *Madonna Canigiani*
(Munich, Alte Pinakothek), the *Madonna dell'Impannata*
(Florence, Palazzo Pitti), the *Madonna of Francis I* (Paris,
Louvre) and the *Madonna della Perla* (Madrid, Prado), this
last formerly in the collection of Charles I. Waldmüller's
homage to Raphael, however, is seen through the eyes
of Correggio.

Literature: Osborne 1876, p. 417.

BERNARDINO PINTORICCHIO c.1454–1513

95 The Virgin and Child

Panel, 57.5 × 40 cm (22⅝ × 15¾ in.)

THERE ARE a number of similar compositions in Pintoricchio's oeuvre in the Kress collection (Raleigh, Museum of Art), Boston (Isabella Stewart Gardner Museum), Cambridge (Fitzwilliam Museum) and Oxford (Ashmolean Museum). All these paintings date from the final quarter of the fifteenth century and reveal the emergence of the artist's mature style. In the present painting the influence of Fiorenzo di Lorenzo is still apparent, although the pyramidal composition of the Virgin and Child is not unrelated to contemporary Florentine art, as evidenced by the works of Ghirlandaio and Verrocchio. The landscape remains wholly Umbrian in style. Carli suggests a date of about 1475–80.

The painter was in great demand as a frescoist, his chief works being in Rome (Vatican, Borgia Apartments), Siena (Duomo, Libreria Piccolomini) and Spello (Collegiata di Santa Maria).

The picture was bought in Paris in August 1815 by Count Joseph von Rechberg (1769–1833), who sold it in September of the same year to Prince Ludwig Kraft Ernst von Oettingen Wallerstein (1791–1870), whose collection was deposited with Prince Albert in 1847 as collateral for a financial loan. The collection was on view prior to sale at Kensington Palace in 1848, but failed to find a buyer, at which point it became the property of Prince Albert. *The Virgin and Child* was among a number of pictures from the collection that were given by Queen Victoria to the National Gallery, London, in 1863 in memory of the Prince Consort and in accordance with his wishes. Of the paintings from the Oettingen Wallerstein collection presented to the Gallery, those from the Italian school are perhaps the least impressive, apart from the triptych by Giusto de' Menabuoi.

Literature: M. Davies, *The Earlier Italian Schools*, 2nd rev. edn, London 1961, p. 436.

246

96 # Saint Christopher carrying the Infant Christ

Panel, 25 × 54.5 cm (9¾ × 21½ in.)

THE ARTIST was a follower of Joachim Patenier in whose studio he appears to have been trained during the early 1520s. He established his own highly productive studio in Antwerp, although the influence of painters like 'Adriaen Ysenbrandt' and Ambrosius Benson from Bruges is also evident.

The long low horizon with the view of a castle, a town and a port depicted in soft tones of blue, green and grey-green, is highly characteristic of the painter and shows Patenier's influence. The broad panorama and wide perspective creates a sense of calm enfolding the figures of Saint Christopher and the Christ Child. The incident is recorded in *The Golden Legend* by Jacobus de Voragine. The saint was a man of large stature who carried the Christ Child across a ford, thus winning for himself the accolade of patron saint of travellers. The discrepancy in size between the two figures is usually exaggerated in paintings. The figures, including the hermit on the right, may be by a different hand, perhaps by a follower of Quinten Massys. Such an act of collaboration may explain why this workshop was so productive. The pose of Saint Christopher may ultimately be derived from the tradition of Van Eyck as continued by Dieric Bouts.

The panel was in the collection of Prince Ludwig Kraft Ernst von Oettingen Wallerstein (1791–1870). It was acquired in 1815, possibly from Count Joseph von Rechberg (1769–1833). The Oettingen Wallerstein collection was offered as collateral to Prince Albert for a financial loan and was on view prior to sale at Kensington Palace in 1848. The collection failed to sell and thus became the property of Prince Albert. In 1863, after his death, Queen Victoria presented the National Gallery, London, with a number of paintings from the collection in accordance with the Prince Consort's wishes. Among them was the present picture and No. 95.

Literature: M. Davies, *Early Netherlandish School*, 3rd rev. edn, London 1968, pp. 117–18.

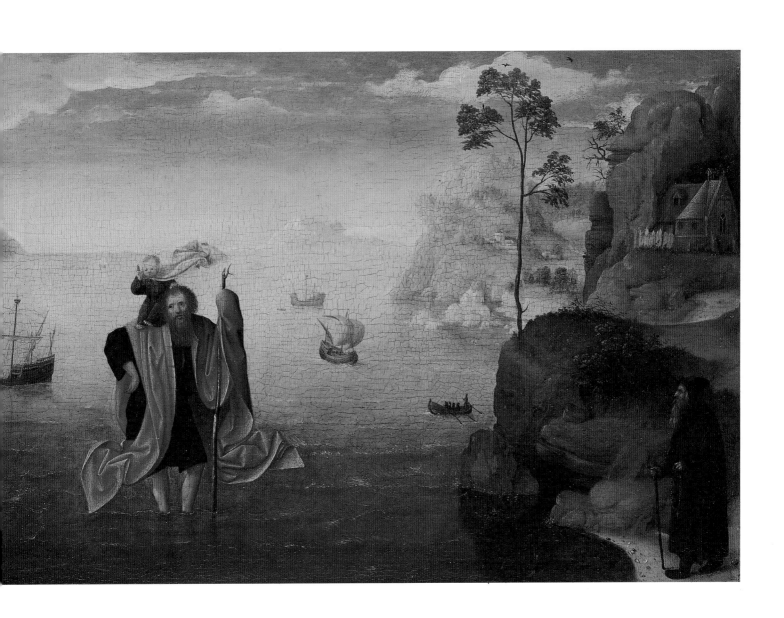

Index of Paintings

Bibliography

BOOKS AND ARTICLES

Adler 1982
W. Adler, *Corpus Rubenianum Ludwig Burchard. Part XVIII. Landscapes and Hunting Scenes*, London 1982

Aillaud, Blankert, Montias 1986
G. Aillaud, A. Blankert, J. M. Montias, *Vermeer*, Paris 1986

Altick 1985
R. D. Altick, *Paintings from Books. Art and Literature in Britain 1760–1900*, Ohio State University Press 1985

Arnold 1977
J. Arnold, 'Elizabethan and Jacobean Smocks and Shirts', *Waffen und Kostümkunde*, xix, 1977, pp. 89–110

Brown 1982
C. Brown, *Van Dyck*, Oxford 1982

Burchard and d'Hulst 1963
L. Burchard and R.-A. d'Hulst, *Rubens Drawings*, Brussels 1963

Buttery 1987
D. Buttery, 'The Picture Frames of Paul Petit, and Frederick, Prince of Wales', *Apollo*, cxxvi, 1987, pp. 12–15

Campbell 1985
L. Campbell, *The Early Flemish Pictures in the Collection of Her Majesty The Queen*, Cambridge University Press 1985

Campbell 1990
L. Campbell, *Renaissance Portraits: European Portrait-Painting in the 14th, 15th and 16th Centuries*, New Haven/London 1990

Castagna and Lorenzoni 1989
R. Castagna and A. M. Lorenzoni, 'Un presunto ritratto di Isabella d'Este eseguito da Giulio Romano', *Civiltà mantovana*, xxv, 1989, pp. 15–26

Clifford 1976
T. Clifford, 'Polidoro and English Design', *Connoisseur*, cxcii, 1976, pp. 282–91

Constable/Links 1989
W. G. Constable, *Canaletto*, 2nd edn (revised by J. G. Links with supplement), Oxford University Press 1989

Corpus 1982–
J. Bruyn, B. Haak, S. H. Levie, et al., *A Corpus of Rembrandt Paintings*, The Hague/Boston/London 1982–

Crelly 1962
W. R. Crelly, *The Painting of Simon Vouet*, New Haven/London 1962

Croft-Murray 1947
E. Croft-Murray, 'The Landscape Background in Rubens's St George and the Dragon', *Burlington Magazine*, lxxix, 1947, pp. 89–93

Von Erffa and Staley 1986
H. von Erffa and A. Staley, *The Paintings of Benjamin West*, New Haven/London 1986

Ertz 1979
K. Ertz, *Jan Brueghel der Ältere (1568–1625): Die Gemälde mit kritischem Oeuvrekatalog*, Köln 1979

Fletcher and Tapper 1983
J. Fletcher and M. Cholmondeley Tapper, 'Hans Holbein the Younger at Antwerp and in England, 1526–8', *Apollo*, cxvii, 1983, pp. 87–93

Friedländer and Rosenberg 1978
M. J. Friedländer and J. Rosenberg, *The Paintings of Lucas Cranach*, revised edn, Cornell University Press 1978

Gainsborough Letters 1963
The Letters of Thomas Gainsborough, 2nd edn (revised and edited by M. Woodall), Ipswich 1963

Garlick 1989
K. Garlick, *Sir Thomas Lawrence*, Oxford 1989

Garrard 1989
M. D. Garrard, *Artemisia Gentileschi: The Image of the Female Hero in Italian Baroque Art*, Princeton University Press 1989

Gerson and Ter Kuile 1960
H. Gerson and E. H. Ter Kuile, *Art and Architecture in Belgium 1600–1800*, Harmondsworth 1960

Girouard 1981
M. Girouard, *The Return to Camelot. Chivalry and the English Gentleman*, London/New Haven 1981

Haskell 1976
F. Haskell and N. Penny, *Taste and the Antique: The Lure of Classical Sculpture 1500–1900*, New Haven/London 1981

Haskell and Penny 1981
F. Haskell and N. Penny, *Taste and the Antique: The Lure of Classical Sculpture 1500–1900*, New Haven/London 1981

Hayes 1975
J. Hayes, *Gainsborough Paintings and Drawings*, London 1975

Holman 1980
T. S. Holman, 'Holbein's Portraits of the Steelyard Merchants: An Investigation', *Metropolitan Museum Journal*, xiv, 1980, pp. 139–58

King 1989
J. N. King, *Tudor Royal Iconography. Literature and Art in an Age of Religious Crisis*, Princeton University Press 1989

Jaffé 1989
M. Jaffé, *Rubens Catalogo Completo*, Milan 1989

Kitson 1967
M. Kitson, 'Claude Lorrain: Two Unpublished Paintings and the Problem of Variants', *Studies in Renaissance and Baroque Art Presented to Anthony Blunt on his 60th Birthday*, London 1967

Kitson 1973
M. Kitson, 'Claude's earliest "Coast Scene with the Rape of Europa"', *Burlington Magazine*, cxv, 1973, pp. 775–9

Kitson 1978
M. Kitson, *Claude Lorrain: Liber Veritatis*, London 1978

Koepplin and Falk 1974
D. Koepplin and T. Falk, *Lukas Cranach. Gemälde, Zeichnungen, Druckgraphik*, Basel/Stuttgart 1974

Krummacher 1963
H. Krummacher, 'Zu Holbeins Bildnissen rheinischer Stahlhofkaufleute', *Wallraf-Richartz Jahrbuch*, xxv, 1963, pp. 181–92

Larsen 1988
E. Larsen, *The Paintings of Anthony van Dyck*, Freren 1988

Levey 1975
M. Levey, 'Lawrence's Portrait of Pope Pius VII', *Burlington Magazine*, cxvii, 1975, pp. 194–204

Levey 1991
M. Levey, *The Later Italian Pictures in the Collection of Her Majesty The Queen*, 2nd edn, Cambridge University Press 1991

Lowenthal 1990
A. W. Lowenthal, *Netherlandish Mannerism in British Collections*, L. and R. Entwistle Gallery, London 1990

Markow 1978
D. Markow, 'Hans Holbein's Steelyard Portraits reconsidered', *Wallraf-Richartz Jahrbuch*, xl, 1978, pp. 39–47

Mérot 1987
A. Mérot, *Eustache le Sueur (1616–1655)*, Paris 1987

Millar 1963
O. Millar, *The Tudor, Stuart and Early Georgian Pictures in the Collection of Her Majesty The Queen*, Oxford 1963

Millar 1969
O. Millar, *The Later Georgian Pictures in the Collection of Her Majesty The Queen*, Oxford 1969

Millar 1977
O. Millar, 'Rubens's Landscapes in the Royal Collection: The Evidence of X-ray', *Burlington Magazine*, cxix, 1977, pp. 631–5

Millar 1992
O. Millar, *The Victorian Pictures in the Collection of Her Majesty The Queen*, Cambridge University Press 1992

Montias 1989
J. M. Montias, *Vermeer and his Milieu. A Web of Social History*, Princeton University Press 1989

Montrose 1980
L. A. Montrose, 'Gifts and Reasons: the Contexts of Peele's "Araygnement of Paris"', *English Literary History*, 47, 1980

Nicolson and Wright 1974
B. Nicolson and C. Wright, *Georges de la Tour*, London 1974

Nicolson 1979
B. Nicolson, *The International Caravaggesque Movement: Lists of Pictures by Caravaggio and his Followers Throughout Europe from 1590 to 1650*, Oxford 1979

Oettinger and Knappe 1963
K. Oettinger and K. A. Knappe, *Hans Baldung Grien und Albrecht Dürer in Nürnberg*, Nürnberg 1963

Offner, 1990
R. Offner, *A Critical and Historical Corpus of Florentine Painting: The Fourteenth Century. The Works of Bernardo Daddi*, section 3, vol. 3, new edn (ed. M. Boskovits), Florence 1990

Oldenbourg 1921
R. Oldenbourg, *P. P. Rubens: Der Meisters Gemälde*, Klassiker der Kunst, Stuttgart/Berlin 1921

Olson 1986
R. J. M. Olson, 'Representations of Pope Pius VII: The First Risorgimento Hero', *Art Bulletin*, lxviii, 1986, pp. 77–93

Osborne 1876
Catalogue of the Paintings, Sculpture and Works of Art at Osborne, London 1876

Osten 1983
G. Osten, *Hans Baldung Grien: Gemälde und Dokumente*, Berlin 1983

Pallucchini and Rossi 1982
R. Pallucchini and P. Rossi, *Tintoretto: Le opere sacre e profane*, Milan 1982

Paulson 1975
R. Paulson, *Emblem and Expression: Meaning in English Art of the Eighteenth Century*, London 1975

Pressly 1987
W. L. Pressly, 'Genius Unveiled: The Self-Portraits of Johann Zoffany', *Art Bulletin*, lxix, 1987, pp. 88–101

Roberts 1979
J. Roberts, *Holbein*, London 1979

Rooses 1886–92
M. Rooses, *L'Oeuvre de P. P. Rubens*, Antwerp 1886–92

Rosenberg and Macé de l'Epinay 1973
P. Rosenberg and F. Macé de l'Epinay, *Georges de la Tour: vie et oeuvre*, Fribourg 1973

Röthlisberger 1961
M. Röthlisberger, *Claude Lorrain: The Paintings*, New Haven 1961

Röthlisberger 1968
M. Röthlisberger, *Claude Lorrain: The Drawings*, Berkeley/Los Angeles 1968

Röthlisberger 1975
M. Röthlisberger, *L'Opera completa di Claude Lorrain*, Milan 1975

Rowlands 1985
J. Rowlands, *Holbein: The Paintings of Hans Holbein the Younger*, Oxford 1985

Shearman 1983
J. Shearman, *The Early Italian Pictures in the Collection of Her Majesty The Queen*, Cambridge University Press 1983

Smith 1829–42
J. T. Smith, *A Catalogue Raisonné of the Works of the Most Eminent Dutch, Flemish and French Painters*, London 1829–42

Stewart 1983
J. Douglas Stewart, *Sir Godfrey Kneller and the English Baroque Portrait*, Oxford University Press 1983

Strong 1963
R. Strong, *Portraits of Queen Elizabeth I*, London 1963

Strong 1969
R. Strong, *The English Icon: English and Jacobean Portraiture*, London 1969

Strong 1972
R. Strong, *Van Dyck: Charles I on Horseback*, London 1972

Strong 1978
R. Strong, *And when did you last see your father! The Victorian Painter and British History*, London 1978

Strong 1979
R. Strong, *The Renaissance Garden in England*, London 1979

Strong 1987
R. Strong, *Gloriana: The Portraits of Queen Elizabeth I*, London 1987

Strong 1992
R. Strong, '"My weeping stagg I crowne": The Persian Lady Reconsidered', *The Art of the Emblem: Essays in Honour of K. J. Höltgen* (ed. M. Bath and A. Young), New York 1992

Tafuri 1989
M. Tafuri, 'Giulio Romano: linguaggio, mentalità, committenti', *Giulio Romano*, exhibition catalogue, Palazzo Te/Palazzo Ducale, Mantua/Milan 1989

Thuillier 1973
J. Thuillier, *L'Opera completa di Georges de la Tour*, Milan 1973

Veevers 1989
E. Veevers, *Images of Love and Religion: Queen Henrietta Maria and court entertainments*, Cambridge University Press 1989

Vertue 1930–55
G. Vertue, Note Books, 6 vols with index vol., *Walpole Society*, vols XVIII (1930), XX (1932), XXII (1934), XXIV (1936), XXVI (1938), XXIX (1947), XXX (1955)

Waterhouse 1962
E. K. Waterhouse, *Painting in Britain 1530 to 1790*, 2nd edn, Harmondsworth 1962

Wendorf 1990
R. Wendorf, *The Elements of Life: Biography and Portrait-Painting in Stuart and Georgian England*, Oxford University Press 1990

White 1982
C. White, *The Dutch Pictures in the Collection of Her Majesty The Queen*, Cambridge University Press 1982

White 1987
C. White, *Peter Paul Rubens: Man and Artist*, New Haven/London 1987

Wilenski 1960
R. H. Wilenski, *Flemish Painters 1430–1830*, London 1960

Wilson 1977
M. I. Wilson, 'Gainsborough, Bath and Music', *Apollo*, CV, 1977, pp. 107–10

Yates 1975
F. A. Yates, *Astraea: The Imperial Theme in the Sixteenth Century*, London 1975

EXHIBITIONS

Baltimore, The Baltimore Museum of Art, 1989
Benjamin West: American Painter at the English Court, The Baltimore Museum of Art, 4 June – 20 August 1989

Berlin, Schloss Charlottenburg, 1973
China und Europa: Chinaverständnis und Chinamode im 17. und 18. Jahrhundert, Schloss Charlottenburg, Berlin, 16 September – 11 November 1973

Birmingham City Museum and Art Gallery, 1989–90
Images of a Golden Age: Dutch Seventeenth-Century Paintings, Birmingham City Museum and Art Gallery, 7 October 1989 – 14 January 1990

Florence, Palazzo Strozzi, 1986–7
Il seicento fiorentino, Palazzo Strozzi, Florence, 21 December 1986 – 4 May 1987

Frederiksborg, Nationalhistoriske Museum, 1990
Laurits Tuxen Portraetter og historiemalerier, Nationalhistoriske Museum, Frederiksborg, 10 September – 25 November 1990

Hampton Court Palace, 1990–1
Henry VIII: Images of a Tudor King, Hampton Court Palace, 13 September 1990 – 14 April 1991

Karlsruhe, Staatliche Kunsthalle, 1959
Hans Baldung Grien, Staatliche Kunsthalle, Karlsruhe, 4 July – 27 September 1959

Leeds, Leeds City Art Gallery, 1989
Images of Women, Leeds City Art Gallery, 1989

Leicester, Leicestershire Museum and Art Gallery/London, 1965–6
Hans Eworth: A Tudor Artist and his Circle, Leicestershire Museum and Art Gallery, Leicester, and National Portrait Gallery, London, 10 November – 28 November 1965 and 14 December 1965 – 9 January 1966

London, Arts Council of Great Britain, 1973
The King's Arcadia: Inigo Jones and the Stuart Court, The Arts Council at the Banqueting House, Whitehall, London, 12 July – 2 September 1973

London, Arts Council of Great Britain/Leicester/Liverpool, 1974–5
British Sporting Painting 1650–1850, The Arts Council at the Hayward Gallery, London, Leicestershire Museum and Art Gallery, Leicester, and Walker Art Gallery, Liverpool, 13 December 1974 – 23 February 1975, 8 March – 6 April 1975 and 25 April – 25 May 1975

London, Hayward Gallery, 1969
The Art of Claude Lorrain, Hayward Gallery, London, 7 November – 14 December 1969

London, Kenwood, 1977
Gainsborough and his Musical Friends, The Iveagh Bequest, Kenwood, London, 5 May – 7 June 1977

London, Kenwood, 1984
John Wootton 1682–1764: Landscapes and Sporting Art in early Georgian England, The Iveagh Bequest, Kenwood, London, 4 July – 30 September 1984

London, National Portrait Gallery, 1971
Sir Godfrey Kneller, National Portrait Gallery, London, 1971

London, National Portrait Gallery, 1977
Johann Zoffany 1733–1810, National Portrait Gallery, London, 14 January – 27 March 1977

London, National Portrait Gallery, 1979–80
Sir Thomas Lawrence 1769–1830, National Portrait Gallery at 15 Carlton House Terrace, London, 9 November 1979 – 16 March 1980

London, National Portrait Gallery, 1982–3
Van Dyck in England, National Portrait Gallery, London, 19 November 1982 – 20 March 1983

London, Royal Academy of Arts, 1946–7
The King's Pictures, Royal Academy of Arts, London, 1946–7

London, Royal Academy of Arts, 1953–4
Flemish Art 1300–1700, Royal Academy of Arts, London, 1953–4

London, Royal Academy of Arts, 1983–4
The Genius of Venice 1500–1600, Royal Academy of Arts, London, 25 January 1983 – 11 March 1984

London, Royal Academy of Arts, 1986
Reynolds, Royal Academy of Arts, London, 16 January – 31 March 1986

London, Royal Academy of Arts/Cambridge, 1979
Painting in Florence 1600–1700, Royal Academy of Arts, London, and Fitzwilliam Museum, Cambridge, 20 January – 18 February and 27 February – 28 March 1979

London, Tate Gallery, 1972–3
The Age of Charles I: Painting in England 1620–1649, Tate Gallery, London, 15 November 1972 – 14 January 1973

London, Tate Gallery, 1980–1
Thomas Gainsborough, Tate Gallery, London, 8 October 1980 – 4 January 1981

London, Tate Gallery/New Haven, 1984–5
George Stubbs 1724–1806
Tate Gallery, London, and Yale Center for British Art, New Haven, 17 October 1984 – 6 January 1985 and 13 February – 7 April 1985

London, Victoria and Albert Museum, 1981–2
Splendours of the Gonzaga, Victoria and Albert Museum, London, 4 November 1981 – 31 January 1982

London, Victoria and Albert Museum, 1984
Rococo Art and Design in Hogarth's England, Victoria and Albert Museum, London, 16 May – 30 September 1984

Manchester, City Art Gallery, 1961
German Art 1400–1800, City Art Gallery, Manchester, 24 October – 10 December 1961

Manchester, City Art Gallery, 1965
Between Renaissance and Baroque European Art 1520–1600, City Art Gallery, Manchester, 10 March – 6 April 1965

Manchester, City Art Gallery/Amsterdam/New Haven, 1987–8
Hard Times: Social Realism in Victorian Art, City Art Gallery, Manchester, Rijksmuseum Vincent Van Gogh, Amsterdam, and Yale Center for British Art, New Haven, 1987–8

New York, Metropolitan Museum of Art, 1989–90
Canaletto, Metropolitan Museum of Art, New York, 30 October 1989 – 21 January 1990

Norwich, Castle Museum, 1955
Still-Life, Bird and Flower Paintings (of the 17th and 18th centuries), Castle Museum, Norwich, 8 October – 4 December 1955

Paris, Grand Palais, 1990–1
Vouet, Galeries nationales du Grand Palais, Paris, 6 November 1990 – 11 February 1991

Paris, Orangerie, 1972
Georges de la Tour, Orangerie des Tuileries, Paris, 10 May – 25 September 1972

Philadelphia, Philadelphia Museum of Art/Berlin/London, 1984
Masters of Seventeenth-Century Dutch Genre Painting, Philadelphia Museum of Art, Gemäldegalerie, Staatliche Museen, Berlin, and Royal Academy of Arts, London, 18 March – 13 May 1984, 8 June – 12 August 1984 and 7 September – 18 November 1984

Raleigh, North Carolina Museum of Art/New Haven, 1987
Sir David Wilkie of Scotland (1785–1841), North Carolina Museum of Art, Raleigh, and Yale Center for British Art, New Haven, 1987

Washington, National Gallery of Art, 1985–6
The Treasure Houses of Britain: Five Hundred Years of Private Patronage and Art Collecting, National Gallery of Art, Washington, 3 November 1985 – 16 March 1986

Washington, National Gallery of Art, 1990–1
Anthony van Dyck, National Gallery of Art, Washington, 1990–1

Washington, National Gallery of Art/Paris, 1982–3
Claude Lorrain 1600–1682, National Gallery of Art, Washington, and Galeries nationales du Grand Palais, Paris, 17 October 1982 – 2 January 1983 and 15 February – 16 May 1983

Picture Credits

Amsterdam, Rijksmuseum: Figs. 44, 47.

Blackburn, Blackburn Museum and Art Gallery: Fig. 54, reproduced courtesy of Blackburn Museum and Art Gallery.

Bologna, Pinacoteca Nazionale: Fig. 36.

Cambridge, Fitzwilliam Museum: Fig. 38.

Cologne, Rheinische Bildarchiv: Fig. 59.

Cracow, National Museum: Fig. 35.

Leningrad, Hermitage Museum: Fig. 5.

Liverpool, Lady Lever Art Gallery: Fig. 1, the Board and Trustees of the National Museums and Galleries on Merseyside.

London, British Library: Figs. 25, 32.
British Museum, Department of Prints and Drawings: Figs. 23, 24, 33, 37, 42, 43, 58.
Illustrated London News Picture Library: Fig. 60.
National Portrait Gallery: Figs. 8, 21, by courtesy of the National Portrait Gallery, London.
National Trust Photograph Library: Fig. 13.
Society of Dilettante: Fig. 6, photo: Courtauld Institute of Art.
Victoria and Albert Museum: Fig. 55, courtesy of the Trustees of the V&A.

New York, Metropolitan Museum of Art: Fig. 31, Bequest of Benjamin Altman, 1913 (14.40.619). All rights reserved. The Metropolitan Museum of Art. Fig. 41, Gift of James Henry Smith, 1902 (02.24). All rights reserved. The Metropolitan Museum of Art.

Oxford, Bodleian Library, University of Oxford: Fig. 9.
Christ Church: Fig. 39, The Governing Body, Christ Church, Oxford.

The Royal Collection: Front and back covers, pages 6–7 (busts: photo. Courtauld Institute of Art), cat. nos. 1–94, Figs. 2–4, 14, 15, 22, 40, 51 (Graham Johnson), 52, 56 (Sir Oliver Millar), reproduced by gracious permission of Her Majesty The Queen.

The Royal Photograph Collection: Figs. 16, 17 (photo: John Freeman), 18, 29, reproduced by gracious permission of Her Majesty The Queen.

Santa Barbara, Museum of Art: Fig. 53.

Vienna, Kunsthistorisches Museum: Fig. 12.

Windsor Castle, Royal Library © 1991 Her Majesty The Queen: Figs. 10, 11, 19 (19783), 20 (26224), 26 (22176), 27, 28, 48–50.

Fig. 60 Sir Alfred Munnings, President of the Royal Academy, conducts Queen Elizabeth, Princess Elizabeth and Princess Margaret round the galleries prior to the opening of the exhibition of 'The King's Pictures' at the Royal Academy in 1946.